Canon' EOS 70D

DUMMIES A Wiley Brand

by Julie Adair King

Canon® EOS 70D For Dummies®

Published by: John Wiley & Sons, Inc., 111 River Street, Hoboken, NJ 07030-5774, www.wiley.com

Copyright © 2014 by John Wiley & Sons, Inc., Hoboken, New Jersey

Published simultaneously in Canada

No part of this publication may be reproduced, stored in a retrieval system or transmitted in any form or by any means, electronic, mechanical, photocopying, recording, scanning or otherwise, except as permitted under Sections 107 or 108 of the 1976 United States Copyright Act, without the prior written permission of the Publisher. Requests to the Publisher for permission should be addressed to the Permissions Department, John Wiley & Sons, Inc., 111 River Street, Hoboken, NJ 07030, (201) 748-6011, fax (201) 748-6008, or online at http://www.wiley.com/go/permissions.

Trademarks: Wiley, For Dummies, the Dummies Man logo, Dummies.com, Making Everything Easier, and related trade dress are trademarks or registered trademarks of John Wiley & Sons, Inc. and may not be used without written permission. Canon is a registered trademark of Canon, Inc. All other trademarks are the property of their respective owners. John Wiley & Sons, Inc. is not associated with any product or vendor mentioned in this book.

LIMIT OF LIABILITY/DISCLAIMER OF WARRANTY: THE PUBLISHER AND THE AUTHOR MAKE NO REPRESENTATIONS OR WARRANTIES WITH RESPECT TO THE ACCURACY OR COMPLETENESS OF THE CONTENTS OF THIS WORK AND SPECIFICALLY DISCLAIM ALL WARRANTIES, INCLUDING WITH-OUT LIMITATION WARRANTIES OF FITNESS FOR A PARTICULAR PURPOSE. NO WARRANTY MAY BE CREATED OR EXTENDED BY SALES OR PROMOTIONAL MATERIALS. THE ADVICE AND STRATEGIES CONTAINED HEREIN MAY NOT BE SUITABLE FOR EVERY SITUATION. THIS WORK IS SOLD WITH THE UNDERSTANDING THAT THE PUBLISHER IS NOT ENGAGED IN RENDERING LEGAL, ACCOUNTING, OR OTHER PROFESSIONAL SERVICES. IF PROFESSIONAL ASSISTANCE IS REQUIRED, THE SERVICES OF A COMPETENT PROFESSIONAL PERSON SHOULD BE SOUGHT. NEITHER THE PUBLISHER NOR THE AUTHOR SHALL BE LIABLE FOR DAMAGES ARISING HEREFROM. THE FACT THAT AN ORGANIZA-TION OR WEBSITE IS REFERRED TO IN THIS WORK AS A CITATION AND/OR A POTENTIAL SOURCE OF FURTHER INFORMATION DOES NOT MEAN THAT THE AUTHOR OR THE PUBLISHER ENDORSES THE INFORMATION THE ORGANIZATION OR WEBSITE MAY PROVIDE OR RECOMMENDATIONS IT MAY MAKE. FURTHER, READERS SHOULD BE AWARE THAT INTERNET WEBSITES LISTED IN THIS WORK MAY HAVE CHANGED OR DISAPPEARED BETWEEN WHEN THIS WORK WAS WRITTEN AND WHEN IT IS READ.

For general information on our other products and services, please contact our Customer Care Department within the U.S. at 877-762-2974, outside the U.S. at 317-572-3993, or fax 317-572-4002. For technical support, please visit www.wiley.com/techsupport.

Wiley publishes in a variety of print and electronic formats and by print-on-demand. Some material included with standard print versions of this book may not be included in e-books or in print-on-demand. If this book refers to media such as a CD or DVD that is not included in the version you purchased, you may download this material at http://booksupport.wiley.com. For more information about Wiley products, visit www.wiley.com.

Library of Congress Control Number: 2013949523

ISBN 978-1-118-33596-3 (pbk); ISBN 978-1-118-338596-3 (ebk); ISBN 978-1-118-46187-7 (ebk)

Manufactured in the United States of America

10 9 8 7 6 5 4 3 2 1

Part 111: Taking Creative Control	205
Chapter 7: Getting Creative with Exposure	207
Kicking Your Camera into High Gear	207
Introducing Exposure Basics: Aperture,	
Shutter Speed, and ISO	209
Understanding exposure-setting side effects	
Doing the exposure balancing act	
Monitoring Exposure Settings	
Choosing an Exposure Metering Mode	
Setting ISO, f-stop, and Shutter Speed	
Controlling ISO	
Adjusting aperture and shutter speed	
Sorting through Your Camera's Exposure-Correction Tools	227
Overriding autoexposure results	
with Exposure Compensation	227
Improving high-contrast shots	
Experimenting with Auto Lighting Optimizer	236
Correcting vignetting with Peripheral	
Illumination Correction	
Dampening noise	
Locking Autoexposure Settings	
Bracketing Exposures Automatically	246
Setting up for automatic bracketing	247
Shooting a bracketed series	
Using Flash in Advanced Exposure Modes	
Understanding your camera's approach to flash	
Using flash outdoors	255
Adjusting flash power with Flash	
Exposure Compensation	
Locking the flash exposure	
Exploring more flash options	260
Chapter 8: Manipulating Focus and Color	265
Reviewing Focus Basics	
Introducing the AF-ON button	
Adjusting Autofocus Performance	
AF Area mode: One focus point or many?	
Changing the AF (autofocus) mode	
Choosing the right autofocus combo	
Manipulating Depth of Field	
mampalating Depth of Field	414

Part 11:	Working with Picture Files	145
Cha	pter 5: Picture Playback	147
	Disabling and Adjusting Image Review	
	Exploring Playback Mode	148
	Switching to Index (thumbnails) view	
	Using the Quick Control screen during playback	
	Jumping through images	
	Rotating pictures	
	Zooming in for a closer view	156
	Viewing Picture Data	
	Basic Information display data	
	Shooting Information display mode	160
	Understanding Histogram display mode	
	Enabling a few display extras	
	Deleting Photos	
	Erasing single images	
	Erasing all images on the memory card	
	Erasing selected images	167
	Protecting Photos	169
	Protecting (or unprotecting) a single photo	
	Protecting multiple photos	170
	Rating Photos	172
	Viewing Your Photos on a Television	174
Cha	pter 6: Downloading, Printing, and Sharing Your Photos \dots	177
	Installing the Canon Software	178
	Sending Pictures to the Computer	
	Connecting camera and computer via USB	
	Connecting to the computer via Wi-Fi	
	Downloading from the camera	
	Downloading from a card reader	
	Processing Raw (CR2) Files	
	Processing Raw images in the camera	
	Converting Raw images in Digital Photo Professional	
	Planning for Perfect Prints	
	Check the pixel count before you print	
	Allow for different print proportions	
	Calibrate your monitor	
	Preparing Pictures for Online Sharing	201

Chapter 2: Choosing Basic Picture Settings	51
Choosing an Exposure Mode	52
Changing the Drive Mode	
Getting Familiar with the Built-in Flash	
Using flash in the fully automatic modes	
Enabling flash in advanced exposure modes	
Using Red-Eye Reduction flash	60
Controlling Picture Quality	60
Diagnosing quality problems	61
Decoding the Image Quality options	63
Considering Resolution: Large, Medium, or Small?	65
Understanding File Type (JPEG or Raw)	
JPEG: The imaging (and web) standard	
Raw (CR2): The purist's choice	
My take: Choose Fine or Raw	72
Chapter 3: Taking Great Pictures, Automatically	
As Easy As It Gets: Auto and Flash Off	
Taking Advantage of Scene (SCN) Modes	
Modifying scene mode results	
Gaining More Control with Creative Auto	
Chapter 4: Exploring Live View Shooting and Movie Making	
Chapter 4: Exploring Live View Shooting and Movie Making Getting Started	
Getting Started	100
Getting Started	100
Getting Started	100 102 103
Getting Started	

Table of Contents

Introduction	1
A Quick Look at What's Ahead	1
Icons and Other Stuff to Note	2
eCheat Sheet	
Practice, Be Patient, and Have Fun!	3
Tructice, be ruitell, and ruver dissimilation	
Part 1: Fast Track to Super Snaps	5
Chapter 1: Getting the Lay of the Land	
Looking at Lenses	
Choosing a lens	
Attaching and removing a lens	
Zooming in and out	
Using an IS (image stabilizer) lens	13
Getting acquainted with focusing	
Adjusting the Viewfinder	15
Adjusting the Monitor Position	
Using the Touchscreen	
Working with Memory Cards	
Exploring External Camera Features	
Topside controls	22
Back-of-the-body controls	24
Front odds and ends	
Connection ports	28
Ordering from Camera Menus	
Navigating the Custom Functions Menu	
Monitoring Critical Camera Settings	34
The Info button: Choosing what the screen shows	
Checking the Camera Settings display	
Viewing the Shooting Settings display	36
Decoding viewfinder data	38
Reading the LCD panel	
Changing Settings via the Quick Control Screen	40
Getting Help from Your Camera	
Reviewing Basic Setup Options	
Cruising the Setup menus	43
Setting up the Lock switch	
Taking two final setup steps	50

Controlling Color	279
Correcting colors with white balance	
Changing the White Balance setting	
Creating a custom White Balance setting	283
Fine-tuning White Balance settings	
Bracketing shots with white balance	
Taking a Quick Look at Picture Styles	
Chapter 9: Putting It All Together	
•	
Recapping Basic Picture Settings	
Setting Up for Specific Scenes	
Shooting still portraits	
Capturing action	
Capturing scenic vistas	
Capturing dynamic close-ups	314
Part 1V: The Part of Tens	317
I WILL EVE THE TWILL OF TENSAME	144444 9 1 1
Chapter 10: Ten Features to Explore on a Rainy Day	319
Enabling Mirror Lockup Shooting	320
Adding Cleaning Instructions to Images	320
Tagging Files with Your Copyright Claim	321
Exploring Wi-Fi Functions	
Experimenting with Creative Filters	324
Shooting in Multiple Exposure Mode	
Investigating Two More Printing Options	
Presenting a Slide Show	329
Editing Movies	
Creating Video Snapshots	
Chapter 11: Ten More Ways to Customize Your Camera	333
Creating Your Own Exposure Mode	333
Creating Your Very Own Camera Menu	
Creating Custom Folders	
Changing the Color Space from sRGB to Adobe RGB	
Changing the Direction of the Dials	
Changing All the Furniture Around	
Disabling the AF-Assist Beam	
Controlling the Lens Focus Drive	
Making the Flashing Red AF Points Go Away	
Considering a Few Other Autofocusing Tweaks	343
Appendix: Glossary of Digital Photography Terms	347
4 4	
Index	359

Supplementary of the conference of the conference of the supplementary o

Introduction

n 2003, Canon revolutionized the photography world by introducing the first digital SLR camera (dSLR) to sell for less than \$1,000, the EOS Digital Rebel/300D. And even at that then-unheard-of price, the camera delivered exceptional performance and picture quality, earning it rave reviews and multiple industry awards. No wonder it quickly became a best seller.

That tradition of excellence and value lives on in the EOS Rebel 70D. Like its ancestors, this baby offers the range of advanced controls that experienced photographers demand plus an assortment of tools designed to help beginners be successful as well. Adding to the fun, this Rebel also offers the option to record full high-definition video, plus an articulating, touchscreen monitor that's not only useful but also just plain cool.

The 70D is so feature-packed, in fact, that sorting out everything can be a challenge, especially if you're new to digital photography or SLR photography, or both. For starters, you may not even be sure what SLR means, let alone have a clue about all the other terms you encounter in your camera manual — resolution, aperture, and ISO, for example. And if you're like many people, you may be so overwhelmed by all the controls on your camera that you haven't yet ventured beyond fully automatic picture-taking mode. That's a shame because it's sort of like buying a Porsche Turbo and never pushing it past 50 miles per hour.

Therein lies the point of *Canon EOS 70D For Dummies*. In this book, you can discover not only what each bell and whistle on your camera does but also when, where, why, and how to put it to best use. Unlike many photography books, this one doesn't require any previous knowledge of photography or digital imaging to make sense of concepts, either. In classic *For Dummies* style, everything is explained in easy-to-understand language, with lots of illustrations to help clear up any confusion.

In short, what you have in your hands is the paperback version of an in-depth photography workshop tailored specifically to your Canon picture-taking powerhouse. Whether your interests lie in taking family photos, exploring nature and travel photography, or snapping product shots for your business, you'll get the information you need to capture the images you envision.

A Quick Look at What's Ahead

This book is organized into four parts, each devoted to a different aspect of using your camera. Although chapters flow in a sequence that's designed to take you from absolute beginner to experienced user, I also tried to make each chapter as self-standing as possible so that you can explore topics that interest you in any order you please.

Here's a quick look at what you can find in each part:

- ▶ Part I: Fast Track to Super Snaps: This part contains four chapters that help you get up and running. Chapter 1 offers a brief overview of camera controls and walks you through initial setup and customization steps. Chapter 2 explains basic picture-taking options, such as shutter-release mode and Image Quality settings, and Chapter 3 shows you how to use the camera's simplest exposure modes, including Scene Intelligent Auto, Creative Auto, and SCN (Scene) modes. Chapter 4 explains the ins and outs of using Live View, the feature that lets you compose pictures on the monitor, and also covers movie recording.
- Part II: Working with Picture Files: As its title implies, this part discusses after-the-shot topics. Chapter 5 explains picture playback features, and Chapter 6 guides you through the process of transferring pictures from your camera to your computer and then getting pictures ready for print and online sharing. You can also get help with converting pictures shot in the Canon Raw file format (CR2) to a standard format in Chapter 6.
- Part III: Taking Creative Control: Chapters in this part help you unleash the full creative power of your camera by moving into semi-automatic or manual photography modes. Chapter 7 covers the all-important topic of exposure; Chapter 8 offers tips for manipulating focus and color; and Chapter 9 provides a quick-reference guide to shooting strategies for specific types of pictures: portraits, action shots, landscape scenes, and close-ups.
- ✓ Part IV: The Part of Tens: In famous For Dummies tradition, the book concludes with two top-ten lists containing additional bits of information. Chapter 10 takes a look at ten features that although not found on most "Top Ten Reasons I Bought My 70D" lists, are nonetheless interesting, useful on occasion, or a bit of both. Chapter 11 closes things out with ten ways to customize your camera not covered in earlier chapters.

Icons and Other Stuff to Note

If this isn't your first *For Dummies* book, you may be familiar with the large round icons that decorate its margins. If not, here's your very own icondecoder ring:

A Tip icon flags information that saves you time, effort, money, or another valuable resource, including your sanity.

When you see this icon, look alive. It indicates a potential danger zone that can result in much wailing and teeth-gnashing if it's ignored.

- ✓ Lots of information in this book is of a technical nature digital photography is a technical animal, after all. But if I present a detail that's useful mainly for impressing your geeky friends, I mark it with this icon.
- This icon highlights information that's especially worth storing in your brain's long-term memory or to remind you of a fact that may have been displaced from that memory by another pressing fact.

Additionally, I need to point out a few other details that will help you use this book:

- Other margin art: Replicas of some of your camera's buttons and onscreen graphics also appear in the margins of some paragraphs and in some tables. I include these images to provide quick reminders of the appearance of the button or option being discussed.
- ✓ **Software menu commands:** In sections that cover software, a series of words connected by an arrow indicates commands you choose from the program menus. For example, if a step tells you, "Choose File⇔Export," click the File menu to unfurl it and then click the Export command on the menu.

eCheat Sheet

As an added bonus, you can find an electronic version of the *For Dummies* Cheat Sheet at www.dummies.com/cheatsheet/canoneos70d. The Cheat Sheet contains a quick-reference guide to all the buttons, dials, switches, and exposure modes on your camera. Log on, print it out, and tuck it in your camera bag for times when you don't want to carry this book with you.

Practice, Be Patient, and Have Fun!

To wrap up this preamble, I want to stress that if you initially think that digital photography is too confusing or too technical for you, you're in very good company. *Everyone* finds this stuff a little mind-boggling at first. Take it slowly, experimenting with just one or two new camera settings or techniques at first. Then, every time you go on a photo outing, make it a point to add one or two more shooting skills to your repertoire. With some time, patience, and practice, you'll soon wield your camera like a pro, dialing in the necessary settings to capture your creative vision almost instinctively.

So without further ado, I invite you to grab your camera and a cup of whatever it is you prefer to sip while you read and then start exploring the rest of this book. Your EOS 70D is the perfect partner for your photographic journey, and I thank you for allowing me, in this book, to serve as your tour guide.

Part I Fast Track to Super Snaps

getting started with anon EOS 70D

In this part . . .

- Get familiar with your camera's buttons, displays, and menus.
- Read about basic photo-taking settings and when to use each.
- Take great pictures easily by using the fully automatic shooting modes.
- Investigate Live View and movie recording.

Getting the Lay of the Land

In This Chapter

- Using an SLR lens
- Adjusting the viewfinder and monitor
- ▶ Practicing touchscreen gestures
- Working with camera memory cards
- Getting acquainted with external camera controls
- Checking and changing camera settings
- Customizing basic camera operations

f you're like me, shooting for the first time with a camera as sophisticated as the Canon EOS 70D produces a blend of excitement and anxiety. On one hand, you can't wait to start using your new equipment,

but on the other, you're a little intimidated by all its buttons,

dials, and menu options.

Well, fear not: This chapter provides the information you need to start getting comfortable with your 70D. Along with an introduction to the camera's external controls, I offer details about working with lenses and memory cards, viewing and adjusting camera settings, and choosing basic setup options.

Looking at Lenses

One of the biggest differences between a point-and-shoot camera and a dSLR (digital single lens reflex) camera is the lens. With a dSLR, you can change lenses to suit different photographic needs, going from an extreme close-up lens to a super-long telephoto, for example. In addition, a dSLR lens has a focusing ring that gives you the option of focusing manually instead of relying on the camera's autofocus mechanism.

I don't have room in this book to go into detail about the science of lenses, nor do I think that an in-depth knowledge of the subject is terribly important to your photographic success. But the next few sections offer advice that may help when you're shopping for lenses, figuring out whether the lenses you inherited from Uncle Ted or found on eBay will work with your 70D, and taking the steps involved in actually mounting and using a lens.

Choosing a lens

To decide which lens is the best partner for your camera, start by considering these factors:

Lens compatibility: Your camera accepts two categories of Canon lenses: those with an EF-S design and those with a plain old EF design.

The EF stands for *electro focus*; the S stands for *short back focus*. And *that* simply means the rear element of the lens is closer to the sensor than with an EF lens. And no, you don't need to remember what the abbreviation stands for. Just make sure if you buy a Canon lens other than one of the two sold as a bundle with the camera, that it carries either the EF or EF-S specification. If you want to buy a non-Canon lens, check the lens manufacturer's website to find out which lenses work with your camera.

Two other lens acronyms to note: First, the 18–55mm and 18–135mm lenses that you can buy as part of a 70D kit are *IS* lenses, which means that they offer *image stabilization*, a feature you can explore a few sections from here. Second, they also carry the designation *STM*. That abbreviation refers to the fact that the autofocusing system uses *stepping motor technology*, which is designed to provide smoother, quieter autofocusing.

Finally, be aware that some lenses can't take full advantage of the Dual Pixel CMOS (see-moss) autofocusing system that's used during Live View and Movie recording. Don't worry about what the name means — the important point is that it produces faster, more accurate autofocusing. If you're interested in learning more, go to the 70D product page at the Canon USA website (www.usa.canon.com), which has a link to a section that explains the technology and lists lenses that support it.

✓ Focal length and the crop factor: The focal length of a lens, stated in millimeters, determines the angle of view that the camera can capture and the spatial relationship of objects in the frame. Focal length also affects depth of field, or the distance over which focus appears acceptably sharp.

You can loosely categorize lenses by focal length as follows:

 Wide-angle: Lenses with short focal lengths — generally, anything under 35mm — are known as wide-angle lenses. A wide-angle lens has the visual effect of pushing the subject away from you and

- making it appear smaller. As a result, you can fit more of the scene into the frame without moving back. Additionally, a wide-angle lens has a large depth of field, which means that both the subject and background objects appear sharp. These characteristics make wide-angle lenses ideal for landscape photography.
- *Telephoto*: Lenses with focal lengths longer than about 70mm are *telephoto* lenses. These lenses create the illusion of bringing the subject closer to you, increase the subject's size in the frame, and produce a short depth of field so that the subject is sharply focused but distant objects are blurry. Telephoto lenses are great for capturing wildlife and other subjects that don't permit up-close shooting.
- Normal: A focal length in the neighborhood of 35mm to 70mm is considered "normal" — that is, somewhere between a wide-angle and telephoto. This focal length produces the angle of view and depth of field that are appropriate for the kinds of snapshots that most people take.

Figure 1-1 offers an illustration of the difference that focal length makes, showing the same scene captured at 42mm (left image) and 112mm (right image). Of course, the illustration shows just two of countless possibilities, and the question of which focal length best captures a scene depends on your creative goals.

42mm

112mm

Figure 1-1: I used a focal length of 42mm to capture the first image and then zoomed to a focal length of 112mm to capture the second one.

Note, however, that the focal lengths stated in this book are so-called *35mm equivalent* focal lengths. Here's the deal: When you put a standard lens on most dSLR cameras, including your70D, the available frame area is reduced, as if you took a picture on a camera that uses 35mm film negatives and then cropped it.

This so-called crop factor varies depending on the camera, which is why the photo industry adopted the 35mm-equivalent measuring stick as a standard. With the 70D, the crop factor is roughly 1.6. So the 18-135mm kit lens, for example, captures the approximate area you would get from a 29-216mm lens on a 35mm film camera. (Multiply the crop factor by the lens focal length to get the actual angle of view.) In Figure 1-2, the red line indicates the image area that results from the 1.6 crop factor.

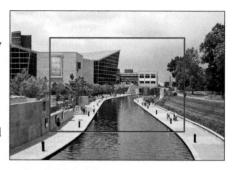

Figure 1-2: The 1.6 crop factor produces the angle of view indicated by the red outline.

When shopping for a lens, remember this crop factor to make sure that you get the focal length designed for the type of pictures you want to take.

✓ Prime versus zoom lenses: A prime lens is a single focal-length lens. With a zoom lens, you get a range of focal lengths in one unit. For example, the kit lens I feature in this book has a focal-length range of 18–135mm.

Why select a lens that offers a single focal length when a zoom lens offers a range of focal lengths? In a word, quality. Because of some lens science I won't bore you with, you typically see some reduction in picture quality at certain points in the range of a zoom lens. On the flip side, a zoom lens is more convenient than carting around a bag of prime lenses, and many zoom lenses today offer very good image quality.

Aperture range: The aperture is an adjustable diaphragm in a lens. By adjusting the aperture size, you can control the amount of light that enters through the lens and strikes the image sensor, thereby controlling exposure. The aperture setting also affects depth of field: A wide-open aperture produces a short depth of field, so the subject is sharply focused but distant objects appear blurry; a narrow aperture produces a long depth of field so that both the subject and distant objects appear sharp.

Chapters 7 and 8 cover these issues in detail. For the purposes of lens shopping, you need to know just a few things.

- Every lens has a specific range of aperture settings. Obviously, the larger that range, the more control you have over exposure and depth of field.
- The larger the maximum aperture, the "faster" the lens. Aperture settings are stated in *f-stops*, with a lower number meaning a larger

aperture. For example, a setting of f/2 results in a more open aperture than f/4. And if you have one lens with a maximum aperture of f/2 and another with a maximum aperture of f/4, the f/2 lens is said to be *faster* because you can open the aperture wider, thereby allowing more light into the camera and permitting the image to be captured in less time. This not only benefits you in low-light situations but also when photographing action, which requires a fast shutter speed (short exposure time). So, all other things being equal, a faster lens is better.

• With some zoom lenses, the maximum and minimum aperture change as you zoom the lens. For example, when you zoom to a telephoto focal length, you usually can't open the aperture as much as you can at a wide-angle setting. You can buy lenses that maintain the same maximum and minimum aperture throughout the whole zoom lens, but you pay more for this feature.

After studying these issues and narrowing down your choices, finding the right lens in the category you want is just a matter of doing some homework. Study lens reviews in photography magazines and online photography sites to find the best performing lens in your price range.

Attaching and removing a lens

Whatever lens you choose, follow these steps to attach it to the camera body:

- Turn the camera off and remove the cap that covers the lens mount on the front of the camera.
- 2. Remove the cap that covers the back of the lens.
- 3. Locate the proper lens mounting index on the camera body.

A mounting index is a mark that tells you where to align the lens with the camera body when connecting the two. Your camera has two of these marks, one red and one white, as shown in Figure 1-3.

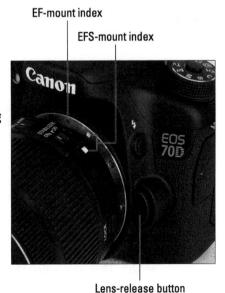

Figure 1-3: Place the lens in the lens mount with the mounting indexes aligned.

Which marker you use to align your lens depends on the lens type:

- Canon EF-S lens: The white square is the mounting index.
- Canon EF lens: The red dot is the mounting index.

With a non-Canon lens, check the lens manual for help with this step.

4. Align the mounting index on the lens with the one on the camera.

The lens also has a mounting index. Figure 1-3 shows the one that appears on the 18–135mm EF-S kit lens.

- Keeping the mounting indexes aligned, position the lens on the camera's lens mount.
- 6. Turn the lens clockwise until it clicks into place.

In other words, turn the lens toward the lens-release button, labeled in Figure 1-3.

To remove a lens, turn the camera off, press the lens-release button, grip the rear collar of the lens, and turn the lens toward the shutter button side of the camera. When you feel the lens release from the mount, lift the lens off the camera. Place the rear protective cap onto the back of the lens, and if you aren't putting another lens on the camera, cover the lens mount with its protective cap, too.

Always switch lenses in a clean environment to reduce the risk of getting dust and dirt inside the camera or lens. For added safety, point the camera slightly down when performing this maneuver to help prevent flotsam in the air from being drawn into the camera by gravity.

Zooming in and out

If you bought a zoom lens, it sports a *zoom ring*. Figure 1-4 shows you the location of the zoom ring on the 18–135mm kit lens; for other lenses, see your lens user guide. With the kit lens, rotate the zoom ring to zoom in and out. A few zoom lenses use a push-pull motion to zoom instead.

The numbers around the edge of the zoom ring, by the way, represent focal lengths. The number that's aligned with the white focal-length indicator, labeled in Figure 1-4, represents the current focal length.

Some lenses, including the 18–135mm kit lens, also have a Lens lock switch, which is located in the position indicated in the figure. When the lens is set to the 18mm position, you can use the switch to lock the lens at that focal length. That way, when the camera is pointing downward, gravity can't cause the lens to extend to a longer focal length (a problem known as *lens creep*).

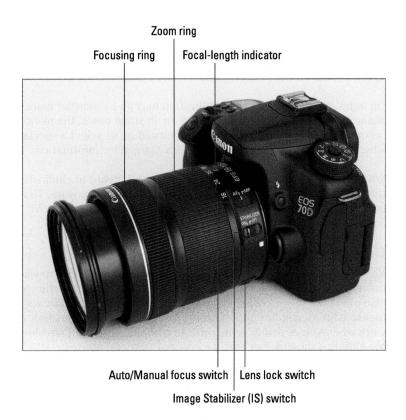

Figure 1-4: Here's a look at the 18-135mm kit lens.

Using an 15 (image stabilizer) lens

Both kit lenses sold with the 70D offer *image stabilization*, indicated by the initials *IS* in the lens name. Image stabilization attempts to compensate for small amounts of camera shake that are common when photographers handhold their cameras and use a slow shutter speed, a lens with a long focal length, or both. Camera shake can result in blurry images, even when your focus is dead-on. Although image stabilization can't work miracles, it enables most people to capture sharp handheld shots in many situations that they otherwise couldn't. The feature works regardless of whether you use autofocusing or manual focusing, and it works for both still photography and movie shooting.

However, when you use a tripod, the system may try to adjust for movement that isn't actually occurring. Although this problem shouldn't be an issue with most Canon IS lenses, if you do see blurry images while using a tripod, try setting the Image Stabilizer (IS) switch (shown in Figure 1-4) to Off. You

also can save battery power by turning off image stabilization when you use a tripod. If you use a monopod, leave image stabilization turned on so it can help compensate for any accidental movement of the monopod. If you shoot in the B (Bulb) mode, Canon recommends that you disable stabilization.

On non-Canon lenses, image stabilization may go by another name: *anti-shake*, *vibration compensation*, and so on. In some cases, the manufacturers recommend that you leave the system turned on or select a special setting when you use a tripod, so check the lens manual for information.

Whatever lens you use, image stabilization isn't meant to eliminate the blur that can occur when your subject moves during the exposure. That problem is related to shutter speed, a topic you can explore in Chapter 7.

Getting acquainted with focusing

Your camera offers an excellent autofocusing system. With some subjects, however, autofocusing can be slow or impossible, which is why your camera also offers manual focusing. Chapter 8 fully explains automatic and manual focusing for viewfinder photography, and Chapter 4 explains how things work when you're using the monitor to compose images (Live View mode) or are shooting movies. But here's a primer to get you started:

- Choosing the focusing method: You set the focusing method via the AF/MF (autofocus/manual focus) switch on the lens. But be careful: If you're in Live View or Movie mode, exit the live preview and return to viewfinder shooting before moving the lens switch from the AF to MF position. This step is needed to avoid damage that can occur if you switch to manual focusing while the continuous autofocusing system that's available for Movie and Live View modes engaged. (Chapter 4 explains this system and everything else about Live View and movie shooting.)
- ✓ **Setting focus in MF mode:** Just rotate the lens focusing ring. Figure 1-4 shows you where to find it on the 18–135mm kit lens.
- Setting focus in AF mode: Press the shutter button halfway to initiate autofocusing. After the scene comes into focus, press the button the rest of the way to take the picture. A couple pointers to remember:
 - How the camera finds its focusing target and when it locks focus depend on autofocus settings that I detail in Chapters 4 and 8.
 - If you're using the kit lens (or any STM lens from Canon), turning the focus ring when in autofocus mode has no effect on the lens it won't turn and it will never hit a physical stop.

Waking up a sleeping lens: With both kit lenses (as well as some other STM lenses), the focusing motor doesn't operate if the camera has gone to sleep because of the Auto Power Off feature, which I explain in the section "Setup Menu 2," later in this chapter. The lens itself goes to sleep if you don't perform any lens operations for a while. Either way, manual focus adjustments aren't possible when the lens is in this state, and automatic focusing during zooming may be delayed. You can wake the camera and lens up by pressing the shutter button halfway.

Two final Focusing 101 tips:

- If you have trouble focusing, you may be too close to your subject; every lens has a minimum focusing distance.
- In order to properly asses focus, you need to adjust the viewfinder to accommodate your eyesight, as outlined next.

Adjusting the Viewfinder

Near the upper right of the rubber eyepiece that surrounds the viewfinder is a dial (see Figure 1-5) that enables you to adjust the viewfinder focus to match your eyesight. The dial is officially known as the *diopter adjustment control*.

If you don't take this step, scenes that appear out of focus through the viewfinder may actually be sharply focused through the lens, and vice versa. Here's how to make the necessary adjustment:

 Remove the lens cap, look through the viewfinder, and press the shutter button halfway to display picture data at the bottom of the viewfinder.

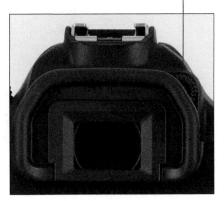

Figure 1-5: Rotate this dial to adjust the viewfinder focus to your eyesight.

In Scene Intelligent Auto mode (represented by the green A+ on the camera's Mode dial), as well as in some of the SCN (Scene) modes, the built-in flash may pop up; ignore it for now and close the unit after you finish adjusting the viewfinder.

2. Rotate the diopter adjustment dial until the data appears sharpest.

If your eyesight is such that you can't get the display to appear sharp by using the dioptric adjustment knob, you can buy an additional eyepiece adapter. Prices range from about \$15–\$30 depending on the magnification you need. Look for an E-series dioptric adjustment lens adapter.

Adjusting the Monitor Position

One of the many cool features of the 70D is its articulating monitor. When you first take the camera out of its box, the monitor is positioned with the screen facing the back of the body, as shown on the left in Figure 1-6, protecting the screen from scratches and smudges. (It's a good idea to place the monitor in this position when you're not using the camera.) When you're ready to start shooting or reviewing your photos, you can place the monitor in the traditional position on the camera back, as shown on the right in Figure 1-6. Or for more flexibility, you can swing the monitor out and away from the camera body and then rotate it to find the best viewing angle, as shown in Figure 1-7.

Figure 1-6: Here you see two possible monitor positions.

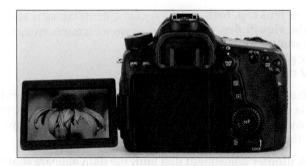

Figure 1-7: You also can unlock the monitor from the body and then rotate the screen to get the best view of things.

Because playing with the monitor is no doubt one of the first things you did after unpacking your camera, I won't waste space walking you through the process of adjusting the screen. (If you need help, the camera manual shows you what to do.) But I want to offer a few monitor-related tips:

- ✓ Don't force things. The monitor twists only in certain directions, and it's easy to forget which way it's supposed to move. So if you feel resistance, don't force things; instead, rely on that feeling of resistance to remind you to turn the screen the other way.
- ✓ Watch the crunch factor. Before positioning the monitor back into the camera, use a lens brush or soft cloth to clean the monitor housing so there's nothing in the way that could damage the screen.
- ✓ Clean smart. To clean the screen, use only the special cloths and cleaning solutions made for this purpose. Do not use paper products such as paper towels because they can contain wood fibers that can scratch the monitor. And never use a can of compressed air to blow dust off the camera the air is cold and can crack the monitor.

Using the Touchscreen

Just as cool as the monitor's flexibility is its touchscreen interface. You can choose menu options, change picture settings, and scroll through your pictures by touching one or two fingers to the screen, just as you can with a tablet, smartphone, or other touchscreen device.

Throughout the book, I tell you exactly where and how to touch the screen to accomplish specific actions. For now, get acquainted with the terminology used to indicate these touchscreen moves, called *gestures* by those who feel the need to assign names to things such as this.

✓ Tap: Tap your finger on a screen item to select it. Give it a try: First, press the Menu button to display the menu screen on the monitor, as shown on the left in Figure 1-8. Along the top of the screen, you see one highlighted icon, representing the current menu, and a row of dimmed icons representing other menus. On the left side of Figure 1-8, Shooting Menu 1 is the current menu. To switch to another menu, tap its icon. For example, tap the icon for Setup Menu 2, labeled on the left in the figure, and that menu appears, as shown on the right.

Tap *gently* — you don't have to use force. To avoid damaging the screen, use the fleshy part of your fingertip, not the nail or any other sharp object, and be sure that your fingers are dry because the screen may not respond if it gets wet. Canon also advises against putting a protective cover over the monitor; doing so can reduce the monitor's responsiveness to your touch.

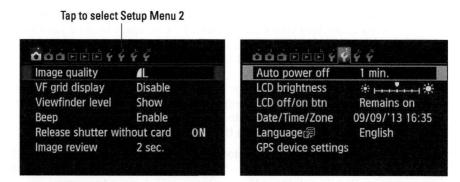

Figure 1-8: Tap a menu icon to display its menu.

▶ Drag: Drag your finger up, down, right, or left across the screen, according to my instruction. To try this gesture, first display Setup Menu 2 and tap LCD Brightness, shown on the left in Figure 1-9, to display the screen shown on the right. Now drag your finger across the scale at the bottom of the screen to adjust the screen brightness. Reset the marker to the middle of the bar after you're done playing around — that setting gives you the most accurate indication of picture brightness.

On this particular screen, you also see triangles at either end of the scale. You can tap those triangles to raise or lower the value represented on the scale. Either way, tap the Set icon to implement the setting and return to the menu.

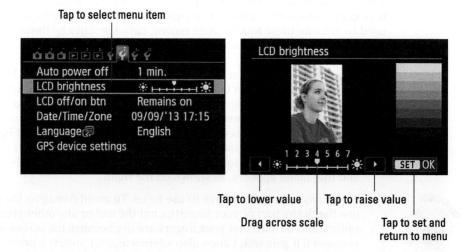

Figure 1-9: Tap the LCD Brightness item (left) and then drag left or right across a scale to adjust the setting (right).

- ✓ **Swipe:** Drag a finger quickly across the screen. You use this gesture, known in some circles as a *flick*, to scroll through your pictures in Playback mode, a topic you can explore in Chapter 5.
- Pinch in/pinch out: To pinch in, place your thumb at one edge of the screen and your pointer finger at the other. Then drag both toward the center of the screen. To pinch out, start in the center of the screen and swipe both fingers outward. Pinching is how you zoom in and out on pictures during playback; again, Chapter 5 provides details.

You can control two aspects of touchscreen behavior:

- Touchscreen response: You can choose from three settings, accessed via the Touch Control option, found on Setup Menu 3 and shown in Figure 1-10.
 - Standard: This setting is the default. The touchscreen is enabled and is set to respond to a "normal" amount of pressure. (Don't ask me how the Powers That Be decided what that pressure level is I don't get invited to those conferences.)

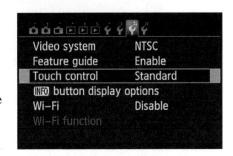

Figure 1-10: Control the touchscreen response through this menu item.

- *Sensitive:* This setting makes the touchscreen more, er, touchy. That is, it responds to lighter pressure. Oddly, though, Canon says that the camera may be slower to respond to a very quick tap at this setting. Your mileage may vary.
- *Disable:* Select this setting to disable the touchscreen function.
 - To restore the touch function, press the Menu button to bring up the menu screens and then rotate the Main dial that's the one just behind the shutter button to select Setup Menu 3. Then rotate the Quick Control dial (the big wheel on the back of the camera) to highlight Touch Control. Press the Set button, rotate the Quick Control dial to highlight Standard or Sensitive, and press the Set button again.
- ✓ Touchscreen sound effects: By default, the camera emits a little "boop" sound every time you tap a touch-controlled setting. If you're sick of hearing it, visit Shooting Menu 1 and look for the Beep setting, shown

in Figure 1-11. The option that disables the boop is Touch to Silence — *silence* being indicated by a little speaker with a slash through it. The Disable setting turns off both the touchscreen sound and the normal beep tone that occurs when the camera finds its focus point.

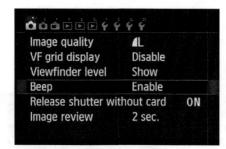

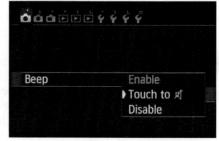

Figure 1-11: Set the Beep option to Touch to Silence to prevent the camera from making a sound when you tap a touch-controlled item.

One final point about the touchscreen: If you connect the camera to a TV or monitor, the touchscreen no longer is available, regardless of the Touch Control option. Don't fret, you just have to use the old-fashioned button-push method of selecting menu options. See "Ordering from Camera Menus," later in this chapter, if you need help.

Working with Memory Cards

Instead of recording images on film, digital cameras store pictures on *memory cards*. Your camera uses a specific type of memory card — an *SD card* (for *Secure Digital*), shown in Figures 1-12 and 1-13.

Most SD cards carry the designation SDHC (for *High Capacity*) or SDXC (for *eXtended Capacity*), depending on how many gigabytes (GB) of data they hold. SDHC cards hold from 4GB to 32GB of data; the SDXC moniker indicates a capacity greater than 32GB. Cards are also assigned a speed rating from 2 to 10, with a higher number indicating a faster data-transfer rate. The memory-card industry recently added a new category of speed rating — Ultra High Speed (UHS). UHS cards also carry a number designation; at present, there is only one class of UHS card, UHS 1. These cards currently are the fastest the planet has to offer. Of course, a faster card means a more expensive card. But to maximize your camera's performance, I recommend that you make the investment in Class 10 or UHS 1 cards. Especially for video recording, a faster

card translates to smoother recording and playback. A faster card also can improve performance when you're shooting a burst of images using the camera's continuous capture feature.

In addition to using regular SD cards, your camera accepts Eye-Fi memory cards, which are special cards that enable you to transmit images from the camera to the computer over a wireless network. It's a cool option, but the cards are more expensive than regular cards and require some configuring that I don't have room to cover in this book. Additionally, Canon doesn't guarantee that everything will work smoothly with Eye-Fi cards and directs you to the Eye-Fi support team if you have trouble. All that said, if an Eye-Fi card is installed in the camera, Setup Menu 1 offers an Eye-Fi Settings option that offers options related to the card. For more details, visit www.eye.fi. (See Chapters 6 and 10 for details about using the camera's own wireless connectivity features.)

Whatever cards you choose, safeguarding them — and the images on them requires a few precautions:

- Inserting a card: Turn the camera off and then put the card in the card slot with the label facing the back of the camera, as shown in Figure 1-12. Push the card into the slot until it clicks into place.
- Formatting a card: The first time you use a new memory card, format it by choosing the Format Card option on Setup Menu 1. This step ensures that the card is properly prepared to record your pictures. See the upcoming section "Setup Menu 1" for details.
- **Removing a card:** First, check the status of the memory card access light, labeled in Figure 1-12. After making sure

Memory card access light

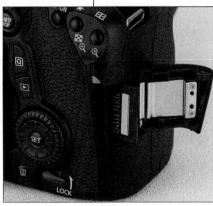

Figure 1-12: Insert the card with the label facing the camera back.

that the light is off, indicating that the camera has finished recording your most recent photo, turn off the camera. Open the memory card door, as shown in Figure 1-12. Depress the memory card slightly until you hear a little click and then let go. The card pops halfway out of the slot, enabling you to grab it by the tail and remove it.

- Handling cards: Don't touch the gold contacts on the back of the card. (See the right card in Figure 1-13.) When cards aren't in use, store them in the protective cases they came in or in a memory card wallet. Keep cards away from extreme heat and cold as well.
- Locking cards: The tiny switch on the left side of the card, labeled Lock switch in Figure 1-13, enables you to lock your card, which prevents any data from being erased or recorded to the card. Press the switch toward the bottom of the card to lock the card con-

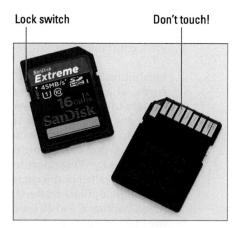

Figure 1-13: Avoid touching the gold contacts on the card.

tents; press it toward the top of the card to unlock the data.

Exploring External Camera Features

Scattered across your camera's exterior are a number of buttons, dials, and switches that you use to change picture-taking settings, review and edit your photos, and perform various other operations. Later chapters detail all your camera's functions and provide the exact steps to follow to access those functions. The next four sections provide a basic road map to the external controls plus a quick introduction to each.

Topside controls

Your virtual tour begins on the top of the camera, shown in Figure 1-14. The items of note here are

- On/Off switch: Okay, you probably already figured this one out. What you may not know is that by default, the camera automatically shuts itself off after one minute of inactivity to save battery power. To wake up the camera, press the shutter button halfway or press the Menu, Info, or Playback button. You can adjust the auto shutdown timing via the Auto Power Off option on Setup Menu 2.
- Mode dial: Through this dial, you select an exposure mode, which determines whether the camera operates in fully automatic, semi-automatic, or manual exposure mode. To adjust the setting, press and hold the unlock button in the center of the dial as you rotate the dial. Chapter 2 introduces you to the various exposure modes.

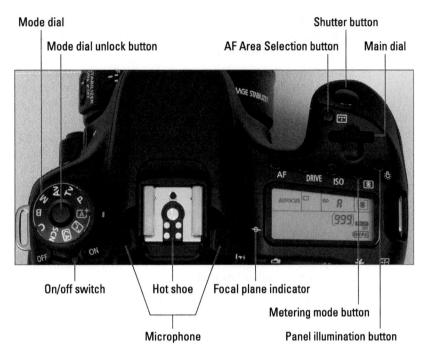

Figure 1-14: The tiny pictures on the Mode dial represent special automatic shooting modes.

- ✓ Hot shoe: The hot shoe is a metal bracket on which you can affix an external flash (or other hot shoe accessory). It's called a hot shoe because it's wired to communicate back and forth from the camera using electrical signals. Don't go poking around the hot shoe: the flash-sync contacts (the little round metal posts) need to be clean and free of debris to work properly.
- Microphone: These two clusters of holes lead to the stereo microphone that picks up sound when you record movies.

- ✓ AF Area Selection button: This button enables you to change the AF Area Selection setting, an autofocus feature that I describe in Chapter 8.
- ✓ Drive button: This button switches between the various shutter-release (drive) modes, such as single frame, self-timer, or high-speed continuous. See Chapter 2 for more information.
- ✓ ISO button: Press this button to access the ISO speed setting, which determines how sensitive the camera is to light. Chapter 7 details this critical exposure setting.

✓ Metering mode button: Yup, you guessed it: This button enables you to choose the camera's metering mode, which determines which part of the scene the camera uses to set exposure. Chapter 7 has details.

- AF button: This button is related to the AF mode setting, which determines when the camera locks focus when you use autofocusing. See Chapter 8 for the lowdown.
- Main dial: You use this dial, labeled in the figure, when selecting many camera settings. In fact, this dial plays such an important role that you'd think it might have a more auspicious name, like The Really Useful Dial, but Main dial it is.
- Shutter release button: You probably already understand the function of this button, too. But what you may not realize is that when you use autofocus and autoexposure, you need to use a two-stage process when taking a picture: Press the shutter button halfway, pause to let the camera set focus and exposure, and then press the rest of the way to capture the image. You'd be surprised how many people mess up their pictures because they press that button with one quick jab, denying the camera the time it needs to set focus and exposure.
- LCD panel illumination button: This button illuminates the top LCD panel with an amber backlight.
- ✓ **Focal plane mark:** Should you need to know the exact distance between your subject and the camera, the *focal plane indicator* is key. This mark indicates the plane at which light coming through the lens is focused onto the image sensor. Basing your measurement on this mark produces a more accurate camera-to-subject distance than using the end of the lens or some other external point on the camera body as your reference point.

Back-of-the-body controls

Traveling over the top of the camera to its back, you encounter the smorgasbord of controls shown in Figure 1-15. Throughout this book, pictures of some of these buttons appear in the margins, as in the upcoming list, to help you locate the button being discussed. Even though I provide the official control names in the following list, don't worry about getting all those straight right now. The list is just to get you acquainted with the *possibility* of what you can accomplish with all these features.

Do note that many buttons have multiple names because they serve different purposes depending on whether you're taking pictures, reviewing images, recording a movie, or performing some other function. In this book, I refer to these buttons by the first label you see in the following list to simplify things. For example, I refer to the AF Point Selection/Magnify button as the AF Point Selection button. Again, though, the margin icons help you know exactly which button is being described.

Camera Settings." A fourth press of the button turns the monitor off. To find out how to customize the button, see "The Info button: Choosing what the screen shows," also later in this chapter.

In Playback, Live View, and Movie modes, pressing this button changes the picture-display style, as outlined in Chapters 4 and 5.

Live View/Movie mode button and switch: Live View is the camera feature that enables you to compose photos using the monitor instead of the viewfinder. To shift to this mode, first move the switch to the camera icon above the Start/Stop button. Then press the button to engage Live View; press again to return to regular (viewfinder) shooting.

To enter Movie mode, move the switch to the red movie camera icon. The live scene appears on the monitor, and you can then press the Start/Stop button to start and stop recording.

- ✓ **AF-ON button:** Just like pressing the shutter button halfway, pressing this button initiates autofocus. See Chapter 8 for more information on when this option can come in handy.
- ✓ AE Lock/FE Lock/Index/Reduce button: As you can guess from the official name of this button, it serves many purposes. The first two are related to still-image capture functions: You use the button to lock in the autoexposure (AE) settings and to lock flash exposure (FE). Chapter 7 details both issues. When using Live View and Movie modes, this button serves only as an exposure lock.

This button also serves two image-viewing functions: It switches the display to Index mode, enabling you to see multiple image thumbnails at once, and it reduces the magnification of images when displayed one at a time. Chapter 5 explains Playback, and Chapter 4 covers Live View and Movie modes.

- AF Point Selection/Magnify button: When you use certain advanced shooting modes, you can press this button to specify which of the autofocus points you want the camera to use when establishing focus. Chapter 8 tells you more. In Playback, Live View, and Movie modes, you use this button to magnify the image display (thus the plus sign in the button's magnifying glass icon). See Chapters 4 and 5 for help with that function.
- Quick Control, or Q, button: You press this button to enter Quick Control mode, which offers one avenue for changing critical picturetaking settings. See "Changing Settings Via the Quick Control Screen" to learn more about this camera feature.

For expediency's sake, I refer to this button from this point forward as just the *Q button*.

- ✓ Playback button: Press this button to switch the camera into picture-review mode. Chapter 5 details playback features.
- ✓ **Set button and Multi-controller:** Figure 1-15 points out the Set button and surrounding controller, known as the *Multi-controller*. These buttons

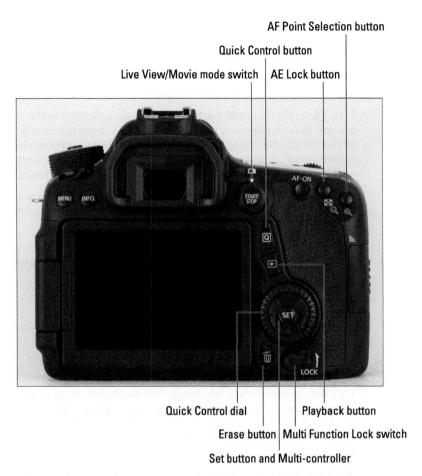

Figure 1-15: Having lots of external buttons makes accessing the camera's functions easier.

With that preamble out of the way, here's the rundown of back-of-the-body features:

- Menu button: Press this button to access the camera menus. I discuss navigating menus later in this chapter.
- ✓ Info button: By default, pressing this button during shooting displays the Camera Settings screen; pressing again displays the Electronic Level; and pressing a third time displays the Shooting Settings display. I describe all three of these screens in the upcoming section, "Monitoring Critical

team up to perform several functions, including choosing options from the camera menus.

You work the Multi-controller by pressing one of the eight tiny arrows around its perimeter. In this book, the instruction "Press the Multi-controller right" means to press the right arrow, for example.

✓ Quick Control dial: The Quick Control dial surrounds the Set button and the Multi-controller. Rotating the dial offers a handy way to quickly scroll through options and settings. It's a time-saver, so I point out when to use it as I provide instructions throughout the book.

- ✓ Erase button: Sporting a trash can icon (the universal symbol for delete), this button erases pictures from your memory card. Chapter 5 has specifics. In Live View and Movie modes, covered in Chapter 4, this button is involved in the focusing process.
- Multi Function Lock switch: You can rotate this switch up, in the direction of the arrow, to lock the Quick Control dial so that you don't accidentally move the dial and change a camera setting that you aren't intending to modify. If you want an even larger safety net, you can set things up so that the switch also locks the Main dial and the Multicontroller. The section "Setting up the Lock switch," toward the end of this chapter, has details.

Front odds and ends

On the front-left side of the camera body are a few more things of note, labeled in Figure 1-16.

- ✓ **Flash button:** Press this button to bring the camera's built-in flash out of hiding when you use the P, Tv, Av, M, B, or C exposure modes. In the other modes, whether the flash pops up depends on the flash mode setting, which I explain in Chapter 2.
- Lens-release button: Press this button to disengage the lens from the lens mount so that you can remove it from the camera. See the first part of this chapter for details on mounting and removing lenses.

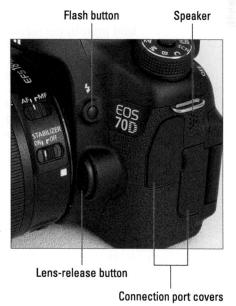

Figure 1-16: Press the Flash button to bring the built-in flash out of hiding.

- ✓ **Speaker:** When you play movies, the sound emanates from the speaker.
- Connection port covers: The covers hide ports for connecting the camera to other devices; see the next section for details.

A couple of sensors and a button are on the right side of the camera, as shown in Figure 1-17:

- ✓ Remote control sensor: When you use the optional Remote Controller RC-6 (or RC-1 or RC-5) wireless remote, the sensor detects the signal from the remote.
- When you press this button, the image in the viewfinder offers an approximation of the depth of field that will result from your aperture setting, or f-stop. Chapter 8 provides details.
- Red-Eye Reduction/self-timer lamp: When you set your flash to Red-Eye Reduction mode, this lamp emits a brief burst of light prior to the real flash: the idea being that your subjects' pupils will constrict in response to the light, thus lessening the chances of red-eye. If you use the camera's self-timer feature, the lamp blinks to provide you with a visual countdown to the

Red-Eye Reduction/self-timer lamp
Remote control sensor

Depth-of-field preview button

Figure 1-17: Here's a look at the right-front doodads.

moment at which the picture will be recorded. See Chapter 2 for more details about Red-Eye Reduction flash mode and the self-timer function.

Connection ports

Hidden under the covers on the left side of the camera, you find inputs for connecting the camera to various devices. The left side of Figure 1-18 shows what lurks beneath the first cover; the right side of the figure shows the connections found under the second cover.

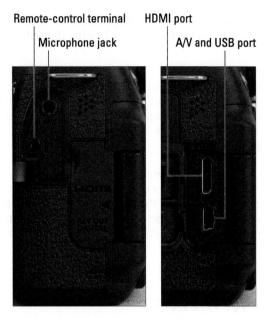

Figure 1-18: These two rubber covers conceal terminals for connecting the camera to other devices.

Starting with the left side, the available connections are

- Microphone jack: If you're not happy with the audio quality provided by the internal microphone when you record movies, you can plug in an external microphone here. The jack accepts a 3.5mm stereo microphone miniplug.
- ✓ Remote-control terminal: As an alternative to using a wireless remote controller to trigger the shutter release, you can attach the Canon Remote Switch RS-60E3 wired controller here.

The controller is a worthwhile investment if you do a lot of long-exposure shooting (such as nighttime shots and fireworks). By using the remote control, you eliminate the chance that the action of your finger on the shutter button moves the camera enough to blur the shot, which is especially problematic during long exposures. And unlike a wireless remote, which must be positioned so that the signal reaches the sensor on the front of the camera, a wired remote can be operated from behind the camera.

- ✓ HDMI terminal: For playback on a high-definition television or screen, you can connect the camera via this terminal, using the optional HDMI Cable HTC-100.
- ✓ A/V and USB connection terminal: This connection point serves two purposes: You can connect your camera to a standard-definition television for picture playback via the optional AVC-DC400ST A/V (audio/video) cable. You use the same terminal to connect the camera to a computer via the supplied USB cable for picture downloading, a topic discussed in Chapter 6.

If you turn the camera over, you find a tripod socket, which enables you to mount the camera on a tripod that uses a quarter-inch screw, plus the battery chamber. And finally, hidden inside the battery chamber is a little flap that covers a connection for attaching the optional AC power adapter kit ACK-E6. See the camera manual for specifics on running the camera on AC power.

Ordering from Camera Menus

Camera menus are organized into the categories labeled in Figure 1-19. However, which menus appear depends on the exposure mode. For example, if you're shooting in Scene Intelligent Auto mode — represented by the green A+ on the Mode dial — you see only a handful of menus because you have limited control over camera operation in that mode. To access the full complement of menus, as shown in the figure, set the Mode dial to one of the advanced exposure modes: P, Av, Tv, M, B, or C.

Note, too, that when you set the camera to Movie mode, the two Live View menus are replaced by Movie menus 1 and 2 (not shown in the

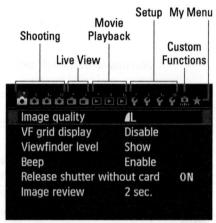

Figure 1-19: All menus appear only when you shoot in an advanced exposure mode.

figure). The icon changes to a little movie-camera symbol to indicate the shift.

I explain all menu options elsewhere in the book; for now, just familiarize yourself with the process of navigating menus and selecting menu options:

✓ Display menus. Press the Menu button. The highlighted menu icon marks the active menu; options on that menu appear automatically on the main part of the screen. In Figure 1-19, Shooting Menu 1 is active, for example.

The number of dots above the icon tells you the menu number — one dot for Shooting Menu 1, two dots for Shooting menu 2, and so on.

- ✓ **Select a different menu.** You have these options:
 - Touchscreen: Tap the menu icon.
 - Main dial or Multi-controller: Rotate the Main dial to or press the Multi-controller left or right to scroll through the menu icons.

As you scroll through the menus, notice that the icons that represent the menus are color coded. The Shooting menus and Live View/Movie menu icons are red; Playback menu icons are blue; Setup menus are a lovely yellow; the Custom Functions menu is orange; and the My Menu icon is green. (Chapter 11 explains the My Menu feature, through which you can create your own, custom menu.)

• Touchscreen: Tap the menu item to display a screen of options related to that item. For example, to adjust the picture Image Quality, display Shooting Menu 1, as shown in Figure 1-19, and then tap Image Quality to display the screen shown in Figure 1-20. Tap the setting you want to use and then tap Set to return to the menu.

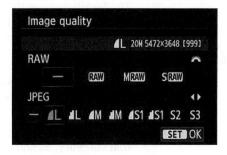

Figure 1-20: Tap the option you want to use and then tap the Set icon to lock in your choice.

In some cases, the available options appear right next to the menu item; just tap the setting you want to use to select it and return to the normal menu display. No need to tap a Set icon.

Quick Control dial and Set button: Rotate the Quick Control dial
to scroll up or down to highlight the feature you want to adjust.
Then press the Set button to display the available options. In most
cases, you then use the Quick Control dial to highlight the desired
option and press Set again. Sometimes, you may need to incorporate the Main dial into the mix; don't sweat it now — I step you
through the process when it's necessary.

You can mix and match techniques, by the way: For example, even if you access a menu option via the control keys, you can use the touchscreen techniques to select a setting.

Exit menus and return to shooting. Press the shutter button halfway and release it or press the Menu button again.

Navigating the Custom Functions Menu

When you select the Custom Functions menu, which is available only when the Mode dial is set to P, Tv, Av, M, B, or C, you delve into submenus containing advanced camera settings. Navigating these screens involves a few special techniques.

Initially, you see the screen shown in Figure 1-21. Some explanation may help you make sense of it:

Custom Functions are grouped into three categories: Exposure, Autofocus, and Operation/Others. The fourth item on the menu enables you to reset all Custom Functions to their default settings. (This option doesn't work while the Mode dial is set to C, which represents the Custom User Mode that I detail in Chapter 11.)

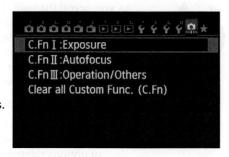

Figure 1-21: Custom Functions are organized into three categories.

✓ After you select a Custom Functions category, you see a menu option in that category, as shown on the left in Figure 1-22. The category number and name appear in the upper-left corner of the screen. In the figure, for example, Custom Function I (C.Fn I): Exposure, is visible.

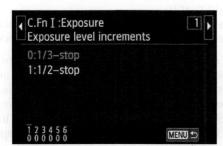

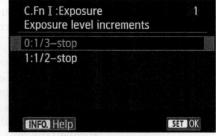

Figure 1-22: The Custom Functions screens aren't as complex as they first appear.

- ✓ The number of the selected function appears in the upper-right corner, and its name appears to the left. In the figure, the first menu item in the Exposure category, Exposure Level Increments, is selected.
- Settings for the current function appear in the middle of the screen. Some screens contain numbered items, in which case the blue text indicates the current setting, and the default setting is represented by the number 0.
 - On other screens, you can turn multiple items on or off via one screen. On these screens, a check mark next to a feature means that it's enabled.
- At the bottom of the screen, the top row of numbers represents the functions in the category, with the currently selected function indicated with a tiny horizontal bar over the number. The lower row shows the number of the current setting for each Custom Function; again, 0 represents the default. So in the figure, all the Custom Functions are currently using the default settings. (A horizontal line instead of a number means that the function is one of those that controls multiple features at a time via the checkmark system.)

To scroll from one Custom Function to the next, tap the left or right scroll arrow at the top of the screen, rotate the Quick Control dial, or press the Multi-controller left or right. When you reach the setting you want to adjust, use either of these techniques:

✓ Touchscreen: Tap the setting you want to use. (In some cases, you may need to tap the up/down arrows on the right side of the screen — not shown in the figures — to scroll the list of settings.)

From here, the process depends on whether you're looking at a screen that enables you to chose only one option or a screen that enables you to select multiple options. In the first case, the Set icon appears, as shown on the right in Figure 1-22. Tap that icon to lock in your choice and exit the setting screen. Your selected setting appears in blue and the number at the bottom of the screen updates to show the number of the option you selected.

For screens that contain the check mark lists, toggle the check mark next to an item on and off by tapping it. When you finish, tap OK to wrap things up or tap Cancel to exit the screen without making any changes.

✓ Buttons: Press the Set button to activate the settings. Use the Quick Control dial or press the Multi-controller up/down to move the highlight box over the option you want to use and then press the Set button. In check box lists, press Set to toggle the check mark on and off; highlight the OK symbol and press Set to finalize your changes. Highlight Cancel and press Set to exit the screen instead.

To exit the Custom Function screens, press the Menu button or tap the Menu icon in the lower right of the screen (see the left screen in Figure 1-22).

Monitoring Critical Camera Settings

Your camera offers a plethora of ways to view camera settings during shooting. Upcoming sections introduce you to these important tools; first, though, a little housekeeping is in order: You need to specify which information screens you want to display when you press the Info button, as described next.

The Info button: Choosing what the screen shows

By default, pressing the Info button during shooting gives you access to the three screens shown in Figure 1-23: the Camera Settings screen, the electronic level, and the Shooting Settings screen. Just press the button to cycle through the three screens; a fourth press turns the monitor off.

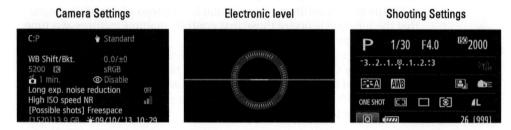

Figure 1-23: Press the Info button to cycle through these three displays.

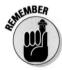

If nothing happens when you press the button, the camera has gone to sleep to save battery power. Wake it up by pressing the shutter button halfway and then try the Info button again. If you still don't get results or one of the screens shown in the figure doesn't appear, the answer lies with the Info Button Display Options item on Setup Menu 3, which controls which screen displays are enabled.

On this menu screen, shown in Figure 1-24, a check mark indicates that the screen is enabled. If you don't care to view a particular screen, highlight its name and press Set or tap the item to toggle its check mark off. To exit the screen, tap OK or highlight it and press Set. (For now, I suggest that you leave all three items selected and work with the camera a bit before you decide which displays to deactivate, if any.)

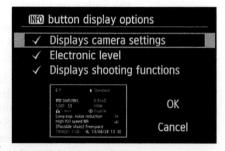

Figure 1-24: Choose which screens the Info button displays during shooting via this menu option.

The next two sections explain more about what you see in the Camera Settings and Shooting Settings displays. There's not much to tell about the electronic level: A green horizontal line through the circle (as shown in Figure 1-23) indicates that the camera is level, and a red line tells you that things are off-kilter. You also can display a level in the viewfinder; see the upcoming section "Decoding Viewfinder Data" to find out how.

If the last screen you displayed before turning the camera off (or before the camera entered sleep mode) was the Shooting Settings screen, you can bring back that screen by simply giving the shutter button a quick half-press.

Checking the Camera Settings display

The screen that appears with your first press of the Info button displays a different collection of settings depending on your exposure mode. In the advanced exposure modes (P, Tv, Av, M, B, and C), you see the data shown in Figure 1-25. In the automatic exposure modes, some of this data is dimmed because you don't have access to the related camera settings in those modes.

Moving from top to bottom of the screen, here's your decoder ring to each line of data:

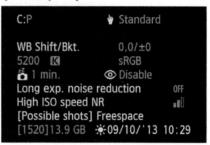

Figure 1-25: Press the Info button when the menus are active to view this screen.

- Camera User Setting mode and Touch Control setting: If you create a custom exposure mode, as I detail in Chapter 11, you can determine which exposure mode you used to set up that custom mode by looking at the C: item on the screen. Here, the letter P indicates that the P (programmed exposure) mode was the basis of the C mode.
 - On the right side of the line, you see the current Touch Control setting on Setup Menu 3, which enables you to adjust the sensitivity of the touchscreen or disable it altogether.
- White Balance Shift/Bracketing: This line relates to color options I cover in Chapter 8. When all the values are 0, as in the figure, White Balance Shift and White Balance Bracketing are both turned off.
- Color Temp and Color Space: Here are two more color settings you can explore in Chapter 8. The first value shows you the Kelvin temperature of your selected white-balance option, and the second shows you the color space, which is either sRGB or Adobe RGB.

- Auto Power Off and Red-Eye Reduction flash mode: The first value is linked to the Auto Power Off feature, which puts the camera to sleep after a specified period of inactivity. You can change the value via Setup Menu 2. The second symbol denotes whether Red-Eye Reduction flash is enabled; that feature is controlled via Shooting Menu 2.
- Long Exposure Noise Reduction: When you use a slow shutter speed (long exposure time), a grain-like defect called *noise* can creep into your picture. This screen item tells you whether you enabled the Long Exposure Noise Reduction feature, designed to combat this type of noise. See Chapter 7 for details on this option, found on Shooting Menu 4.
- ✓ High ISO Speed NR: Using a high ISO (light sensitivity) setting can also produce noise, so the camera offers a tool designed to combat that type of noise as well. The High ISO Speed NR item on the Camera Settings screen tells you what strength you selected for related menu item, found on Shooting Menu 4. Two bars, as in the figure, indicates that the Standard setting is in force. See Chapter 7 for more details.
- ✓ Possible Shots/Freespace: The blue values under this labels indicate how much storage space remains on your camera memory card. How many pictures you can fit into that space depends on the Image Quality setting you select. Chapter 2 explains this issue.
- ✓ Date/Time/Zone: Here you see what the camera thinks is the current date and time; you can change its clock via the Date/Time/Zone item on Setup Menu 2. The little sun symbol means that you told the camera to automatically adjust its clock to account for daylight saving time.

Viewing the Shooting Settings display

Shown in Figure 1-26, the Shooting Settings display contains the most critical photography settings, including aperture, shutter speed, and ISO. Note that the display is relevant only to regular still-photography shooting, though. When you switch to Live View mode or Movie mode, settings appear superimposed over the image on the monitor.

The data shown in the display depends on the exposure mode. The figure shows data that's included when you work in one of the advanced modes, such as P (programmed autoexposure). In the fully automatic

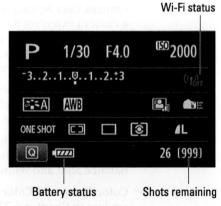

Figure 1-26: Here's a look at the Shooting Settings display as it appears in the P exposure mode.

modes as well as in Creative Auto mode, you see far fewer settings because you can control fewer settings in those modes. Figure 1-26 labels three key points of data that are helpful in any mode, however:

✓ Shots remaining: This number indicates how many more pictures can fit on your memory card at the current settings.

Don't confuse this number with the value to the left — 26, in the figure. That second value indicates the *maximum burst frames*. This number relates to shooting in one of the Continuous capture Drive modes, where the camera fires off multiple shots in rapid succession as long as you hold down the shutter button. During shooting, picture data is stored temporarily in the camera's *memory buffer* (internal data-storage tank) until it can be recorded to the memory card. If the number drops to 0, give the camera a moment to catch up with your shutter-button finger.

- ✓ Battery status: A "full" battery icon like the one in the figure shows that
 the battery is fully charged. If the icon appears empty, you better have
 your spare battery handy if you want to keep shooting.
- ✓ Wi-Fi status: Look to this area of the screen to see whether the built-in Wi-Fi system is enabled. (Chapters 6 and 10 explain the Wi-Fi functions.)

You can use the Shooting Settings display to both view and adjust certain picture-taking settings. Here's what you need to know:

- Turning on the Shooting Settings display: Press the Info button until the display appears. After you take a picture, the display should reappear automatically. And, if you turn the camera off while the screen is visible, it also reappears automatically when you next fire up the camera. During shooting, you can redisplay the screen at any time by pressing the shutter button halfway *unless* you use the Info button to display one of the other displays between shots.
- Adjusting settings: While the Shooting Settings display is active, you can change some shooting settings by rotating the Main dial, the Quick Control dial, or by using a dial in combination with one of the camera buttons. For example, in the shutter-priority autoexposure mode (Tv, on the Mode dial), rotating the Main dial changes the shutter speed. And if you press the ISO button, you're taken to the screen where you can adjust the ISO setting.

Additionally, if you press the Q button or tap the Q icon in the lower-left corner of the screen, you shift from the Shooting Settings screen to the Quick Control screen, which gives you access to even more camera settings. See "Changing Settings via the Quick Control Screen" for details on how this feature works.

Decoding viewfinder data

When the camera is turned on, you can view critical exposure settings and a few other pieces of information in the viewfinder. Just put your eye to the viewfinder and press the shutter button halfway to activate the display. In Live View mode, you use the LCD monitor as viewfinder; the viewfinder is disabled (ditto for Movie mode), so you don't want to be in these modes if you want to get information from the viewfinder. (See Chapter 4 for details about Live View and Movie modes.)

The viewfinder data changes depending on what action you're undertaking and what exposure mode you're using. For example, if you set the Mode dial to P (for programmed autoexposure), you see the basic set of data shown in Figure 1-27: shutter speed, f-stop (aperture setting), exposure compensation setting, and ISO setting. Additional data appears when you enable certain features, such as Flash Exposure Compensation. The black markings in the center of the screen relate to autofocusing; as with the other data, these markings depend on your autofocusing settings and exposure mode. (Depending on your autofocusing options, you also see one

Battery status

Figure 1-27: Viewing camera information at the bottom of the viewfinder.

or more rectangles, representing focusing points, flash red briefly when you press the shutter button halfway.)

Again, I detail each viewfinder readout as I explain your camera options throughout the book, but I want to point out now one often-confused value. You might expect that the value at the far right end of the viewfinder (34, in Figure 1-27) indicates the number of shots you can take before you memory card is full. Instead, it's the maximum burst frame number I mention in the preceding section: the number of shots you can take in one of the Continuous capture modes before the camera's memory buffer is full. Also make note of the handy battery status icon in the left corner of the display. When the symbol appears full, as in the figure, your battery is fully charged.

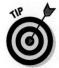

In addition to adjusting the viewfinder to your eyesight, as explained earlier in this chapter, you can customize the display via the following menu options:

✓ VF Grid Display (Shooting Menu 1): Enable this option to display a grid like the one shown on the left in Figure 1-28. The grid is especially helpful for checking the camera alignment with respect to objects in the scene, such as making sure the horizon line is level.

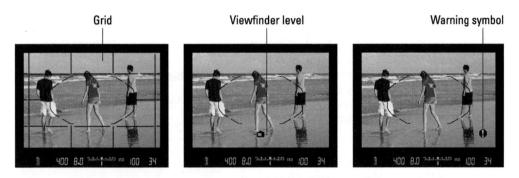

Figure 1-28: You can display a grid (left), an electronic level (center), and feature alert (right) in the viewfinder.

✓ Viewfinder Level (Shooting Menu 1): If you turn this option on, you see a little camera symbol at the bottom of the viewfinder, as shown on the middle in the figure. Horizontal lines at the edge of the camera symbol, as shown in the figure, indicate that the camera is level. Note, though, that the tool indicates only horizontal tilt and not forward/backward tilt.

As another option, you can set the Depth-of-field Preview button to display a level that uses the viewfinder grid and autofocus points to indicate the camera orientation. You assign this function via the Custom Controls option found in the Operation/Others section of the Custom Functions menu. See Chapter 11 for more information about adjusting button functions.

Warnings in Viewfinder (Custom Function 3 in the Operation/ Others category): By default, the camera displays the alert symbol you see on the right in Figure 1-28 when you enable the Monochrome Picture Style or apply White Balance correction. (I explain both features in Chapter 8.) You also can choose to display the alert when you enable ISO Expansion or Spot metering, both detailed in Chapter 7. On the Custom Functions menu screen, shown

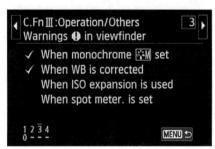

Figure 1-29: Specify when you want the warning symbol to appear via this Custom Functions menu item.

in Figure 1-29, items with a check mark trigger the warning symbol. You can toggle the check mark on and off by tapping the item or by highlighting it and pressing the Set button.

Reading the LCD panel

Another way to keep track of shooting information is through the LCD panel on top of the camera, shown in Figure 1-30. Don't see any data in the panel? The camera is probably in sleep mode; give the shutter button a half-press to wake it up.

As with the viewfinder and Shooting Settings display, the panel shows you the shots remaining value and battery status, as labeled in Figure 1-30. One other critical setting is also present: The status of the camera's built-in Wi-Fi feature. By default, it's turned off, as indicated in the figure. See Chapters 6 and 10 to find out more about this feature.

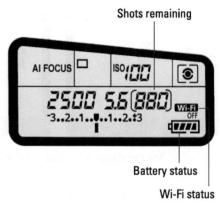

Figure 1-30: The top LCD panel is another useful situational awareness tool.

In dim lighting, you can press the little lightbulb button above the right corner of the display to illuminate the panel. If you take a picture in B (Bulb) mode, the panel won't illuminate while the shutter button is down, however.

Changing Settings via the Quick Control Screen

The Quick Control screen enables you to change certain shooting settings without using the function buttons (ISO button, Metering mode button, and so on) or menus. You can use this screen to adjust settings in any exposure mode, but the settings that are accessible depend on the mode you select.

To try it out, set the Mode dial to Tv (as shown in Figure 1-31) so that what you see on your screen looks like what you see in the upcoming figures. Then display the Shooting Settings screen (press the Info button as needed to get there) and either press the Q button or tap the Q icon in the lower-left corner of the screen.

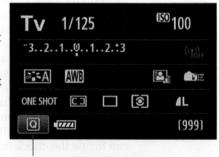

Tap to enter Quick Control mode

Figure 1-31: To shift to Quick Control mode from the Shooting Settings screen, tap the Q icon or press the Q button.

Either way, the screen shifts into Quick Control mode, and one of the options on the screen becomes highlighted. For example, the White Balance option is highlighted in Figure 1-32. (AWB stands for Auto White Balance.)

Now take these steps to adjust a setting:

1. Select the setting you want to adjust.

Either tap the setting on the touchscreen or use the Multicontroller to highlight it.

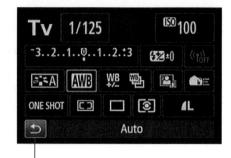

Return icon

Figure 1-32: The active option appears highlighted.

When you first highlight some options, a little text box pops up to tell you what the setting is designed to do. Tap the x button in the upper right of the box to get rid of it. If you find these text boxes annoying, you can turn them off through the Feature Guide option on Setup Menu 3.

2. Select the option you want to use.

You can use these techniques:

- To scroll through the available settings, rotate the Quick Control dial. The current setting appears at the bottom of the screen. For example, in Figure 1-32, the Auto setting is selected for the White Balance option.
- To display all the possible settings on a single screen, tap the option or press the Set button. For example, if you're adjusting the White Balance setting and tap the icon or press Set, you see the screen shown in Figure 1-33. Then tap the option you want to use or highlight it by rotating the Quick Control dial or using the Multi-controller. After selecting your choice, tap the return icon (the curved)

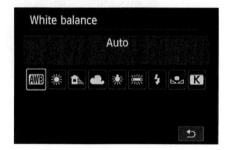

Figure 1-33: From the Quick Control screen, tap the selected item or press the Set button to display all available settings.

arrow in the lower-right corner of the screen) or press the Set button to return to the Quick Control screen.

A few controls require a slightly different approach, but don't worry — I spell out all the needed steps throughout the book.

- 3. Exit Quick Control mode and return to shooting mode using any of these techniques.
 - Tap the Return symbol, labeled in Figure 1-32.
- Q
- Press the Q button.
- Press the shutter button halfway and release it.

Getting Help from Your Camera

Your camera has a built-in help system that you can consult if you can't remember what a certain option does. It's easy to use: Any time you see a screen that displays the Info/Help symbol in the lower-left corner, as shown on the left in Figure 1-34, press the Info button or tap the Info screen symbol to reveal the help screen, as shown on the right. Scroll up and down the screen by using the Quick Control dial or the Multi-controller or by tapping the up and down arrows on the right side of the screen. Return to the preceding screen by pressing the Info button or tapping the Info icon again.

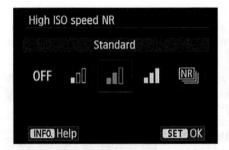

Figure 1-34: If you see the Info/Help icon (left), you can tap the icon or press the Info button to display information about the selected feature (right).

Reviewing Basic Setup Options

One of the many advantages of investing in the 70D is that you can customize its performance to suit the way *you* like to shoot. Later chapters explain

options related to actual picture taking; the rest of this chapter details options related to initial camera setup.

Cruising the Setup menus

As you might expect, the majority of the basic operational options live on the Setup menus, which you can explore in the next four sections. Remember that some menus and menu options are unavailable when the camera is set to Scene Intelligent Auto, Flash Off, Creative Auto (CA), or SCN mode.

Setup Menu 1

At the risk of being conventional, start your camera customization by opening Setup Menu 1, shown in Figure 1-35.

Here's a quick rundown of each menu item:

Select Folder: Through this option, you can select the folder on the memory card that will store your images. By default, the camera creates the initial folder for you and stores all your

Figure 1-35: Start your camera customization on Setup Menu 1.

images there; stick with the default settings for now. When you're ready to get more sophisticated, check out Chapter 11, which explains how you can create custom folders. You might create one folder to hold your work images and one to store family photos, for example.

- File Numbering: This option controls how the camera names your picture files.
 - *Continuous:* This is the default; the camera numbers your files sequentially, from 0001 to 9999, and places all images in the same folder. The initial folder name is 100Canon; when you reach image 9999, the camera creates a new folder, named 101Canon, for your next 9,999 photos. This numbering sequence is retained even if you change memory cards, which helps to ensure that you don't wind up with multiple images that have the same filename.

 Auto Reset: The camera restarts file numbering at 0001 each time you put in a different memory card or create a new folder. This isn't a good idea, for the reason just stated.

With both this option and Continuous, beware one gotcha: If you swap memory cards and the new card contains images, the camera may pick up numbering from the last image on the new card, which throws a monkey wrench into things. To avoid this problem, format the new card before putting it into the camera. (See the upcoming bullet point for help.)

- Manual Reset: Select this setting if you want the camera to begin a new numbering sequence, starting at 0001, for your next shot. The camera then returns to whichever mode you previously used (Continuous or Auto Reset).
- Auto Rotate: If you enable this feature, your picture files include a piece of data that indicates whether the camera was oriented in the vertical or horizontal position when you shot the frame. Then, when you view the picture on the camera monitor or on your computer, the image is automatically rotated to the correct orientation.

To automatically rotate images both in the camera monitor and on your computer monitor, stick with the default setting. In the menu, this setting is represented by On followed by a camera icon and a monitor icon, as shown in Figure 1-35. If you want the rotation to occur just on your computer and not on the camera, select the second On setting, which is marked with the computer monitor symbol but not the camera symbol. To disable rotation for both devices, choose the Off setting.

Note, though, that the camera may record the wrong orientation data for pictures that you take with the camera pointing directly up or down. Also, whether your computer can read the rotation data in the picture file depends on the software you use; the programs bundled with the camera can perform the auto rotation.

Format Card: The first time you insert a new memory card, use this option to *format* the card, a maintenance function that wipes out any existing data on the card and prepares it for use by the camera.

If you used your card in another device, such as a digital music player, be sure to copy those files to your computer before you format the card. You lose *all* data on the card when you format it, not just picture files. Also, some cards, including Eye-Fi cards, hold software that you need to install on your computer before you format.

When you choose the Format option, you can opt to perform a normal card formatting process or a *low-level* formatting. The latter gives your memory card a deeper level of cleansing than ordinary formatting and thus takes longer to perform. Normally, a regular formatting will do.

✓ Eye-Fi Settings: If an Eye-Fi memory card is installed, this menu option appears to enable you to control the wireless transmission between the camera and your computer. When no Eye-Fi card is installed, the menu option is hidden, as it is in Figure 1-35. I don't cover Eye-Fi cards in this book, but if you want more details about the product, visit www.eye.fi.

Setup Menu 2

Setup Menu 2, shown in Figure 1-36, offers these options:

Auto Power Off: To help save battery power, your camera automatically powers down after a certain period of inactivity. By default, the shutdown happens after 1 minute, but you can change the delay to as long as 30 minutes. You can disable auto shutdown altogether by selecting the Disable setting, but even if you do, the monitor turns off after 30 minutes.

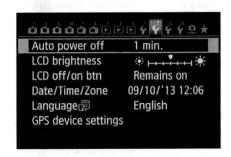

Figure 1-36: Setup Menu 2 offers more ways to customize basic operations.

✓ LCD Brightness: This option enables you to make the camera monitor brighter or darker. I show you how to take this step using the touchscreen in the section "Using the Touchscreen," earlier in this chapter, so I won't repeat all the details here.

If you take this step, what you see on the display may not be an accurate rendition of exposure. So keeping the brightness at its default center position is a good idea unless you're shooting in very bright or dark conditions. As an alternative, you can gauge exposure when reviewing images by displaying a Brightness histogram, a tool that I explain in Chapter 5.

- ✓ LCD Off/On BTN: By default, the Shooting Settings screen remains displayed on the monitor even if you press the shutter button halfway, and you must press the Info button to turn off the display. If you prefer to have the monitor go dark when you press the shutter button, change this setting from Remains On to Shutter Button.
- Date/Time/Zone: When you turn on your camera for the very first time, it automatically displays this option and asks you to set the date, time, and time zone. You also can specify whether you want the clock to update automatically to accommodate daylight saving time (accomplish this via the little sun symbol).

- Language: Set the language of text displayed on the camera monitor. Screens in this book display the English language, but I find it entertaining on occasion to hand our camera to a friend after changing the language to, say, Swedish. I'm a real yokester, yah?
 - If you change your language (intentionally or by accident) to something freaky, you'll appreciate the little speech bubble icon next to the Language setting for those times when you can't read the word for *Language*.
- ✓ **GPS Device Settings:** If you attach the optional GPS unit (Canon GP-E2), you can access device settings through this menu option.

Setup Menu 3

Continuing to Setup Menu 3, you find the following goodies, shown in Figure 1-37.

✓ Video System: This option is related to viewing your images and movies on a television. Select NTSC if you live in North America or other countries that adhere to the NTSC video standard; select PAL for playback in areas that follow that code of video conduct.

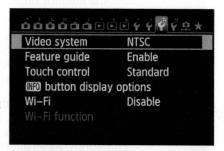

Figure 1-37: Head to Setup Menu 3 to enable or disable the Wi-Fi functions.

Feature Guide: When this option is enabled and you switch exposure modes (via the Mode dial) or choose certain other camera options, notes appear on the monitor to explain the feature. The guide screens disappear after a few seconds automatically or, in some cases, after you tap the little x in the upper right of the message box.

Although the Feature Guide screens are helpful at first, having them appear all the time is a pain after you get familiar with your camera. So I leave this option set to Disable — and for the sake of expediency in this book, I assume that you keep the option turned off as well. (If not, just don't be concerned when my instructions don't mention the screens in the course of showing you how to work the camera.)

- ✓ Touch Control: This setting controls the touchscreen interface. For details, flip back to the section "Using the Touchscreen."
- ✓ Info Button Display Options: As I cover in the earlier section "The Info button: Choosing what the screen shows," this setting determines which information screens appear when you press the Info button during shooting.
- ✓ Wi-Fi: By default, the Wi-Fi interface is turned off. When you're ready to take advantage of the Wi-Fi features, set the option to Enable. Note that movie recording is disabled when the Wi-Fi feature is turned on.
- ✓ Wi-Fi Function: Here's the route to the various wireless connectivity options built into your camera; Chapters 6 and 10 get you started on using these features.

Setup Menu 4

Setup Menu 4 contains the offerings shown in Figure 1-38. But note that you get access to all the menu items only when the Mode dial is set to one of the advanced exposure modes (P, Tv, Av, M, B, or C).

- Sensor Cleaning: Choose this option to access features related to the camera's internal sensorcleaning mechanism. These work like so:
 - Auto Cleaning: By default, Camera Settings on Setup Menu 4.
 the camera's sensor-cleaning mechanism activates each time you turn the camera on and off.

Figure 1-38: You can set the camera back

to its default settings by choosing Clear All

This process helps keep the image sensor — which is the part of the camera that captures the image — free of dust and other particles that can mar your photos. You can disable this option, but it's hard to imagine why you would choose to do so.

- Clean Now: Select this option and press Set to initiate a cleaning cycle. For best results, set the camera on a flat surface during cleaning.
- Clean Manually: In the advanced exposure modes, you can access
 this third option, which prepares the camera for manual cleaning
 of the sensor. I don't recommend this practice; sensors are delicate, and you're really better off taking the camera to a good service center for cleaning.
- Battery Info: Select to see battery information. There's more here than you might think: You can see what type of battery you have in the camera (or if you're connected to the power grid), how much power you have left (as a percentage), the number of photos you've taken on this battery (movie recordings aren't counted), and the battery's recharge performance. For this last feature, three green bars mean that the battery is working fine; two bars means that recharging is slightly below par; and one red bar means that you should invest in a new battery as soon as possible.
- Certification Logo Display: You have my permission to ignore this screen, which simply displays logos that indicate a couple electronicsindustry certifications claimed by the camera. You can find additional logos on the bottom of the camera.
- Custom Shooting Mode (C Mode): You can create your very own exposure mode through this option, which I detail in Chapter 11.
- Clear All Camera Settings: Choose this option to restore the default shooting settings. You can't perform this task while the Mode dial is set to C. Also be aware that not all camera settings are reset when you choose this menu option; the camera manual has a list of items that remain unchanged. Look in the "Before You Start" section of the electronic manual provided on the CD in your camera box.
 - If you just want to restore the original Custom Functions settings, instead open the Custom Functions menu and choose Clear All Custom Functions.
- **Copyright Information:** If you want to include copyright information in the image *metadata* (invisible text data that gets stored with the image file), this option gets the job done. Chapter 10 provides instructions.

Firmware Version: This screen tells you the version number of the camera firmware (internal operating software). When you select the menu option, you see a firmware item both for the camera and for your lens (assuming that you use a compatible Canon lens). At the time of publication, the current firmware version was 1.1.1 for the camera and 1.5.0 for the 18–135mm kit lens.

Keeping your firmware up to date is important, so visit the Canon website (www.canon.com) regularly to find out whether your camera sports the latest version. Follow the instructions given on the website to download and install updated firmware if needed.

Setting up the Lock switch

After working your way through the Setup menus, head for the Custom Functions menu and verify the status of the Multi Function Lock option, found in the Operation/Others section of the menu and shown in Figure 1-39. This setting is critical because it determines the results of moving the Lock switch on the back of the camera to the locked position.

By default, the switch only affects the Quick Control dial. When the dial is unlocked, rotating it while using the M exposure mode changes the aperture

Figure 1-39: This Custom Function determines what control is affected by the Lock switch on the back of the camera.

setting (f-stop), and spinning it while using the Av, Tv, or P mode changes the amount of Exposure Compensation. (I explain these exposure controls in Chapter 7.) If you set the switch to the locked position, rotating it has no effect on those settings, a *Lock* alert appears in the Shooting Settings display, and an L appears in the viewfinder and LCD panel to remind you that the dial is locked. You can still use the dial while navigating menus, selecting other camera settings, and while reviewing pictures.

If you prefer, you can also set the switch to lock the Main dial and the Multicontroller so that an errant movement doesn't accidentally adjust a camera setting. A check mark next to the control's name on the menu indicates that the lock will be in force; toggle the check mark on and off by tapping the item or highlighting it and pressing the Set button. (See the earlier section "Navigating the Custom Functions Menu" if you need help.)

While using this book, stick with the default setup, shown in the figure. Otherwise, my instructions won't work.

Taking two final setup steps

Shooting Menu 1, shown in Figure 1-40, offers two more basic setup options:

Beep: By default, your camera beeps after certain operations, such as after it sets focus when you use autofocusing. If you're doing top-secret surveillance and need the camera to hush up, set this option to Disable.

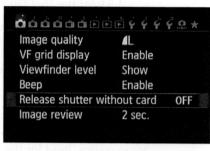

This option also controls whether

Figure 1-40: I recommend disabling the Release Shutter without Card option.

This option also controls whether the touchscreen emits a sound

with each tap. If you want to hear the focusing and other operational beeps but not the touchscreen sounds, choose the Touch to Silence option instead of Enable.

Release Shutter without Card: Setting this option to Disable prevents shutter button release when no memory card is in the camera. If you turn on the option, you can take a picture and then review the results for a few seconds in the camera monitor. The image isn't stored anywhere, however; it's only temporary.

If you're wondering about the point of this option, it's designed for use in camera stores, enabling salespeople to demonstrate cameras without having to keep a memory card in every model. Unless that feature somehow suits your purposes, keep this option set to Disable.

Choosing Basic Picture Settings

In This Chapter

- Spinning the Mode dial
- ▶ Changing the shutter-release mode
- Adding flash
- ▶ Understanding the Image Quality setting (resolution and file type)

very camera manufacturer strives to ensure that your first encounter with the camera is a happy one. To that end, the camera's default settings make it as easy as possible for you to take a good picture the first time you press the shutter button. At the default settings, your camera works about the same way as any point-and-shoot camera: You compose the shot, press the shutter button halfway to focus, and then press the button the rest of the way to take the picture.

Although you can get a good photo using the default settings in many cases, they're not designed to give you optimal results in every situation. You may be able to take a decent portrait, for example, but probably need to tweak a few settings to capture action. Adjusting a few options can help turn that decent portrait into a stunning one, too.

So that you can start fine-tuning settings to your subject, this chapter explains the most basic picture-taking options, such as the exposure mode, shutter-release mode (officially called Drive mode), and the Image Quality option. They may not be the most exciting options (don't think I didn't notice you stifling a yawn), but they make a big difference in how easily you can capture the photo you have in mind.

Note: This chapter relates to still photography; for information about shooting movies, see Chapter 4.

Choosing an Exposure Mode

The first picture-taking setting to consider is the exposure mode, which you select via the Mode dial, shown in Figure 2-1. Remember that before you can rotate the dial, you must press and hold the lock button in the center of the dial.

Your exposure mode choice determines how much control you have over two critical exposure settings — aperture and shutter speed — as well as many other options, including those related to color, autofocusing, and flash photography.

Canon categorizes the exposure modes as follows:

- ✓ Basic Zone: The Basic Zone category includes the following point-and-shoot modes, represented on the Mode dial with the icons shown in the margins:
 - Scene Intelligent Auto:
 The most basic mode; the camera analyzes the scene and then handles everything but framing and focusing.

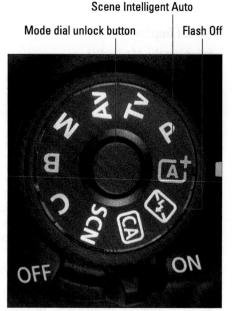

Figure 2-1: Settings on the Mode dial determine the exposure mode.

- Flash Off. Just like Scene Intelligent Auto except that flash is disabled.
- Creative Auto: Like Scene Intelligent Auto on steroids, this mode takes control of most settings but gives you an easy way to tweak some picture qualities, such as how much the background blurs.
- Scene modes: You also get seven fully automatic modes geared to capturing specific types of scenes:
 Portrait, for taking traditional portraits.

Landscape, for capturing scenic vistas.

Close-up, for shooting subjects at close range.

Sports, for capturing moving subjects.

Night Portrait, for outdoor photographs of people at night.

Handheld Night Scene, for taking pictures in dim lighting without a tripod.

HDR Backlight Control, for getting better results with high contrast scenes, such as a dark subject set against a bright background. (The HDR stands for *high dynamic range; dynamic range* refers to the range of brightness values in an image.)

After setting the Mode dial to SCN, choose the specific scene type via the Quick Control screen, as shown in Figure 2-2.

Chapter 3 tells you more about these modes, but be forewarned: To remain easy to use, all these modes prevent you from taking advantage of advanced exposure, color, and autofocusing features. You can adjust options discussed in this chapter, but the camera controls most everything else.

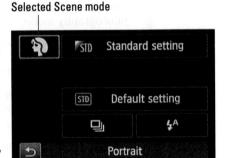

Figure 2-2: Use the Quick Control screen to select from the available SCN (scene) modes.

Creative Zone: When you're ready to take full control over the camera, step up to one of the Creative Zone modes. This category includes the advanced exposure modes (P, Tv, Av, and M), which I detail in Chapter 7. In addition, this zone offers B mode, which stands for *bulb*. With a bulb exposure, the shutter stays open as long as you keep the shutter button pressed; this option is handy for shooting fireworks and other special subjects where you want to control exposure time "on the fly" rather than dialing in a specific shutter speed between shots. This zone also offers C mode, which is a custom mode you can create using your own favorite settings. Chapter 11 explains how to register the settings you want to use in C mode.

Keeping track of all these zones is a little confusing, so to keep things a little simpler, I use the generic term *fully automatic exposure modes* to refer to the Basic Zone modes and *advanced exposure modes* to refer to the Creative Zone modes.

Changing the Drive Mode

The Drive mode setting tells the camera what to do when you press the shutter button: Record a single frame or a series of frames, or record one or more shots after a short delay.

Your camera offers the following Drive modes, which are represented by the symbols you see in the margin:

- Ш
- ✓ Single: This setting, which is the default for all exposure modes except the Portrait and Sports Scene modes, records a single image each time you press the shutter button. In other words, this is normal photography mode.
- Continuous: Sometimes known as burst mode, this mode records a continuous series of images as long as you hold down the shutter button. You can choose from two burst-mode settings:
 - High-speed continuous: At this setting, the camera can capture a maximum of about 7 frames per second (fps). This setting is the default for Sports Scene mode.
 - Low-speed continuous: This setting drops the maximum capture rate to about 3fps. It's the default for Portrait Scene mode.

Why would you want to capture fewer than the maximum number of shots? Well, frankly, unless you're shooting something that's moving at a really, really fast pace, not too much is going to change between frames when you shoot at 7 fps.

Keep in mind that the number of frames you can record per second depends in part on your shutter speed. To achieve 7fps at the Highspeed Continuous setting, you need a shutter speed of 1/500 second or faster. Also, some other functions, such as using flash, slow down the capture rate. The speed of your memory card plays a role in how fast the camera can capture images, too.

- ✓ **Silent Single Shooting:** Although your camera isn't entirely silent in this mode, some sounds are less audible than in normal Single mode. There's a drawback, though: The delay that occurs between the time you press the shutter button and the picture is recorded *shutter lag*, in photo lingo is slightly longer than with the normal Single mode.
- ✓ **Silent Continuous Shooting:** This mode, too, tries to dampen some camera sounds while permitting you to fire off about three frames a second. The warning about shutter lag time applies here, too.

In some autofocusing situations, the camera beeps when focusing is achieved even in the silent modes. To silence that sound, set the Beep option on Shooting Menu 1 to Disable.

✓ 10-Second Self-Timer/Remote Control: Want to put yourself in the picture? Select this mode, depress the shutter button, and run into the frame. You have about 10 seconds to get yourself in place and pose before the image is recorded. If you change your mind in the meantime, you can cancel the self-timer countdown by pressing the Drive button.

You can also use the self-timer function to avoid any possibility of camera shake. The mere motion of pressing the shutter button can cause slight camera movement, which can blur an image. Put the camera on a tripod and then activate the self-timer function. This enables "hands-free" — and therefore motion-free — picture taking.

As an alternative, purchase one of the Canon remote-control units. You can opt for a wireless unit or one that plugs into the remote-control terminal on the left side of the camera. (Read about both in Chapter 1.) Either way, set the Drive mode to this option or the following one when you want to trigger the shutter release with the remote control.

Your camera offers one other remote-trigger option, too: You can connect the camera wirelessly to a smartphone, tablet, or computer and trigger the shutter release through that device. Chapter 10 talks more about this feature.

✓ **2-Second Self-Timer/Remote Control:** This mode is available only in P, Tv, Av, M, and C exposure modes. It works just like the other Self-Timer/ Remote Control mode but with just a 2-second capture delay.

You can view the current Drive mode in the Shooting Settings screen and the LCD panel, in the areas labeled in Figure 2-3.

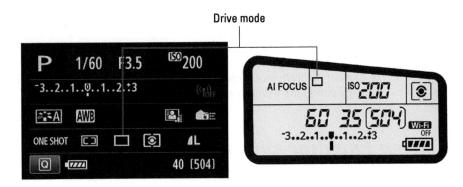

Figure 2-3: Look here for the symbol representing the Drive mode.

To change the Drive mode, you have two options:

button: Press the Drive button on the top of the camera to display the available modes on the monitor, as shown in Figure 2-4. Tap the setting you want to use or highlight it by using the Main dial, the Quick Control dial, or the Multicontroller. To lock in your choice, tap the return arrow or press the Drive button or the Set button.

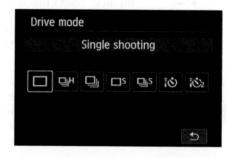

Figure 2-4: You can access all these Drive options only in advanced exposure modes.

In the LCD panel, all data except the Drive mode disappears as soon as you press the Drive button. As you change the setting, the icon updates to show the currently selected option. Press the Drive button again or press Set after you choose your setting.

✓ **Quick Control screen:** After activating the Quick Control screen, highlight the Drive mode icon, as shown in Figure 2-5. The name of the current setting appears at the bottom of the screen. Rotate the Main dial to cycle through the available Drive mode options. Alternatively, tap the Drive mode icon or highlight it and press Set to access the same selection screen featured in Figure 2-4.

Figure 2-5: You also can change the Drive mode setting via the Quick Control screen.

Your selected Drive mode remains in force until you change it or switch to an exposure mode for which the selected Drive mode isn't available.

Getting Familiar with the Built-in Flash

The built-in flash offers an easy, convenient way to add light to a dark scene. Whether you can use flash depends on your exposure mode, as outlined in the next few sections.

Before you digest that information, note these universal tips:

- regarding flash status. A lightning bolt like the one in the lower
 left of Figure 2-6 tells you that
 the flash is enabled. The word
 Busy along with the lightning
 bolt means that the flash is occupied calculating the flash setting
 or, after the shot, needs a few
 moments to recharge the flash.
 The Busy alert also appears on
 the Shooting Settings screen.
- The effective range of the builtin flash depends on the ISO setting. The ISO setting affects the camera's sensitivity to light; Chapter 7 has details. At the lowest ISO setting, ISO 100, the maximum reach of the flash

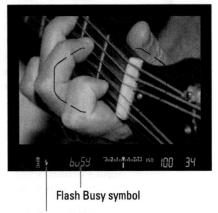

Flash On symbol

Figure 2-6: A Busy signal means that the flash is recharging.

- ranges from about 7 to 11 feet, depending on whether you're using a telephoto or wide-angle lens, respectively. To illuminate a subject that's farther away, use a higher ISO speed or an auxiliary flash that offers greater power than the built-in flash.
- ✓ **Don't get too close.** Position the lens at a minimum distance of about 3.5 feet from the subject, or the flash may not illuminate the entire subject.
- ✓ Watch for shadows cast by the lens or a lens hood. When you shoot with a long lens, you can wind up with unwanted shadows caused by the flash light hitting the lens. Ditto for a lens hood.

Using flash in the fully automatic modes

Whether flash is available and how much control you have over it depends on the exposure mode. Here's how things shake out:

- Flash Off and Landscape, Sports, and HDR Backlight Control Scene modes: Flash is disabled.
- ✓ Scene Intelligent Auto, Creative Auto, and Portrait and Close-up Scene modes: Choose from three flash settings:
 - *Auto flash:* The camera decides when to fire the flash, basing its decision on the lighting conditions.

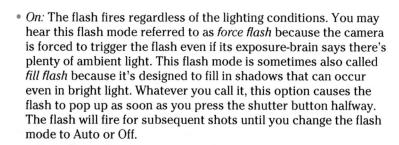

- Off: The flash does not fire, no way, no how. Even if the built-in flash is raised because you used it on the previous shot, it still won't fire.
- Night Portrait Scene mode: Auto flash is used for this mode; the camera decides whether flash is needed.
- Handheld Night Scene mode: In this exposure mode, the camera takes four frames in rapid succession and merges them to get a sharper result than you might otherwise obtain when hand-holding the camera in dim lighting. By default, flash is turned off, and this is the best choice if you're shooting landscapes. If you're photographing people or a close-up subject at night, you can enable flash to help illuminate the subject. The flash will fire on the first shot only; warn people to keep smiling until all four frames are captured.

For exposure modes that allow flash, you can view the current flash setting in the Shooting Settings screen. Figure 2-7 shows you how the screen appears in Scene Intelligent Auto mode.

To change the flash setting, press Q to bring up the Quick Control screen. The left screen in Figure 2-8 shows you how the screen looks in Scene Intelligent Auto mode. Next, highlight the Flash mode setting, as shown in the figure, and then rotate the Main dial or Quick Control dial to cycle through the available settings. Or, if

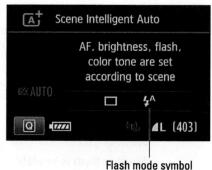

Figure 2-7: This symbol tells you that the flash is set to Auto mode.

you prefer, tap the flash icon or press Set to display all your choices on one screen, as shown on the right in the figure. Make your selection and then tap

the return arrow or press Set to go back to the Quick Control screen. Then press the Q button again or give the shutter button a quick half-press to exit the Quick Control screen.

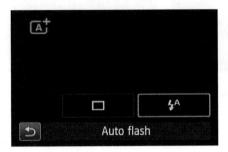

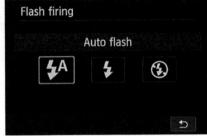

Figure 2-8: Change the flash setting via the Quick Control screen.

Enabling flash in advanced exposure modes

In the advanced exposure modes, you don't choose from the Auto, On, and Off flash modes as you do for some of the automatic shooting modes. Instead, if you want to use the built-in flash, you press the Flash button on the side of the camera. (See Figure 2-9.) The flash pops up and fires on your next shot. Don't want flash? Just close the flash unit.

You do, however, have access to flash options that aren't available in the fully automatic exposure modes. Chapter 7 explains them all. Until you're ready to dig into those features, just make sure that flash firing is enabled. Bring up Shooting Menu 2, select Flash Control, and verify that Flash Firing is set to Enable, as illustrated in Figure 2-10.

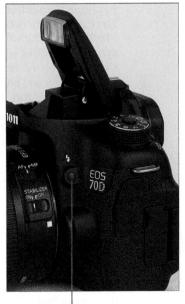

Figure 2-9: In the advanced exposure modes, press the Flash button to raise the built-in flash.

Flash button

Flash control
riasii control
Red—eye reduc. Disable Mirror lockup OF

Flash control	
Flash firing	Enable
E-TTL II meter.	Evaluative
Flash sync. speed	in Av mode AUTO
Built-in flash setti	ngs
External flash fund	c. setting
External flash C.Fr	setting
Clear settings	MENU 5

Figure 2-10: Set this option to Enable for normal flash firing in the advanced exposure modes.

Using Red-Eye Reduction flash

For any exposure mode that permits flash, you can enable a Red-Eye Reduction feature. When you turn on this feature, the Red-Eye Reduction lamp on the front of the camera lights when you press the shutter button halfway. The light constricts the subject's pupils, which helps reduce the chances of redeye. The flash fires when you press the shutter button the rest of the way. Turn the feature on and off via Shooting Menu 2, as shown in Figure 2-11.

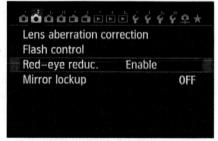

Figure 2-11: Turn Red-Eye Reduction flash mode on and off via Shooting Menu 2.

The viewfinder, LCD panel, and Shooting Settings display don't offer any indication that Red-Eye Reduction is enabled. However, the Camera Settings screen displays a little eyeball icon and the word *Enable* or *Disable*. To display the screen, press the Info button until it appears; see Chapter 1 for more about this display.

After you press the shutter button halfway in Red-Eye Reduction flash mode, a row of vertical bars appears in the center of the viewfinder data display. A few moments later, the bars turn off one by one. For best results, wait until all the bars are off to take the picture. (The delay gives the subject's pupils time to constrict in response to the Red-Eye Reduction lamp.) In addition, when you use the default autofocusing settings, the built-in flash may pulse briefly to help the camera find its focusing target; you can disable this feature via the AF-Assist Beam Firing option, found in the Autofocus Custom Functions category.

Controlling Picture Quality

One final control to check before any shoot is the Image Quality setting, which determines two important aspects of your pictures: *resolution*, or pixel

count; and *file format*, which refers to the type of computer file the camera uses to store your picture data.

As the setting name implies, resolution and file format play a role in the quality of your photos, so selecting the right Image Quality option is an important decision. Why not just dial in the maximum quality level and be done with it? Well, that's the right choice for some photographers. But because choosing that maximum setting has some disadvantages, you may find that stepping down a notch or two on the quality scale is a better option for some pictures.

To help you figure out which setting meets your needs, the rest of this chapter explains exactly how resolution and file format affect your pictures. Just in case you're having quality problems related to other issues, though, the next section provides a handy quality-defect diagnosis guide.

Diagnosing quality problems

When I use the term *picture quality*, I'm not talking about the composition, exposure, or other traditional characteristics of a photograph. Instead, I'm referring to how finely the image is rendered in the digital sense.

Figure 2-12 illustrates the concept: The first example is a high-quality image, with clear details and smooth color transitions. The other examples show five common digital-image defects.

Each defect is related to a different issue, and only two are affected by the Image Quality setting. So if you aren't happy with your image quality, first compare your photos with those in the figure to properly diagnose the problem. Then try these remedies:

- ✓ Pixelation: When an image doesn't have enough *pixels* (the colored tiles used to create digital images), details aren't clear, and curved and diagonal lines appear jagged. The fix is to increase image resolution, which you do via the Image Quality setting. See the upcoming section, "Considering Resolution: Large, Medium, or Small?" for details.
- ✓ **JPEG artifacts:** The "parquet tile" texture and random color defects that mar the third image in Figure 2-12 can occur in photos captured in the JPEG (*jay*-peg) file format, which is why these flaws are referred to as *JPEG artifacts*. This defect is also related to the Image Quality setting; see the "Understanding File Type (JPEG or Raw)" section, later in this chapter, to find out more.
- ✓ Noise: This defect gives your image a speckled look, as shown in the lower-left example in Figure 2-12. Noise is caused by a high ISO setting or by a long exposure time; Chapter 7 explores these topics and discusses possible remedies.

- ✓ **Color cast:** If colors are out of whack, as shown in the lower-middle example in Figure 2-12, try adjusting the camera's White Balance setting. Chapter 8 covers this control.
- Lens/sensor dirt: A dirty lens is the first possible cause of the kind of defects you see in the last example in Figure 2-12. If cleaning your lens doesn't solve the problem, dust or dirt may have made its way onto the camera's image sensor.

Your camera has an internal sensor-cleaning mechanism that runs every time you turn the camera on or off. You also can request a cleaning session at any time via the Sensor Cleaning option on Setup Menu 4. If that proves inadequate, a manual sensor cleaning is necessary.

You can do this job yourself, but I don't recommend it because you can easily damage your camera if you aren't careful. Instead, find a local camera store that offers this service. Sensor cleaning typically costs about \$50, but some places offer the service for free if you bought the camera there.

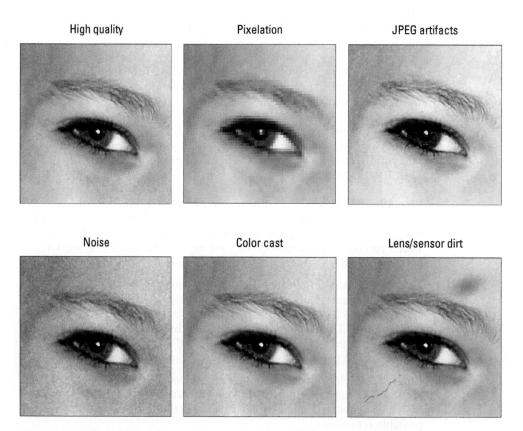

Figure 2-12: Refer to this symptom guide to determine the cause of poor image quality.

I should stress that I took some image-processing liberties to exaggerate the flaws in my example images to make the symptoms easier to see. With the exception of an unwanted color cast or a big blob of lens or sensor dirt, these defects may not even be noticeable unless you print or view your image at a very large size. And the subject matter of your image may camouflage some flaws; most people probably wouldn't detect a little JPEG artifacting in a photograph of a densely wooded forest, for example.

In other words, don't consider Figure 2-12 as an indication that your camera is suspect in the image quality department. By following the guidelines in this chapter and the others mentioned in the preceding list, you can resolve any quality issues that you may encounter.

Decoding the Image Quality options

Your camera's Image Quality setting determines both the image resolution and file format of the pictures you shoot. To access the control, you can go two routes:

✓ Quick Control screen: In the advanced exposure modes, you can choose the option via the Quick Control screen. To do so, select the Image Quality option, as shown on the left in Figure 2-13. Then rotate the Main dial or Quick Control dial to cycle through the available settings. Or give the option symbol a tap or press the Set button to display the screen shown on the right, which contains all the possible options.

On this screen, tap the options you want to use. Or, if you want to go old-school, use the Main dial to change Raw settings, and the Quick Control dial or the Multi-controller to select a JPEG setting. Tap the Return arrow or press the Set button to finish the job.

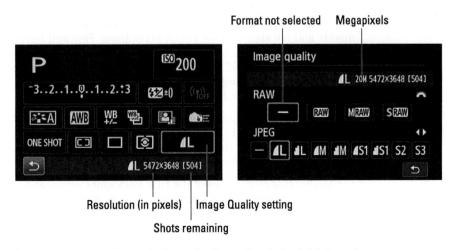

Figure 2-13: You can change the Image Quality setting via the Quick Control screen.

Shooting Menu 1: You also can access the Image Quality options via this menu, as shown in Figure 2-14. After you select the menu option, you see the screen shown on the right in Figure 2-13. Going the menu route is the only way to change the setting in the fully automatic exposure modes.

Figure 2-14: You also can select the option via Shooting Menu 1.

If you're new to digital photography, the available settings won't make much sense until you read the rest of this chapter, which explains format

and resolution in detail. But even if you're schooled in those topics, you may need some help deciphering the way that the settings are represented on your camera. As you can see from Figure 2-13, the options are presented in rather cryptic fashion, so here's your decoder ring:

- ✓ At the bottom of the Quick Settings screen, you see two bits of information about the current setting, as labeled in Figure 2-13: the resolution (pixel count) and the number of subsequent shots you can fit on your memory card at that setting. The next section explains pixels and resolution.
- ✓ This same information bar appears at the top of the screen when you change the setting via Shooting Menu 1 or the settings screen (refer to the right screen in Figure 2-13). The first value here, though, tells you the total pixel count, measured in *megapixels* (MP). (A megapixel equals 1 million pixels.)

- The next two rows of the settings screen show icons representing the Image Quality settings. The settings marked with the little arc symbols capture images in the JPEG file format, as do the S2 and S3 settings. The arc icons represent the level of JPEG compression, which affects picture quality and file size. You get two JPEG options: Fine and Normal. The smooth arcs represent the Fine setting; the jagged arcs represent the Normal setting. Both S2 and S3 use the JPEG Fine recording option. Check out the upcoming section "JPEG: The imaging (and web) standard" for details about JPEG.
- Within the JPEG category, you can choose from five resolution settings, represented by L, M, and S1, S2, and S3 (*large, medium*, and *small, smaller, smallest*). See the next section for information that helps you select the right resolution.
- For all shooting modes except the HDR Backlight Control and Handheld Night Scene modes, you can select the Raw file format, and you can specify whether you want the file captured at the maximum pixel count (the plain old Raw setting), medium resolution (M), or small (S). The upcoming section "Raw (CR2): The purist's choice" explains the Raw format.

- You can capture the image in both the Raw and JPEG formats. Of course, this option fills up your memory card faster because you're creating two image files. To bypass one of the two formats, select the horizontal bar at the start of the line. (In the figure, I deselected the Raw format, for example.)
- ✓ The Main dial and arrow icons to the right of the file types are a reminder that you can use the Main dial to cycle through the Raw settings and press the Multi-controller right/left to select the JPEG settings. You also can use the Quick Control dial to change the JPEG setting. If the touchscreen is enabled, though, it's easier to simply tap the setting you want to use.

Which Image Quality option is best depends on several factors, including how you plan to use your pictures and how much time you care to spend processing your images on your computer. The rest of this chapter explains these and other issues related to the Image Quality settings.

Considering Resolution: Large, Medium, or Small?

To decide upon an Image Quality setting, the first decision you need to make is how many pixels you want your image to contain. *Pixels* are the little square tiles from which all digital images are made; *pixel* is short for *pic*ture *ele*ment. You can see some pixels close up in the right image in Figure 2-15, which shows a greatly magnified view of the eye area in the left image.

Figure 2-15: Pixels are the building blocks of digital photos.

The number of pixels in an image is referred to as its *resolution*. Your camera offers five resolution levels, which are assigned the generic labels Large, Medium, and Small (1-3) and are represented by the initials L, M, and S (1-3). Table 2-1 shows you the pixel count that results from each option.

Table 2-1 Symbol	The Resolution Side of the Quality Settings	
	Setting	Pixel Count
L et e	Large	5472 x 3648 (20MP)
М	Medium	3648 x 2432 (8.9MP)
S1	Small 1	2736 x 1824 (5.0MP)
S2	Small 2	1920 x 1280 (2.5MP)
S3	Small 3	720 x 480 (0.30MP)

In the table, the first pair of numbers in the Pixel Count column represents the image *pixel dimensions* — the number of horizontal pixels and the number of vertical pixels. The values in parentheses indicate the total resolution, which you get by multiplying the horizontal and vertical pixel values. This number is usually stated in *megapixels*, or MP for short. The camera displays the resolution value using only one letter M, however (refer to Figures 2-13 and 2-14). Either way, 1MP equals 1 million pixels.

To choose the right setting, you need to understand the three ways that pixel count affects your pictures:

Print size: Pixel count determines the size at which you can produce a high-quality print. If you don't have enough pixels, your prints may exhibit the defects you see in the pixelation example in Figure 2-12 — or worse, you may be able to see the individual pixels, as in the right example in Figure 2-15. Depending on your photo printer, you typically need anywhere from 200 to 300 pixels per linear inch, or *ppi*, of the print. To produce an 8 x 10 print at 200 ppi, for example, you need a pixel count of 1600 x 2000, or just less than 2MP.

Even though many photo-editing programs enable you to add pixels to an existing image, doing so isn't a good idea. For reasons I won't bore you with, adding pixels — *upsampling* — doesn't enable you to successfully enlarge your photo. In fact, it typically makes matters worse.

Screen display size: Resolution doesn't affect the quality of images viewed on a monitor, television, or other screen device the way it does for printed photos. Instead, resolution determines the *size* at which the image appears. This issue is one of the most misunderstood aspects of digital photography, so I explain it thoroughly in Chapter 6. For now,

just know that you need *way* fewer pixels for onscreen photos than you do for printed photos. In fact, the smallest resolution setting available on your camera, 720 x 480 pixels, is plenty for e-mail sharing. At larger sizes, the recipient usually can't view the entire picture without scrolling the display (or the photo is resized to fit the monitor, which defeats the purpose of having a large file in the first place).

✓ File size: Every additional pixel increases the amount of data required to create a picture file. So, a higher-resolution image has a larger file size than a low-resolution image.

Large files present several problems:

- You can store fewer images on your memory card, on your computer's hard drive, and on removable storage media, such as a DVD. (Your camera manual contains a chart showing how many pictures will fit on a specific size memory card at each of the Image Quality settings, if you're interested.)
- The camera needs more time to process and store the image data on the memory card after you press the shutter button.
- When you share photos online, larger files take longer to upload and download.
- Some e-mail programs refuse to let you attach very large photo files to your messages.
- When you edit photos in your photo software, your computer needs more resources and time to process large files.

So what do you do if you aren't sure how large you want to print your images? What if you want to print your photos *and* share them online? Here are my recommendations:

- Always shoot at a resolution suitable for print. You then can create a low-resolution copy of the image in your photo editor for use online. Chapter 6 shows you how.
- ✓ For everyday images, Medium is a good choice. I find the Large setting to be overkill for most casual shooting, creating huge files for no good reason. Keep in mind that even at the Medium setting, your pixel count (3648 x 2432) is enough to produce an 8 x 10 print at 300 ppi.
- Choose Large for an image that you plan to crop, print very large, or both. The benefit of maxing out resolution is that you have the flexibility to crop your photo and still generate a decent-sized print of the remaining image. Figure 2-16 offers an example. When shooting this photo, I couldn't get closer to the butterfly than the first picture shows. But because I had the resolution set to Large, I was able to crop the shot to the composition in the right image and still produce a good print. In fact, I could print it much larger than fits here.

Figure 2-16: When you can't get close enough to fill the frame with the subject, capture the image at the Large resolution setting and crop later.

✓ Reduce resolution if shooting speed is paramount or you're running out of space on your memory card. When you're shooting action and the shotto-shot capture time is slower than you'd like, dialing down the resolution may help. And of course, fewer pixels means that you can fit more images in the space available on your memory card. You'll see the shots-remaining value in the displays increase as you choose a lower resolution setting.

Understanding File Type (JPEG or Raw)

In addition to establishing resolution, the Image Quality setting determines the *file format*, which refers to the type of image file that the camera produces. Your 70D offers two formats — JPEG and Raw (sometimes seen as *raw* or *RAW*), with a couple variations of each. The next sections explain each setting.

JPEG: The imaging (and web) standard

This format is the default setting on your camera, as it is for most digital cameras. JPEG is popular for two main reasons:

Immediate usability: JPEG is a longtime standard for digital photos. All web browsers and e-mail programs can display JPEG files, so you can share photos online immediately after you shoot them. You also can get JPEG photos printed at any online or a local printer. Additionally, any program that has photo capabilities, from photo-editing programs to word processing programs, can handle JPEG files.

✓ **Small files:** JPEG files are smaller than Raw files. And smaller files mean that your pictures consume less room on your camera memory card and on your computer's hard drive. (Again, look in the camera manual for a chart that shows how many pictures fit within a specified amount of memory at each of the Image Quality settings.)

The downside is that JPEG creates smaller files by applying *lossy compression*. This process actually throws away some image data. Too much compression leads to the defects you see in the JPEG artifacts example in Figure 2-12.

On your camera, the amount of compression depends on whether you choose an Image Quality setting that carries the label Fine or Normal. The difference between the two breaks down as follows:

Normal: Switch to Normal, and the compression amount rises, as does the chance of seeing some artifacting. Notice the jaggedy-ness of the Normal icon, as shown in the margin? That's your reminder that all may not be "smooth" sailing when you choose a Normal setting.

Note, though, that even the Normal setting doesn't result in anywhere near the level of artifacting that you see in Figure 2-12. Again, that example is exaggerated to help you recognize artifacting defects. In fact, if you keep your print or display size small, you aren't likely to notice a great deal of difference between the Fine and Normal compression levels. The impact of the setting becomes apparent only when you greatly enlarge a photo.

Given that the differences between Fine and Normal aren't that easy to spot until you really enlarge the photo, is it okay to shift to Normal and enjoy the benefits of smaller files? Well, only you can decide what level of quality your pictures demand. For most photographers, the added file sizes produced by the Fine setting aren't a huge concern, given that the prices of memory cards fall all the time. Long-term storage is more of an issue; the larger your files, the faster you fill your computer's hard drive and the more DVDs or CDs you need for archiving purposes. I prefer to take the storage hit in exchange for the lower compression level of the Fine setting. You never know when a casual snapshot is going to be so great that you want to print or display it large enough that even minor quality loss becomes a concern. And of all the defects that you can correct in a photo editor, artifacting is one of the hardest to remove. So stick with Fine when shooting in the JPEG format. Or, if you don't want *any* risk of artifacting, change the file type to Raw (CR2), explained next.

Whichever format you select, be aware of one more important rule for preserving the original image quality: If you retouch pictures in your photo software, don't save the altered images in the JPEG format. Every time you alter and save an image in the JPEG format, you apply another round of lossy compression. And with enough editing, saving, and compressing, you *can* eventually get to the level of image degradation shown in the JPEG example in Figure 2-12, at the start of this chapter. (Simply opening and closing the file does no harm.)

Always save your edited photos in a nondestructive format. TIFF is a good choice and is a file-saving option available in most photo-editing programs. Should you want to share the edited image online, create a JPEG copy of the TIFF file when you finish making all your changes. That way, you always retain one copy of the photo at the original quality captured by the camera.

Raw (CR2): The purist's choice

When you shoot in any exposure mode except the HDR Backlight Control or Handheld Night Scene mode, you can choose a format called *Camera Raw*, or just *Raw* (as in, uncooked) for short.

Each manufacturer has its own flavor of Raw files; Canon's are CR2 files (or, on some older cameras, CRW). You'll see that three-letter designation at the end of your picture filenames on your computer.

Raw is popular with advanced photographers, for two reasons:

- Greater creative control: With JPEG, internal camera software tweaks your images, adjusting color, exposure, and sharpness as needed to produce the results that Canon believes its customers prefer (or according to settings you chose). With Raw, the camera simply records the original, unprocessed image data. The photographer then copies the image file to the computer and uses *raw conversion* software to produce the actual image, making decisions about color, exposure, and so on at that point. The upshot is that "shooting Raw" enables you, not the camera, to have the final say on the visual characteristics of your image.
- ✓ Higher bit depth: Bit depth is a measure of how many distinct color values an image file can contain. JPEG files restrict you to 8 bits each for the red, blue, and green color components, or channels, that make up a digital image, for a total of 24 bits. That translates to roughly 16.7 million possible colors. On the 70D, a Raw file delivers a higher bit count, collecting 14 bits per channel.

Although jumping from 8 to 14 bits sounds like a huge difference, you may not really ever notice any difference in your photos — that 8-bit palette of 16.7 million values is more than enough for superb images.

Where having the extra bits can come in handy is if you really need to adjust exposure, contrast, or color after the shot in your photo-editing program. In cases where you apply extreme adjustments, having the extra original bits sometimes helps avoid a problem known as *banding* or *posterization*, which creates abrupt color breaks where you should see smooth, seamless transitions. (A higher bit depth doesn't always prevent the problem, however, so don't expect miracles.)

✓ Best picture quality: Because Raw doesn't apply the destructive compression associated with JPEG, you don't run the risk of the artifacting that can occur with JPEG.

But of course, as with most things in life, Raw isn't without its disadvantages. To wit:

You can't do much with your pictures until you process them in a Raw converter. You can't share them online, for example, or put them into a text document or multimedia presentation. You can print them immediately if you use the Canon-provided software, but most other photo programs require you to convert the Raw files to a standard format first. Ditto for retail photo printing. So when you shoot Raw, you add to the time you must spend in front of the computer.

For times when you want to process Raw files and a computer isn't handy, your camera has a built-in Raw converter. I show you how to use it as well as the converter in the Canon software in Chapter 6. Note that the in-camera converter works *only* on files captured at the first (largest) Raw setting, though. It refuses to play with files captured using the Raw (M) or Raw (S) setting.

- ✓ Raw files are larger than comparable JPEGs. Unlike JPEGs, Raw doesn't apply lossy compression to shrink files. This means that Raw files are significantly larger than JPEGs, so they take up more room on your memory card and on your computer's hard drive or other picture-storage devices. Thankfully, the 70D has three sizes of Raw files for you to choose from:
 - Raw: Captures the photo at the Large setting (5472 x 3648 pixels)
 - M Raw: Produces a Medium file (4104 x 2736 pixels)
 - S Raw: Limits the pixel count to 2736 x 1824 (the same as the JPEG Small 1 option)

That enables you to shrink the file size by reducing the photo's resolution, but not at the expense of overall quality.

Whether the upside of Raw outweighs the down is a decision that you need to ponder based on your photographic needs, schedule, and computer-comfort level.

My take: Choose Fine or Raw

At this point, you may be finding all this technical goop a bit much — that baffled look on your face is a giveaway — so allow me to simplify things for you. Until you have time or energy to completely digest all the ramifications of JPEG versus Raw, here's a quick summary:

- ✓ If you require the absolute best image quality and have the time and interest to do the Raw conversion process, shoot Raw. Choose a size that matches your output need: Small for onscreen, Medium for most printing needs, and Large for the largest size possible. Again, though, remember that the in-camera converter works only on the Large size Raw files (that is, not M Raw or S Raw). See Chapter 6 for more information on the conversion process.
- If great photo quality is good enough and you don't have wads of time to process Raw images, stick with one of the Fine JPEG settings (Large/ Fine, Medium/Fine, or Small/Fine).
- To enjoy the best of both worlds, consider capturing the picture in both formats — assuming, of course, that you have an abundance of space on your memory card and your hard drive. Otherwise, creating two files for every photo on a regular basis isn't really practical.

Taking Great Pictures, Automatically

In This Chapter

- Shooting your first pictures
- Setting focus and exposure automatically
- Getting better results by using the automatic scene modes
- ▶ Understanding the Ambience and Lighting/Scene Type features
- ▶ Gaining more control with Creative Auto mode

re you old enough to remember the Certs television commercials from the 1960s and 1970s? "It's a candy mint!" declared one actor.

"It's a breath mint!" argued another. Then a narrator declared the debate a tie and spoke the famous catchphrase: "It's two, two, two mints in one!"

Well, that pretty much describes the 70D. On one hand, it provides a range of powerful controls, offering just about every feature a serious photographer could want. On the other, it also offers fully automated exposure modes that enable people with no experience to capture beautiful images. "It's a sophisticated photographic tool!" "It's as simple as 'point and shoot'!" "It's two, two, two cameras in one!"

Of course, you probably bought this book for help with your camera's advanced side, so that's what other chapters cover. This chapter, however, is devoted to your camera's point-and-shoot side, explaining how to get the best results from the fully automatic exposure modes.

Although the fully automated modes work in Live View mode, where you use the monitor to compose your shots, some picture-taking steps (including autofocusing) are different than when you use the viewfinder. This chapter assumes that you're using the viewfinder; see Chapter 4 for help with Live View photography.

As Easy As It Gets: Auto and Flash Off

For the most automatic of automatic photography, set your camera's Mode dial to one of the following settings:

- Scene Intelligent Auto: The name of this mode, labeled in Figure 3-1, refers to the fact that the camera analyzes the scene and selects the picture-taking options that it thinks will best capture the subject.
- Flash Off: Also labeled in the figure, this mode does the same thing as Scene Intelligent Auto, except flash is disabled. This mode provides an easy way to ensure that you don't break the rules when shooting in locations that don't permit flash.

In either mode, follow these steps to take a picture:

1. Set the focusing switch on the lens to the AF (autofocus) position, as shown in Figure 3-2.

The figure features the 18–135mm kit lens; the switch

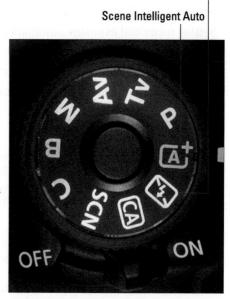

Flash Off

Figure 3-1: These two modes are identical, except that one disables flash.

looks the same on the 18–55mm kit lens. If you own a different lens, the switch may look and operate differently; check your lens manual for details. (Note that these steps assume that your lens offers autofocusing; if not, ignore autofocusing instructions and focus manually.)

2. Unless you're using a tripod, set the Image Stabilizer switch to the On setting, as shown in Figure 3-2.

Image stabilization helps produce sharper images by compensating for camera movement that can occur when you handhold the camera. If you're using a tripod, you can save battery power by turning stabilization off. Again, if you use a lens other than one of the two kit lenses, check your lens manual for details about its stabilization feature, if provided.

3. Set the Drive mode.

By default, the camera sets the Drive mode to Single, which means that you capture one picture with each press of the shutter button. The Single mode is represented by the single rectangle symbol you see in Figure 3-3.

To access the other settings, the fastest route is via the Drive button on top of the camera. You also can adjust the setting through the Quick Settings screen.

4. Select the Image Quality setting via Shooting Menu 1.

Chapter 2 spells out the intricacies of this setting. If you're not up for digesting the topic, keep the setting at the default (Large/Fine). The icon representing that setting looks like the one shown in Figure 3-3.

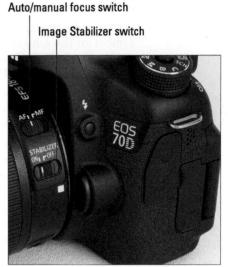

Figure 3-2: Set the lens switch to AF to use autofocusing.

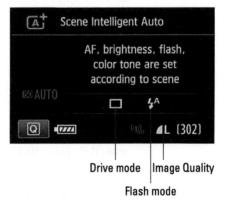

Figure 3-3: In Scene Intelligent Auto and Flash Off modes, you still have control over the Drive mode and Image Quality settings.

5. In Scene Intelligent Auto mode, set the Flash mode to Auto.

In this mode, the flash fires if the camera thinks it's necessary. The symbol for the Auto flash mode appears as shown in Figure 3-3; if you see the Flash Off or Flash On symbol instead, use the Quick Control screen to adjust the option.

If you're shooting a portrait in dim lighting, try enabling Red-Eye Reduction flash (found on Shooting Menu 2). Chapter 2 has more about this feature and other flash topics.

Looking through the viewfinder, frame the image so that your subject appears within the autofocus brackets.

Those brackets, labeled in Figure 3-4, represent the area of the frame that contains the autofocus points.

7. Press and hold the shutter button halfway down.

The autofocus and autoexposure systems begin to do their thing. In dim light, the flash pops up when you use the Scene Intelligent Auto exposure mode. Additionally, the flash may emit an *AF-assist beam*, a few rapid pulses of light designed to help the autofocusing mechanism find its target.

After the camera meters exposure, it displays its chosen aperture (f-stop) and shutter speed settings at the bottom of the viewfinder. In Figure 3-5, for example, the shutter speed is 1/500 second, and the f-stop is f/6.3. You also see the current ISO setting and the maximum burst rate (in this case, 100 and 34, respectively). (Chapter 7 details shutter speed, f-stops, and ISO; see Chapter 1 for information about the maximum burst rate.)

Figure 3-4: Frame your subject so that it falls within the autofocus brackets.

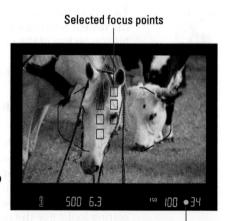

Focus-achieved light

Figure 3-5: When you photograph stationary subjects, the green focus indicator lights when the camera locks focus.

If the shutter speed value blinks, the camera needs to use a slow shutter speed to expose the picture. Because any movement of the camera or subject can blur the picture at a slow shutter speed, use a tripod and tell your subject to remain as still as possible.

When focus is established, one or more autofocus points appear to indicate which areas are in focus, as shown in Figure 3-5. (The camera typically locks focus on the object closest to the lens.) In most cases, you also hear a beep and see the focus indicator light, labeled in the figure. Focus is now locked as long as you keep the shutter button halfway down.

These focus signals vary if the camera detects a moving subject, however. You may hear a series of small beeps, and the focus lamp may not light. Both signals mean that the camera switched to an autofocusing option that enables it to adjust focus as necessary up to the time you take the picture. As long as you keep the subject within the area covered by the autofocus brackets, focus should be correct.

8. Press the shutter button the rest of the way to take the picture.

When the camera finishes recording image data to the memory card, the picture appears briefly on the monitor. See Chapter 5 to find out more about picture playback.

I need to add two more pointers about these modes:

- **Exposure:** In dim lighting, the camera may need to use a very high ISO setting, which increases the camera's sensitivity to light, or very slow shutter speed (longer exposure time). Both can create *noise*, a defect that makes your picture look grainy. See Chapter 7 for tips on dealing with this and other exposure problems.
- ✓ Color: Color decisions are handled automatically. Normally, the camera's color brain does a good job of rendering the scene, but if you want to tweak color, you're out of luck.

Taking Advantage of Scene (SCN) Modes

In Scene Intelligent Auto and Flash Off modes, the camera tries to figure out what type of picture you want to take. If you don't want to rely on the camera to make that judgment, you can choose from one of seven automatic *scene modes* that are designed to capture specific subjects using traditional recipes. For example, most people prefer portraits that have softly focused backgrounds, so Portrait mode selects settings that can blur the background. And action shots typically show the subject frozen in time, so that's the route the camera takes in Sports mode.

Scene modes also apply color, exposure, contrast, and sharpness adjustments to the picture according to the traditional characteristics of the scene type. Landscape mode produces more vibrant colors (especially in the blue-green range, for example).

Upcoming sections describe each scene mode, but first, a few basics. To select a scene mode, turn the Mode dial to SCN, as shown in Figure 3-6. Then bring up the Shooting Settings screen, where the current scene mode is indicated by the icon and label at the top of the screen, as shown on the left in Figure 3-7. To select a different mode, use the Quick Control screen, as shown on the right.

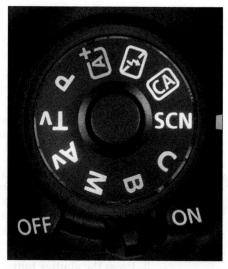

Figure 3-6: Set the Mode dial to SCN to access the scene modes.

Current scene mode

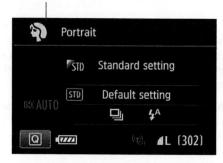

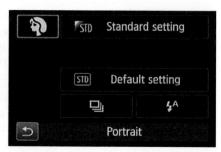

Figure 3-7: Use the Quick Settings screen to choose your scene mode.

You're pretty limited in access to picture settings in all the scene modes, but depending on the mode, you may be able to adjust the following settings:

Shoot by Ambience: This option, available in all the scene modes except HDR Backlight Control, enables you to play with image colors and request a darker or brighter exposure on your next shot. The section "Taking a look at the Shoot by Ambience options," later in this chapter, explains your choices. Look for the setting marked by the little triangle symbol, as labeled in Figure 3-8; adjust the option via the Quick Control screen.

Shoot by Lighting or Scene Type: This option, also labeled in the figure, is available only in Portrait, Landscape, Close-up, and Sports modes. It manipulates color and is primarily designed to eliminate color casts that can occur in some types of lighting. Check out "Eliminating color casts with Shoot by Lighting or Scene Type," also later in this chapter, for details. Again, this setting is accessed by the Quick Control on the scene mode. screen.

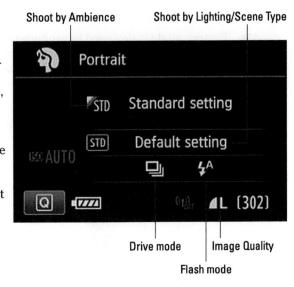

Figure 3-8: Whether you can adjust these settings depends on the scene mode.

- ✓ Drive mode: The icon representing this setting appears in the area labeled in Figure 3-8. To access this setting, detailed in Chapter 2, press the Drive button or use the Quick Control screen.
- Flash: Flash is disabled in Sports and Landscape modes; in Night Portrait scene, on the other hand, the flash is locked at Auto mode, which means the camera decides if flash is needed. For Handheld Night Scene mode, you can enable or disable flash; and for the other modes, you can choose from Auto, On, and Off. Adjust the setting via the Quick Control screen, and again, refer to Chapter 2 for more help with the basics of using your flash. When you do use flash, you can enable Red-Eye Reduction flash via Shooting Menu 2.
- ✓ Image Quality: You can change this setting, which controls resolution and file type, only via Shooting Menu 1. Chapter 2 explains the impact of that setting; if you're unsure which option to choose, stick with the default (Large/Normal). The symbol next to the menu item should look like the one shown in Figure 3-8. Note that you can't use the Raw setting for the HDR Backlight Control and Handheld Night Scene modes.

As for the actual picture-taking process, everything works pretty much as outlined in the steps provided earlier in the first section of this chapter. You do need to be aware of a few variations, which I spell out in the upcoming sections.

Portrait mode

Portrait mode is designed to produce the classic portrait look featured in Figure 3-9: a sharply focused subject against a blurred background. In photography lingo, this picture has a *short depth of field*.

Figure 3-9: Portrait setting produces a softly focused background.

One way to control depth of field is to adjust an exposure control called *aperture*, or *f-stop setting*, so Portrait mode attempts to use an f-stop setting that produces a short depth of field. But the range of f-stops available to the camera depends on the lens and the lighting conditions, so one picture taken in Portrait mode may look very different from another. Additionally, the amount of background blurring depends on the distance of the subject from the background, the focal length of your lens, and how close you get to your subject. For greater background blurring, move the subject farther from the background, use a telephoto lens (or zoom to the longest focal length your lens offers), and get closer to the subject. See Chapter 8 for an in-depth discussion of this topic.

Along with favoring an f-stop that produces a shorter depth of field, Portrait mode results in a slightly less sharp image, the idea being to keep skin texture soft. Colors are also adjusted to enhance skin tones. A few other facts to note:

✓ **Drive mode:** The default Drive mode is Low-speed Continuous, which records as many as 3 frames per second (fps) as long as you hold down the shutter button. Press the Drive button or use the Quick Control screen to select a different Drive mode.

✓ **Autofocusing:** Portrait mode employs the One-Shot AF (autofocus) mode. This is one of three AF modes, all detailed in Chapter 8. In One-Shot mode, the camera locks focus when you press the shutter button halfway. Typically the camera locks focus on the closest object that falls within the autofocus brackets.

Landscape mode

Landscape mode, designed for capturing scenic vistas, city skylines, and other large-scale subjects, produces a large depth of field. As a result, objects both close to the camera and at a distance appear sharply focused, as in Figure 3-10.

Like Portrait mode, Landscape mode achieves its depth-of-field goal by manipulating the aperture (f-stop) setting. Consequently, the extent to which the camera succeeds in keeping everything in sharp focus depends on your lens and on the available light. To fully understand this issue and other factors that affect depth of field, see Chapters 7 and 8.

Whereas Portrait mode tweaks the image to produce soft, flattering skin tones, Landscape mode results in sharper, more contrasty, photos. Color saturation is increased as well, and blues and greens appear especially bold. Other critical settings work as follows:

Figure 3-10: Landscape mode produces a large zone of sharp focus.

Autofocusing: Landscape mode uses One-Shot AF mode; focus locks when you press the shutter button halfway. Focus usually is set on the nearest object that falls within the autofocus brackets.

In this mode, the built-in flash is disabled, which is typically no big deal. Because of its limited range, the flash is of little use when shooting most landscapes, anyway. But for some still-life shots, such as of a statue at close range, a flash may prove helpful. Try switching to Creative Auto mode, detailed later in this chapter, if you want to use flash.

Close-up mode

Close-up mode doesn't enable you to focus closer to your subject than normal as it does on some non-SLR cameras. The close-focusing capabilities of your camera depend entirely on the lens you use. (Your lens manual should specify the minimum focusing distance.)

Choosing Close-up mode does tell the camera to try to select an aperture (f-stop) setting that results in a short depth of field, which blurs background objects so that they don't compete for attention with your main subject. I took this creative approach to capture the orchid in Figure 3-11. As with Portrait mode, though, how much the background blurs varies depending on a number of factors, all detailed in Chapter 8.

Figure 3-11: Close-up mode also produces short depth of field.

As far as color, sharpness, and contrast, the camera doesn't play with those characteristics as it does in Portrait and Landscape modes. So in that regard, Close-up mode is the same as Scene Intelligent Auto and Flash Off modes.

Other settings that apply to Close-up mode:

- ✓ Drive mode: The Drive mode is set to Single by default, so you record one photo each time you fully press the shutter button. However, you can use any of the other options you prefer. Don't know how those work? Chapter 2 explains.
- Autofocusing: The AF mode is set to One-Shot mode; again, that means that when you press the shutter button halfway, the camera locks focus, usually on the nearest object.

Sports mode

Sports mode helps you photograph moving subjects, such as the soccer player in Figure 3-12. In this mode, the camera selects a fast shutter speed, which is needed to "stop motion." *Shutter speed* is an exposure control that you can explore in Chapter 7.

Colors, sharpness, and contrast are all standard in Sports mode, with none of the adjustments that occur in Portrait and Landscape mode. Other settings to note include the following:

- Drive mode: The default Drive mode is High-speed Continuous, which records up to 7fps as long as you hold down the shutter button.
- Autofocusing: The AF mode is set to AI Servo, which is designed for moving subjects. When you press the shutter button halfway, the camera establishes focus on whatever is at the center of the frame. But

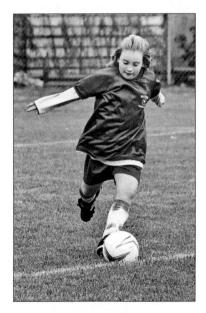

Figure 3-12: To capture moving subjects and minimize blur, try Sports mode.

if the subject moves, the camera attempts to refocus up to the moment you take the picture. For this feature to work correctly, you must adjust framing so that your subject remains within the autofocusing brackets.

As with Landscape mode, the built-in flash is off-limits in Sports mode. The other critical thing to understand is that whether the camera can select a shutter speed fast enough to stop motion depends on the available light and the speed of the subject. In dim lighting, a subject moving at a rapid pace may appear blurry even when photographed in Sports mode. And the camera may need to increase light sensitivity by boosting the ISO setting, which has the unhappy side effect of creating *noise*, a defect that looks like grains of sand.

Night Portrait mode

As its name implies, Night Portrait mode is designed to deliver a better-looking portrait at night (or in any dimly lit environment). Night Portrait does so by combining flash with a slow shutter speed. That slow shutter speed produces a longer exposure time, which enables the camera to rely more on ambient light and less on the flash to expose the picture. The result is a brighter background and softer, more even lighting.

Shutter speed is covered in detail in Chapter 7. For now, the important thing to know is that the slower shutter speed used by Night Portrait mode means that you need a tripod. If you handhold the camera, you run the risk of camera shake blurring the image. Your subjects also must stay still during the exposure.

Night Portrait mode also differs from regular Portrait mode in that it renders the scene in the same way as Scene Intelligent Auto in terms of colors, contrast, and sharpness. So shots taken in Night Portrait mode typically display sharper, bolder colors than those taken in Portrait mode.

Other Night Portrait settings to note:

- ✓ Drive mode: The default setting is Single, but you also can switch to any of the other Drive mode options. Just press that Drive button on top of the camera to access the settings.
- ✓ **Autofocusing:** The AF mode is set to One-Shot, which locks focus when you press the shutter button halfway down.

Handheld Night Scene mode

Any camera movement during an exposure can blur your photo. And when you take a picture in dim lighting, the risk is increased because the camera needs a longer exposure time, meaning you have to hold the camera still longer. That's the scenario that led to the Handheld Night Scene mode: As its name implies, it's designed to produce a sharper handheld picture in dim lighting.

When you press the shutter button, the camera records four shots in quick succession, then blends the images in a way that reduces blurring while still producing a good exposure. Don't worry about the details — just know that this magic formula, whatever it is, works pretty well, although pictures may not be as sharp as when you use a tripod.

You don't have to reserve this setting for nighttime shots, by the way. For example, I used it to capture the shot in Figure 3-13, taken from the top flight of stairs inside a lighthouse. I knew it would be enough of a struggle to climb up the 200-some steps to get to that vantage point, and I wasn't about to add a tripod to my load. So I just leaned over the railing, pointed the camera

downward, held my breath, and pressed the shutter button. At a shutter speed of 1/40 second — slow by photographic standards — that would normally be a recipe for a blurry image, but with the help of the Handheld Night Scene mode, the shot is acceptably sharp.

Figure 3-13: I used Handheld Night Scene to capture this handheld shot from a vantage point at the top of a lighthouse.

A couple of points about this mode:

- ✓ Drive mode: The Single Drive mode is set by default, but the camera records the four successive images with one press of the shutter button anyway, as if you were using one of the Continuous Drive modes. Setting the Drive mode to the Continuous modes has no effect you still get just four shots per shutter press. You can, however, use one of the Self-Timer modes to delay the capture of those four shots. See Chapter 2 for the complete scoop on Drive mode.
- Flash: You can set the Flash mode to on or off. For landscapes, disable flash, but for portraits, flash is a good idea. The flash fires on the first frame to guarantee that your subject will be well lit, and then the other three frames are taken without flash. Warn your subjects to remain still even after the flash fires, or they may appear blurry in the photo.

Using flash can result in a couple other problems, too: If you're really close to your subject, the image may appear too bright. Back away a little to see if that solves the problem. Additionally, if both subject and background are within the reach of the flash, the camera may have trouble aligning the four frames, resulting in a blurry photo.

- Autofocusing: The One-Shot AF mode is in force, so focus is locked when you press the shutter button halfway down.
- Frame area: The angle of view of the final image is a little smaller than what you see through the viewfinder. This occurs because the camera usually needs to crop the image a little in order to get the four frames to align properly. The actual size of the image remains the same it just contains a slightly smaller subject area than normal. So compose your image with a little extra margin around the edges to compensate.
- Moving subjects: Moving subjects may create blur in your picture because they'll be captured at slightly different areas in each frame. For example, if you look closely at my lighthouse shot (refer to Figure 3-13), you may be able to notice some blurring of the people climbing the stairs.

Image Quality: This mode works only with images recorded in the JPEG format. In fact, you can't select Raw as the file format when this mode is active. If you select Raw prior to selecting the Handheld Night Scene mode, the camera automatically changes the format to Large/Fine.

Finally, give the camera all the help you can by holding it as still as possible while the four frames are being captured. If possible, find a ledge or other surface on which you can brace the camera, and try tucking your elbows into your sides for additional stability.

HDR Backlight Control mode

When a scene contains both very dark and very bright areas, the camera has a difficult time recording the entire range of brightness values — its "eyes" aren't nearly as adept as ours at seeing the whole picture, as it were. That's where the HDR Backlight Control feature comes in.

A bit of background about the terminology: *HDR* stands for *high dynamic range*. *Dynamic range* refers to the range of brightness values that a device can record. HDR refers to an image that contains a greater spectrum of brightness values than can normally be captured by a camera. In order to produce this result, the photographer records a series of images at different exposures and then uses HDR software to merge the images in a way that results in more detail in both the darkest and brightest parts of a photo.

About the Backlight Control part of the mode name? Well, a backlit image is one in which the light source is behind the subject, which often produces a photograph background that's well exposed but a subject that's too dark. If you tweak exposure settings, you can get your subject to be bright, but not without also brightening the background and, usually, "blowing out the highlights," or making the lightest areas of the scene *too* bright. HDR Backlight Control to the rescue: It helps brighten the darkest parts of the image while holding onto more highlight detail than is otherwise possible.

When you press the shutter button in this mode, the camera records three images, adjusting exposure between each frame. One frame is exposed to capture the highlights, another for the *midtones* (areas of medium brightness), and another for the shadows. Then the three are merged into one final HDR image. You can see an example in Figure 3-14. I took the left picture using the Scene Intelligent Auto mode; for the right image, I used HDR Backlight Control. Both the highlight and the shadow areas in the HDR version contain more detail. Note, too, that the frame area for the two images is slightly different: As with the Handheld Night Scene, the camera needs to crop the image a little in order to properly align the multiple frames into one.

For best results, use a tripod; this ensures that each frame records the same image area, helping the camera to properly align frames when merging them. Also, frame a little loosely so that when the images are merged, you won't lose important parts of the scene due to the cropping that occurs. Finally, keep in mind that anything that's moving in the scene usually appears at partial opacity in different parts of the frame in the merged image. (On the other hand, you may be able to claim that you captured a ghost in your picture. . . .)

Scene Intelligent Auto

HDR Backlight Control

Figure 3-14: Try shooting high-contrast scenes with HDR Backlight Control to retain more detail in both shadows and highlights.

Other final details to note:

- Image Quality: Like the Handheld Night Scene mode, HDR Backlight Control is a JPEG-only creature. You can't shoot in the Raw format in this mode.
- ✓ Drive mode: The camera fires off three shots in succession with each press of the shutter button, regardless of whether the Drive mode is set to Single or one of the Continuous modes. You can use one of the Self-Timer modes to delay the shutter release if desired.
- Flash: Flash is disabled.
- Autofocus: One-Shot AF is used, so focus is locked when you press and hold the shutter button halfway.

Modifying scene mode results

With the Scene Intelligent Auto and Flash Off modes, what you see on the playback monitor is what you get — you can't modify the camera settings to get different results on the next shot. But with certain Scene modes, you can play around a little with color, sharpness, contrast, and exposure through the Shoot by Ambience and Shoot by Lighting/Scene Type features.

Key words here: Play around *a little*. These features don't give you anywhere near the level of control as the advanced exposure modes or even as much as Creative Auto mode, explained at the end of this chapter. But they do offer an easy way to start exploring your creative possibilities and begin thinking about how *you* want to record a scene.

My only beef with these features is that they aren't presented in the most user-friendly fashion. For starters, the feature names don't give vou a lot of information about what you can accomplish by using them. And the displayed names of the default settings - shown on the Shooting Settings screen in Figure 3-15 are Standard and Default. Well, that's helpful, huh? Then again, if it weren't for confusing stuff like this, you might not need my input, so I probably shouldn't complain.

Figure 3-15: These settings enable you to adjust picture color, contrast, sharpness, and exposure when shooting in the scene modes.

At any rate, the next two sections give you a better idea of what you can accomplish with these options.

Taking a look at the Shoot by Ambience options

Chapter 8 introduces the Picture Style feature, which enables you to choose how the camera "processes" your original picture data when you use one of the JPEG Image Quality settings. You can choose the Landscape Picture Style for bold, sharp colors, for example, or select Portrait to give skin a warm, soft look. (Yes, the camera offers Landscape and Portrait exposure modes and Landscape and Portrait Picture Styles. Don't get me started.)

You can control Picture Styles only in the advanced exposure modes, however — that option is off-limits in the other modes. But as compensation, the scene modes (except HDR Backlight Control) and Creative Auto mode give you Shoot by Ambience, which lets you accomplish results similar to those that you could achieve by using Picture Styles. You also get two Shoot by Ambience settings that enable you to achieve exposure adjustments similar to what you can produce with Exposure Compensation, another feature that's available only in the advanced exposure modes.

Here's a description of each Shoot by Ambience setting:

- Standard: Consider this the "off" setting. When you select this option, the camera makes no adjustment to the characteristics normally produced by your selected scene mode.
- Vivid: Increases contrast, color saturation, and sharpness.
- ✓ **Soft:** Creates the appearance of slightly softer focus.
- **Warm:** Warms colors and slightly softens focus.
- ✓ **Intense:** Boosts contrast and color saturation even more than the Vivid setting. Also results in a slightly darker overall exposure.
- Cool: Adds a cool color cast and slightly darkens the exposure.
- **Brighter:** Lightens the photo.
- Darker: Darkens the photo.
- ✓ Monochrome: Creates a black-and-white photo, with an optional color tint.

All adjustments are applied *in addition* to whatever adjustments occur by virtue of your selected scene mode. For example, Landscape mode already produces slightly sharper, more vivid colors than normal. If you add the Vivid Shoot by Ambience option, you amp things up another notch.

In addition, you can control the amount of the adjustment through a related setting, Effect. You can choose from three Effect levels — Low, Standard, and Strong; or Low, Medium, and High, depending on the Shoot by Ambience setting. For the Monochrome setting, the Effect setting enables you to switch

from a black-and-white image to a monochrome image with a warm (sepia) or cool (blue) tint.

As a quick example of the color effects you can create, Figure 3-16 shows the same subject taken at four different Shoot by Ambience settings. I took all pictures in the Landscape scene mode. For the three variations — Vivid, Warm, and Intense — I set the Effect option to the maximum setting.

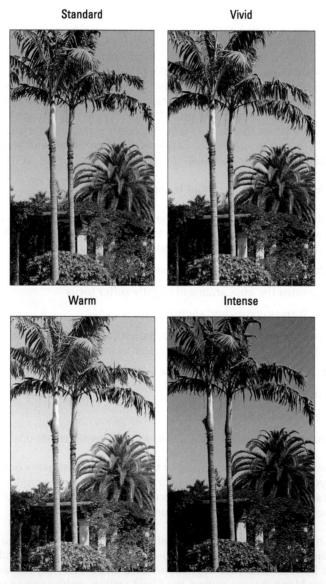

Figure 3-16: To create these Shoot by Ambience variations, I used the maximum amount of adjustment for the Vivid, Warm, and Intense settings.

Although the color effects are entertaining, I think you'll get more use out of the Brighter and Darker settings, as they give you a way to overrule the camera's exposure decisions. For example, in the left image in Figure 3-17, the exposure of the background was fine, but the flower was overexposed. So I set the Shoot by Ambience option to Darker, set the Effect option to Medium, and shot the flower again to produce the improved exposure you see on the right.

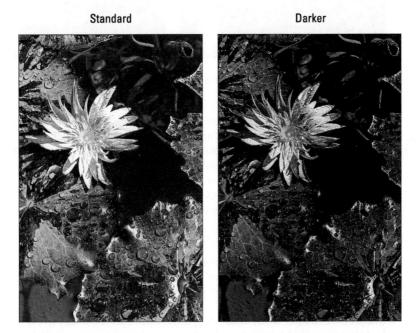

Figure 3-17: If the initial exposure leaves your subject too bright, choose the Darker setting and reshoot.

When you're ready to try the Shoot by Ambience option, here's the fastest way to adjust the setting:

- 1. Display the Quick Settings screen and use the Multi-controller to select the Shoot by Ambience setting, as shown on the left in Figure 3-18.
- 2. Rotate the Main dial to cycle through the available settings.

As soon as you shift from the Standard setting to one of the other settings, the Effect option appears, as shown on the right in the figure.

3. Use the Multi-controller to select the Effect setting and then rotate the Main dial to set the level of the adjustment.

Or, if you're using the Monochrome setting, you can choose a regular black-and-white photo, a sepia tone, or a blue-and-white tint.

Figure 3-18: Select the setting you want to use via the Quick Settings screen.

You also can go the touchscreen route, but things work a little differently (and in fact take a little longer than just using the steps I just outlined). After you tap the Shoot by Ambience setting, you access a screen showing all the possible options; make your choice and then press the Return arrow to return to the Quick Settings screen. Then tap the Effects option, and tap the vertical bars to adjust the level of the adjustment. Tap the Return arrow again or press the Q button to exit the Quick Settings screen.

Eliminating color casts with Shoot by Lighting or Scene Type

This option might be better named "Eliminate Color Cast" because that's what it's designed to do: remove unwanted color casts that can occur when the camera makes a *white balance* misstep.

Chapter 8 explains white balancing fully, but in short, it has to do with the fact that every light source emits its own color cast — candlelight, a warm hue; flash, a slightly cool hue, and so on. The camera's White Balance mechanism compensates for the color of the light so that colors are rendered accurately.

Normally, the camera uses automatic white balancing, and things turn out fine. But if a scene is lit by different types of light, each throwing its own color bias into the mix, the camera sometimes gets confused, and colors may be out of whack. The left image in Figure 3-19 has an example — a white-balance error caused the scene to be too yellow. The image on the right shows the correct image colors.

Figure 3-19: If your photo has a color cast (left), you may be able to use the Shoot by Lighting/Scene Type option to eliminate it (right).

In the advanced exposure modes, you deal with color casts by changing the White Balance setting; again, Chapter 8 shows you how. You can't access the White Balance setting in the scene modes, but in Portrait, Landscape, Close-Up, and Sports modes, you can use the Shoot by Lighting or Scene Type option to tell the camera to balance colors for a specific light source.

You can choose from the following settings:

- ightharpoonup Default: Colors are balanced for the light source automatically.
- ✓ Daylight: For bright sunlight.
- ✓ Shade: For subjects in shade.
- ightharpoonup Cloudy: For shooting under overcast skies.
- Tungsten Light: For incandescent and tungsten bulbs; not available for Landscape scene mode.

- Fluorescent Light: For subjects lit by fluorescents. *Note:* This may not be suitable for some compact-fluorescent lights. Try Tungsten Light if you get bad results. Also not available for Landscape scene mode.
- Sunset: Helps capture brilliant sunset colors, especially when you're shooting into the sun.

Don't aim the lens directly at the sun or look through the viewfinder directly into the sun. You can damage the camera and hurt your eyes.

Select the setting via the Quick Control screen, as shown in Figure 3-20. For example in Figure 3-20, the Default (no adjustment) setting is selected.

Figure 3-20: Adjust this option via the Quick Control screen.

Gaining More Control with Creative Auto

When you use the scene modes, the camera selects settings that render your subject using the traditional "look" for the scene — blurry backgrounds for Portrait mode, greater depth of field and bold colors for landscapes, and so on. Depending on the scene mode, you may be able to modify colors and exposure somewhat by using the Shoot by Ambience and Shoot by Lighting or Scene Type options, but all in all, you're fairly limited as to the look of your pictures.

Creative Auto mode enables you to take a bit more control. As its name implies, this mode is still mostly automatic, but if you check the monitor after taking a shot and don't like the results, you can make the following adjustments for your next shot:

- Enable or disable the flash.
- Adjust color, sharpness, contrast, and exposure through the Shoot by Ambience option, as explained a little earlier in the chapters.
- ✓ Soften or sharpen the apparent focus of the picture background.

What about the Shoot by Lighting or Scene Type option that's available in the scene modes? Sorry, that dog won't hunt in Creative Auto mode. But remember that using that option typically isn't necessary: It's designed to fix white-balancing issues, and in Creative Auto mode, the camera uses automatic white balancing, which works well for the majority of shooting situations.

Here's how to use Creative Auto mode:

1. Set the Mode dial on top of the camera to the CA setting.

The Creative Auto version of the Shooting Settings screen appears, as shown in Figure 3-21.

2. To adjust the Drive mode, Flash, Shoot by Ambience, and Background Blur settings, use the Quick Control screen.

As usual, you can either tap the Q icon on the screen or press the Q button to get to the screen. Either way, one of the settings becomes selected, and a text label appears at the bottom of the screen to remind you what the highlighted setting does. In Figure 3-22, for example, the Background Blur setting is highlighted.

See the upcoming list for details about each option.

3. To adjust the Image Quality setting, use Shooting Menu 1.

You can't change that setting via the Quick Control screen in Creative Auto mode.

4. Frame, focus, and shoot.

From this point on, everything works as outlined for the Scene Intelligent Auto mode, explained near the start of this chapter.

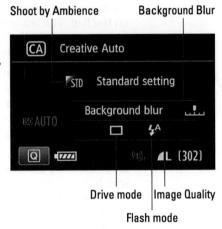

Figure 3-21: In Creative Auto mode, the Shooting Settings screen displays this information.

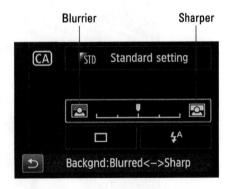

Figure 3-22: Use this control to make the background sharper or more blurry.

The settings you choose remain in effect from shot to shot. If you turn the camera off or switch to a different exposure mode, though, the settings return to their defaults.

Now for the promised explanations of how the Creative Auto options work:

Shoot by Ambience: This setting enables you to alter how the camera processes the photo, enabling you to tweak color, contrast, and exposure slightly. The earlier section "Taking a look at the Shoot by Ambience options" explains this feature.

✓ Background Blur: This feature gives you some control over depth of field, or the distance over which focus appears acceptably sharp. Consider the images in Figure 3-23, for example. In both shots, I set focus on the flag. The left image features a long depth of field, so both the flag and the tractor in the background are sharp. Comparatively, the right image has a very shallow (short) depth of field, so the tractor is blurry.

Unfortunately, this feature doesn't play nice with the flash. If the flash mode is set to Auto, as in the figure, the Background Blur setting is available, but if the camera sees the need for flash, the Background Blur feature stomps off in a huff as soon as the flash pops up. If you set the flash mode to On, the Background Blur setting is dimmed in the display.

Assuming that the flash doesn't get in your way, use the Main dial to move the little indicator on the bar to the left to shorten depth of field, which makes distant objects appear blurrier, and move the indicator to the right to make distant objects appear sharper. (Refer to Figure 3-23.) You can also drag along the blurring scale or tap the icons at either end to adjust the setting.

f/22, large depth of field

f/2.8, short depth of field

Figure 3-23: You can choose to make background objects appear sharp (left) or blurry (right).

The camera creates this shift in depth of field by adjusting the aperture setting (f-stop), which is an exposure control you can explore in Chapter 7. A lower f-stop number produces a more shallow depth of field, for a blurrier background, as shown on the right in Figure 3-23; a higher f-stop setting produces a greater depth of field, for a sharper background, as shown on the left.

The range of f-stops available depends on your lens. Additionally, because aperture also plays a critical role in exposure, the range of f-stops the camera can choose — and, therefore, the extent of focus shift you can achieve with this setting — depends on the available light. The camera gives priority to getting a good exposure, assuming that you'd prefer a well-exposed photo to one that has the background blur you want but is too dark or too light. Understand, too, that when the aperture changes, the camera also must change the shutter speed, ISO (light sensitivity setting), or both to maintain a good exposure.

At slow shutter speeds, moving objects appear blurry, regardless of your depth of field. But even for still subjects, a slow shutter speed creates the risk that camera shake during the exposure will blur the image. A blinking shutter speed value in the viewfinder alerts you to a potentially risky shutter speed; put your camera on a tripod to avoid camera shake. Look for the shutter speed on the left side of the viewfinder display when you press the shutter button halfway.

To find out more about depth of field, aperture, shutter speed, ISO, and exposure, see Chapters 7 and 8. In the meantime, note these easy ways to tweak depth of field beyond using the Background Blur slider:

- For blurrier backgrounds, move the subject farther from the background, get closer to the subject, and zoom in to a tighter angle of view, if you use a zoom lens.
- For sharper backgrounds, do the opposite of the preceding.
- ✓ Drive mode: The Single mode is selected by default, but you can choose any Drive mode option, all explained in Chapter 2. Remember that you can access the settings by pressing the Drive mode button or by using the Quick Control screen.
- ✓ Flash: You can set the flash mode to Auto, On, or Off. For the Auto and On settings, you can use the Red-Eye Reduction flash feature, found on Shooting Menu 2. See Chapter 2 for more information about flash photography.

Exploring Live View Shooting and Movie Making

In This Chapter

- Getting acquainted with Live View and Movie modes
- Customizing the monitor display
- Exploring autofocusing options
- Selecting camera settings and taking pictures in Live View mode
- Recording and playing movies

ike many dSLR cameras, the 70D offers *Live View*, a feature that enables you to use the monitor instead of the viewfinder to compose photos. You must rely on the monitor to compose shots during movie recording; using the viewfinder isn't possible.

In many respects, shooting in Live View mode is no different from using the viewfinder. But a few aspects, such as autofocusing, are quite different. So the first part of this chapter provides an overview of the Live View and Movie mode features and discusses precautions to take to avoid damaging the camera when using either feature. Following that, you can find details on taking still photos in Live View mode and shooting and viewing movies.

Note: In figures in this chapter, data at the bottom of the screen appears differently than it does on your monitor. In the figures, data displays against a plain black bar, but on your screen, it's superimposed over the image. In some cases, this also applies to data at the top of the screen. The difference is due to the technology I use to capture the image that the monitor displays; for reasons that I won't bore you with, it's not possible to capture the superimposed data properly. I trust the discrepancy won't throw you off too much.

Getting Started

The basics of using Live View and Movie modes are pretty simple:

Switching from viewfinder photography to Live View mode: Set the Live View switch to the still camera icon, as shown in Figure 4-1, and then press the Start/Stop button. You hear a clicking sound as the internal mirror that normally sends the image from the lens to the viewfinder flips up. Then your subject appears on the monitor, and you can no longer see anything in the viewfinder. Instead of the normal Shooting Settings screen, you see symbols representing certain camera settings displayed over the live image, as shown in Figure 4-2. (If you see different symbols, don't panic; what's displayed depends on your camera settings and the Live View display options, which I cover later in the chapter.)

If nothing happens when you press the Start/Stop button, one of these two issues is the likely culprit:

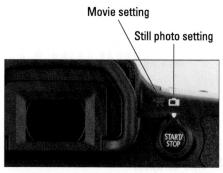

Figure 4-1: Set the switch to the camera icon for still photography and to the movie camera icon to record movies.

Figure 4-2: Picture data is superimposed over the live preview.

- The camera is asleep. By default, the camera powers down after one minute of inactivity. Wake it up by pressing the Start/Stop button and then press again.
- Live View shooting is disabled. To turn it on, visit Live View Menu 1 and set the Live View Shoot option to Enable, as shown in Figure 4-3.

As with certain other menus, the options on the Live View menus vary depending on your exposure mode. The menu in Figure 4-3 reveals options available when you shoot in the advanced exposure modes; in the fully automatic modes, you lose access to the last two options on the menu. You also can't access an entire second Live View menu when you shoot in the fully auto modes.

Shooting photos in Live View mode: Most steps are the same as for viewfinder photography. Autofocusing methods, however, are quite different, as I explain in the upcoming section, "Focusing in Live View and Movie Modes."

If you don't care to explore those details now, just frame your subject so that it's within the area indicated by the rectangular brackets in the frame (refer to Figure 4-2). By default, the camera uses an autofocusing

Live View shoot.	Enable
AF method	ピ+Tracking
Continuous AF	Enable
Touch Shutter	Disable
Grid display	Off
Aspect ratio	3:2
Expo. simulation	Enable

Figure 4-3: The Live View Shoot option determines whether Live View photography is possible.

method called Face+Tracking, which means that if it finds faces in the scene, it will lock focus onto one of those faces; if not, it will focus on the nearest object. Press the shutter button halfway to set focus, and then press the rest of the way to take the picture.

Recording movies: The first step is to turn off the camera's Wi-Fi function, which you accomplish via Setup Menu 3. You can't record movies while the Wi-Fi system is active.

Next, move the Live View switch to the movie camera icon, labeled in Figure 4-1. Again, the monitor displays the live scene along with some shooting data. To start and stop recording, press the Start/Stop button.

- Adjusting camera settings: For the most part, you use the same techniques as for viewfinder photography, selecting options on the menus, using the Quick Control screen, and so on. I provide details throughout the chapter. But note these critical differences up front:
 - The touchscreen Quick Control icon (Q) resides in the upper-right corner of the screen. (Refer to Figure 4-2.) During viewfinder shooting, it's in the lower-left corner.
 - Certain buttons don't perform the same functions as during viewfinder photography. For example, the AF Point Selection button plays a different role in focusing than it does during viewfinder photography.
 - Exposure modes work differently in Movie mode. The camera operates as it does in Scene Intelligent Auto mode for all Mode dial settings except the advanced exposure modes. Furthermore, you can control aperture and shutter speed only in M (manual exposure) mode. In P, Tv, and Av modes, the camera controls exposure, although you gain control over other settings, such as White Balance, that you don't have in the fully automatic modes.

- Viewing photos and movies: Press the Playback button to look at your images and movies. To switch back to shooting, give the Playback button another press or give the shutter button a half-press and then release it. Check out the end of this chapter to discover some special options available for movie playback; see Chapter 5 for details on playback features available for still photos and a couple that work for both photos and movies as well as for video snapshots, a specialty movie function that I cover in Chapter 10.
- Returning to viewfinder photography: To exit Live View mode, press the Start/Stop button. To exit Movie mode, rotate the Live View switch to the still-photography icon and then press the Start/Stop button.

As you may have guessed from the fact that I devote a whole chapter to Live View photography and movie recording, these points are just the start of the story, however. The rest of the chapter goes into detail about all your photographic and movie-recording options. First, though, the next section provides some safety tips to keep in mind when you use either feature.

Reviewing Live View and Movie mode cautions

Be aware of the following safety rules when you use Live View and Movie modes:

- Cover the viewfinder to prevent light from seeping into the camera and affecting exposure. The camera ships with a cover designed just for this purpose. In fact, it's conveniently attached to the camera strap. To install it, first remove the rubber eyecup that surrounds the viewfinder by sliding it up and out of the groove that holds it in place. Then slide the cover into the groove and over the viewfinder (Orient the cover so that the *Canon* label faces the viewfinder.)
- Using Live View or Movie mode for an extended period can harm your pictures and the camera. This damage can occur because using the monitor full-time causes the camera's innards to heat up more than usual, and that extra heat can create the right electronic conditions for noise, a defect that looks like speckles of sand.

- More critically, the increased temperatures can damage the camera. The symbol shown in the margin appears on the monitor when the camera is getting too hot. Initially, the symbol is white. If you continue shooting and the temperature continues to increase, the symbol turns red and blinks, alerting you that the camera soon will shut off automatically.
- Aiming the lens at the sun or other bright lights also can damage the camera. Of course, you can cause problems doing this even during normal shooting, but the possibilities increase when you use Live View and Movie mode.

- Live View and Movie modes put additional strain on the camera battery. The extra juice is needed to power the monitor. If you do a lot of Live View or movie shooting, you may want to invest in a second battery so that you can have a spare on hand when the first one runs out of gas.
- The risk of camera shake during handheld shots is increased. When you use the viewfinder, you can help steady the camera by bracing it against your face. But when you compose shots using the monitor, you have to hold the camera away from your body to view the screen, making it harder to keep the camera still. Any camera movement during the exposure can blur the shot, so I recommend using a tripod for still photography. The same is true for movie recording unless you like that "jiggling frame" effect that's all the rage with some Hollywood directors.

If you do handhold the camera, enabling Image Stabilization can compensate for a bit of camera shake. On either kit lens, just set the Stabilizer switch to On.

Customizing the display

You can choose from a few display options, each of which adds different types of information to the screen. Here's a look at your decorating possibilities:

✓ Press Info to change the amount and type of data displayed, as illustrated in Figure 4-4. Data varies according to your exposure mode, focusing mode, and other settings. In Movie mode, some data changes to show movie-recording options instead of still-photography settings. Later sections decode all the symbols for you.

The chart in the upper-right corner of that lower-left screen is a *Brightness histogram*, which is a tool you can use to gauge whether your current settings will produce a good exposure. See the discussion on interpreting a Brightness histogram in Chapter 5 to find out how to make sense of what you see. A few Live View histogram details:

- The histogram doesn't appear in Movie mode.
- For Live View mode in the advanced exposure modes, you must set the Exposure Simulation option on Live View Menu 1 to Enable for the histogram to appear. This is the default setting, and the one that's always used in the fully automatic settings.
- When you use flash, the histogram is dimmed; the histogram can't display accurate information because the final exposure will include light from the flash and not just the ambient lighting.
- The histogram also is dimmed if you use the Handheld Night Scene, HDR Backlight Control, or B (Bulb) exposure modes.

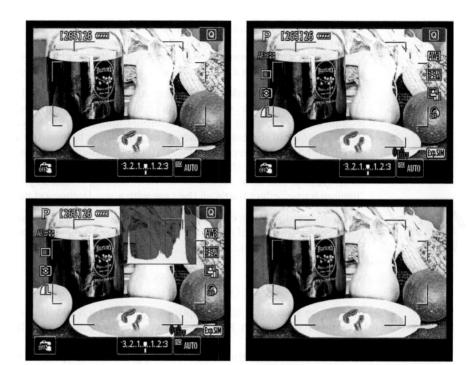

Figure 4-4: Press the Info button to cycle through information display styles.

✓ **Display an electronic level.** In addition to the four displays shown in the figure, you can add an electronic level to the mix; just press the Info button to cycle through the display styles until the level appears. A green line through the center of the level indicates that the camera is level.

There's a gotcha with respect to this feature, though: The level doesn't appear when the AF (autofocus) method is set to Face+Tracking, which is the default setting. You can change the AF Method setting via the Quick Control screen, Live View Menu 1, or Movie Menu 1. Also make sure that the Info button is set to display the level; make that happen via the Info Button Display Options setting on Setup Menu 3.

✓ Display a grid. To assist you with composition, the camera can display one of three alignment grids on the monitor. In Live View mode, enable the grid via Live View Menu 1; in Movie mode, set the option on Movie Menu 2.

- Adjust the shutdown of the exposure-information display. By default, exposure information such as f-stop and shutter speed disappears from the display after 16 seconds if you don't press any camera buttons. If you want the exposure data to remain visible for a longer period, you can adjust the shutdown time, but only if the Mode dial is set to an advanced exposure mode. Look for the Metering Timer option on Live View Menu 2 in still-photography mode and on Movie Menu 1 in Movie mode. The metering mechanism uses battery power, so the shorter the cutoff time, the better.
- Control exposure simulation. For still-photo shooting in the advanced exposure modes, you can specify how you want the camera to simulate exposure. Make the call via Live View Menu 1, shown in Figure 4-5. You have three options:
 - Enable: The brightness of the scene on the monitor is as close as
 possible to the actual exposure. This setting is the default and the
 one used when you shoot in the fully automatic exposure modes.
 - During Preview: The second option the one that's labeled with the little aperture symbol displays the scene at the standard monitor brightness, with the goal of making the image easy to see. To display the scene at the actual exposure brightness, press and hold the Depth-of-field preview button (front right side of the camera, just beneath the lens).
 - Pressing the button with either this option or Enable selected also gives you a preview of how the selected f-stop will affect depth of field (how much of the scene appears in sharp focus). Chapter 7 explains f-stops.
 - Disable: Use this option if you want the monitor to display the scene at standard brightness no matter what the actual image exposure will be.

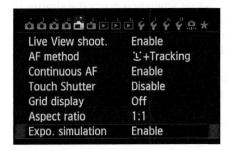

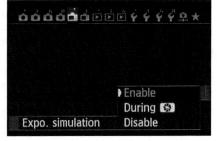

Figure 4-5: Choose Enable if you want the monitor brightness to reflect the actual exposure of the picture.

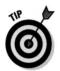

View the display on a TV. You can send the monitor signal to a television via a standard A/V cable or an HDMI cable (both must be purchased separately) for shooting as well as for playback. Chapter 5 provides help with connecting the camera to a TV. Keep in mind, though, that you lose all touchscreen operations when the camera is tethered to a TV or monitor: You must use camera buttons to control things.

In addition, you can connect the camera to your computer with the supplied USB cable or via Wi-Fi and then use the Canon EOS Utility software (provided in your camera box) to operate the camera remotely. See the software manual, provided on one of the two CDs in the camera box, for more information. You might want to take advantage of this feature when your presence near the camera might be disruptive, as when shooting wildlife, or dangerous, as when your kid asks you to record a movie of the class science experiment. (Remember that for movies, you need to connect the camera by cable because when Wi-Fi is turned on, movie recording is disabled.) See Chapter 6 for help connecting the camera to your computer.

Focusing in Live View and Movie Modes

Assuming that your lens supports autofocusing, you can choose from auto or manual focusing. Both methods involve different options than viewfinder focusing, though; read the next several sections to get the scoop.

Disabling continuous autofocusing

Your camera is set by default to start autofocusing as soon as you engage Live View or Movie mode. You may be able to see the picture going in and out of focus and hear the autofocus motor as the camera searches for a focusing target. For still photography, the idea is to have the camera find a preliminary focusing target so that when you press the shutter button halfway to set the final focusing distance, the camera can lock focus more quickly. For movies, continuous autofocusing is designed to track your subject as it moves through the frame during the recording.

This feature — called Continuous AF for Live View mode, and Movie Servo AF for Movie mode — presents some downsides:

When recording movies with sound, the internal microphone may pick up the noise of the autofocus motor. The autofocusing system is very quiet, so you may not experience this issue frequently. If you do, use an external microphone and place it far enough from the camera that it doesn't pick up the focusing sounds. Focusing with some lenses

- is quieter than with others for example, STM lenses (which includes both kit lenses) were created especially for smoother, quieter operation.
- Continuous autofocusing may falter in some scenarios. The focusing system can have trouble locking on subjects that are moving very quickly toward or away from the lens as well as on subjects that are very close to the lens. In addition, during movie recording, zooming the lens may cause the camera to lose and then reset focus. The same can happen if you pan the camera (move it up, down, right, or left to follow the subject). Use slower camera movements for smoother, less obvious focus transitions.
- This feature is a power hog. All that activity by the autofocusing motor is a big drain on the camera battery.
- For Live View photography, you can't use Quick mode autofocusing with continuous autofocusing. As its name implies, Quick mode is the fastest Live View autofocusing option. Unfortunately, if you set the AF mode to Quick, the camera disables continuous autofocusing. This issue applies only to still photography; Quick mode AF isn't available for movie recording.
- ✓ To switch to manual focusing (MF), you must exit Live View or Movie mode if continuous autofocusing is enabled. If you make this change when continuous autofocusing is in progress, you may damage the camera or the lens. So return to viewfinder shooting, move the lens switch to MF, and then shift back to Live View or Movie mode.

For these reasons, I typically disable continuous autofocusing for still photography. For shots in which the subject may be moving — making continuous focus tracking a plus — I prefer to go back to viewfinder photography because it offers faster focus tracking with less battery drain. (Chapter 8 has details on viewfinder autofocusing.) For movie recording, on the other hand, I typically rely on continuous autofocusing.

How you enable continuous autofocusing depends on whether you're shooting stills or movies:

Live View photography: Turn the feature on and off via the Continuous AF option on Live View menu 1, as shown on the left in Figure 4-6. Remember, when the AF Method is set to Quick mode, this option is unavailable.

When continuous autofocusing is enabled, you can lock focus by pressing and holding the shutter button halfway down or by pressing the AF-ON button. When you release the button, continuous autofocusing begins anew.

Live View shoot.	Enable
AF method	と+Tracking
Continuous AF	Enable
Touch Shutter	Disable
Grid display	Off
Aspect ratio	3:2
Expo. simulation	Enable

AF method	じ+Tracking
Movie Servo AF	Enable
Silent LV shoot.	Mode 1
Metering timer	16 sec.

Figure 4-6: The continuous autofocusing feature goes by different names depending on whether you're using Live View (left) or Movie mode (right).

- Movie mode: You can turn off continuous autofocusing in three ways:
 - Movie Menu 1: Control the option via the Movie Servo AF setting, as shown on the right in Figure 4-6.
 - Touchscreen: You also can turn the feature on or off by tapping the icon labeled in Figure 4-7. A green dot on the icon means the feature is enabled. Note that if you disable the feature via the menu, the screen icon no longer appears.

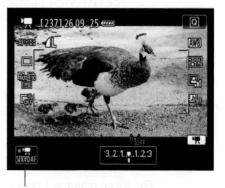

Tap to turn continuous AF on/off

Figure 4-7: In Movie mode, you also can disable continuous autofocusing via the touchscreen.

 Flash button: Press the button to toggle the feature on and off. Again, watch for the green dot on the screen icon to go on and off while you press the button.

Before you start recording, you also can set focus by pressing the shutter button halfway or by pressing the AF-ON button. If you turn off Movie Servo AF, you then can release the button, and focus will remain locked at the current focus distance. Otherwise, continuous autofocusing begins again when you release the button.

During movie recording, however, you can set autofocus only by pressing the AF-ON button. Using the shutter button doesn't work.

Choosing an AF (autofocus) mode

For autofocusing, the AF mode determines the autofocusing method, as it does for viewfinder shooting. But the options for Live View and Movie autofocusing work differently from the normal ones, which I cover in Chapter 8. For Live View photography, you get all four of the following options, represented on the display by the icons you see in the margins. For Movie mode, you lose the Quick mode option.

Upcoming sections detail the AF modes; here's a quick introduction to each one:

AF 노[3]

✓ Face+Tracking: This setting is the default. If the camera detects a face, it
automatically focuses on that face. When no faces are detected, the
camera instead uses the FlexiZone-Multi autofocusing option.

AF()

✓ FlexiZone-Multi: The camera automatically selects the focusing point, usually locking onto the closest object. In the advanced exposure modes, you can limit the camera's choice of focusing areas by selecting one of several focus zones spread throughout the frame.

AF Ouick

FlexiZone-Single: You specify which of the available focusing points the camera should use to establish focus.

✓ Quick mode: In this mode, the camera uses the same autofocusing system as it does for viewfinder photography. As its name implies, Quick mode offers the fastest autofocusing of the Live View AF options. The downside is that it blanks out the Live View display temporarily as it sets focus, which can be a little disconcerting if you're not expecting it to happen. And, as I mention a few paragraphs ago, it's not available for movie recording and isn't compatible with continuous autofocusing.

Even with Quick mode, autofocusing is slower than when you use the view-finder to compose your pictures. The difference has to do with how the camera performs the focusing operation, a technical detail not worth exploring here. Just know that for fastest autofocusing for still photography, shift out of Live View mode and go with the viewfinder.

When you do you choose Live View mode or set the camera to Movie mode, an icon representing the current AF mode appears in the upper left of the display, as shown on the left in upcoming Figure 4-8.

Don't see the AF icon? Press Info to cycle through the various display modes until one appears. What other data shows up depends on the display mode and your exposure mode; the screens in Figure 4-8 show the monitor as it appears in the P (programmed autoexposure) mode with all data but the histogram displayed.

To change the AF mode setting, use these methods:

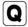

Quick Control screen: Press the Quick Control button or tap the Q icon (upper right of the screen). Then select the icon that represents the focusing method, as shown on the right in Figure 4-8. To select the mode you want to use, tap it or use the Main dial, Quick Control dial, or Multicontroller to highlight it. To exit the Quick Control screen, tap the Return arrow or press the Q button.

Note that the figure on the right shows the screen as it appears during Live View photography; you don't see the fourth option (AF Quick) in Movie mode.

- ✓ **AF button:** Press the AF button on top of the camera to access a screen offering the available settings.
- Menus: For still photography, choose AF Method from Live View Menu 1, as shown on the left in Figure 4-9. For Movie recording, the option appears on Movie Menu 1, as shown on the right.

AF mode symbol

Figure 4-8: You can adjust the AF mode via the Quick Control screen.

Live View shoot.	Enable
AF method	じ+Tracking
Continuous AF	Enable
Touch Shutter	Disable
Grid display	Off
Aspect ratio	3:2
Expo. simulation	Enable

AF method	じ+Tracking
Movie Servo AF	Enable
Silent LV shoot.	Mode 1
Metering timer	16 sec.

Figure 4-9: You also can adjust the autofocusing method via Live View Menu 1 for still photos (left) or via Movie Menu 1 for movie recording (right).

Face+Tracking autofocusing

AF L I In this mode, which is the default for both still photography and movie recording the camera searches for faces in the frame. If it finds one it of recording, the camera searches for faces in the frame. If it finds one, it displays a white focus frame over the face, as shown on the left in Figure 4-10.

> In a group shot where more than one face is recognized by the camera, you see arrows on either side of the focus frame. To choose a different face as the focusing target, tap the face or use the Multi-controller to move the target frame over the face.

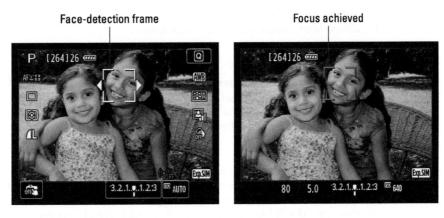

Figure 4-10: The white frame represents the face chosen for focusing; the frame turns green when focus is achieved.

To lock focus on the face, press and hold the shutter button halfway down or press and hold the AF-ON button. When focus is locked, the focus frame turns green, as shown on the right in the figure, and the camera emits a beep. (Disable the sound effect via the Beep option on Shooting Menu 1.) If focus isn't successful, the focus frame turns red.

When the conditions are *just right* in terms of lighting, composition, and phase of the moon, this setup works fairly well. However, it has a number of "issues":

- People must be facing the camera to be detected because the feature is based on the camera recognizing the pattern created by the eyes, nose, and mouth.
- The camera may mistakenly focus on an object that has a similar shape, color, and contrast to a face.
- Face detection sometimes gets tripped up if the face isn't just the right size with respect to the background, is tilted at an angle, is too bright or dark, or is partly obscured.
- Autofocusing isn't possible when a subject is very close to the edge of the frame. The camera alerts you to this issue by displaying a gray frame instead of a white one over your subject. You can always temporarily reframe to put the subject within the acceptable autofocus area, lock focus, and then reframe to your desired composition.

If the camera can't detect a face, it operates as it does when you use FlexiZone-Multi autofocusing, explained next.

FlexiZone-Multi autofocusing

By default, this mode is based on focus points spread throughout the area indicated by the framing marks you see in Figure 4-11. Note that Figure 4-11 shows the framing marks for Live View photography; in Movie mode, the framing marks occupy a different area of the screen due to the 16:9 aspect ratio of movie frames.

In the fully automated exposure modes, you don't have any control over which points the camera uses to establish focus. Typically, focus is set on the object closest to the camera. When you press the shutter button halfway or press the AF-ON button, one or more focus points turns green, as shown on the right in the figure, to indicate the areas of the frame that were used to establish focus. You also hear a beep indicating that focus is set.

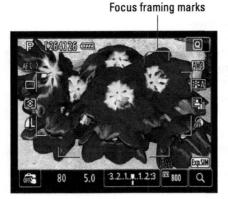

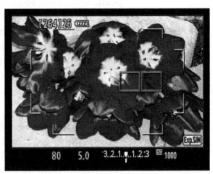

Figure 4-11: In fully automatic exposure modes, compose your shot so your subject is within these framing marks.

When you set the mode dial to P, Tv, Av, M, B, or C, you can break the focusing area into several smaller zones — thus, *FlexiZone* focusing — and limit the camera to finding its focusing point within one of those zones.

Exactly how many focusing points and zones are available depends on the following factors:

- ✓ Live View photography: The key here is the Aspect Ratio setting on Live View Menu 1. By default, the picture aspect ratio is 3:2 and you get 31 focusing points and 9 focus zones. But if you change the aspect ratio, things change:
 - 3:4 and 1:1 aspect ratios: 25 focus points and 9 zones
 - 16:9 aspect ratio: 21 focus points and 3 zones
- ✓ **Movie mode:** You get 21 focus points and 3 zones *unless* the Movie Recording Size option (Movie Menu 2) is set to 640 x 480, in which case you get 25 points and 9 zones.

Yeah, I hear you — this stuff gets a little deep in the weeds, but don't worry too much about how many points and zones are available. It's not like you can control them, anyway. Just remember the techniques you use to select a zone:

- Switch from automatic focus point selection to zone selection. Press the Set button or the Erase button (the blue trash can button) to display a large rectangle indicating the current focus zone, as shown in Figure 4-12.
- Select the focus zone. Tap the subject to display a frame that represents the closest zone frame. Or use the Multicontroller to move the zone frame.
- Quickly select the center zone. Press the Set button or the Erase button again.

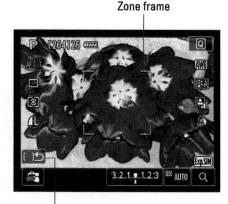

Exit Zone mode

Figure 4-12: Press the Set button to toggle to zone focusing and then tap an area of the frame to locate the zone frame.

Switch back to automatic focus selection. Tap the icon labeled Exit Zone mode in Figure 4-12 or press the Set or Erase button one more time.

The focusing technique for zone focusing is the same as for automatic selection: If continuous autofocusing is enabled, the camera hunts for its focus point in the zone frame. If you press and hold the shutter button halfway, the frame turns green and you hear the focus beep, indicating that focus is locked as long as you keep the shutter button pressed halfway. You also can use the AF-ON button to set focus.

FlexiZone-Single autofocusing

FlexiZone-Single AF mode lets you select a specific autofocus point. You see a single, small focus frame at the center of the screen, as shown on the left in Figure 4-13. The figure shows how the frame looks in Live View mode; in Movie mode, it's a little larger. Either way, the next step is to move the frame over your subject. For example, I moved the frame over the soup garnish in the right screen in the figure. You can either use the Multi-controller to adjust the frame position or just tap the screen to place the frame.

As in FlexiZone-Multi mode, you can press the Set button or Erase (trash can) button to immediately move the focus frame back to the center of the frame.

Focusing works the same as in the AF methods already discussed; press the shutter button halfway or hold down the AF-ON button to set and lock focus. If the camera can't focus on the spot you selected, the frame turns red.

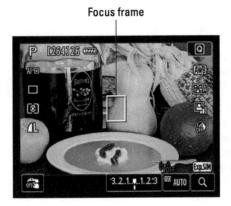

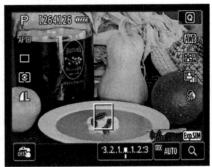

Figure 4-13: In FlexiZone-Single mode, use the Multi-controller or tap the screen to move the focus frame over your subject.

Quick mode autofocusing

As its name implies, Quick mode offers the fastest autofocusing during Live View or movie shooting. So why isn't Quick mode the default setting? Well, it's a little more complex to use. In addition, the monitor display goes dark during the time the camera is focusing, which can throw off the unsuspecting photographer. Finally, you can't use Quick mode for movie shooting — it's for still photography only. Nor is continuous autofocusing, explained earlier in this chapter, available for Quick mode.

On the up side, the technique you use to autofocus is almost exactly the same as the one you use during viewfinder photography, so it may feel more comfortable to you than the other Live View and Movie autofocusing methods.

Follow these steps to try it out:

1. Set the AF Method option to Quick Mode.

Use the Quick Control screen or Live View Menu 1.

2. Choose an AF Area Selection Mode.

This setting gives the camera some direction about where in the frame it should set focus. Press the AF Area Selection button (top of the camera, just forward of the Main dial) to display the screen shown in Figure 4-14. Keep pressing the button to cycle through the three mode choices, represented by the symbols labeled in the figure:

- 19-point automatic selection: The camera chooses the focus point for you, with the location of the 19 available focus points indicated by the same brackets that appear in the viewfinder during autofocusing. I label them in Figure 4-15.
- Zone AF: In this mode, you tell the camera to concentrate on a specific zone of autofocus points. The screen appears as shown on the left in Figure 4-16. You see all 19 focus points, represented by rectangles, with white framing brackets around the selected zone. For example, in the figure, the center zone of nine points is selected. Use the Multi-controller, Ouick Control dial, or Main dial to select a different zone or just tap one of the points in the zone you want to use.

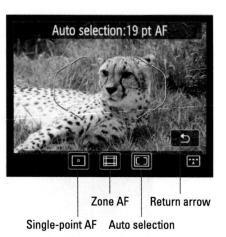

Figure 4-14: Press the AF Area Selection button to access this screen.

19-point auto brackets 3.2.1. . 1.2:3 E AUTO

Figure 4-15: At the default AF Area Selection setting (19-point automatic selection), you see the regular autofocusing brackets on the screen.

To quickly select the center zone, press the Set button.

 Single-point AF: In this mode, you select a specific focus point. The chosen point is represented by the white rectangle, as shown on the right in Figure 4-16. To choose a different point, tap it or use the Multi-controller to move the focus box.

Again, you can press the Set button to select the center point quickly.

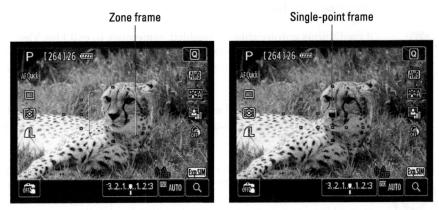

Figure 4-16: Quick Mode autofocusing also enables you to use Zone AF (left) and Single-point AF mode (right) to specify your focusing target.

To exit the AF Area Selection screen, tap the return arrow (labeled in Figure 4-14) or press the shutter button halfway and release it. (If you go the latter route, the monitor turns off briefly and then back on again.)

- 3. Frame the shot so that your subject is under the selected autofocus area.
- 4. Press and hold the shutter button halfway down.

The monitor turns off, and the autofocusing mechanism kicks into gear. (It may sound as though the camera took the picture, but don't worry — that isn't actually happening.) When focus is achieved, the camera beeps, the Live View display reappears, and the focus point (or points) used to achieve focus appear green. Focus remains locked as long as you keep the shutter button pressed halfway.

If the camera can't find a focusing target, the focus point (or points) turn orange and blink. Try using manual focusing (explained next) or getting a little farther from your subject — you may be exceeding the minimum focusing distance of the lens.

5. Press the shutter button the rest of the way to take the picture.

You also can use the AF-ON button to set focus; see Chapter 8 for more about this camera feature.

Manual focusing

Manual focusing is the easiest of the Live View focusing options — and in most cases, it's faster, too.

If continuous autofocusing is enabled, remember to exit Live View or Movie mode before you move the lens switch to the MF (manual focus position). Moving the switch while continuous autofocusing is engaged can damage your equipment.

After setting the lens to MF mode, simply rotate the lens focusing ring to set focus. On the monitor display, the letters MF take the place of the usual AF mode icon.

I find that most people who shy away from manual focusing do so because they don't trust their eyes to judge focus. But thanks to a feature that enables you to magnify the Live View preview, you can feel more confident in your manual focusing skills. See the next section for details.

Zooming in for a focus check

Here's a cool focusing feature not available during viewfinder photography: You can magnify the Live View display to ensure that focus is accurate. This trick works during manual focusing or in any AF mode except Face+Tracking mode. Follow these steps:

1. Press the AF Point Selection button or tap the Zoom icon in the lower right of the screen (see Figure 4-17).

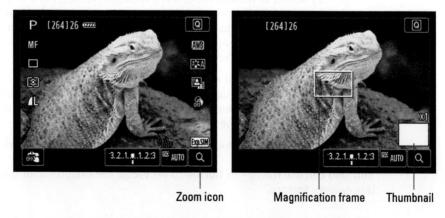

Figure 4-17: Tap the Zoom symbol (left) to switch to magnified view (right).

Most shooting data disappears, and you see a magnification frame on the screen plus a white box in the lower-right corner, as shown on the right in Figure 4-17. The white rectangle is a thumbnail representing the entire image area.

The value x1 appears above the thumbnail to show you that you're viewing the image at its regular size (no magnification).

2. Move the focusing frame over your subject.

Tap the screen or use the Multi-controller to position the frame.

3. Press the AF Point Selection button or tap the Zoom icon again to magnify the display.

Your first press or tap displays a view that's magnified five times, as shown in Figure 4-18. Now the thumbnail icon changes, and the tiny white rectangle indicates the area of the frame you're viewing. Additionally, a scroll arrow appears on each side of the frame, as labeled in the figure.

If needed, tap the scroll arrows or use the Multi-controller to scroll the display.

Press the AF Selection Point button or tap the Zoom icon again for a x10 (ten-times) magnification.

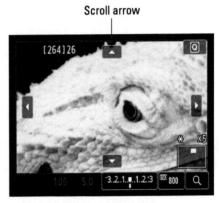

Figure 4-18: Tap the scroll arrows or use the Multi-controller to scroll the zoomed display.

4. To exit magnified view, press the AF Point Selection button or tap the Magnify icon again.

Pretty cool, yes? Just a couple of tips on using this feature:

- Press the Erase button or the Set button to quickly shift the magnification frame to the center of the screen.
- Exit magnified view before you actually take the picture. Otherwise, exposure may be off. However, if you do take the picture in magnified view, the entire frame is captured not just the area currently displayed on the monitor.

Exploring Other Live View Options

After sorting out the focusing rigmarole, understanding the rest of the Live View photography options is a piece of cake. The next three sections explore these remaining features.

Setting the photo aspect ratio

When you shoot with the viewfinder, photos have a 3:2 aspect ratio (the relationship of a photo's width to its height). But in Live View mode, you can choose a different aspect ratio if you shoot in the advanced exposure modes. Select one of the following aspect ratios from Live View Menu 1, shown in Figure 4-19:

1	3:2: The standard aspect ratio
	and the same as 35mm film (as
	well as a 4 x 6-inch print)

- 4:3: The aspect ratio of older television and computer screens
- ✓ 16:9: The aspect ratio of most new TVs and monitors
- ✓ 1:1: Produces square photos

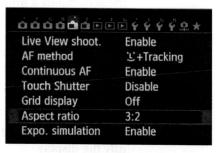

Figure 4-19: When you use Live View in the advanced exposure modes, you can change the picture aspect ratio.

How many pixels your image contains depends on the aspect ratio; at the 3:2 setting, you get the full complement of pixels delivered by your chosen Image Quality setting. (Chapter 2 explains that setting.) Note, too, that if you set the Image Quality option to record JPEG pictures, the camera creates the different aspect ratios by cropping a 3:2 original — and the cropped data can't be recovered. Raw photos, although they appear cropped on the camera monitor, actually retain all the original data, which means you can change your mind about the aspect ratio later, when you process your Raw files. (Read about that subject in Chapter 6.)

At any setting except 3:2, the Live View display updates to indicate the framing area. For example, Figure 4-20 shows the framing area produced by the 1:1 aspect ratio.

Adjusting other Live View picture settings

Before getting into the details of adjusting picture settings, I want to point out the following limitations so you don't waste your time trying to figure out how to use the related features:

Figure 4-20: The live preview indicates the aspect ratio — 1:1, in this shot.

- Certain Custom Functions are unavailable. If an option on the Custom Functions menu is dimmed, the camera can't deal with the feature in Live View mode. A few options in the Autofocus group of Custom Functions are available only when you use the Quick mode of autofocusing.
- **✓ Some flash options are affected.** To wit:
 - Flash Exposure Lock doesn't work. I cover this flash feature in Chapter 7.
 - The modeling flash feature found on some Canon Speedlite flash units doesn't work.
 - The sound of the shutter release is different. When you take a flash shot in Live View mode, the camera's shutter sound leads you to believe that two shots have been recorded; in reality, though, only one photo is captured.
- Exposure is calculated differently in Continuous Drive modes. You can use any of the Continuous Drive modes (introduced in Chapter 2), but the camera uses the exposure settings chosen for the first frame for all images. And as with flash shots, you hear two shutter sounds for the first frame in the continuous sequence.

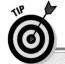

Quieting the camera with Silent LV Shooting

In the advanced exposure modes (P, Tv, Av, M, B, and C), you can enable a feature called Silent LV Shooting, found on Live View Menu 1 and Movie Menu 2. This feature enables you to control how much noise the camera makes when you take a picture using Live View or snap a still photo during movie recording. Well, sort of, anyway — you can't achieve completely silent operation with the 70D. And if you use flash, the feature is disabled.

You can choose from three settings:

- Mode 1: This setting is the default; it tamps down camera noise slightly.
- Mode 2: In this mode, designed for still photography, keep holding the shutter button

down after taking a picture to delay the sound the camera makes at the end of the exposure. This option enables you to wait to release the button until a moment when the camera noise won't be objectionable. Note, though, that continuous shooting isn't possible in this mode. Also, if you use a remote control unit, the camera behaves as if you selected Mode 1.

Disable: This mode turns off the camera's sound dampeners. Choose this setting if you use a non-Canon flash unit; otherwise, the flash won't fire. Also choose Disable if you're using a lens extension tube or a TS-E lens (Tilt-Shift for EOS) other than the TS-E 17mm f/4L or TS-E 24mm f/3.5L II lens.

Now that you know what you can't do, here's what you can do. First, when Live View is enabled, you can set the display to reveal many of the same picture settings that normally appear on the Shooting Settings screen — and then some. Figure 4-21 shows the screen as it appears when you shoot in the P exposure mode and display the maximum shooting data. (Press the Info button to cycle through the various Live View displays.)

The onscreen symbols break down into three categories: Information only symbols; settings that you can adjust via the Quick Control screen; and options you can access by tapping the touchscreen. Here's how things shake out:

Figure 4-21: Symbols representing the current picture settings appear on the Live View

- Information only data: Labeled in Figure 4-21, this data includes
 - Exposure mode: For the figure, the P (programmed autoexposure) mode was in force. When you shoot in the Scene Intelligent Auto mode, an icon representing the type of scene the camera detected appears along with the exposure mode symbol. Your camera manual has a long list of icons that indicate what type of photo the camera detected, but don't waste time memorizing them. If you have a certain scene type in mind, you're better off choosing a scene mode via the SCN exposure mode.
 - Shots remaining: Here's the number of pictures you can fit on your memory card.
 - Maximum burst: This number is related to the Continuous drive modes; it indicates how many pictures will fit in the camera's internal memory buffer before you need to stop shooting and give the camera time to catch up with writing the picture data to the memory card.
 - Battery status: A full battery icon like the one in the figure means that you're good to go.

- Exp. Sim: In the lower-right corner, an Exp Sim symbol represents the setting of the Exposure Simulation setting on Live View Menu 1, which I detail in the earlier section "Customizing the display." The symbol shown in Figure 4-21 represents the default setting, Enable. At this setting, the brightness of the scene is as close as possible to the actual exposure of the photo. Remember that if flash is enabled, the feature is automatically turned off and thus dimmed in the display. If you set the Exposure Simulation setting to During Preview (you press the Depth of Preview button to see the exposure simulation) or Disable, the icon appears as a camera with the letters DISP.
- Wi-Fi status: This symbol tells you whether the camera's Wi-Fi transmitter is turned on. A dimmed symbol like the one in the figure indicates that the feature is off. Change the setting via Setup Menu 3.

In addition, you may see these additional symbols scattered around the screen if you use the related features, all of which I cover in later chapters:

- AEB appears when you enable Automated Exposure Bracketing.
 The lines under the exposure meter show you the range of exposure stops you set the feature to use.
- FEB indicates that Flash Exposure Bracketing is enabled.
- *D+:* Means that you enabled Highlight Tone Priority.
- HDR/Multiple Exposures/ Multi-Shot Noise Reduction:
 A symbol appearing in the portion of the screen highlighted in Figure 4-22 indicates that you have one of these features turned on. The symbol in Figure 4-22 represents the HDR function.
- Flash ready symbol: If the flash is raised, you see a lightning bolt when the flash is ready to fire. If flash is disabled because of a conflicting picture setting (such as the HDR feature),

HDR/Multiple Exposure/ Multi-Shot Noise Reduction

Flash disabled

Figure 4-22: This area of the screen is reserved for displaying the status of the HDR, Multiple Exposure, or Multi-Shot Noise Reduction feature.

you see the flash with the slash through it, as shown in the figure.

- Touch-control settings: A symbol surrounded by a rectangular border indicates that tapping that symbol produces a result. In the case of the Q icon in the upper right, of course, a tap shifts the screen to Quick Control mode. But during Live View shooting, you also can tap to adjust the following settings, labeled in Figure 4-23:
 - Touch shutter: This feature enables you to focus the shot and release the shutter simply by tapping your subject on the monitor. When the option is disabled, the word Off appears with the symbol, as in Figure 4-23. Just tap the icon to toggle the feature on and off; see

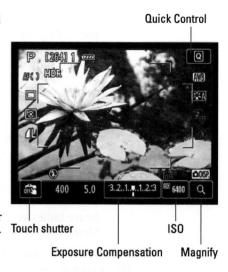

Figure 4-23: A border around a symbol indicates a tappable function.

the upcoming section "Using the touch shutter" for details about using it.

Make sure this feature is turned off if you want to use the touchscreen to select a focus point without triggering the shutter release.

• Exposure Compensation: In the P, Tv, and Av exposure modes, you can apply Exposure Compensation to force a brighter or darker picture than the camera's autoexposure brain thinks is appropriate. After you tap the meter, a scale appears atop the image; drag your finger along the scale to adjust the setting. Or tap the minus and plus signs underneath the scale to raise or lower image brightness a notch at a time. To exit the screen, tap the return arrow in the upper-right corner or press Set.

You also can adjust this setting the old-fashioned way: After making sure that Lock switch under the Quick Control dial is set to the unlock position, rotate the dial. (If nothing happens, wake up the exposure meter by giving the shutter button a quick half-press.)

Either way, assuming that you set the Exposure Simulation option on Live View Menu 1 to Enable, the monitor updates as you change the setting — to a certain limit. The image on the monitor becomes brighter or darker only up to shifts of \pm 0 and as low as \pm 5.0. See Chapter 7 to get a primer on exposure compensation.

 ISO: Tapping this option enables you to adjust the ISO setting, an exposure control I cover in Chapter 7. Again, you see a scale after you tap the option; this time, drag along the scale or tap the left and right arrows beneath it. Tap the return arrow to exit the screen.

Pressing the ISO button on top of the camera is another route to the same option.

- Magnified display: Except when using the Face+Tracking AF mode, you can tap the Zoom icon to magnify the display to verify focus.
 See the earlier section "Zooming in for a focus check" for details.
- ✓ Settings adjustable via the Quick Control display: After you press the Q button or tap the Q icon on the display, you can adjust the settings labeled in Figure 4-24 and described in the following list. With some settings, the preview updates to show you the result of your choice. To exit Quick Control mode, tap the return arrow or press the Quick Control button.
 - *AF mode:* The AF mode symbol appears regardless of whether you set your lens to manual or autofocus. When manual focus is active, the letters MF appear instead of the AF Mode symbol.
 - *Drive mode:* The icon you see in the figure represents Single Drive mode, in which you capture one image for each press of the shutter button. See Chapter 2 for information about other drive modes.

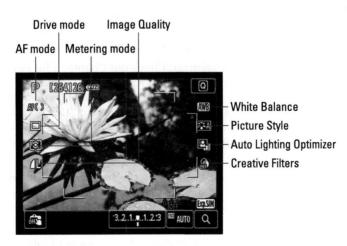

Figure 4-24: You can use the Quick Control screen to modify these settings.

Metering mode: Chapter 7 also explores this option, which determines which part of the frame the camera uses to calculate exposure. By default, the camera uses evaluative metering, which means that exposure is based on the entire frame. The symbol shown in the figures represents that setting.

As with the Drive mode, you also can access this setting via a button on top of the camera; it's marked with the symbol you see in the margin here. Either way, if you use the Partial or Spot metering setting, a circle appears in the center of the display to indicate the area that's being used to calculate exposure.

- Image Quality: Chapter 2 explains this setting, which sets the resolution (pixel count) and file type (JPEG or Raw). The symbol shown in the figure represents the Large/Fine setting. When you select this setting, an Info icon appears on the screen; tap that icon or press the Info button to select one of the Raw Image Quality options.
- White Balance: This setting, which you can explore in Chapter 8, determines how the camera compensates for the color of the light source that's illuminating your subject. The symbol in the figure represents the Automatic White Balance setting.
- Picture Style: Chapter 8 also details Picture Styles, which affect
 picture color, contrast, and sharpness. After selecting this setting,
 press Info or tap the Info icon to access a screen that enables you
 to tweak the characteristics of the selected Picture Style.
- Auto Lighting Optimizer: Check out Chapter 7 for help understanding this feature, which aims to improve image contrast. By default, the Standard setting is used; the symbol shown in the figure represents that setting. Note that by default, this option is always disabled for the M (Manual) and B (Bulb) exposure modes; to enable the feature for those modes, tap the check mark next to the Info icon or press the Info button.

In the P, Tv, and Av modes, experiment with disabling Auto Lighting Optimizer if your picture appears too bright even after you've requested a darker photo through the Exposure Compensation setting.

• *Creative Filters:* This feature lets you apply Creative Filters (Grainy Black and White, Soft Focus, and Art Bold are a few examples) to photos as you take them. Chapter 10 has more information.

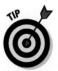

Using the touch shutter

Here's one final Live View photography feature to try: When touchscreen operation is enabled, you can tap the monitor to set focus and trigger the shutter release. Follow these steps:

1. Enable the Touch Control option on Setup Menu 3.

You can select Standard or Sensitive as the menu option; your choice determines how firm of a touch you need to use to get the touchscreen to respond.

2. Shift to Live View mode.

Just move that Live View switch to the camera position and then press the Start/Stop button.

3. Look for the Touch Shutter icon in the lower-left corner of the monitor.

I label the icon in Figure 4-25. By default, the touch-shutter feature is turned off, so the word Off appears with the icon.

4. Tap the icon to toggle the touch shutter function on.

You also can turn the feature on via Live View Menu 1.

5. Compose your shot and then tap the subject on the monitor.

If you're focusing manually, the camera releases the shutter to take the picture. For autofocusing, the camera attempts to focus on the spot you tapped. If it's successful, it releases the shutter

Touch Shutter on/off

Figure 4-25: Turn the touch-shutter function on and off by tapping its icon.

to take the picture. If focus can't be achieved, the camera won't record the photo.

A few fine points: In the FlexiZone-Multi autofocus mode, the camera instead behaves as if FlexiZone-Single mode is active. The Continuous Drive modes don't function; you can't shoot a burst of images using the touch shutter. Nor does the touch shutter operate when the Live View display is magnified. And finally, to shoot a bulb exposure (using the B exposure mode), tap the screen once to open the shutter and tap again to end the exposure.

Turn off the touch shutter function after you're done using it. Otherwise, it's easy to forget that the feature is enabled and accidentally take a picture when your tap is really meant to select an autofocusing point or zone.

Recording Your First Movie

By moving the Live View switch to the Movie position, you can record high-definition video, with or without sound. The camera records movies in the MOV format, which is a popular file format for storing digital video. Movie filenames begin with the characters MVI_.

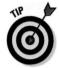

For best recording results, use a high-speed memory card (class 10 or UHS-1). With slower cards, the camera may not be able to write the movie data to the card fast enough to keep pace with recording. If this happens, a vertical bar appears on the right side of the screen to indicate how much data is yet to be sent to the card. When the indicator appears full, movie recording is halted automatically.

Assuming that your card is fit for the job, recording a movie using the default settings is a cinch:

1. Disable the Wi-Fi function via Setup Menu 3.

You can't record a movie while the Wi-Fi feature is turned on.

2. To use an external microphone, plug the mic into the port on the left side of the camera.

Otherwise, sound is recorded via the internal microphone, positioned in the location shown on the left in Figure 4-26. Plug an external mic into the jack labeled on the right in the figure.

3. Set the Mode dial to Scene Intelligent Auto (the green A+).

In this mode, the camera handles all exposure settings for you, which is the way to go unless you're an experienced videographer.

4. Set the Live View switch to the Movie setting.

The viewfinder shuts off, and the live preview appears on the monitor. You see various data onscreen, as shown on the left in Figure 4-27. The next section explains what each bit of information means. For now, the critical detail is the available recording time, which depends on how much free space exists on your memory card and the Movie Recording Size setting, which determines the movie file size. (I explain this option later.)

Figure 4-26: You can record sound using the internal mic (left) or attach an external microphone (right).

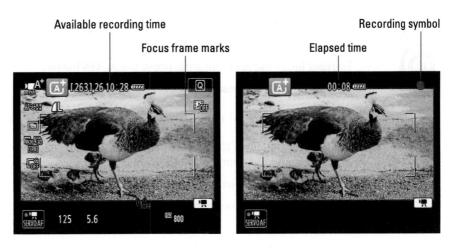

Figure 4-27: The display shows how many minutes of video will fit on your memory card (left) and, after you begin recording, elapsed recording time (right).

5. Frame your initial shot and set focus.

By default, the camera uses continuous autofocusing (Movie Servo AF) and the Face+Tracking AF mode, which I explain earlier in this chapter. If the camera detects a face, it automatically focuses on that face; otherwise, it shifts to FlexiZone-Multi AF mode and typically focuses on the closest object found within the framing marks labeled in Figure 4-27.

To use manual focusing, first shift back to viewfinder shooting and then move the lens switch to the MF position. (This step prevents possible damage that can occur if you move the switch while continuous autofocusing is in progress.) Return to Movie mode and bring the subject into focus using the lens focusing ring.

6. To start recording, press the Start/Stop button.

Most shooting data disappears, and a red "recording" symbol appears, as shown on the right in Figure 4-27. Now, instead of showing you the length of the recording that will fit on your memory card, the display shows the elapsed recording time.

The maximum movie length at the default recording settings is 16 minutes, which is how long it takes for the file to reach 4 gigabytes (GB), the file size limit. When you reach that limit, the camera creates a new movie file to hold the next 16 minutes of video. Recording stops automatically when the total recording time reaches 29 minutes and 59 seconds.

To reset focus during recording, press the AF-ON button.

7. To stop recording, press the Start/Stop button again.

At the default settings, your movie is recorded using the following settings:

- ✓ Full HD video quality (1920 x 1080p, or pixels) at 30 frames per second (fps), using the IPB compression setting
- Audio recording enabled
- Evaluative (whole frame) exposure metering
- Automatic white balancing
- Auto Lighting Optimizer applied at the Standard setting
- Auto Picture Style

But of course, you didn't buy this book so that you could remain trapped in the camera's default behaviors. So the upcoming sections explain all your recording options, which range from fairly simply to fairly not.

Customizing Movie Recording Settings

After you set the Live View switch to the Movie position, you can display critical recording settings on the monitor, shown in Figure 4-28. If you don't see the same data, press the Info button to cycle through different display styles. The figure shows the screen as it appears when you shoot in the P exposure mode; the data varies slightly depending on your exposure mode.

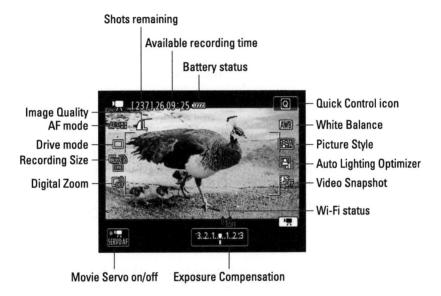

Figure 4-28: Press the Info button to change the data display.

The following list offers insights into a few screen symbols; upcoming sections provide more details about recording settings.

- ✓ The Drive mode, shots remaining, and Image Quality settings relate only to still shots you capture during a recording. See the later section "Snapping a Photo During Recording" for help.
- ▶ By default, the camera controls the aperture, shutter speed, and ISO. Pressing the shutter button halfway displays the shutter speed, f-stop, and ISO for the still shot, which may be different than for the movie recording. However, you can switch to manual exposure control for the movie by setting the Mode dial to M. This option is best left to experts and involves more details than I have room to cover, so see the camera instruction manual for the full story.

Regardless of exposure mode, you can't adjust the metering mode; evaluative (whole frame) metering is always used.

In P, Tv, and Av modes, the exposure meter indicates the amount of Exposure Compensation. Exposure Compensation enables you to adjust the brightness of your next recording. If the bar under the meter is at the center position, as shown in Figure 4-28, no compensation has been applied. You can tap the setting and then adjust it by dragging your finger along the scale that appears: Drag right for a brighter picture; drag left for a darker picture.

In P, Tv, and Av exposure modes, you can press the AE Lock button to disable automatic exposure adjustment. When you use autoexposure, the camera adjusts exposure during the recording as needed. If you prefer to use the same settings throughout the recording — or to lock in the current settings during the recording — you can use AE (autoexposure) Lock. Just press the AE Lock button. A little asterisk appears in the lower left of the screen.

To cancel AE Lock during recording, press the AF Point Selection button. When recording is stopped, AE Lock is cancelled automatically after 16 seconds by default; this shutoff timing is determined by the Metering Timer option on Movie Menu 1.

Focus options: You select and adjust focus settings just as you do for Live View photography; see the earlier section, "Focusing in Live View and Movie Modes" for details. Quick Mode autofocusing isn't available for movie recording, however.

By default, continuous autofocusing — Movie Servo AF — is enabled. Toggle continuous autofocusing on and off by tapping the icon in the lower left of the screen (refer to Figure 4-28). You also can change this setting via Movie Menu 1.

After you begin recording, you can reset focus only by pressing the AF-ON button. Pressing the shutter button halfway doesn't work.

To adjust other movie recording options, you can go two routes:

Movie Menus 1 and 2: The Movie menus appear only after you set the Live View switch to the Movie setting. Which menu options appear depend on the exposure mode; some advanced settings are unavailable in the fully automatic exposure modes.

✓ Quick Control screen: You can also adjust some recording options via the Quick Control screen. The icons running down the left and right side of the screen, labeled in Figure 4-28, represent these settings. Again, the Image Quality and Drive mode settings apply only to still photos you shoot during recording. I explain the movie-only options, Recording Size and Digital Zoom, later in this chapter; see Chapter 10 for a look at the Video Snapshot feature. The other settings affect exposure and color the same as they do for still photography and are explained in Chapters 7 and 8.

Movie Menu 1

Start customizing your production with the options on Movie Menu 1, shown in Figure 4-29. Note that you can access only the first two options when you shoot in the fully automatic exposure modes.

AF Method: This option does the same thing as the AF mode option available via the Quick Control screen: It sets the autofocusing method, as outlined ear lier in this chapter. Remember, you can't use Quick mode autofocusing for movie recording.

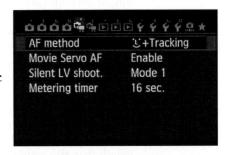

Control screen: It sets the autofocusing method, as outlined earlier in this chapter. Remember,

Figure 4-29: You must set the exposure mode to P, Tv, Av, M, B, or C to access the entire cadre of Movie Menu 1 options.

- Movie Servo AF: Here's where to enable or disable continuous autofocusing if you forget that you can do it more quickly by tapping the screen icon (refer to Figure 4-28). For more about this feature, see the earlier section, "Disabling continuous autofocusing."
- ✓ **Silent LV Shooting:** This feature relates only to still photos that you take during recording. Stick with the default, Mode 1, until you have time to explore the commentary found in the earlier sidebar in this chapter.
- Metering Timer: This option is the one that adjusts the auto shut-off timing of the exposure meter, as explained in the earlier section, "Customizing the display." By default, the meter shuts down and disappears from the display after 16 seconds. The setting also controls the automatic cancellation of AE Lock, as explained in the preceding section.

Movie Menu 2

Movie Menu 2, shown in Figure 4-30, includes the following settings:

- ✓ **Grid Display:** Display one of three grid styles to help ensure alignment of vertical and horizontal structures when you're framing the scene.
- Movie Recording Size: This option determines movie resolution (frame size, in pixels), frames per second (fps), frame aspect ratio, and file compression method. This setting is a

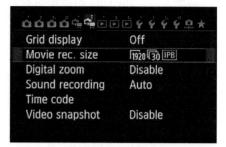

Figure 4-30: Options controlling video quality and sound recording reside on Movie Menu 2.

little complex, so see the next section if you don't know what option to choose.

- ✓ Digital zoom: This feature, which I detail later in the chapter, records the movie using just the central portion of the image sensor to create the illusion that you shot the movie using a lens with a longer focal length than the actual lens.
- Sound Recording: Via this menu item, you adjust microphone volume and a couple other sound options. See "Choosing audio recording options," later in this chapter, for help.
- ✓ Time Code: This feature is for advanced videographers who edit movies on the computer. The time code is an invisible counter that synchronizes video and audio during shooting. The feature is on by default, but if you choose the menu option, you can control how the time code counter works and whether the time code appears onscreen during shooting and playback:
 - *Count Up:* Choose Rec Run (the default) to have the time counter running only during shooting. At the Free Run setting, the counter runs even when you're not shooting.
 - Start Time Setting: Establish the start time of the counter. Set the
 time manually, setting the hour, minute, second, and frame number
 of the start time. Or you can tell the camera to use the current
 start time with the camera's internal clock. The Reset option sets
 the counter back to whatever time you selected via the other two
 options.

- *Movie Recording Count:* Normally, the monitor displays the elapsed recording time at the top of the screen (refer to Figure 4-27). If you choose Time Code, the time code is displayed instead.
- Movie Playback Count: This one affects playback: At the default (Rec Time) setting, the screen displays the recording time and playback time; at Time Code, you see the time code instead.
- *Drop Frame:* Okay, here's one that's even higher on the video-wonk scale: This feature, which is provided only when the Video System option on Setup Menu 3 is set to NTSC, accounts for discrepancies that occur between the actual time and the time code when the frame rate setting is 30fps or 60fps. The Enable setting automatically corrects the problem by skipping time code numbers; you see the initials DF (for Drop Frame) when this setting is in force. Select Disable, and the discrepancy isn't corrected. In this case, you see the letters NDF (Non-Drop Frame).
- Video Snapshot: Create multiple brief movie clips and combine the clips into one movie. Turn off this feature for regular movie recording and see Chapter 10 for how to create video snapshots.

Setting the Movie Recording Size option

Through this setting, you set movie resolution, frames per second (fps), and the file-compression method. You can access the option via Movie Menu 2, in which case you see the somewhat obtuse screen shown in Figure 4-31.

You also can adjust the setting via the Quick Control screen, as shown in Figure 4-32. If you go that route, the available settings are displayed along the bottom of the screen.

Either way, you get the following choices:

- ✓ 1920 x 1080 pixels, 30fps (16:9 aspect ratio)
- ✓ 1920 x 1080 pixels, 24fps (16:9)
- ✓ 1280 x 720 pixels, 60fps (16:9)
- ✓ 640 x 480 pixels, 30fps (4:3)

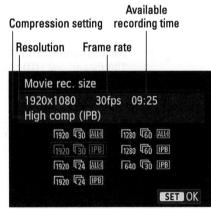

Figure 4-31: After you choose a resolution setting, the screen updates to show the length of the movie that will fit on your memory card.

The frame rate options depend on the Video System option on Setup Menu 2, which sets the camera to one of two video standards: NTSC or PAL. NTSC is the standard in North America and Japan; PAL is used in Europe, China, and many other countries. If you choose NTSC, you see the recording options shown in Figure 4-31 and in the preceding list. If you select PAL, you can choose frame rates of 24, 25, and 50 instead of 24, 30, and 60.

Figure 4-32: You also can access the setting via the Quick Control screen.

Notice, too, that for each of the resolution and frames per second offerings except the 640 x 480 pixel option, you

can choose from two compression settings: IPB and ALL-I. The default, IPB, produces smaller files but results in individual frames that may be slightly lower in quality than the ALL-I setting. That second setting is designed for video enthusiasts who plan to edit their footage, in which case the quality of the individual frames is important.

Here's a bit more information to help you choose the best resolution, frame rate, and compression combo:

- For high-definition (HD) video, choose 1920 x 1080 (Full HD) or 1280 x 720 (Standard HD). The 640 x 480 setting gives you standard definition (SD) video. This smaller size video is useful for videos that you want to post online.
- ✓ The resolution and compression settings determine file size and the maximum length of your movie. The following list shows the maximum approximate recording time of a single movie clip for each of the resolution and compression combinations:
 - 1920 x 1080: IPB, 16 minutes; ALL-I, 5 minutes
 - 1280 x 720: IPB, 18 minutes; ALL-I, 6 minutes
 - 640 x 480: IPB, 29 minutes, 59 seconds (ALL-I not available)

For most people, the default setting (1920 x 1080, 30fps, IPB) makes the most sense. You'll get good quality without the huge file sizes required for the ALL-I compression option.

WARNING!

The maximum file size for a movie is 4GB. However, you can keep shooting until you reach a total time of 29 minutes, 59 seconds — the camera automatically creates a new file to hold your new clip. You have to play back each clip separately or join them together in a movie-editing program if you want one continuous 30-minute (or so) movie.

At the SD setting $(640 \times 480 \text{ frame size})$, the maximum movie length is still just shy of 30 minutes even though you can fit more minutes of recording in the 4GB file-size limit. (Don't yell at me. I don't set the limits; I just report them.)

Either way, when the maximum recording time is up, the camera automatically stops recording. You can always start a new recording, however, and, again, you can join the segments in a movie-editing program later, if you want.

Frame rate affects playback quality. Higher frame rates transfer to smoother playback, especially for fast-moving subjects, but the frame rate also influences the crispness of the picture. To give you some reference, 30fps is the NTSC standard for television-quality video, and 24fps is the motion picture standard. Movies shot at 60fps tend to appear very sharp and detailed. It's hard to explain the difference in words, so experiment to see which look you prefer. The uber-high frame rate is also good for maintaining video quality if you edit your video to create slow-motion effects. Additionally, if you want to "grab" a still frame from a video to use as a photograph, 60fps gives you more frames from which to choose.

Choosing audio recording options

In the fully automatic exposure modes, the Sound Rec. option on Movie Menu 2 gives you just two options: You can enable or disable audio recording. If you set the Mode dial to one of the advanced exposure options, you access the audio controls shown on the left in Figure 4-33. The settings apply whether you use the internal microphone or attach an external one.

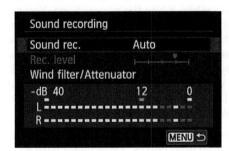

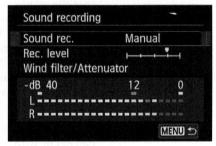

Figure 4-33: The sound meter at the bottom of the screen offers guidance if you set audio recording levels manually.

The audio controls work as follows:

- ✓ Sound Rec.: At the default setting, Auto, sound is recorded, with the camera automatically adjusting recording volume. To control recording levels yourself, choose Manual. To record a silent movie, choose Disable.
- **Rec. Level:** If you choose the Manual sound-recording option, this option becomes available, as shown on the right in Figure 4-33, enabling you to set the recording volume. To guide you, a volume-level meter appears at the bottom of the screen, as shown in the figure.

Audio levels are measured in decibels (dB). Levels on the volume meter range from –40 (very, very soft) to 0 (as much as can be measured digitally without running out of room).

For best results, adjust the recording level until the sound peaks consistently in the -12 range, as shown in Figure 4-33. The indicators on the meter turn yellow in this range, which is good. (The extra space beyond that level, called *headroom*, gives you both a good signal and a comfortable margin of error.) If the sound is too loud, the volume indicators will peak at 0 and appear red — a warning that the audio may be distorted.

If you choose the Manual Sound Recording option, the meters appear on the live preview during recording to help you keep track of audio levels.

- Wind Filter/Attenuator: Choose this option to access the following two audio options:
 - Wind Filter: Ever seen a newscaster out in the field, carrying a microphone that looks like it's covered with a big piece of foam? That foam thing is a wind filter. It's designed to lessen the sounds that the wind makes when it hits the microphone. You can enable a digital version of the same thing via the Wind Filter menu option. Essentially, the filter works by reducing the volume of noises that are similar to those made by wind. The problem is that some noises not made by wind can also be muffled when the filter is enabled. So when you're indoors or shooting on a still day, keep this option set to Disable. Also note that when you use an external microphone, the Wind Filter feature has no effect.
 - Attenuator: This feature is designed to eliminate distortion that can occur with sudden loud noises. Experiment with enabling this feature if you're shooting in a location where this audio issue is possible.

Using Movie Digital Zoom

Digital zoom enables you to capture a movie using a smaller area of the image sensor than normal. The result is a movie that gives you a smaller angle of view, as if you zoomed to a longer focal length to record the scene — or, to put it another way, as if you shot the movie using the whole sensor and then cropped away the perimeter of each frame.

The best way to understand the feature is to try it:

1. Set the movie size to one of the 1920 x 1080 resolution settings.

This is the only resolution that permits digital zooming. You adjust the setting via the Quick Control screen or Movie Menu 2.

2. Enable Digital Zoom from via the Quick Control screen, as shown in Figure 4-34.

You also can turn on the feature via Movie Menu 2. Either way, select the Approx. 3-10x (zoom) option. The preview updates to show you the new framing area, as shown on the right in Figure 4-34.

3. Press the Multi-controller up to zoom in; press down to zoom out.

You also can tap the zoom icon in the lower right of the screen, labeled in Figure 4-35. The current zoom ratio appears above the little movie camera icon, as labeled in the figure.

Digital Zoom icon

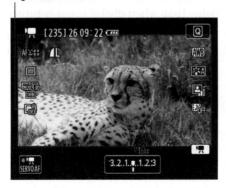

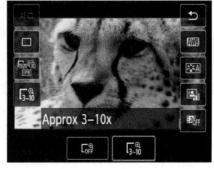

Figure 4-34: Digital zoom records the movie using just the central portion of the image sensor, creating the illusion that you shot the footage with a zoom lens.

4. If autofocusing, press the shutter button halfway or press the AF-ON button to set focus.

The camera automatically uses the FlexiZone-Single AF mode, using the center focus point as the focusing target.

- If focusing manually, set focus by turning the lens focusing ring.
- Press the Start/Stop button to start and then stop recording as usual.
- To return to regular shooting, disable digital zoom via the menu or Quick Control screen.

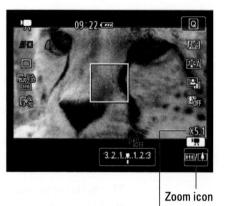

Current zoom ratio

Figure 4-35: Press the Multi-controller up or down to zoom in or out.

Because you're not making use of the full image sensor, the resulting movie quality may not appear as finely rendered as without digital zoom. Also note these other caveats:

- You can't take a still photo during recording when digital zoom is enabled.
- ✓ The maximum ISO speed when using digital zoom is ISO 6400.
- Autofocusing may be slower than usual because the camera has to use a different type of autofocusing than when digital zoom is turned off.
- Perhaps most critically, continuous autofocusing doesn't work when digital zoom is enabled, even if the Movie Servo AF feature is turned on.

Snapping a Photo During Recording

You can take a still photo during recording without exiting Movie mode. Just press the shutter button to take the shot. The camera records the still photo as a regular image file, using the same Picture Style, White Balance, and Auto Lighting Optimizer settings you chose for your movie. The Image Quality setting determines the picture resolution and file format, as outlined in Chapter 2. You can choose single-frame or continuous as the Drive mode; evaluative (whole frame) exposure metering is always used.

There are a few drawbacks to this feature:

- ✓ If you're shooting a movie at one of the Movie Recording Size settings that results in the 16:9 aspect ratio, the area included in your still photo is different from what's in the movie shots. All still photos have an aspect ratio of 3:2, so you gain some image area at the top and bottom and lose it from the sides.
- You can't use flash.
- Your movie will contain a still frame at the point you took the photo; the frame lasts about 1 second. Ouch. If you're savvy with a video editor, you can edit each still photo out of the video, but if you shoot 50 stills in 5 minutes of video, editing is going to take a while.

Playing Movies

Chapter 5 explains how to connect your camera to a television set for bigscreen movie playback. To view movies on the camera monitor, press the Playback button and display the movie in full-frame view. You can spot a movie file by looking for the little movie camera icon in the upper left of the screen. You also see a big playback symbol in the center of the screen, as shown in Figure 4-36.

If you see thumbnails instead of a full movie frame on the screen, tap the thumbnail or use the Multi-controller to highlight it and then press Set to display the file in the full-frame view. You can't play movies in thumbnail view.

Figure 4-36: To start movie playback, just tap the big playback arrow.

Use these techniques to start, stop, and control playback:

- Start playback. You have two options:
 - *Tap the playback arrow.* I label this in Figure 4-36. Your movie begins playing, with a progress bar and time-elapsed value provided at the top of the screen, as shown on the right in Figure 4-36.
 - *Press the Set button or tap the Set icon.* Now you see the first frame of your movie plus a slew of control icons, as shown in Figure 4-37. To start playback, tap the Play icon or use the Multi-controller to highlight it and then press the Set button.
- ✓ Pause playback. Tap the screen or press the Set button. To resume, tap
 the playback symbol or press Set again.

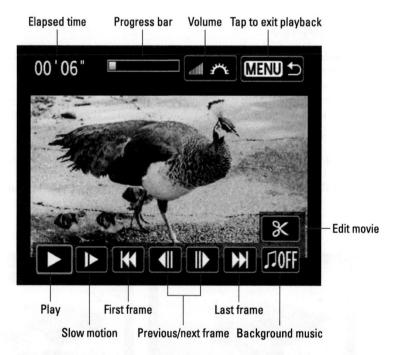

Figure 4-37: If the playback controls disappear, just press the Set button to redisplay them.

- Play in slow motion. Tap the slow-motion icon or select it and press Set. Press the Multi-controller right to increase playback speed; press left to decrease it. You also can adjust the speed by dragging your finger along the scale that appears in the upper-right corner during slo-mo playback.
- Adjust volume. Rotate the Main dial. Note the little white wheel and a volume display bar at the top right of the display it reminds you to use the Main dial to adjust volume. Note that the dial controls volume only for on-camera playback. If you connect the camera to a TV, control the volume using the TV controls instead.

- Fast forward/fast rewind. To fast-forward, tap or select the Next Frame icon. Then hold down the Set button. To rewind, tap or select the Previous Frame icon and hold down the Set button.
- ✓ Go forward/back one frame while paused. Highlight or tap the Next Frame or Previous Frame icon, respectively, and then press the Set button.
- ✓ **Skip to the first or last frame.** Tap the first or last frame icons, respectively, or highlight the icon and press Set.
- ✓ View a still photo you shot during the recording. If you took this step, the photo is displayed for about 1 second automatically during playback. You can also view the separate image file after you exit the movie playback; see Chapter 5 for still-photo playback details.
- ✓ Edit the movie. Tap the Edit icon or highlight it and press Set. Then follow the instructions in Chapter 10 to trim frames from the start or end of the movie the limits of the editing you can do in-camera.
- Exit playback. Tap the Menu icon or press the Menu button.

If you connect your camera to a TV or monitor for viewing, you can't use the touchscreen controls; you must use the camera buttons to control playback.

Part II Working with Picture Files

 $\label{lem:visit_www.dummies.com/extras/canon} \ to \ see \ ideas \ for \ creating \ better \ photographs.$

In this part . . .

- Explore all the playback features.
- See how to download photos to your computer.
- Read how to process Raw files.
- Get tips for better prints.
- Find out how to prepare photos for sharing online.

Picture Playback

In This Chapter

- Exploring playback functions
- Deciphering the playback displays
- Deleting, protecting, and rating photos and movies
- Connecting your camera to a TV for big-screen playback

ithout question, one of the best things about digital photography is being able to view pictures right after you shoot them. No more guessing whether you got the shot you want or need to try again; no more wasting money on developing and printing pictures that stink. But seeing your pictures is just the start of the things you can do when you switch your camera to playback mode. You also can review the settings you used to take the picture, display graphics that alert you to exposure problems, and add file markers that protect the picture from accidental erasure. This chapter tells you how to use all these playback features and more.

Many features discussed in this chapter apply to still photos, movies, and video snapshots. For some playback functions that apply only to movies, see Chapter 4. Chapter 10 covers video snapshots.

Disabling and Adjusting Image Review

After you take a picture, it automatically appears briefly on the camera monitor. By default, the instant-review period lasts 2 seconds. You can customize this behavior via the Image Review option on Shooting Menu 1, shown in Figure 5-1. You can select from the following options:

- Select a specific review period: Pick 2, 4, or 8 seconds.
- Off: Disables automatic instant review. Turning off the monitor saves battery power, so keep this option in mind if the battery is running low. You can still view pictures by pressing the Playback button.

Figure 5-1: Use this option to control the timing of instant picture review.

✓ Hold: Displays the current image until the camera automatically shuts off to save power. See the Chapter 1 section about Setup Menu 2 to find out about the Auto Power Off feature.

You can quickly return to shooting, no matter the setting, by pressing the shutter button halfway. Note that the Image Review feature doesn't work for movies or video snapshots; you must put the camera in Playback mode to view those masterpieces.

Exploring Playback Mode

To switch your camera to Playback mode, just press the Playback button, labeled in Figure 5-2.

Here are the absolute basics of Playback mode:

- Scrolling through pictures: Rotate the Quick Control dial, press the Multi-controller right or left, or swipe your fingertip horizontally across the touchscreen.
- **Return to shooting:** Press the Playback button or give the shutter button a quick half-press and release it.

For still photos, you may see your image only, as in Figure 5-2, or see a little or a lot of shooting data along with the image. For a movie or video snapshot, you always see at minimum a big playback arrow that you can tap to start playback. For any type of file, you can press the Info button to change how much data appears; see "Viewing Picture Data," later in this chapter, for help deciphering what you see. You can also display multiple images at a time; the next section tells all.

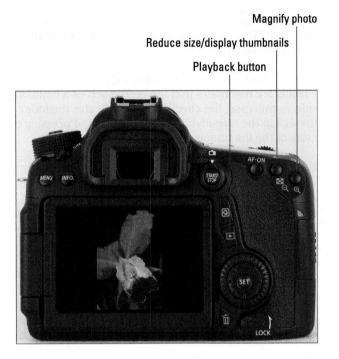

Figure 5-2: The default Playback mode displays one picture at a time.

Switching to Index (thumbnails) view

Instead of viewing one image at a time, you can display four or nine thumbnails on the screen, as shown in Figure 5-3. To switch from full-frame view to thumbnails view — called *Index view* in Canon parlance — you have two options. The simplest is to use the touchscreen: Pinch inward to shift from full-frame to four-thumbnail view; pinch inward again to display nine thumbnails.

Figure 5-3: You can view four or nine thumbnails at a time.

The other method is to press the AE Lock button — labeled *Reduce size/display thumbnails* in Figure 5-2. Your first press displays four thumbnails; press again to display nine thumbnails.

Note the little blue checkerboard and magnifying glass icons under the button. Blue labels are reminders that the button serves a function in Playback mode. In this case, the checkerboard indicates the Index function, and the minus sign in the magnifying glass tells you that pressing the button reduces the size of the thumbnail.

Remember these other factoids about Index display mode:

Select a thumbnail. For some playback operations, you start by selecting a thumbnail. A highlight box surrounds the currently selected thumbnail; for example, in Figure 5-3, the upper-left photo is selected.

To select a different file, tap its thumbnail, rotate the Quick Control dial, or press the Multi-controller up, down, right, or left.

- Scroll from one screen of thumbnails to another. Swipe your finger up or down the screen or rotate the Main dial.
- Reduce the number of thumbnails. For touchscreen operation, pinch outward to reduce the number of thumbnails and return to full-frame view.

If you're in a button-pressing mood, press the AF Point Selection button, labeled *Magnify photo* in Figure 5-2. This button also has a blue magnifying glass icon, this time with a plus sign in the center to indicate that pressing it enlarges the thumbnail. Press once to switch from nine thumbnails to four; press again to switch from four thumbnails to single-image view.

For a quicker way to shift from Index view to full-frame view, select a photo and then press Set or tap the thumbnail.

Using the Quick Control screen during playback

During playback, you can access a handful of functions via the Quick Control screen. Here's how it works:

1. Press the Quick Control button.

If you were viewing pictures in Index mode, the camera shifts temporarily to full-frame playback. Then various icons appear on the left and right sides of the screen, as shown in Figure 5-4.

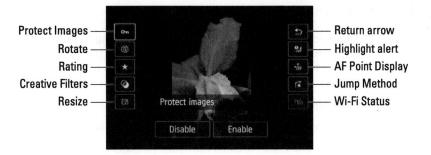

Figure 5-4: During playback, you can control these features via the Quick Control screen.

2. Select one of the playback function icons.

Either tap the icon or press the Multi-controller up or down to select it. The selected icon is surrounded by the orange box; for example, in the figure, the Protect Images feature is active.

The name of the selected feature appears at the bottom of the screen, along with symbols that represent the available settings for that option. For example, in Figure 5-4, you see the two options available for the Protect Images feature (Disable and Enable).

You can read more about rotating, rating, protecting, and jumping through images in other sections of this chapter. And the section "Enabling a few display extras" details the Highlight Alert and AF Point Display features. See Chapter 10 for a look at the Creative Filters, and visit Chapter 6 for information about the Resize and Wi-Fi features.

3. Select the setting you want to use.

Either tap the option or rotate the Main dial or Quick Control dial to select it. You also can press the Multi-controller left or right.

4. To exit the Quick Control screen, tap the return arrow (labeled in Figure 5-4) or press the Quick Control button again.

Jumping through images

If your memory card contains scads of files, here's a trick you'll love: By using the Jump feature, you can rotate the Main dial to leapfrog through them rather than scrolling through them one by one to get to the file you want to see. You also can search for the first photo, movie, or video snapshot taken on a specific date, tell the camera to display only movies and video snapshots or only stills, or display images with a specific rating or stored in a certain folder.

You can choose from the following jumping options:

- ✓ 1 Image: This option, in effect, disables jumping, restricting you to browsing pictures one at a time. So what's the point? You can use this setting to scroll pictures using the Main dial in addition to using the touchscreen, Multi-controller, or Quick Control dial.
- ✓ 10 Images: Select this option to advance 10 images at a time.
- ✓ 100 Images: Select this option to advance 100 images at a time.
- ✓ Date: If your card contains files shot on different dates, you can jump between dates with this option. For example, if you're looking at the first of 30 pictures taken on June 1, you can jump past all others from that day to the first file created on, say, June 5.
- ✓ **Folder:** If your memory card contains multiple folders as it might if you create custom folders as outlined in Chapter 11 this option jumps you from the current folder to the first photo in a different folder.
- Movies: Does your memory card contain both still photos and movies? If you want to view only the movie files, select this option. Then you can rotate the Main dial to jump from one movie to the next without seeing any still photos. (Video snapshots are considered movies, so they're included in the playback lineup as well.)
- ✓ **Stills:** This one is the opposite of the Movies option: Your movies and video snapshots are hidden when you jump through files.
- Image Rating: This Jump mode relates to the Rating feature covered later in this chapter. You can choose to view all rated photos, movies, or video snapshots; only those with a specific rating; or those without any rating at all.

Use these methods to specify which type of jumping you want to do:

✓ **Quick Control screen:** After displaying the Quick Control screen, select the Jump mode option, as shown on the left in Figure 5-5. You see a row of icons across the bottom of the screen, each one representing a different jump method. (I labeled the more cryptic icons in the figure.) Tap the method you want to use or use the Main dial, Quick Control dial, or Multi-controller to highlight its icon.

If you select the Rating mode, as I did in Figure 5-5, tap the Info icon or press the Info button to display the second screen in the figure. Then select the rating option that applies to the files you want to view when jumping. You can choose files that have no rating; files that have any rating; or select a certain rating (one star, five stars, and so on). Tap the return arrow or press the Menu button to exit the rating selection screen and return to the screen on the left in the figure.

To exit the Quick Control screen, tap the return arrow or press the Quick Control button again.

Figure 5-5: You can specify a Jump mode by using the Quick Control screen.

▶ Playback Menu 2: Choose the Image Jump option, highlighted on the left in Figure 5-6, to display the right screen in the figure, which presents the Jump settings. Tap your choice or highlight it by using the Quick Control dial or Multi-controller. If you choose the Rating option, as in the figure, rotate the Main dial to select the rating of the files you want to see. You also can tap the little arrows next to the selected rating symbol in the lower-left corner of the screen. After making your choice, tap Set or press the Set button.

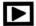

Press the Playback button to exit the menu and return to playback mode.

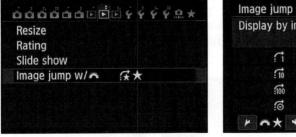

Figure 5-6: Or select the Jump method from Playback Menu 2.

After selecting a Jump mode, take the following steps to jump through your photos during playback:

1. Set the camera to display a single photo.

You can use jumping only when viewing a single photo at a time. To leave Index mode, just press the Set button or tap the selected thumbnail.

2. Rotate the Main dial or swipe two fingers across the screen.

The camera jumps to the next image, movie, or video snapshot according to the jump method you selected.

If you select any Jump setting except 1 Image, a jump bar appears for a few seconds at the bottom of the monitor, as shown in Figure 5-7, indicating the current Jump setting.

3. To exit Jump mode, just start scrolling through pictures using the Quick Control dial, Multicontroller, or touchscreen.

Now you're back to regular Playback mode.

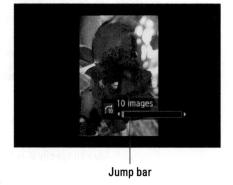

Figure 5-7: Rotate the Main dial to start jumping through pictures.

Rotating pictures

When you take a picture, the camera can record the image *orientation*: that is, whether you held the camera horizontally or on its side to shoot vertically. This bit of data is added into the picture file. Then when you view the picture, the camera reads the data and rotates the image so that it appears upright in the monitor, as shown on the left in Figure 5-8, instead of on its side, as shown on the right. The image is also rotated automatically when you view it in the Canon photo software that shipped with your camera (as well as in other programs that can read the rotation data).

Figure 5-8: Display a vertically oriented picture upright (left) or sideways (right).

Official photo lingo uses the term *portrait orientation* to refer to vertically oriented pictures and *landscape orientation* to refer to horizontally oriented pictures. The terms stem from the traditional way that people and places are captured in painting and photographs — portraits, vertically; landscapes, horizontally.

By default, the camera tags the photo with the orientation data and rotates the image automatically both on the camera and on your computer screen. But you have other choices, as follows:

- ✓ **Disable or adjust automatic rotation:** Select Auto Rotate on Setup Menu 1, as shown in Figure 5-9. Then choose from these options, listed in the order they appear on the menu:
 - On, camera and computer: This option is the default.
 - On, computer only: Pictures are tagged with orientation data but rotated only on your computer monitor.

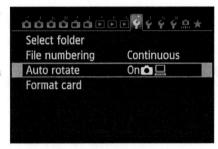

Figure 5-9: Go to Setup Menu 1 to disable or adjust automatic image rotation.

 Off: New pictures aren't tagged with the orientation data, and existing photos aren't rotated during playback on the camera, even if they are tagged.

Rotate pictures during playback: If you stick with the default Auto Rotate setting, you can rotate pictures during playback via the Quick Control screen. Tap the Rotate icon (labeled in Figure 5-10), and then tap one of the three orientation icons at the bottom of the screen. You also can press the Multi-controller up/down to select the Rotate icon and press right/left or rotate the Main dial or Quick Control dial to select the orientation icons. Either way, the display updates as you select an orientation icon. Tap the return arrow (upper right of the screen) or press the Quick Control button a second time to exit the Quick Control screen.

If the Auto Rotate menu option is set to Off or computer-rotation only, the Quick Control technique only adds the rotation data to the image file — your picture doesn't rotate on the camera monitor. However, you can still rotate pictures for on-camera display via the Rotate option on Playback Menu 1.

Choose the menu option to display your photos. In Index display mode, select the image that needs rotating. In full-frame display, just scroll to the photo. Either way, press Set or tap the Set icon once to rotate the image 90 degrees; press or tap again to rotate 180 degrees from the first press (270 total degrees); press or tap once more to return to 0 degrees, or back where you started. Press the Playback button to return to viewing pictures. The photo remains in its rotated orientation only if the Auto Rotate option is set to the default.

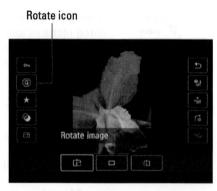

Figure 5-10: The fastest way to rotate individual images is to use the Quick Control screen.

These steps apply only to still photos; you can't rotate movies or video snapshots.

Zooming in for a closer view

During playback, you can magnify a photo to inspect small details, as shown in Figure 5-11. As with image rotating, zooming works only for still photos and only when you're displaying photos one at a time, though. So if you're viewing pictures in Index display mode, press Set or tap the thumbnail to return to full-frame view.

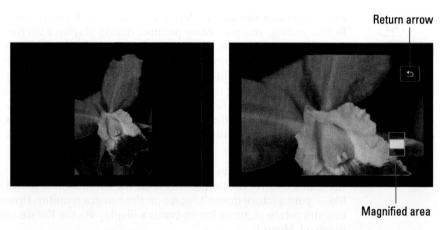

Figure 5-11: After displaying your photo in full-frame view (left), you can magnify the image for a closer view (right).

When the image is magnified, a little thumbnail representing the entire image appears in the lower right of the monitor, as shown in the right image in Figure 5-11. The white box indicates the area of the image that's visible.

To take advantage of this feature, use either of these approaches:

✓ Touchscreen zooming: Using your thumb and forefinger, pinch outward from the center of the screen to magnify the display; pinch inward to zoom out. To scroll the magnified display, just drag your finger in the direction you want to scroll. To exit to full-image view, tap the Return arrow (labeled on the right in Figure 5-11).

- **✓ Button zooming:** Use these navigation techniques to operate the display via buttons instead of the touchscreen:
 - Zoom in. Press and hold the AF Point Selection button (refer to Figure 5-2) until you reach the magnification you want. (Again, note the blue magnifying glass label under the button — the plus sign reminds you that you use the button to magnify the view.)
 - *View another part of the picture.* Use the Multi-controller to scroll the display to see another portion of the image.
 - Zoom out. To zoom out to a reduced magnification, press the AE Lock button. (Note that the magnifying glass label contains a minus sign, for zoom out.) Continue holding down the button until you reach the magnification you want.
 - Return to full-frame view when zoomed in. When you're ready to exit the magnified view, you don't need to keep pressing the AE Lock button until you zoom out all the way. Instead, press the Playback button, which quickly returns you to full-frame view.

Here's an especially neat trick you can use no matter which zoom approach you prefer: While the display is zoomed, you can rotate the Quick Control dial to display the same area of the next photo at the same magnification. For example, if you shot a group portrait several times, you can easily check each one for shut-eye problems.

Viewing Picture Data

When you review still photos, you can press the Info button to change the type of shooting data that appears with the photo. Choose from the following display styles, shown in Figure 5-12:

Basic Information

Shooting Information

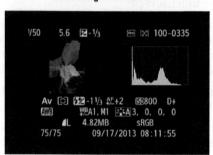

Histogram

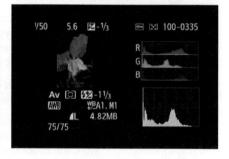

Figure 5-12: Press the Info button to change the amount of picture data displayed with your photo.

- No Information: True to its name, this display option shows just your picture, with no shooting or file data. The exception to the rule: If you visit Playback Menu 3 and enable the Highlight Alert, AF Point Display, or Playback Grid options, the data associated with those features appears even in No Information mode. See "Enabling a few display extras," found a ways down the road from here, for details.
- Basic Information: What's this? Two settings with clear-cut names? Holy cannoli, pretty soon you won't need me at all. Well, at least check out the next section, which explains the basic data that appears in this display mode.
- ✓ **Shooting Information:** This mode gives you a slew of tiny symbols and numbers, all representing various shooting settings, plus a histogram (the graph in the upper right of the screen). If you need help deciphering all the data, it's presented two sections from here.
- Histogram: This mode gives you a Brightness histogram plus an RGB histogram. Head to "Understanding Histogram display mode," later in this chapter, to find out what wisdom you can glean from these little graphs.

A couple of notes before you start exploring each display mode:

- When you view horizontally oriented images on your camera monitor, some data is actually overlaid on the image instead of appearing above or to the side the photo, as it does in the figures in this book. The difference is due to the process used to capture the camera screens for publication. Don't worry about it — the data itself is the same; only the positioning varies.
- ✓ If you shot your picture using Scene Intelligent Auto, Flash Off, Creative Auto, or a Scene mode, you see less data in Shooting Information and Histogram display modes than appears in Figure 5-12. You get the full complement of data only if you took the picture in the advanced exposure modes.
- ✓ You can access the various display modes for movies and video snapshots, but the data displayed will relate to the movie or snapshot. Also, the histograms relate to the first frame of the movie or snapshot and go blank as soon as you start movie playback. You can't change the display mode while the movie or snapshot is playing.

Basic Information display data

In Basic Information mode, you see the following bits of information (labeled in Figure 5-13):

✓ Shutter speed, f-stop (aperture), and Exposure Compensation setting: Chapter 7 explains these exposure settings, the last of which appears in the display only if you enabled it when you took the shot.

For movies and video snapshots, the movie length takes the place of the shutter speed and f-stop values.

- Protected status: A key icon appears if you used the Protect Images feature to prevent the file from being erased when you use the normal file-deleting feature. You can find out how to protect files later in this chapter.
- **Rating:** If you rated the file, you can see how many stars you assigned it. See the section "Rating Photos," for details.

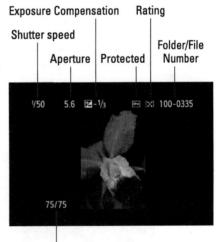

Figure 5-13: You can view basic exposure and file data in this display mode.

Frame number/total frames

- ✓ Folder number and last four digits of file number: See Chapter 1 for information about how the camera assigns folder and file numbers. And visit Chapter 11 for details on how you can create custom folders if you're into that sort of organizational control.
- ✓ Frame number/total frames: Displayed in the bottom-left corner of the screen, this pair of values shows you the current frame number and the total number of frames on the memory card. For example, in Figure 5-13, you see frame 75 of 75.

Shooting Information display mode

Shooting Information display mode presents a thumbnail of your image along with scads of shooting data. You also see a *Brightness histogram* — the chartlike thingy on the top right of the screen. You can get schooled in the art of reading histograms in the next section. (Remember, just press the Info button to cycle through the other display modes to this one.)

How much data you see, though, depends on the exposure mode you used to take the picture, as illustrated in Figure 5-14. The screen on the left shows the data dump that occurs when you shoot in the advanced exposure modes, where you can control all the settings indicated on the playback screen. When you shoot in the other exposure modes, you get a far-less detailed playback screen. For example, the screen on the right in Figure 5-14 shows the data that appears for a picture taken in Close-up mode. Here, you can view the Shoot by Ambience and Shoot by Lighting and Scene Type settings you used, but not all the individual exposure and color settings that appear for pictures shot in the advanced exposure modes.

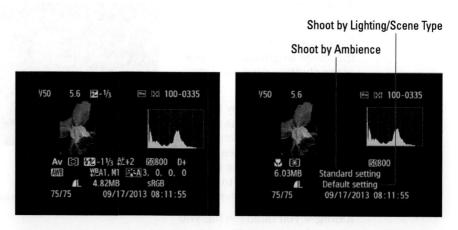

Figure 5-14: How much data appears depends on which exposure mode you used to shoot the picture.

I'm going to go out on a limb here and assume that if you're interested in the Shooting Information display mode, you're shooting in the advanced exposure modes, so the rest of this section concentrates on that level of playback data. To that end, it helps to break the display into five rows of information: the row along the top of the screen and the four rows that appear under the image thumbnail and histogram. The following list tells you what you see in each row. (Note that in Figures 5-15 through 5-17, I show all possible shooting data for the purpose of illustration. If a data item doesn't appear on your monitor, it simply means that the feature wasn't enabled when you captured the photo.)

- Row 1 data: You see the same data that appears in the Basic Information display mode, explained in the preceding section.
- ✓ Row 2 data: For photos, this row contains the exposure settings labeled in Figure 5-15, along with the status of a Custom Function feature called AF (autofocus) Microadjustment. You can find details about exposure in Chapter 7 and dig into the autofocus option in Chapter 8.

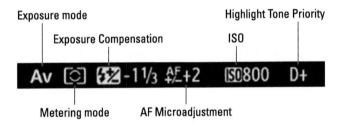

Figure 5-15: This row contains additional exposure information.

A few other points about this row of data:

- The Exposure mode symbol is replaced by a double-rectangle symbol if you took the picture using the Multiple Exposure option (covered in Chapter 7). For still photos taken during movie recording, a little movie camera icon takes the place of the Exposure mode symbol.
- If you turned on Multi Shot Noise Reduction when taking the photo, you see an NR symbol in place of the Flash Exposure Compensation symbol. And if you used flash but without any Flash Exposure Compensation, you see just the lightning bolt symbol.
- For movies, you see a little movie camera symbol plus the letter A (for movies taken in the fully automatic modes) or M (for movies shot in Manual exposure mode). Seeing no letter means that you used the P, Tv, or Av exposure mode. In Manual mode, you also see the f-stop and shutter speed used to record the movie.

Row 3 data: Figure 5-16 labels the data found in this row, which features color settings you can explore in Chapter 8. Again, the display differs for movies: You see only the movie file size on this row.

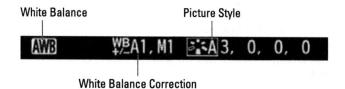

Figure 5-16: This data relates to color settings.

Row 4 data: Here (the top row of Figure 5-17) you see the Image Quality setting, file size, and Color Space (another color option covered in Chapter 8). Note that for pictures taken in both the Raw and JPEG formats, the file size reflects the heft of the Raw file only. For movies, the Image Quality symbol is swapped out for data showing the Movie Recording Size option.

If you shot with or applied a Creative Filter to the file, resized the file, or processed it using the built-in Raw processing function, you see a symbol that looks like a paint brush over a photo next to the Image Quality symbol.

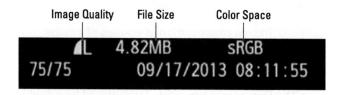

Figure 5-17: The bottom two rows of the display offer this data.

✓ Row 5 data: Wrapping up the smorgasbord of shooting data, the bottom row of the playback screen (also shown in Figure 5-17) shows the frame number and total number of frames as well as the date and time of the shot. If you use Eye-Fi memory cards, you also see a small icon depicting the card's wireless connection status.

Understanding Histogram display mode

A variation of the Shooting Information display, the Histogram display offers the data you see in Figure 5-18. Again, you see an image thumbnail, but some of the detailed color and exposure information that you see in the Shooting Information display is left out, making room for an additional histogram: the RGB histogram. Again, remember that this figure shows you the playback screen for pictures taken in the advanced exposure modes; in the other exposure modes, you see slightly different data, but you still get two histograms. For movies and video snapshots, the histograms relate to the first frame of the movie and go blank after playback begins.

The next two sections explain what information you can gain from both types of histograms.

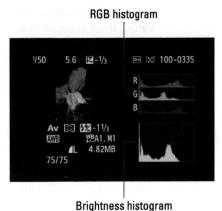

Figure 5-18: Histogram display mode replaces some shooting data with an RGB histogram.

Interpreting a Brightness histogram

One of the most difficult photo problems to correct in a photo-editing program is known as "blown" or "clipped" highlights. In plain English, both terms

mean that highlights — the brightest areas of the image — are so overexposed that areas that should include a variety of light shades are instead totally white. For example, in a cloud image, pixels that should be light to very light gray become white because of overexposure, resulting in a loss of detail in those clouds.

You can of course get an idea of exposure by viewing the photo on the monitor, but because the image brightness may vary depending on the ambient light and the monitor brightness, you're provided with a more accurate analysis of exposure. The Brightness histogram shown in Figure 5-19 is

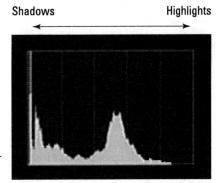

Figure 5-19: The Brightness histogram indicates the tonal range of an image.

simply a graph that indicates the distribution of shadows, highlights, and *midtones* (areas of medium brightness) in an image. Photographers use the term "tonal range" to describe this aspect of their pictures.

The horizontal axis of the graph represents the possible picture brightness values from black (a value of 0) to white (a value of 255). And the vertical axis shows you how many pixels fall at a particular brightness value. A spike indicates a heavy concentration of pixels. For example, in Figure 5-19, which shows the histogram for the orchid image in Figure 5-18, the histogram indicates a broad range of brightness values but with very few at the brightest end of the spectrum.

Keep in mind that there is no "perfect" histogram that you should try to duplicate. Instead, interpret the histogram with respect to the amount of shadows, highlights, and midtones that make up your subject. For example, don't expect to see lots of shadow pixels in a photo of a white polar bear standing amid a snowy landscape. Pay attention, however, if you see a very high concentration of pixels at the far right or left end of the histogram, which can indicate a seriously overexposed or underexposed image, respectively.

In Figure 5-19, the lack of white pixels may seem odd for the orchid photo — after all, the center of the flower does contain some white areas. (Refer to the close-up view shown in Figure 5-11.) When I shot this photo, I purposely underexposed the image just a hair to avoid the possibility of blowing out those highlights. So, the histogram offered reassurance that I didn't overshoot the exposure, which can be difficult to determine from just looking at the image itself.

Your camera offers a second overexposure warning system, called Highlight Alert, which is disabled by default. You can read more about it two sections from here.

Reading an RGB histogram

In Histogram display mode, you see two histograms: the Brightness histogram (refer to Figure 5-19) and an RGB histogram, shown in Figure 5-20.

To make sense of an RGB histogram, you need to know that digital images are known as *RGB images* because they're created from three primary colors of light: red, green, and blue. The brightness values of each of the three colors are stored in separate data vats called *channels*. Whereas the Brightness histogram reflects the brightness of all three color channels rolled into one, RGB histograms let you view the values for each channel.

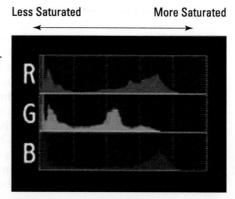

Figure 5-20: The RGB histogram can indicate problems with color saturation.

When you look at the brightness data for a single channel, though, you glean information about *color saturation* rather than image brightness. I don't have space in this book to provide a full lesson in RGB color theory, but the short story is that when you mix red, green, and blue light, and each component is at maximum brightness, you create white. Zero brightness in all three channels creates black. If you have maximum red and no blue or green, though, you have fully saturated red. If you mix two channels at maximum brightness, you also create full saturation. For example, maximum red and blue produce fully saturated magenta.

Where colors are fully saturated, you can lose picture detail. For example, a rose petal that should have a range of tones from medium to dark red may instead be a flat blob of dark red. So the upshot is that if all the pixels for one or two channels are slammed to the right end of the histogram, you may be losing picture detail because of overly saturated colors. If all three channels show a heavy pixel population at the right end of the histogram, you may have blown highlights — again, because the maximum levels of red, green, and blue create white. Either way, you may want to adjust the exposure settings and try again.

A savvy RGB histogram reader can also spot color balance issues by looking at the pixel values. But frankly, color balance problems are fairly easy to notice just by looking at the image on the camera monitor.

If you're a fan of RGB histograms, however, you may be interested in another possibility: You can swap the standard Brightness histogram that appears in Shooting Information display mode with the RGB histogram. Just set the Histogram Disp option on Playback Menu 3 to RGB instead of Brightness.

Enabling a few display extras

Playback Menu 3, shown in Figure 5-21, enables you to add the following features to picture playback in any display mode, including the No Information mode:

Highlight Alert: If you enable this option, areas of the photo that are completely white blink on and off to alert you of possible blown highlights. Depending on the number and location of the "blinkies," you may or may not want to

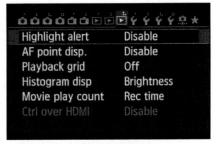

Figure 5-21: You can enable a few additional playback display options via Playback Menu 3.

adjust exposure settings and retake the photo. For example, if someone's face contains the blinking spots, you should take steps to correct the problem. But if the blinking occurs in, say, a bright window behind the subject, and the subject looks fine, you may choose to simply ignore it.

- ✓ AF Point Display: Turn this option on to view the focus point or points that the camera used when setting the focusing distance, as shown in Figure 5-22. Focus points appear as red rectangles on the screen.
- Playback Grid: Through this option, you can display one of three different grids over your photo. The grids are useful for checking the alignment of vertical and horizontal structures in the photo.

You also can toggle the Highlight Alert and AF Point Display on and off via the Quick Control screen, as shown in Figure 5-23. Just tap the icons labeled in the figure.

When you spot a clunker during your picture review, you can erase it in a few ways, as outlined in the next three sections.

Erasing single images

To delete photos one at a time, display the photo (in single image view) or select it (in Index view). Then press the Erase button. The words *Cancel* and *Erase* appear at the bottom of the screen, as shown in Figure 5-24. To zap that photo into digital oblivion, either tap Erase or use the Multicontroller or Quick Control dial to highlight it and then press the Set button.

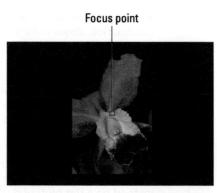

Figure 5-22: Enable AF Point Display to see the focus point the autofocusing system used to establish focus.

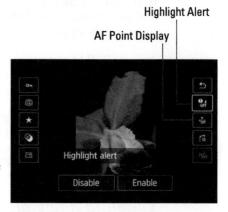

Figure 5-23: You can quickly toggle these two options on and off via the Quick Control screen.

Figure 5-24: Press the Erase button and then tap Erase to delete the current image.

Erasing all images on the memory card

To erase all images on the memory card — with the exception of those you locked by using the Protect Images feature discussed later in this chapter — take the following steps:

1. Display Playback Menu 1, shown on the left in Figure 5-25.

Figure 5-25: Use the Erase option on Playback Menu 1 to delete multiple images quickly.

- 2. Choose Erase Images to display the screen shown on the right in Figure 5-25.
- 3. Choose All Images on Card.

You then see a confirmation screen.

4. Choose OK to go ahead and dump the photos.

If your card contains multiple folders, you can limit the cardwide image dump to just the images in a specific folder. Take these same steps but choose All Images in Folder in Step 3. You then display a list of folders; choose the folder you want to empty and then tap Set or press the Set button. (See Chapter 11 to find out how to create folders in addition to the ones the camera creates by default.)

Erasing selected images

To erase more than a few but not all images on your memory card, save time and trouble by using this alternative to deleting photos one by one:

1. On Playback Menu 1, choose Erase Images.

You see the main Erase Images screen.

2. Choose Select and Erase Images, as shown in Figure 5-26.

You see the current image in the monitor. At the top of the screen, a little check box appears, as shown on the left in Figure 5-27. (The box is empty until you take the next step.)

3. Tag the image for deletion.

Tap the check box, press the Set button, or tap the Set icon to put a check mark in the box, thereby declaring it ready for the trash. If

Figure 5-26: You can delete multiple selected images at once.

a check mark in the box, thereby declaring it ready for the trash. If you change your mind, tap the box or the icon or press the Set button again to remove the check mark.

Selected for erasure

Figure 5-27: Tap the check box or press the Set button to tag images you want to delete.

- 4. Scroll to the next image.
- Keep repeating Steps 3 and 4 until you mark all images you want to trash.

If you don't need to inspect each image closely, you can display up to three thumbnails per screen. (Refer to the image on the right in Figure 5-27.) Just press the AE Lock button (or pinch the image) to shift into this display. Use the same methods to tag images for erasure and to scroll through photos as you do when viewing them one at a time.

To return to full-frame view, press the AF Point Selection button or pinch outward on the thumbnail.

6. After tagging all the photos you want to delete, press the Erase button or tap the OK icon.

You see a confirmation screen asking whether you really want to get rid of the selected images.

7. Tap OK or highlight it and press Set.

The selected images are deleted, and you return to the Erase Images menu.

8. Tap the Menu icon or press the Menu button to return to Playback Menu 1.

Or, to continue shooting, press the shutter button halfway and release it.

Protecting Photos

You can protect pictures from accidental erasure by giving them protected status. After you take this step, the camera doesn't allow you to delete the picture from your memory card, regardless of whether you press the Erase button or use the Erase Images option on Playback Menu 1.

I also use the protection feature when I want to keep a handful of pictures on the card but delete the rest. Instead of using the Select and Erase Images option, which requires that you tag each photo you want to delete, I protect the handful I want to preserve. Then I use the Erase All Images option to dump the rest — the protected photos are left intact.

Although the Erase functions don't touch protected pictures, formatting your memory card *does* erase them. For more about formatting, see the Chapter 1 section related to Setup Menu 1, which contains the Format Card tool.

Also note that when you download protected files to your computer, they show up as read-only files, meaning that the photo can't be altered. So if you want to be able to edit your photos, be sure to remove the protected status before downloading.

Anyway, protecting a picture on the camera is easy. You can use either of the techniques outlined in the next two sections.

Protecting (or unprotecting) a single photo

To apply protection to just one or two photos, the Quick Control screen offers the fastest option. Display the photo you want to protect in full-frame view. Or in Index view, select the photo by moving the highlight box over it. Then press the Quick Control button and tap or highlight the Protect Images

symbol, labeled in Figure 5-28. Choose Enable at the bottom of the screen, and a little key symbol appears at the top of the frame, as shown in the figure. Tap the return arrow (upper right of the screen) or press the Quick Control button again to exit the Quick Control display.

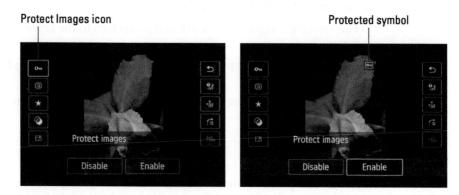

Figure 5-28: You can use the Quick Control screen to protect the current photo.

If you later want to remove the protected status, follow the same steps but choose Disable on the Quick Control screen.

Protecting multiple photos

When you want to apply protected status to — or remove it from — more than a couple photos, going through Playback Menu 1 is faster than using the Quick Control screen. Take these steps:

1. Display Playback Menu 1 and choose Protect Images, as shown on the left in Figure 5-29.

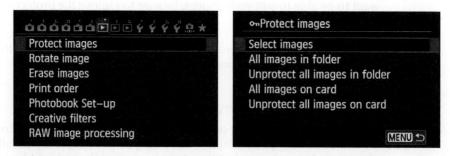

Figure 5-29: This option prevents you from erasing pictures using the normal picture-deletion techniques.

You then see the options shown on the right in the figure:

- Select Images: Choose the photos you want to protect.
- All Images in Folder: Protects all the photos in a folder. Unless
 your memory card contains multiple folders, this option protects
 all your pictures. If you do have multiple folders, you can select a
 folder in the next step.
- *Unprotect All Images in Folder:* This does the opposite, in case you protected those images and no longer need them locked down.
- All Images on Card: A handy option to protect all photos on the card.
- Unprotect All Images on Card: Removes protected status from all pictures on the card.

2. Choose an option from the list.

What happens now depends on which option you chose:

• Select Images: An image appears on the monitor, along with a little key icon in the upper left of the screen, as shown on the left in Figure 5-30. Scroll to the first picture you want to protect and then tap the Set icon or press the Set button. Now a key icon appears with the data at the top of the screen, as shown in the image on the right side of the figure. After you finish protecting photos, press the Menu button or tap the Menu icon to exit the protection screens.

You can also pinch the display to show more (4 or 9) photos, then touch the photo to protect it. Don't forget to tap Set or press the Set button to lock your choices in.

- All Images in Folder or Unprotect All Images in Folder: You see a screen
 where you can select a specific folder. Select that folder, tap Set or
 press the Set button, and then tap OK or press the Set button again.
- All Images on Card or Unprotect All Images on Card: Choose OK on the confirmation screen.

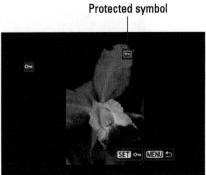

Figure 5-30: The key icon indicates that the picture is protected.

To remove protection from individual pictures, follow these same steps, choosing Select Images in Step 2. When you display the locked picture, just press or tap Set to turn off the protection. The little key icon disappears from the top of the screen to let you know that the picture is no longer protected.

Rating Photos

Many image browsers provide a tool that you can use to assign a rating to a picture: five stars for your best shots, one star for those you wish you could reshoot, and so on. But you don't have to wait until you make it to your computer, because your camera offers the same feature. If you later view your pictures in the Canon image software, as detailed in the next chapter, you can see the ratings you assigned and even sort pictures according to rating.

You assign a rating to a photo either via the Quick Control screen or Playback Menu 2. For rating just a photo or two, either works fine, but for rating a batch of photos, using the menu is fastest. Here's how the two options work:

✓ **Quick Control screen:** Display your photo in full-screen view and then press the Quick Control button and choose the Rating icon, as shown on the left in Figure 5-31. Along the bottom of the screen (right side of the figure), tap or highlight the icon representing the number of stars you want to give the photo and then tap the return arrow or press the Quick Control button to return to the normal playback screen. You must exit the Quick Control screen before rating a second photo — there's no way to advance to another image while the Quick Control screen is active. To remove a rating, choose the Off option.

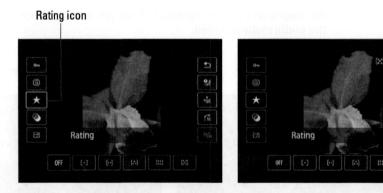

Figure 5-31: You can rate photos via the Quick Control screen.

Playback Menu 2: Choose the Rating option, as shown in Figure 5-32, to access the screen shown on the left in Figure 5-33. Above the image, you get a control box for setting the rating of the current picture — just press the Multi-controller up or down to give the photo anything from one to five stars. You also can tap the up/down arrows at the bottom of the thumbnail to set the rating level.

Figure 5-32: Rating photos is a great organizational tool.

The values next to the control box indicate how many other photos on the card have been assigned each of the ratings. For example, in the figure, the numbers tell me that my card contains one 2-star photo, one 4-star photo, and two 5-star photos.

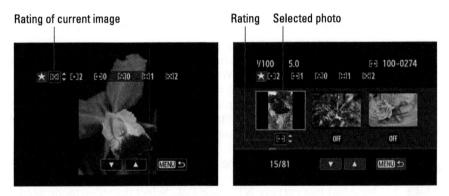

Figure 5-33: Tap the up or down arrows to adjust the photo rating.

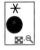

You can press the AE Lock button or pinch the thumbnail inward to display three thumbnails at a time, as shown on the right in Figure 5-33. Use the Quick Control dial or Multi-controller to highlight a thumbnail — or just give the thumbnail a tap to select it. Its rating appears in the box right below the thumbnail. A value of Off means you haven't rated the photo yet. You can raise or lower the rating by pressing the Multi-controller up or down or by tapping the arrows at the bottom of the screen.

To go back to the one-image display, press the AF Point Selection button or pinch a thumbnail outward.

After rating your photos, press the Menu button or tap the Menu icon to return to the Playback Menu 2.

Viewing Your Photos on a Television

Your camera is equipped with a feature that allows you to play your pictures and movies on a television screen. In fact, you have three playback options:

- Regular video playback: Haven't made the leap yet to HDTV? No worries: You can set the camera to send a regular standard-definition audio and video signal to the TV. You'll need to purchase the Canon AVC-DC400ST cable to do so.
- HDTV playback: If you have a high-definition television, you can set the camera to high-def playback. However, you need to purchase an HDMI cable to connect the camera and television; the Canon part number you need is HDMI cable HTC-100. Do not use the HDMI port with anything other than the HDMI HTC-100 cable or a quality equivalent.
- For HDMI CEC TV sets: If your television is compatible with HDMI CEC, your camera enables you to use the TV's remote control to rule your playback operations. You can put the camera on the coffee table and sit back with your normal remote in hand to entertain family and friends with your genius. To make this operation work, you must enable the Ctrl Over HDMI option on Playback Menu 3. (The option is dimmed if you're not connected to a compatible TV.)

Before you begin connecting your camera to your TV, you may need to adjust one camera setting — Video System — which you find on Setup Menu 3. You have just two options: NTSC and PAL. Select the video mode used by your part of the world. (In the United States, Canada, and Mexico, NTSC is the standard.) The camera should have shipped from the factory with the right setting selected, but it never hurts to double-check.

With the right cable in hand and the camera turned off, open the little rubber door that covers the video-out ports — it's the door closest to the back of the camera — as shown in Figure 5-34. The camera has two *ports* (connection slots): one for a standard audio/video (A/V) signal and one for the HDMI signal. The A/V port is the same one you use to connect the camera via USB for picture download.

The smaller plug on the A/V cable attaches to the camera. For A/V playback, your cable has three plugs at the other end: Put the yellow one into your TV's video jack and the red and white ones into your TV's stereo audio jacks. For HDMI playback, a single plug goes to the TV.

At this point, I need to point you to your TV manual to find out exactly which of its jacks to use to connect your camera. You also need to consult your manual to find out which channel to select for playback of signals from auxiliary input devices.

After you sort out that issue, turn on your camera to send the signal to the TV set. If you don't have the latest and greatest HDMI CEC capability (or lost your remote), you can control playback using the same camera controls as you normally do to view pictures on your camera monitor.

Understand that as soon as you plug your camera into a TV, the camera monitor goes dark — which means touch-screen operations are no longer possible. So you must use the camera buttons (or remote control) to operate any playback functions.

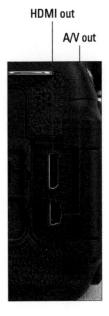

Figure 5-34: You can connect your camera to a television via the A/V port or HDMI port.

Downloading, Printing, and Sharing Your Photos

In This Chapter

- Looking at the Canon photo software
- > Transferring pictures to your computer
- Processing Raw (CR2) files
- Getting the best prints from your files
- ▶ Preparing pictures for online sharing

or many photographers, moving pictures from camera to computer — downloading — is one of the more confusing aspects of the art form. Unfortunately, providing you with detailed downloading instructions is impossible because the steps vary depending on which computer software you use to do the job.

To give you as much help as possible, however, this chapter shows you how to get things done using the Canon software provided with your camera. In addition, this chapter covers a few other after-the-shot tasks, including processing files that you shoot in the Raw (CR2) format, getting the best results when you print your photos, and preparing photos for online sharing. Be sure to also visit Chapter 10 for information about more sharing and printing options available via the camera's wireless connectivity features.

Installing the Canon Software

Canon provides you with several photo programs, which are found on the CD that ships with your camera and also are available for download from the Canon website (for the United States, www.usa.canon.com). Just head for the support pages for the 70D, where you'll find a link to camera software.

Two crucial bits of business about installing the software:

- ✓ **Installing without a CD/DVD drive:** If your computer doesn't have a CD/DVD drive, download the version of the software that's labeled specifically for users who can't install from the CD. Then dig out the USB cable that shipped with the camera. At some point during installation, you'll be prompted to attach your camera to the computer via the cable.
- Getting the latest versions: Depending on when you bought your camera, the CD may not have the most current versions of the programs. In fact, Canon posted some updates to some critical software components, including the one that facilitates wireless image transfer, shortly after the 70D was released. So if you install from the CD, check the website to make sure that you have the most current versions of the program. Look for the files labeled as updates to the existing software rather than downloading the whole initial software package. Again, you may be prompted to connect your camera to the computer during installation of the program.

For most programs, you can see the version number by choosing Helpr About on a Windows computer or by choosing About from the program's menu on a Mac. But for one program, Canon EOS Utility, Windows users need to click the Preferences button on the main screen, click OK to ignore the warning that appears, and then click the About button on the resulting screen.

To accomplish the downloading and file-processing tasks covered in this chapter, you need to install the following programs:

One especially neat feature of using this software is that you can view the camera *metadata*, which is invisible data stored in the camera file. The metadata includes the major camera settings you used to shoot the picture. To display and hide the metadata panel, click the arrow labeled in the figure. The data appears in the Shooting Info panel in the lower-right corner of the window.

Click to open Help menu

Click there to hide/display metadata

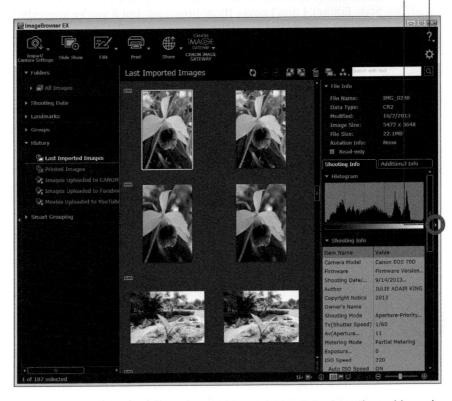

Figure 6-1: Canon ImageBrowser EX provides easy-to-use photo viewing and organizing tools.

- ✓ Canon Digital Photo Professional: Designed for more advanced users, this product offers a higher level of control over certain photo functions. But its most important difference from ImageBrowser EX is that it offers a tool to convert photos that you shoot in the Raw (CR2) format into a standard format (JPEG or TIFF). I show you how later in the chapter.
 - You also can view metadata in this program; click the Info button at the top of the program window to display the metadata in a separate window.
- Canon EOS Utility and WFT Pairing software: EOS Utility is required for downloading pictures to the camera and also for controlling the camera remotely from a computer. (See Chapter 10 for details on that intriguing idea.) The WFT Pairing tool is needed for connecting to the camera via Wi-Fi.

You also have the option of installing a program designed for sharing ideos on YouTube (Movie Uploader for YouTube), for joining images into a panorama (PhotoStitch), and for creating your own Picture Styles (Picture Style Editor). I don't cover these programs, but if you're interested in exploring them, one of the CDs in the camera box contains digital manuals for using them.

Sending Pictures to the Computer

Whatever photo software you choose, you can take the following approaches to downloading images to your computer:

- Connect the camera to the computer via a USB cable or through the built-in Wi-Fi system. The cable is supplied in the camera box. For wireless transfer, the computer must be connected to a wireless network.
- Use a memory card reader. With a card reader, you pop the memory card out of your camera and into the card reader instead of hooking the camera to the computer. Many computers and printers now have card readers, and you also can buy standalone readers for less than \$30.

For most people, I recommend using a card reader. Sending pictures directly from the camera, whether via cable or wirelessly, requires that the camera be turned on during the download process, wasting battery power. That said, I include information about both options in the next sections.

Connecting camera and computer via USB

Follow these steps to connect the camera to your computer with the USB cable:

1. Make sure the camera battery is fully charged.

Running out of battery power during the transfer process can cause problems, including lost picture data. If you have an AC adapter, use it to power the camera during picture transfers.

- 2. Turn your computer on.
- 3. Turn the camera off.
- Insert the smaller of the two plugs on the USB cable into the A/V Out/Digital port on the side of the camera.

This port is behind the door that's just around the corner from the left side of the monitor, as shown in Figure 6-2.

USB port

- 5. Plug the other end of the cable into a USB port on the computer.
- 6. Turn on the camera.

A computer icon appears on the camera monitor to let you know that it's in computer-transfer mode. To move forward with the download process using Canon EOS Utility, skip to the section "Downloading from the camera," later in the chapter.

Connecting to the computer via Wi-Fi

You can connect your camera to your computer via a wireless network. However, the computer must be attached to a local wireless network — as in, a wireless system set up in your house or office. You can't connect via a public hotspot that requires you to log in to a web page to access the network.

Because the steps you take to set up the camera for a wireless connection depend on your computer operating system (Windows or Mac) and your wireless network setup, I can provide only a general overview of the connection routine. For detailed information, read the electronic Wi-Fi manual provided on one of the camera CDs. I'll be tech guru.

With that disclaimer out of the way, here's how to start connecting without wires:

1. Visit Setup Menu 2 and set the Auto Power Off option to Disable.

Otherwise, the camera may inadvertently go to sleep, interrupting the wireless connection. (Don't forget to turn this option back to the default, 1 minute, or some other reasonable shut-off time after you complete your Wi-Fi excursion.)

2. Open Setup Menu 3 and set the Wi-Fi option to Enable, as shown in Figure 6-3.

The camera displays a message telling you that you can't shoot movies while Wi-Fi is enabled. The Wi-Fi Function option underneath the Wi-Fi option also becomes available.

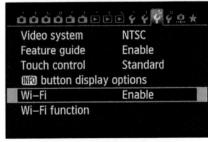

Figure 6-3: Enable Wi-Fi operations here.

3. Choose the Wi-Fi Function option.

The first time you choose the menu option, you're prompted to enter a nickname for the camera. Select OK to display the keyboard input screen shown in Figure 6-4. (If you've already taken this step, skip to Step 5.)

4. Enter a camera nickname.

Use these techniques:

- Enter a character. Tap a character to activate the keyboard and enter that character into the text box. Or press the Q button to activate the keyboard and then use the Main dial,
 - Quick Control dial, or Multi-controller to highlight a letter. Press Set to enter the letter in the text box. You can press the Q button to toggle between the text box and keyboard.

name.

- Access additional characters. Select the icon labeled in Figure 6-4 to cycle through four keyboards: One contains all caps; the second, lowercase letters; and the third and fourth, numbers and symbols.
- Delete a character. Move the cursor in front of the character by tapping the forward/backward arrows (labeled in the figure) or by using the Main dial, Quick Control dial, or Multi-controller. Then press the Erase button or tap the Erase icon.

 Wi–Fi function
 Remote control (EOS Utility)

After entering your nickname, press the Menu button or tap the Menu icon. You see a confirmation screen; select OK to move forward. Then the camera displays the Wi-Fi Function command center, shown in Figure 6-5.

Figure 6-4: The first time you use the Wi-Fi

system, you're asked to give the camera a

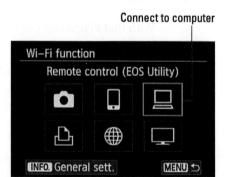

Figure 6-5: Select the Wi-Fi function you want to use from this screen.

5. Select the computer icon labeled in Figure 6-5.

You then see the screen shown in Figure 6-6 . . . aaaaaaaaaaand here's where I sort of have to bail on you. From this point forward, the options you choose depend on your wireless network setup. At some point, however, you may have to enter a security code for your network; use the same keyboard entry techniques I spelled out in Step 4.

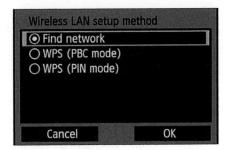

Figure 6-6: Follow the prompts to configure the camera to connect to your wireless network. (Have a tech guru handy.)

If all goes well, you should see the screen shown on the left in Figure 6-7 after you enter your network information. Select OK to display the screen shown on the right in the figure. As the screen demands, now is the time to start the so-called *pairing software*, which is the WFT Pairing Software that's installed at the same time you install the Canon EOS Utility tool. Look for the program in the same folder as the EOS Utility program and start it manually if it doesn't launch automatically. When the things are working the way they should, the computer detects the camera, and you see a box similar to the one shown in Figure 6-8 on your computer. (The figure shows the Windows 7 version.)

Figure 6-7: Choose OK (left) to display the prompt shown on the right.

After you click the Connect button, the camera displays a screen telling you that it found your computer and asks for your permission to go ahead with the connection, as shown on the left in Figure 6-9. Select OK to display the screen shown on the right in the figure; this screen enables you to save all the connection data so you don't have to enter it each time you want to connect to the computer.

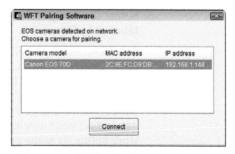

Figure 6-8: When the camera is detected by the pairing software, click the camera name and click Connect.

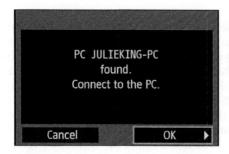

Figure 6-9: Follow the prompts on these screens to store the connection settings you just entered.

Your computer should then be connected to the camera, and you can now use the steps outlined in the next section to use Canon EOS Utility to download your photos. The screen shown in Figure 6-10 appears on the camera monitor; when you're ready to disconnect the camera from the computer, choose the Exit option.

Also disable the Wi-Fi feature after you finish downloading. When it's turned on, you can't record movies or connect the camera via cable to your

Figure 6-10: Choose Exit to sever the wireless connection.

computer or a TV. Some other menu options also become unavailable while Wi-Fi is turned on.

Downloading from the camera

After you connect your camera to the computer, fire up Canon EOS Utility, shown in Figure 6-11. This program window may pop up automatically after you connect your camera to the computer, or your operating software may offer a link to launch the tool. If not, locate the program and start it up yourself. Then take these steps:

Figure 6-11: Canon EOS Utility is the key to downloading pictures directly from your camera.

Click the Lets You Select and Download Images option.

You see a window that looks similar to the one in Figure 6-12, with thumbnails of the images on your memory card.

Figure 6-12: Select the thumbnails of the images you want to transfer.

2. Select the images you want to copy to the computer.

Each thumbnail contains a check box in its lower-left corner. To select an image for downloading, click the box to put a check mark in it.

3. Click the Download button.

A screen appears that tells you where the program wants to store your downloaded pictures, as shown in Figure 6-13.

Figure 6-13: You can specify where you want to store the photos.

4. Verify or change the storage location for your pictures.

To put the pictures in a location different from the one the program suggests, click the Destination Folder button and then select the storage location and folder name you prefer.

5. Click OK to begin the download.

A progress window appears, showing you the status of the download.

When the download is complete, you can disconnect the camera and computer. For wireless downloading, choose the Exit option shown on the screen in Figure 6-10. If you connected the camera via USB cable, turn off the camera and then unplug the cable. Either way, note that downloading pictures does not remove them from your memory card; you're simply transferring copies of the original files.

A couple of fine points here:

✓ Setting download preferences: While the camera is connected and turned on, click the Preferences button at the bottom of the EOS Utility browser (refer to Figure 6-12) to open the Preferences dialog box, where you can specify many aspects of the transfer process.

- Auto-launching the other Canon programs: After the download is complete, the EOS Utility may automatically launch Canon Digital Photo Professional or ImageBrowser EX. Visit the Linked Software panel of the EOS Utility's Preferences dialog box to specify which software you want to use or choose None to disable auto-launch altogether.
- Closing the EOS Utility: The browser window doesn't close automatically after the download is complete. You must return to it and click the Ouit button to shut it down.

Downloading from a card reader

Chapter 1 shows you how to safely remove your memory card from the camera for downloading. After you take that step and put your card into a card reader, the dialog box shown in Figure 6-14 may appear automatically. This window is the jump-off point for memory card transfers. If you don't see it after a few moments, you can access it by opening ImageBrowser EX, clicking the Import Camera Settings menu at the top of the screen (refer to Figure 6-1), and selecting Import Images from Memory Card. Note that depending on your operating system and the program preferences you install, the dialog box shown in Figure 6-14 may also have an option to print directly from the memory card (not shown in the figure).

Figure 6-14: Choose which memory card pictures get transferred to the computer.

After the window appears, take these steps:

1. Click the Lets You Select and Download Images option.

You see the browser window shown in Figure 6-15. (The figure shows the Windows version of the window; on a Mac, the controls you see at the top of the screen in the figure appear at the bottom of the window. Go figure.)

Figure 6-15: Select images to download from the browser window.

2. Select the images you want to download.

- To select the first photo: Click its thumbnail.
- To select additional pictures: Ctrl+click (Windows) or #+click (Mac) their thumbnails.
- To quickly select all images: Press Ctrl+A in Windows or #+A on a Mac.

3. Click the Image Download button.

A window opens to show you where the downloader wants to put your files and the name it plans to assign the storage folder, as shown in Figure 6-16.

Figure 6-16: Tell the software where to store photos via this dialog box.

If you're not happy with the program's choices, click the Change Settings button to open a dialog box where you can select a different storage location. In the same dialog box, you can also choose to have the files renamed when they're copied. Click OK to close the Change Settings dialog box.

4. Click the Starts Download button.

The software starts copying files from your memory card to your computer. When the download is finished, your pictures appear in ImageBrowser EX. You must close the downloader windows yourself; they don't automatically disappear.

Processing Raw (CR2) Files

Chapter 2 introduces you to the Raw format, which captures images as raw data. Although you can print Raw files immediately if you use the Canon software, you can't take them to a photo lab for printing, share them online, or edit them in your photo software until you process them using a raw converter tool.

You can do the job in two ways: Take advantage of the camera's built-in Raw processor or do the job after downloading, using a program that offers a Raw converter. Digital Photo Professional, the Canon software that shipped with your camera, has such a tool. The next two sections spell out each option.

Processing Raw images in the camera

For the quickest, most convenient Raw processing, take advantage of the Raw Image Processing feature on Playback Menu 1. However, understand one limitation: *You can save processed files only in the JPEG format.* As I discuss in Chapter 2, that format results in some quality loss because of the file compression that JPEG applies. You can determine the level of JPEG compression applied to the processed file when you work through the in-camera conversion steps, but if you want to produce the best quality from your Raw images, use a software solution and save your processed file in the TIFF format instead. TIFF doesn't apply the same type of file-degrading compression as JPEG.

That said, in-camera Raw processing is a great option for times when you need JPEG copies of your Raw images for immediate online sharing. (JPEG is the standard format for online use.) Follow these steps to convert a photo:

1. Set the Mode dial to an advanced exposure mode (P, Tv, Av, M, B, or C).

Otherwise the menu item in Step 3 won't be available.

2. Display Playback Menu 1 and then select RAW Image Processing, as shown in Figure 6-17.

The camera displays the first Raw photo on the memory card. (If the menu option is dimmed, check to see that the Wi-Fi option on Setup Menu 4 is disabled. When it's turned on, it interferes with this camera function.)

Figure 6-17: You can convert Raw files to JPEG files right in the camera.

3. Find the photo you want to convert.

If you're in single-image view, you see the image thumbnail plus the controls shown on the left in Figure 6-18. To select a different image, use the Multi-controller or Quick Control dial to scroll through your photos. In Index mode (multiple thumbnails displayed on the screen), select the photo by highlighting its thumbnail. See Chapter 5 for help navigating playback screens.

4. Press Set or tap the Set icon.

The Raw processing options appear, as shown on the right in Figure 6-18. To scroll through the options, use the Multi-controller. As you select each icon, the name of the adjustment appears at the top of the screen. For example, in Figure 6-18, the Brightness option is selected.

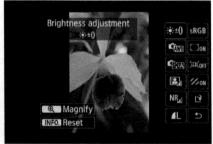

Figure 6-18: You can tinker with a variety of photo characteristics when you process the Raw file.

You have a number of options:

- Brightness: Adjust the overall image exposure.
- White Balance: Select the white balance, which accounts for the color temperature of the lighting in the scene to produce white whites. For more information on white balance, turn to Chapter 8.

- *Picture Style:* Select a picture style (Portrait, Landscape, Monochrome, and so on). See Chapter 8 for more information on Picture Styles.
- Auto Lighting Optimizer: Use this option to affect image contrast.
 Auto Lighting Optimizer is covered in Chapter 7.
- High ISO speed noise reduction: Applies noise reduction to high ISO photos according to the strength you select. Check out Chapter 7 for more information.
- *Image-recording quality:* Sets the JPEG quality (Fine or Normal) and pixel count for the converted photo. (Chapter 2 has details.) Use Fine for best picture quality. Choose a photo size that meets or exceeds the capabilities of your intended output medium.
- *Color space:* Apply the sRGB or Adobe RGB color profile to the processed file. Chapter 11 has more information on the two color spaces; until you digest that information, stick with sRGB.
- Peripheral illumination correction: If enabled, this setting brightens
 the corners of a photo to automatically correct vignetting. Chapter
 7 has an example of this image defect, which makes the corners of
 images appear darker than they should.
- Distortion correction: When enabled, this setting automatically fixes distortion caused by the lens. You don't typically need to enable this unless you're using a lens that causes noticeable bulging or pinching of the image. All lenses have some distortion, especially at wide-angle focal lengths (24mm and shorter). To see whether your lens creates distortion, take a photo of a brick wall or something with horizontal and vertical lines and compare the results of enabling and disabling this setting.
- Chromatic aberration correction: This feature works like the one available via the Lens Aberration Correction option on Shooting Menu 2. It attempts to correct color fringing, a defect that can occur with some lenses. See Chapter 8 for details.

5. Adjust the picture characteristics as you see fit.

You can go about this in two ways:

Use the Quick Control dial or Main dial to cycle through the available settings for each option. After highlighting a processing option, simply rotate the Quick Control dial or Main dial, and the setting will change.

Some options are very simple. For example, High ISO speed noise reduction is either enabled or disabled. Others, such as Picture Style, have more options — and you can tweak the results further if you want. For the more complicated settings, I recommend using the next method.

• Press Set or tap the option's icon: This opens the settings screen and displays all the possible options. For example, in Figure 6-19. you see the options for the Picture Style setting. In this case, you can choose an overall Picture Style and then press the Info button or tap the Info icon to modify the style. Press Set or tap the return arrow to lock in the changes and go back to the main screen.

While you're adjusting settings, remember these tricks:

return arrow or press the AE Lock button.

- To return to the original settings for all options, press the Info button or tap the Info icon on the main Raw processing screen (right screen, Figure 6-18).
- For a close-up look at the photo, tap the Magnify icon or press the AF Point Selection button. In the zoomed view, use the Multicontroller to scroll the display.

To return to the normal magnification, tap the

as here.

6. Select the Save option, as shown in Figure 6-20, to save the photo.

You see a confirmation screen; press OK to go forward. The screen that appears tells you the filename of the photo as well as the name of the folder where the photo is being saved.

7. Press OK to finish.

Figure 6-20: Choose this option to save the

Picture Style:Shot settings

INFO.

3,0,0,0

Save icon

Converting Raw images in Digital Photo Professional

processed file in the JPEG format. Processing Raw images in Digital Photo Professional gives you a number

of advantages over using the in-camera processor. First, you can save the file in a nondestructive file format, TIFF, which retains the maximum image quality. Second, you have access to a few controls not found on the camera, and, finally, you have the advantage of evaluating the photo on a big monitor instead of the camera's monitor.

After downloading photos to your computer, follow these steps to try it out:

- 1. Open Digital Photo Professional to view thumbnails of your images.
- 2. Click the thumbnail of the image you want to process and then choose View⇔Edit in Edit Image Window.

Your photo appears inside an editing window, as shown in Figure 6-21. The window's appearance varies depending on your program settings. If you don't see the Tool palette on the right side of the window, choose View

Tool Palette or click the Tool Palette icon to display it. (Other View menu options enable you to customize the window display.)

3. Choose Adjustment⇔Work Color Space.

By default, the program uses the color space selected when you shot the picture (sRGB or Adobe RGB). But you can select from a couple of other options if you prefer. The color space determines the spectrum of colors your image can contain; sRGB is the best option if you're not yet schooled in this subject, which I cover in Chapter 11.

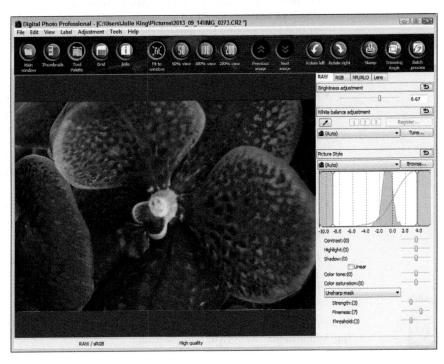

Figure 6-21: You can convert Raw images using Digital Photo Professional.

4. Adjust the image using controls in the Tool palette.

The Tool palette offers four tabs of controls for adjusting photos. You can find complete details in the program's Help system, but here are some tips for a couple critical options on these tabs:

RAW tab: On this tab, you find controls for tweaking exposure, white balance, color, and sharpness. For white balance, you can choose a specific setting or click the little eyedropper and then click an area of the image that should be white, black, or gray to remove any color cast. Using the Picture Style option, you can apply one of the camera's Picture Style options to the photo.

If you captured the picture in Live View and set the aspect ratio to anything other than 3:2, the thumbnail at the bottom of the RAW tab (not shown in the figure) shows a border over the image to indicate how the photo will be cropped to achieve that ratio. Remember, Raw images are captured using the 3:2 aspect ratio — and then the Raw processing function crops the original to the aspect ratio you chose. To change the aspect ratio or crop area, choose Tools Start Trimming/Angle Adjustment tool, which displays your picture in a separate editing window and provides options for setting the aspect ratio and cropping the image. (The program's Help system, available via the Help menu, has details.) You can use this same tool to crop an image captured in the 3:2 aspect ratio, by the way.

- RGB tab: From this tab, you adjust exposure further by using Tone Curve adjustment, a tool that may be familiar to you if you've done any advanced photo editing. You can make additional color and sharpness adjustments here as well, but make those changes using the controls on the Raw tab instead. (The RGB tab options are provided primarily for manipulating JPEG and TIFF photos and not for Raw conversion.)
- NR/ALO tab: On this tab, you find controls for softening image noise and can apply the Auto Lighting Optimizer effect instead of using the in-camera correction.
- Lens tab: Click the Tune button to access the options that enable you to access certain lens correction options, including the Peripheral Illumination and Chromatic Aberration features discussed in Chapters 7 and 8, respectively.

At any time, you can revert the image to the original settings by choosing Adjustment Revert to Shot Settings.

5. Choose File⇔Convert and Save.

You see the standard file-saving dialog box with a few additional controls. Here's the rundown of critical options:

• Save as Type: Choose Exif-TIFF (8bit). This option saves your image in the TIFF file format, which preserves all image data. Don't choose the JPEG format; doing so is destructive to the photo because of the lossy compression that's applied. (Chapter 2 explains JPEG compression.)

A bit is a unit of computer data; the more bits you have, the more colors your image can contain. Some photo-editing programs can't open 16-bit files, or else they limit you to a few editing tools, so stick with the standard, 8-bit image option unless you know that your software can handle the higher bit depth. If you prefer 16-bit files, you can select TIFF 16bit as the file type.

- Output Resolution: This option does not adjust the pixel count of an image, as you might imagine. It only sets the default output resolution to be used if you send the photo to a printer. The final resolution will depend on the print size you choose, however. See the next section for more information about printing and resolution.
- Embed ICC Profile in Image: Select this check box to include the color-space data in the file. If you then open the photo in a program that supports color profiles, the colors are rendered more accurately. ICC refers to the International Color Consortium, the group that created color-space standards.
- Resize: Clear this check box so that your processed file contains all its original pixels.

6. Enter a filename, select the folder where you want to store the image, and then click Save.

A progress box appears, letting you know that the conversion is going forward. Click the Exit button (Windows) or the Terminate button (Mac) to close the progress box when the process is complete.

7. Click the Main Window button (upper-right corner of program window) to return to the image browser.

8. Close Digital Photo Professional.

You see a dialog box that tells you that your Raw file was edited and asks whether you want to save the changes.

9. Click Yes to store your raw-processing "recipe" with the Raw file.

The Raw settings you used are then kept with the original image so that you can create additional copies of the Raw file easily without having to make all your adjustments again.

Again, these steps give you only a basic overview of the process. If you regularly shoot in the Raw format, take the time to explore the Digital Photo Professional Help system so that you can take advantage of its other features.

If you prefer, you can jump from ImageBrowser EX directly to the Digital Photo Professional Raw processing window. In ImageBrowser EX, open the Edit menu and choose Process Raw Images.

Planning for Perfect Prints

Images from your camera can produce dynamic prints, and getting those prints made is easy and economical, thanks to an abundance of digital printing services in stores and online. For home printing, today's printers are better and less expensive than ever, too. That said, getting the best prints requires a bit of knowledge and prep work on your part. The next three sections help you avoid the three most common printing problems.

Check the pixel count before you print

Resolution — the number of pixels in your digital image — plays a huge role in how large you can print your photos and still maintain good picture quality. You can get the complete story in Chapter 2, but here's a quick recap:

Choose the right resolution before you shoot. Set resolution via the Image Quality option on Shooting Menu 1 or, in the advanced exposure modes, via the Quick Control display.

You must select the Image Quality option *before* you capture an image, which means that you need some idea of the ultimate print size before you shoot. When you do the resolution math, remember to consider any cropping you plan to do.

Aim for a minimum of 200 pixels per inch (ppi). You'll get a wide range of recommendations on this issue, even among professionals. In general, if you aim for a resolution in the neighborhood of 200 ppi, you should be pleased with your results. If you want a 4 x 6 print, for example, you need at least 800 x 1200 pixels (px).

Depending on your printer, you may get even better results at a slightly lower resolution. On the other hand, some printers do their best work when fed 300 ppi, and a few request 360 ppi as the optimum resolution.

Unfortunately, because most printer manuals don't bother to tell you what image resolution produces the best results, finding the right pixel level is a matter of experimentation. Don't confuse *ppi* with the manual's statements related to the printer's dpi. *Dots per inch (dpi)* refers to the number of dots of color the printer can lay down per inch; many printers use multiple dots to reproduce one image pixel.

If you're printing photos at a retail kiosk or at an online site, the software you use to order prints should determine the resolution of your files and then suggest appropriate print sizes. If you're printing on a home printer, though, you need to be the resolution cop. If your photo is destined for publication in a magazine or newspaper, ask the publisher what resolution is required.

What if you don't have enough pixels for the print size you have in mind? Well, if you can't compromise on print size, you have two choices:

- Keep the existing pixel count and accept lowered photo quality. In this case, the pixels simply get bigger to fill the requested print size. When pixels grow too large, they produce pixelation: The picture starts to appear jagged, or stair-stepped, along curved or oblique lines.
- Add more pixels and accept lowered photo quality. In some photo programs, you can use a process called *resampling* to add pixels to an existing image. Some other photo programs even resample the photo automatically for you, depending on the print settings you choose.

Although adding pixels might sound like a good option, it actually doesn't help. You're asking the software to make up photo information out of thin air, and the resulting image usually looks worse than the original. You don't see pixelation, but details turn muddy.

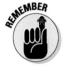

Just to hammer home the point and show you the impact of resolution picture quality, Figures 6-22 and 6-23 show you the same image as it appears at 300 ppi (the resolution required by the publisher of this book), at 50 ppi, and then resampled from 50 ppi to 300 ppi. As you can see, there's just no way around the rule: If you want the best-quality prints, you need the right pixel count from the get-go.

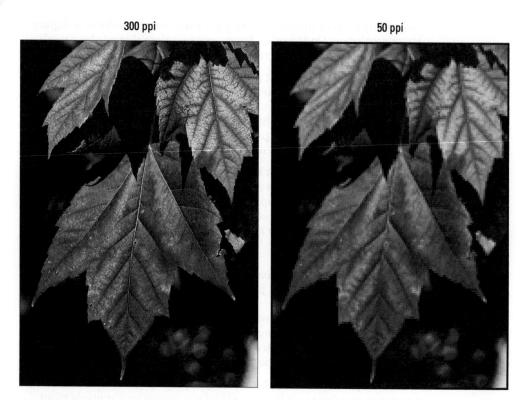

Figure 6-22: A high-quality print depends on a high-resolution original.

Allow for different print proportions

By default, your camera produces images that have a 3:2 aspect ratio, which means that they translate perfectly to the standard 4×6 print size.

To print at other standard sizes — 5×7 , 8×10 , 11×14 , and so on — you need to crop the photo to match those proportions. Alternatively, you can reduce the photo size slightly and leave an empty margin along the edges of the print as needed.

As a point of reference, both images in Figure 6-24 are original, 3:2 images. The blue outlines indicate how much of the original can fit within a 5×7 " frame and an 8×10 " frame, respectively.

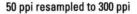

Figure 6-23: Adding pixels in a photo editor doesn't rescue a low-resolution original.

To allow yourself some printing flexibility, leave at least a little margin of background around your subject when you shoot, as Julie did when shooting the photo in Figure 6-15. That way you don't clip off the edges of the subject, no matter what print size you choose. (Some people refer to this margin padding as *head room*, especially when describing portrait composition.)

Note that all these tips also apply if you use the Live View option that lets you change the photo aspect ratio from 3.2 to 4.3, 16.9, or 1.1. In fact, you'll have to crop or shrink your photos to fit even a 4×6 snapshot in that case.

Figure 6-24: Composing shots with a little head room enables you to crop to different frame sizes.

Calibrate your monitor

Your photo looks perfect on your computer monitor, but when you print the picture, the image colors or brightness are way off. Assuming that your printer is functioning properly and you chose the correct print settings when shipping the file to the printer, this problem is probably related to your monitor, not the printer.

If the monitor isn't calibrated, chances are that it's not displaying an accurate rendition of image colors. The same caveat applies to monitor brightness: You can't gauge the real exposure of a photo if the brightness of the monitor is cranked way up or down. Many of today's monitors are very bright, providing ideal conditions for web browsing and watching movies but not for photo editing. So you may need to turn the brightness way, way down to get to a true indication of image exposure.

To ensure that your monitor is displaying photos on a neutral canvas, you can start with a software-based *calibration utility*, which is just a small program that guides you through the process of adjusting your monitor.

If you use a Mac, its operating system (OS) offers a built-in calibration utility, the Display Calibrator Assistant; Windows 7 offers a similar tool: Display Color Calibration.

Software-based tools, though, depend on your eyes to make decisions during the calibration process. For a more reliable calibration, you may want to invest in a hardware solution, such as the Pantone huey PRO (\$99, visit www.pantone.com) or the Datacolor Spyder4Express (\$89, www.datacolor.com) or X-Rite ColorMunki Display (\$190, www.colormunki.com). These products use a device known as a *colorimeter* to accurately measure display colors.

Whichever route you take, the calibration process produces a monitor *profile*, which is a data file that tells your computer how to adjust the display to compensate for any monitor color casts or brightness and contrast issues. Your Windows or Mac OS loads this file automatically when you start your computer. Your only responsibility is to perform the calibration every month or so because monitor colors do drift over time.

Even with a perfectly calibrated monitor, however, don't expect perfect color matching between printer and monitor. Printers simply can't reproduce the entire spectrum of colors that a monitor can display. In addition, monitor colors always appear brighter because they are, after all, generated with light.

Preparing Pictures for Online Sharing

Have you ever received an e-mail message containing a photo so large that you can't view the whole thing on your monitor without scrolling the e-mail window? This annoyance occurs because monitors can display only a limited number of pixels. The exact number depends on the screen resolution setting, but suffice it to say that most of today's digital cameras produce photos with pixel counts in excess of what the monitor can handle.

Thankfully, the newest e-mail programs incorporate features that automatically shrink the photo display to a viewable size. But that doesn't change the fact that a large photo file means longer downloading times and, if recipients hold onto the picture, a big storage hit on their hard drives.

Sending a high-resolution photo is the thing to do if you want the recipient to be able to generate a good print. But it's polite practice to ask people if they want to print 11×14 glossies of your new puppy before you send them a dozen 20-megapixel shots.

For simple onscreen viewing, I limit photos to about 800 px across and 600 px down. That ensures that people who use an e-mail program that doesn't offer the latest photo-viewing tools can see the entire picture without scrolling the viewer window.

At the lowest Image Quality setting on your camera, S3, pictures contain 720 x 480 px. Recording your originals at that tiny size isn't a good idea, though, because if you want to print the photo, you won't have enough pixels to produce a good result. Instead, shoot your originals at a resolution appropriate for print and then create a "low-res" copy of the picture for e-mail sharing or for other online uses, such as posting to Facebook.

In addition to resizing images, also check their file types; if the photos are in the Raw or TIFF format, you need to create a JPEG copy for online use. Web browsers and e-mail programs can't display Raw or TIFF files.

You have a few ways to tackle both bits of photo prep:

- You can use the camera's Raw converter to create a JPEG copy of your picture, selecting the file size you want during the conversion process.
- Using Canon Digital Photo Professional, you can convert both Raw and TIFF files to JPEG. (See the program's Help system for assistance.)
- For JPEG pictures, you can create a small copy right in the camera. The only exceptions are pictures captured using the S3 Quality setting at 740 x 480 px, they're already the smallest images the camera can create.

You can read more about the Raw conversion process earlier in this chapter. To take the third approach, creating a small copy of a JPEG original, go one of these two routes:

✓ Playback Menu 2: Choose Resize, as shown in Figure 6-25. You see a photo along with a Resize icon in the upper-left corner and a Set icon in the lower-right corner, as shown on the left in Figure 6-26.

Scroll to the picture you want to resize and then tap the Set icon or press the Set button. You see display size options available for the photo, as shown on the right in Figure 6-26. Which sizes appear

Figure 6-25: Choose the Resize command to make a low-resolution copy of an image.

depends on the size of the original photo; you're offered only sizes that produce a smaller picture. The text label above the options indicates the file size and pixel count of the selected setting.

Tap the setting you want to use (or highlight it and press Set) to display a confirmation screen. Choose OK, and the camera creates your low-res copy and displays a text message along with a seven-digit number. The first three numbers indicate the folder number where the copy is stored and the last four numbers are the last four numbers of the image filename. Be sure to note the filename of the small copy so that you can tell it apart from its high-pixel sibling later. Choose OK one more time to wrap up.

Figure 6-26: Tap the Set icon (left) to display the available photo sizes (right).

Quick Control screen: Display the photo you want to resize, shift to Quick Control mode (press the Q button), and then highlight the Resize icon, as shown in Figure 6-27. Size options appear at the bottom of the screen; tap the one you want to use or use the Multicontroller, Main dial, or Quick Control dial to highlight it and press Set. From that point, things work the same as just described.

Resize icon

Figure 6-27: You also can resize photos from the Quick Control screen during playback.

Part III Taking Creative Control

Get ideas at www . dummies . com/extras/canon for saving your photos long-term.

In this part . . .

- Get a handle on exposure and flash settings.
- Find out how to solve exposure problems.
- Master the autofocusing system.
- Check out color controls.
- Choose the right settings for specific photographs.

Getting Creative with Exposure

In This Chapter

- Exploring advanced exposure modes: P, Tv, Av, M, B, and C
- ▶ Getting a grip on aperture, shutter speed, and ISO
- Choosing an exposure metering mode
- ▶ Tweaking exposure results
- Taking advantage of Automatic Exposure Bracketing (AEB)
- Using advanced flash options

y using the simple exposure modes I cover in Chapter 3, you can take good pictures with your Canon 70D. But to fully exploit your camera's capabilities — and, more importantly, to exploit *your* creative capabilities — you need to explore your camera's advanced exposure modes, represented on the Mode dial by the letters P, Tv, Av, M, B, and C.

This chapter explains everything you need to know to start taking advantage of these modes. First, you get an introduction to three critical exposure controls: aperture, shutter speed, and ISO. In addition, this chapter explains advanced exposure features, such as exposure compensation and metering modes, and digs deeper into the topic of flash photography.

Kicking Your Camera into High Gear

For full access to all your camera's exposure controls, set the Mode dial to one of its advanced exposure modes, highlighted in Figure 7-1.

Using these modes lets you manipulate two critical exposure controls, *aperture* and *shutter speed*. That's not a huge deal in terms of exposure because the camera typically gets that part of the picture right in the fully automatic modes. But changing the aperture setting also affects the distance over

which focus is maintained (depth of field), and shutter speed determines whether movement of the subject or camera creates blur. The next part of the chapter explains the details; for now, just understand that having input over these settings provides you with creative options that you don't enjoy in the fully automatic modes.

Each advanced mode offers a different level of control over aperture and shutter speed, as follows:

- P (programmed autoexposure): The camera selects the aperture and shutter speed, but you can choose from different combinations of the two.
- Tv (shutter-priority autoexposure): You select a shutter speed, and the camera chooses the aperture setting that produces a good exposure.

Advanced exposure modes

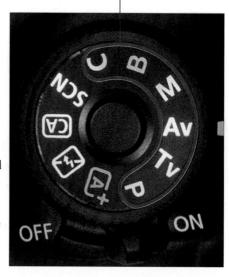

Figure 7-1: To fully control exposure and other picture properties, choose one of these exposure modes.

Why Tv? Well, shutter speed controls exposure time; Tv stands for time value.

- Av (aperture-priority autoexposure): The opposite of shutter-priority autoexposure, this mode asks you to select the aperture setting thus Av, for aperture value. The camera then selects the appropriate shutter speed to properly expose the picture.
- ✓ M (manual exposure): In this mode, you specify both shutter speed and aperture. Although that prospect may sound intimidating, it's actually the fastest and least complicated way to dial in exactly the exposure settings you want to use. And even in M mode, the camera assists you by displaying a meter that tells you whether your exposure settings are on target.

Setting the Mode dial to M has *no effect* on whether autofocusing or manual focusing is enabled. You set the focusing method via the switch on the lens and can use auto or manual focusing in any exposure mode.

✓ B (Bulb): Bulb mode is a variation of Manual mode. You still control aperture and shutter speed, but instead of setting a specific shutter speed, you hold the shutter button down for the length of time you want the image to be exposed.

Bulb mode is great for night photography, catching lightning in action, and photographing thunderstorms and fireworks because it enables you to experiment with different shutter speeds simply by holding the shutter button down for different lengths of time. You don't have to fiddle with changing the shutter speed between each shot.

✓ C (Camera User Settings): Camera User Settings is another special mode. You can register (save) most camera settings (including exposure mode, menu options, and so forth) and instantly recall them by selecting C from Mode dial. To put it another way, you can create your own, custom exposure mode. I show you how to do it in Chapter 11.

Again, these modes won't make much sense if you aren't schooled in the basics of exposure. To that end, the next several sections provide a quick lesson in this critical subject.

Introducing Exposure Basics: Aperture, Shutter Speed, and 150

Any photograph is created by focusing light through a lens onto a light-sensitive recording medium. In a film camera, the film negative is that medium; in a digital camera, it's the *image sensor*.

Between the lens and the sensor are two barriers, the aperture and shutter, which control how much light strikes the sensor. The design of the aperture, shutter, and sensor vary depending on the camera, but Figure 7-2 illustrates the basic concept.

The aperture and shutter, along with a third feature, ISO, determine *exposure*, which is what most of us would describe as picture brightness. This three-part formula works as follows:

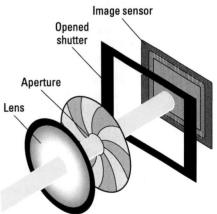

Figure 7-2: The aperture size and shutter speed determine how much light strikes the image sensor.

✓ **Aperture (controls amount of light):** The *aperture* is an adjustable hole in a diaphragm set inside the lens. By changing the size of the aperture, you control the size of the light beam that can enter the camera. Aperture settings are stated as f-stop numbers — or simply, *f-stops* — and are expressed with the letter *f* followed by a number: f/2, f/5.6, f/16, and so on.

The lower the f-stop number, the larger the aperture opening, as illustrated in Figure 7-3.

The range of aperture settings depends on your lens; the lens manual should spell out which settings are available to you.

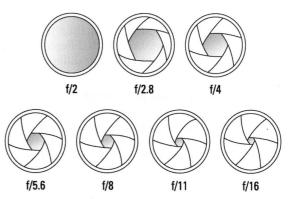

Figure 7-3: The smaller the f-stop number, the larger the aperture opening.

Shutter speed (controls duration of light): Set behind the aperture, the shutter

works something like, er, the shutters on a window. When you aren't taking pictures, the camera's shutter stays closed, preventing light from striking the sensor. When you press the shutter button, the shutter opens to allow light that passes through the aperture to hit the sensor. The exception is when you use Live View mode; in that mode, the shutter remains open so that your image can form on the sensor and be displayed on the monitor. When you press the shutter release in Live View mode, the shutter first closes and then reopens for the actual exposure.

The length of time that the shutter is open is the *shutter speed* and is measured in seconds: 1/60 second, 1/250 second, 2 seconds, and so on. The 70D offers a shutter speed range of 30 seconds to 1/8000 second. However, when you use the built-in flash, the top shutter speed is 1/250 second; this limitation is due to the way that the flash has to synchronize with the opening of the shutter. With some external Canon flash units, you can access the whole range of shutter speeds, however.

ISO (controls light sensitivity): ISO, which is a digital function rather than a mechanical structure on the camera, enables you to adjust how responsive the sensor is to light. The term *ISO* is a holdover from film days, when an international standards organization rated film stock according to light sensitivity: ISO 100, ISO 200, ISO 400, ISO 800, and so on. A higher ISO rating means greater light sensitivity.

On a digital camera, the sensor doesn't actually get more or less sensitive when you change the ISO. Rather, the light "signal" that hits the sensor is amplified or dampened through electronics wizardry, sort of like how raising the volume on a radio boosts the audio signal. But the upshot is the same as changing to a more light-reactive film stock: A higher ISO means that less light is needed to produce the image, enabling you to use a smaller aperture, faster shutter speed, or both.

By default, your camera offers an ISO range from 100 to 12800, but through a tweak I discuss in the section "Controlling ISO," later in this chapter, you can raise the ISO ceiling as high as 25600.

Distilled to its essence, the image-exposure formula is this simple:

- Aperture and shutter speed together determine the quantity of light that strikes the image sensor.
- ✓ ISO determines how much the sensor reacts to that light.

The tricky part of the equation is that aperture, shutter speed, and ISO settings affect your pictures in ways that go *beyond* exposure. You need to be aware of these side effects, explained in the next sections, to determine which combination of the three exposure settings will work best for your picture.

Understanding exposure-setting side effects

You can create the same exposure with different combinations of aperture, shutter speed, and ISO, which Figure 7-4 illustrates. Although the figure shows only two variations of settings, your choices are pretty much endless — you're limited only by the aperture range the lens allows and the shutter speeds and ISO settings the camera offers.

f/13, 1/25 second, ISO 200

Figure 7-4: Aperture and shutter speed affect depth of field and motion blur.

However, the settings you select impact your image beyond mere exposure, as follows:

- Aperture affects depth of field, or the distance over which focus remains acceptably sharp.
- Shutter speed determines whether moving objects appear blurry or sharply focused.
- ISO affects the amount of image noise, which is a defect that looks like specks of sand.

The next three sections detail these exposure side effects.

Aperture and depth of field

The aperture setting, or f-stop, affects *depth of field*, or the distance over which acceptable focus is maintained. With a shallow depth of field, your subject appears more sharply focused than faraway objects; with a large depth of field, the sharp-focus zone spreads over a greater distance from the lens.

When you reduce the aperture size — "stop-down the aperture," in photo lingo — by choosing a higher f-stop number, you increase depth of field. For example, notice that the background in the left image in Figure 7-4, taken at f/13, appears sharper than the right image, taken at f/5.6.

Aperture is just one contributor to depth of field, however. The camera-to-subject distance and the focal length of your lens also play a role. Depth of field is reduced as you move closer to the subject or increase the focal length of the lens (moving from a wide-angle lens to a telephoto lens, for example). See Chapter 8 for the complete story on depth of field.

One way to remember the relationship between f-stop and depth of field is to think of the f as focus: The higher the f-stop number, the larger the zone of sharp focus. Please don't share this tip with photography elites, who will roll their eyes and inform you that the f in f-stop most certainly does not stand for focus but, rather, for the ratio between aperture size and lens focal length — as if that's helpful to know if you aren't an optical engineer.

Shutter speed and motion blur

At a slow shutter speed, moving objects appear blurry; a fast shutter speed captures motion cleanly. Compare the water motion in the photos in Figure 7-4, for example. At a shutter speed of 1/25 second (left photo), the water blurs. At 1/125 second (right photo), the water appears more sharply focused. The shutter speed needed to freeze action depends on the subject's speed.

If your picture suffers from overall image blur, like you see in Figure 7-5, where even stationary objects appear out of focus, the camera moved during the exposure — which is always a danger when you handhold the camera at slow shutter speeds. The longer the exposure time, the longer you have to hold the camera still to avoid the blur caused by camera shake.

How slow is too slow? It depends partly on your lens: Camera shake affects your picture more with a lens that has a long focal length. For example, you may be able to use a slower shutter speed when you shoot with a 55mm lens than if you switch to a 200mm lens. And of course, how still you can hold the camera depends on your physical capabilities. The best idea is to do your own tests to find your handholding limit. Check out Chapter 6 to find out how to see each picture's shutter speed when you view your test images using the Canon software.

Figure 7-5: Slow shutter speeds increase the risk of allover blur caused by camera shake.

To avoid the issue altogether, use a tripod or otherwise steady the camera. If you need to handhold, improve your odds of capturing a sharp photo by turning on image stabilization, if your lens offers it. (On the kit lenses, turn the Stabilizer switch to On.)

150 and image noise

As ISO increases, making the image sensor more reactive to light, you increase the risk of *noise*. Noise looks like bits of sand and is similar in appearance to film *grain*, a defect that often mars pictures taken with high-ISO film. Figure 7-6 offers an example.

Ideally, you should always use the lowest ISO setting to ensure top image quality. Sometimes, though, the lighting conditions don't permit you to do so. Take the rose image in Figure 7-6 as an example. On my first attempt, taken at ISO 100, f/6.3, and 1/40 second, the flower was slightly blurry, as shown on the left in Figure 7-7. I was using a tripod, so camera shake wasn't the problem. A very slight breeze was moving the flower just enough that a 1/40 second shutter speed wasn't fast enough to freeze the action. My aperture was at the maximum opening the lens offered, so the only way to allow a faster shutter speed was to raise the ISO. By increasing the ISO to 200, I was able to use a shutter speed of 1/80 second, which captured the flower cleanly, as shown on the right.

Figure 7-6: Caused by a very high ISO or long exposure time, noise becomes more visible as you enlarge the image.

ISO 100, f/6.3, 1/40 second

ISO 200, f/6.3, 1/80 second

Figure 7-7: Raising the ISO enabled me to bump the shutter speed up enough to permit a blur-free shot of the flower, which was moving in the breeze.

Fortunately, you don't encounter serious noise on the 70D until you really crank up the ISO. In fact, you may even be able to get away with a fairly high ISO if you keep your print or display size small. Some people probably wouldn't even notice the noise in the left image in Figure 7-6 unless they were looking for it, for example. But as with other image defects, noise becomes more apparent as you enlarge the photo, as shown on the right in that same figure. Noise is also easier to spot in shadow areas of your picture and in large areas of solid color.

A high ISO isn't the only cause of noise, however. A long exposure time can also produce the defect, so how high you can raise the ISO before the image gets ugly varies depending on shutter speed.

Doing the exposure balancing act

When you change any of the three exposure settings — aperture, shutter speed, or ISO — one or both of the others must also shift to maintain the same image brightness.

Say you're shooting a soccer game, and although the exposure looks great, the players appear blurry at the current shutter speed. If you raise the shutter speed, you have to compensate with either a larger aperture (to allow in more light during the shorter exposure) or a higher ISO setting (to make the camera more sensitive to the light). Which way you should go depends on whether you prefer the shorter depth of field that comes with a larger aperture or the increased risk of noise that accompanies a higher ISO. Of course, you can also adjust both settings if you choose to get the exposure results you need.

All photographers have their own approaches to finding the right combination of aperture, shutter speed, and ISO, and you'll no doubt develop your own system when you become more practiced at using the advanced exposure modes. In the meantime, here's how I suggest that you handle things:

- Use the lowest ISO setting unless the lighting conditions are such that you can't use the aperture and shutter speed you want without raising the ISO.
- If your subject is moving, give shutter speed the next highest priority. Choose a fast shutter speed to ensure a blur-free photo, or on the flip side, select a slow shutter speed to intentionally blur that moving object, an effect that can create a heightened sense of motion. When shooting waterfalls, for example, using a slow shutter speed gives the water that blurry, romantic look. (Chapter 9 has an example.)
- For nonmoving subjects, make aperture a priority over shutter speed, setting the aperture according to the depth of field you have in mind. For portraits, for example, try using a wide-open aperture (a low f-stop number) to create a short depth of field and a nice, soft background for your subject.

Be careful not to go too shallow with depth of field when shooting a group portrait, though. Unless all the subjects are the same distance from the camera, some may be outside the zone of sharp focus. A short depth of field also makes action shots more difficult because you have to be spot-on with focus. With a larger depth of field, the subject can move a greater distance toward or away from you before leaving the sharp-focus area, giving you a bit of a focusing safety net.

Keeping all this information straight is a little overwhelming at first, but the more you work with your camera, the more the whole exposure equation will make sense to you. You can find tips in Chapter 9 for choosing exposure settings for specific types of pictures; keep moving through this chapter for details on how to monitor and adjust aperture, shutter speed, and ISO settings.

Monitoring Exposure Settings

When you press the shutter button halfway, the f-stop, shutter speed, and ISO speed appear in the view-finder, as shown in Figure 7-8, and in the Shooting Settings display and LCD panel, as shown in Figure 7-9. In Live View mode, the exposure data appears at the bottom of the monitor and takes a form similar to what you see in the viewfinder. (See Chapter 4 for details about Live View.)

The value at the far right of the view-finder and lower right of the Shooting Settings display — 40, in Figures 7-8 and 7-9 — indicates the number of frames that can fit in the camera's memory buffer when you use the Continuous Drive modes, which I cover in Chapter 2. For purposes of exposure, don't worry about it.

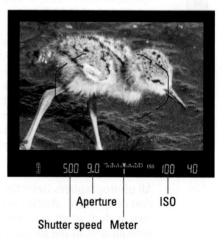

Figure 7-8: The shutter speed, f-stop, and ISO speed appear in the viewfinder.

Also be aware that in the viewfinder, LCD panel, and on the monitor in Live View mode, shutter speeds are presented as whole numbers, even if the shutter speed is set to a fraction of a second. For example, for a shutter speed of 1/500 second, you see just the number 500. When the shutter speed slows to 1 second or more, you see quote marks after the number: 1" indicates a shutter speed of 1 second, 4" means 4 seconds, and so on.

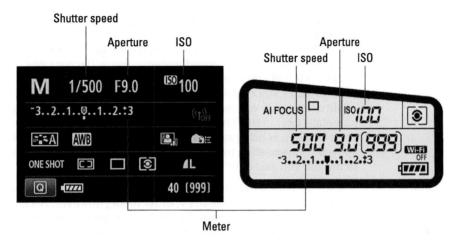

Figure 7-9: You also can view the settings in the Shooting Settings display and LCD panel.

In all exposure modes except B (Bulb), the displays also offer an *exposure meter*, labeled in Figures 7-8 and 7-9. The meter serves different purposes depending on your exposure mode:

In manual exposure (M) mode, the meter indicates whether your settings will properly expose the image. Figure 7-10 gives you three examples. When the *exposure indicator* (the bar under the meter) aligns with the center point of the meter, as shown in the middle example, the current settings will produce a proper exposure. If the indicator moves toward the minus side of the scale, as in the left example in the figure, the image will be underexposed. If the indicator moves to the right of center, as in the right example, the image will be overexposed. The farther the indicator moves toward the plus or minus sign, the greater the potential exposure problem.

Figure 7-10: In manual exposure (M) mode, the meter indicates whether exposure settings are on target.

Keep in mind that the information reported by the meter is dependent on the *metering mode*, which determines what part of the frame the camera uses to calculate exposure. You can choose from four metering modes, covered in the next section. In P, Tv, and Av modes, the meter displays the current Exposure Compensation setting. Remember, in those modes the camera sets either the shutter speed or aperture, or both, to produce a good exposure — again, depending on the current metering mode. Because you don't need the meter to tell you whether exposure is okay, the meter instead indicates whether you enabled Exposure Compensation, a feature that forces a brighter or darker exposure than the camera thinks is appropriate. (Look for details later in this chapter.) When the exposure indicator is at 0, no compensation is being applied. If the indicator is to the right of 0, you applied compensation to produce a brighter image; when the indicator is to the left, you asked for a darker photo.

In some lighting situations, the camera *can't* select settings that produce an optimal exposure in the P, Tv, or Av mode, however. Because the meter indicates the Exposure Compensation amount in those modes, the camera alerts you to exposure issues as follows:

- Av: The shutter speed blinks to let you know that the camera can't select a shutter speed that will produce a good exposure at the aperture you selected. Choose a different f-stop or adjust the ISO.
- *Tv*: The aperture value blinks to tell you that the camera can't open or stop down the aperture enough to expose the image at your selected shutter speed. Your options are to change the shutter speed or ISO.
- P: Both the aperture and shutter speed blink if the camera can't select a combination that will properly expose the image. Your only option is to change the ISO setting.

Exposure stops: How many do you want to see?

A *stop* is an increment of exposure. To increase exposure by one stop means to adjust the aperture or shutter speed to allow twice as much light into the camera as the current settings permit. To reduce exposure by one stop, you use settings that allow half as much light. Doubling or halving the ISO value also adjusts exposure by one stop.

By default, major exposure settings are based on one-third stop adjustments. If you prefer, you can tell the camera to present exposure adjustments in larger increments so that you don't have to cycle through as many settings each time you want to make a change. Set things up through these options, found in the Exposure section of the Custom Functions menu:

- Exposure level increments: Affects shutter speed, aperture, Exposure Compensation, Flash Compensation, and autoexposure bracketing. Also determines the increment used to indicate the amount of under- or overexposure in the meter. You can raise the increment to 1/2 stop.
- ISO Speed Setting Increments: Affects ISO settings only; you can change from the default 1/3 stop to a full stop of adjustment.

Obviously, the default setting, 1/3 stop, provides the greatest degree of exposure fine-tuning, so I stick with that option.

In B (Bulb) mode, you see neither the meter nor the shutter speed in the displays. Remember, in this mode, the shutter stays open as long as you hold down the shutter button, so the camera has no idea what shutter speed you're going to use or how it will affect the exposure. Instead, the shutter speed readout says *Bulb*, and the elapsed shooting time (in seconds) appears in the area that normally shows the number of shots remaining.

As for the C mode, which is your custom exposure mode, the way the camera behaves depends on which exposure mode you used as the basis for the custom mode. Chapter 11 explains this feature.

Choosing an Exposure Metering Mode

The *metering mode* determines which part of the frame the camera analyzes to calculate exposure. Your camera offers four metering modes, described in the following list and represented in the Shooting Settings display and LCD panel by the icons you see in the margin. (See Figure 7-11 for help finding the icons.) However, you can access all four modes only in the advanced exposure modes.

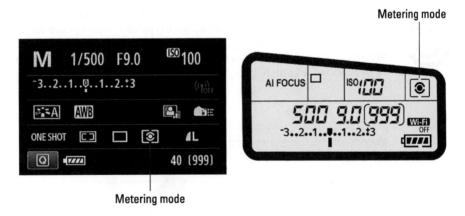

Figure 7-11: This symbol represents the exposure metering mode.

Evaluative metering: The camera analyzes the entire frame and then selects exposure settings designed to produce a balanced exposure. This setting is always used for the fully automatic exposure modes.

Partial metering: The camera bases exposure on an area covering about 8 percent of the center of the frame. •

✓ **Spot metering:** Exposure is based on just the central 3 percent of the frame, with the metering area indicated by a circle in the viewfinder display, as shown in Figure 7-12.

Center-Weighted Average metering: The camera bases exposure on the entire frame but puts extra emphasis — or weight — on the center.

In most cases, Evaluative metering does a good job. But it can get thrown off when a dark subject is set against a bright background or vice versa. For example, in the left image

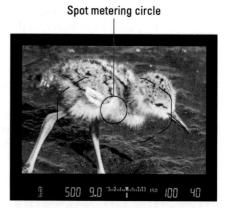

Figure 7-12: The circle indicates the Spot metering area.

in Figure 7-13, the bright background caused the camera to underexpose the statue, which was the point of interest for the photo. Switching to Partial metering properly exposed the statue. (Spot metering would produce a similar result for this particular subject.)

Of course, if the background is very bright and the subject is very dark, the exposure that does the best job on the subject typically overexposes the background. You may be able to reclaim some lost highlights by turning on Highlight Tone Priority, explored later in this chapter, or, if you want to expand the range of both shadows and highlights, by using HDR Mode, also covered later.

Evaluative

Partial

Figure 7-13: In Evaluative mode, the camera underexposed the statue; switching to Partial metering produced a better result.

To change the metering mode, use these techniques:

Metering mode button: The button is located on top of the camera, at the right end of the LCD panel. When you press the button, all data except the metering mode icon disappears from the panel, and the screen shown in Figure 7-14 appears on the monitor. Use the Multi-controller, Main dial, or Ouick Control dial to cycle through the available settings. You also can tap your selection on the monitor. Wrap up by pressing the Set button or by tapping the return arrow on the monitor.

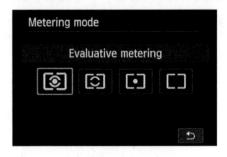

Figure 7-14: Press the Metering mode button to display this screen and select your metering mode.

Quick Control screen: After shifting to the Quick Control screen, choose the icon highlighted in Figure 7-15 and rotate the Main dial or Quick Control dial to cycle through the four modes. Or tap the icon or press Set to display the screen showing all four modes together, as shown in Figure 7-14.

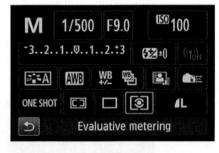

Figure 7-15: You can also change the setting via the Quick Control screen.

In theory, the best practice is to check the metering mode before each shot and choose the mode that best

matches your exposure goals. But in practice, it's a pain, not just in terms of having to adjust yet one more setting but also in terms of having to *remember* to adjust one more setting. So until you're comfortable with all the other controls on your camera, just stick with Evaluative metering. It produces good results in most situations. After all, you can see in the monitor whether you like your results, and if not, adjust exposure settings and reshoot. This option makes the whole metering mode issue a lot less critical than it is when you shoot with film.

However — and this is an important however — for viewfinder photography, your choice of metering mode determines when the camera sets the final exposure for your picture. In Evaluative mode, exposure is locked when you press the shutter button halfway, but in the other modes, exposure is adjusted up to the time you press the button all the way to take the picture. Should you want to lock exposure before that point, you can use the technique outlined in the later section, "Locking Autoexposure Settings."

For Live View photography, exposure is always set at the moment you snap the picture, regardless of the metering mode.

Setting 150, f-stop, and Shutter Speed

If you want to control ISO, aperture (f-stop), or shutter speed, set the camera to one of the advanced exposure modes. Then check out the next several sections to find the exact steps to follow in each of these modes.

Controlling 150

To recap the ISO information presented at the start of this chapter, your camera's ISO setting controls how sensitive the image sensor is to light. At higher ISO values, you need less light to expose an image. Remember the downside to raising ISO, however: The higher the ISO, the greater the possibility of noisy images. Refer to Figure 7-6 for a reminder of what that defect looks like.

In the fully automatic exposure modes, the camera controls ISO. In the advanced exposure modes, you can use auto ISO adjustment or select a specific setting. You also can specify limits for the camera to follow when you use auto ISO adjustment.

You can view the ISO setting in all three displays, as shown in Figure 7-16. To adjust the setting, you have these options:

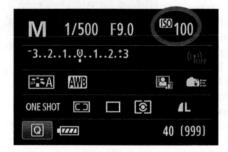

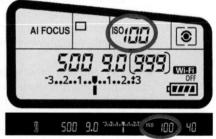

Figure 7-16: Look here for the current ISO setting.

✓ **ISO button:** Press the ISO button (top of the camera, just above the LCD panel). The ISO value becomes activated in the panel and viewfinder, and the screen shown in Figure 7-17 appears on the monitor. Use the Main dial, Quick Control dial, or Multi-controller to adjust the setting, or if you're in a touchscreen mood, drag your finger along the scale or tap the left and right arrows. Close out the process by pressing the Set button or by tapping the return arrow on the monitor.

While the selection screen is displayed, you can tap the Info icon or press the Info button to quickly select Auto ISO mode.

- Quick Control screen: After shifting to the Quick Control screen, highlight the ISO setting and then rotate the Main dial or Quick Control dial to adjust the setting. Or, to access the selection screen shown in Figure 7-17, tap the ISO setting or press the Set button.
- Shooting Menu 3: Select ISO Speed Settings, as shown on the left in Figure 7-18, and then choose ISO Speed, as shown on the right, to set the ISO value you want to use.

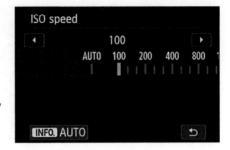

Figure 7-17: Pressing the ISO button brings up this ISO selection screen.

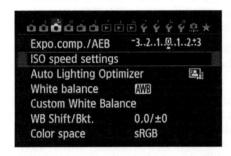

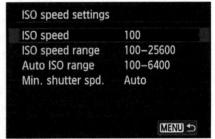

Figure 7-18: Shooting Menu 3 offers additional ISO setup options.

The other menu options on the screen shown on the right in the figure enable you to modify the range of ISO values available and to control how the camera selects an ISO setting when you use the Auto ISO option. The menu options work as follows:

- ✓ **ISO Speed Range:** By default, you can select from ISO values ranging from 100 to 12800. But via this menu option, you can select a higher minimum setting and expand the maximum value to as high as 25600, as illustrated in Figure 7-19. After choosing the menu option, highlight either value to display controls for adjusting the value. (The Maximum setting is selected in the figure.) A couple of fine points to note:
 - By default, the maximum ISO value the camera uses for movies is 6400, even if you select the 12800 setting via the menu. However, by setting the Maximum value to 12800/H, you give the camera permission to jack up the ISO to 12800 for movies. (The H stands for high, which should be a reminder to expect noise in your movie.)

SO speed	100
SO speed range	100-25600
Auto ISO range	100-6400
Min. shutter spd.	Auto

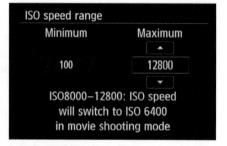

Figure 7-19: You can expand the maximum ISO value to ISO 25600.

- The maximum setting for still shooting is ISO 25600, which is also tagged with an H. For movies, the camera automatically selects the 12800/H setting when the H 25600 option is in force.
- If you enable Highlight Tone Priority, an exposure feature covered later in this chapter, the lowest possible ISO setting becomes 200. You also lose access to the top ISO setting (H 26500).
- Auto ISO Range: Use this option to set the minimum and maximum ISO settings you want the camera to use when you go with Auto ISO adjustment.
- Min. Shutter Speed: This setting relates to shooting in the P and Av exposure modes. If you leave the setting at Auto (the default), the camera automatically shifts the ISO so that the value isn't lower than the shutter speed. You also can select a specific shutter speed, in which case the camera shifts to auto ISO adjustment only if the shutter speed falls to your selected value or lower. This setting isn't applied when you use flash, however. Also, the camera will choose a slower shutter speed than you designate if that's the only way to produce a good exposure.

In Auto ISO mode, the Shooting Settings display, LCD panel, and Live View display initially show Auto (or A) as the ISO value. But when you press the shutter button halfway, the value changes to show you the ISO setting the camera selected. You also see the selected value rather than Auto in the viewfinder. *Note:* When you view shooting data during playback, you may see a value reported that isn't on the list of "official" ISO settings — ISO 320, for example. This happens because in Auto mode, the camera can select values all along the available ISO range, whereas if you select a specific ISO setting, you're restricted to specific notches within the range.

Adjusting aperture and shutter speed

You can adjust aperture and shutter speed only in the advanced exposure modes. To see the current exposure settings, press the shutter button halfway. The following actions then take place:

- ✓ The exposure meter comes to life. If autofocus is enabled, the autofocus mechanism starts to do its thing.
- ✓ The aperture and shutter speed appear in the viewfinder, LCD panel, and the Shooting Settings display. (Refer to Figures 7-8 and 7-9.) In Live View mode, the settings appear at the bottom of the monitor, assuming that you're using a display mode that reveals shooting data. (Press the Info button to cycle through the Live View display modes.)
- ✓ In manual exposure (M) mode, the exposure meter lets you know whether the current settings will expose the image properly. In the other modes, the camera indicates an exposure problem by flashing the shutter speed or the f-stop value. (See the section "Monitoring Exposure Settings," earlier in this chapter, for details.)

The technique you use to change the exposure settings depends on the exposure mode:

- ✓ P (programmed autoexposure): The camera displays its recommended aperture and shutter speed. To select a different combination, rotate the Main dial. But note that your change applies only to the current shot. Also — and this is a critical point — you can't stray from the initial shutter speed and aperture when you use flash.
- ✓ Tv (shutter-priority autoexposure): Rotate the Main dial to change the shutter speed. As you do, the camera adjusts the aperture as needed to achieve the proper exposure.

✓ Av (aperture-priority autoexposure): Rotate the Main dial to set the f-stop. The camera automatically adjusts the shutter speed.

The range of possible f-stops depends on your lens and, with most zoom lenses, on the zoom position (focal length) of the lens. For the 18–135mm kit lens featured in this book, for example, you can select apertures from f/3.5 to f/22 when zoomed to the shortest focal length (18mm). At the maximum focal length (135mm), the aperture range is from f/5.6 to f/36.

If you're handholding the camera, be careful that the shutter speed doesn't drop so low that you run the risk of camera shake. If your scene contains moving objects, make sure that the shutter speed is fast enough to stop action (or slow enough to blur it, if that's your creative goal).

- ✓ M (manual exposure): Select aperture and shutter speed like so:
 - To adjust shutter speed: Rotate the Main dial.
 - To adjust aperture: Rotate the Quick Control dial.
- ✓ B (Bulb exposure): Rotate the Main dial to set the f-stop. You control shutter speed through the shutter button: The shutter remains open as long as you hold the button down.
- ✓ C (Camera User Settings) mode: Use the same technique as for the exposure mode you used as the basis for your custom mode. For example, if you based the C mode on the Av mode, you can adjust f-stop by rotating the Main dial.
- You also can use the Ouick Control screen to adjust settings in all these modes except P. First, choose the setting you want to adjust. For example, in Figure 7-20, the aperture setting is highlighted, and the name of the option appears at the bottom of the screen. Rotate the Main dial or Quick Control dial to adjust the setting. You also can tap the f-stop or shutter speed to display a screen with a setting scale; drag your finger along the scale or tap the arrows above it to adjust the setting. Press the return arrow or the Set button to exit the screen.

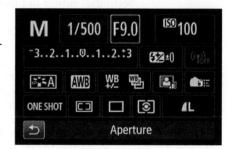

Figure 7-20: You can also use the Quick Control screen to adjust aperture and shutter speed in the M, Tv, and Av exposure modes.

Keep in mind that when you use P, Tv, and Av modes, the settings that the camera selects are based on what it thinks is the proper exposure. If you don't agree with the camera, you have two options. Switch to manual exposure (M) mode and simply dial in the aperture and shutter speed that deliver the exposure you want, or if you want to stay in P, Tv, or Av mode, tweak the autoexposure settings by using Exposure Compensation, one of the exposure-correction tools described in the next section.

What's Safety Shift?

Do you have one of those well-meaning neighbors who always insists on "helping" you with tricky household repairs, but who invariably just winds up making things more complicated? That's my analogy to the Safety Shift feature, found among the Exposure Custom Functions, as shown here. The idea is that if you shoot in the P, Tv, or Av modes and select certain exposure settings that the camera thinks will under- or overexpose the photo, it steps in and overrides those settings to give you the exposure that *it* wants to see. By default, the feature is disabled. The other two settings work like so:

- Shutter speed/Aperture: When you shoot in Tv mode, the camera changes your selected shutter speed setting when it deems fit. In Av mode, the camera shifts your selected f-stop.
- ISO Speed: This one works in P, Tv, and Av modes. If the camera believes the ISO setting you selected isn't going to work, it changes the setting for you, just as if you selected the Auto ISO setting.

Both options seem okay on the surface — until you encounter a situation where you and the camera disagree on the ultimate exposure, or you really need to use a certain shutter speed, f-stop, or ISO. Because trust me, this option is buried so deep in the menus that you will forget that you enabled one of these options and spend a lot of time trying to figure out why the camera won't do your bidding. To put it another way, tell this helpful neighbor that you're okay on your own and stick with the Disable setting.

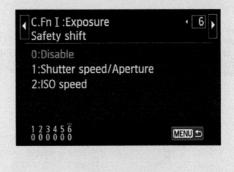

Sorting through Your Camera's Exposure-Correction Tools

In addition to the normal controls over aperture, shutter speed, and ISO, your camera offers a collection of tools that enable you to solve tricky exposure problems. The next sections give you the lowdown on these features.

Overriding autoexposure results with Exposure Compensation

In P, Tv, and Av modes, you can enjoy autoexposure support but retain some control over the final exposure. If the image the camera produced is too dark or too light, you can use *Exposure Compensation*, sometimes called *EV Compensation*. (The *EV* stands for *exposure value*.) This feature tells the camera to produce a darker or lighter exposure than its autoexposure mechanism thinks is appropriate. Here's how it works:

Exposure compensation is stated in EV values, as in +2.0 EV. Possible values range from +5.0 EV to -5.0 EV.

- ✓ Each full number on the EV scale represents an exposure shift of one *full stop*. In plain English, it means that if you change the Exposure Compensation setting from EV 0.0 to EV −1.0, the camera adjusts exposure settings to result in half as much light as the current settings. If you raise the value to EV +1.0, the settings are adjusted to double the light.
- ✓ A setting of EV 0.0 results in no exposure adjustment.
- For a brighter image, raise the EV value. For a darker image, lower it.

Exposure compensation is especially helpful when your subject is lighter or darker than the background. For example, see the first image in Figure 7-21. Because of the bright sky, the camera chose an exposure that made the tree too dark. Setting the Exposure Compensation value to EV +1.0 resulted in a properly exposed tree.

EV +1.0

Figure 7-21: For a brighter exposure than the autoexposure mechanism chooses, dial in a positive Exposure Compensation value.

Sometimes you can cope with situations like this one by changing the Metering mode setting, as discussed earlier in this chapter. The images in Figure 7-21 were metered in Evaluative mode, for example, which meters exposure over the entire frame. Switching to Partial or Spot metering probably wouldn't have helped in this case because the center of the frame was bright. In any case, I find it easier to simply adjust Exposure Compensation than to experiment with metering modes.

You can take several roads to applying exposure compensation. Here are the two most efficient:

Quick Control dial: First, make sure that the Lock switch under the dial is set to the unlocked position. Next, wake up the exposure system by pressing the shutter button halfway and releasing it. Now rotate the Ouick Control dial to adjust the Exposure Compensation value. As you do, the meter in the LCD panel and Shooting Settings display updates to show you the current setting, as shown in Figure 7-22.

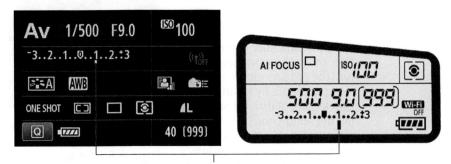

Exposure Compensation amount

Figure 7-22: The meter indicates the current level of Exposure Compensation in the P, Tv, and Av exposure modes.

I find it really easy to rotate the dial by accident and change the Exposure Compensation setting without being aware of my mistake. For this reason, I keep the Lock switch set to the Lock position until I'm in need of Exposure Compensation.

Quick Control screen: Highlight the exposure meter and rotate the Ouick Command dial to move the exposure indicator left or right along the meter. For this technique, the position of the dial's Lock switch is irrelevant; rotating the dial moves the indicator along the meter even when the dial is locked.

You can also follow one of these two paths:

- ✓ **Shooting Menu 2:** Select Expo. Comp/AEB, as shown in Figure 7-23.
- Quick Control screen: Tap the exposure meter or highlight it and then press Set.

Either way, you see the screen shown in Figure 7-24. This is a tricky screen, so pay attention:

- The screen has a double purpose: You use it to enable automatic exposure bracketing (AEB) as well as exposure compensation. If you're not careful, you can change the wrong setting.
- To apply exposure compensation, move the exposure indicator (the red line on the meter) along the scale by rotating the Quick Control dial, by pressing the Multi-controller left or right, or tapping the plus or minus signs, labeled Exposure Compensation controls in the figure. If you rotate the Main dial, you adjust the AEB setting instead.

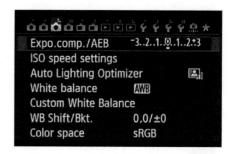

Figure 7-23: You also can apply the adjustment via this menu option.

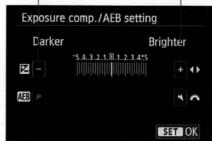

Figure 7-24: Be careful that you adjust Exposure Compensation and not AEB (Auto Exposure Bracketing).

Tap Set or press the Set button to lock in the amount of exposure compensation and exit the screen.

When you dial in an adjustment of greater than three stops, the notch under the viewfinder meter disappears and is replaced by a little triangle at one end of the meter — at the right end for a positive Exposure Compensation value and at the left for a negative value. However, the meter on the Shooting Settings screen and on Shooting Menu 2 adjust to show the proper setting.

The way that the camera arrives at the brighter or darker image you request depends on the exposure mode:

- In Av (aperture-priority) mode, the camera adjusts the shutter speed but leaves your selected f-stop in force.
- ✓ In Tv (shutter-priority) mode, the camera opens or stops down the aperture, leaving your selected shutter speed alone.
- In P (programmed autoexposure) mode, the camera decides whether to adjust aperture, shutter speed, or both.

These explanations assume that you have a specific ISO setting selected rather than Auto ISO. If you use Auto ISO, the camera may adjust that value instead.

A final, and critical, point about exposure compensation: When you power off the camera, it doesn't return you to a neutral setting (EV 0.0). The setting you last used remains in force until you change it, so always zero out the setting at the end of a shoot.

Improving high-contrast shots

When a scene contains both very dark and very bright areas, achieving a good exposure can be difficult. If you choose exposure settings that render the shadows properly, the highlights are often overexposed, and if you go the other direction, you lose detail in the shadows. Your camera offers three tools to try in this situation:

- ✓ HDR Backlight Control mode: This mode, which you access through the SCN setting on the Mode dial, captures three images at different exposures and blends them for a final result that contains a greater tonal range (range of shadows to highlights) than can be captured in a single frame. It's easy to use (Chapter 3 provides details), but like all the fully automated modes, it prevents you from accessing the other exposure, color, and focus options available in the advanced exposure modes.
- Highlight Tone Priority: This option, explained next, takes a single shot but in a manner that renders highlights better without losing shadow detail.
- ✓ HDR mode: Like HDR Backlight Control mode, this mode captures three images at three different exposures and blends the three into a single image. The difference is that you have control over how much exposure varies between frames in this mode. Keep thumbing through the chapter for details.

Enabling Highlight Tone Priority

Figure 7-25 offers an example of a subject that can benefit from Highlight Tone Priority. In the left image, the dark lamppost in the foreground looks fine, but

the white building behind it became so bright that all detail was lost. The same thing occurred in the highlight areas of the green church steeple. In the right image, captured using Highlight Tone Priority, the difference is subtle, but if you look at that white building and steeple, you can see that the effect does make a difference. Now the windows in the building are at least visible, the steeple has regained some of its color, and the sky, too, has a bit more blue.

Highlight Tone Priority off

Highlight Tone Priority on

Figure 7-25: The Highlight Tone Priority feature can help prevent overexposed highlights.

This feature is turned off by default, which may seem like an odd choice after looking at the improvement it made to the scene in Figure 7-25. What gives? The answer is that in order to do its thing, Highlight Tone Priority needs to play with a few other camera settings, as follows:

✓ The ISO range is reduced to ISO 200–12800 (up to ISO 6400 for movies). The camera needs the more limited range in order to favor the image highlights. Losing the highest ISO is no big deal — the noise level at that setting can make your photo unattractive anyway. But in bright light, you may miss the option of lowering the ISO to 100 because you may be forced to use a smaller aperture or a faster shutter speed than you like.

- Auto Lighting Optimizer is disabled. This feature, which attempts to improve image contrast, is incompatible with Highlight Tone Priority. So read the upcoming section that explains Auto Lighting Optimizer, to determine which of the two exposure tweaks you want to use.
- Shadows may exhibit slightly more noise. Again, noise is the defect that looks like speckles in your image.

Enable Highlight Tone Priority via Shooting Menu 4, shown in Figure 7-26. Note that the "on" option is indicated by a D+ symbol — the *D* stands for *dynamic range*, which is the tech term for the tonal range of an image. So, D+ equals greater dynamic range.

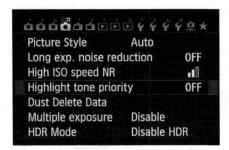

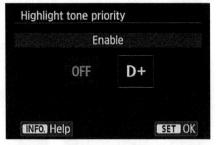

Figure 7-26: Enable Highlight Tone Priority from Shooting Menu 4.

As a reminder that Highlight Tone Priority is enabled, a D+ symbol appears near the ISO value in the Shooting Settings display, as shown in Figure 7-27. The same symbol appears in the viewfinder and LCD panel. Notice in Figure 7-27 that the symbol that represents Auto Lighting Optimizer is dimmed because that feature is automatically disabled when you turn on Highlight Tone Priority.

Exploring automated HDR photography

HDR mode works similarly to the HDR Backlight Control Scene mode that I cover in Chapter 3: The camera auto-

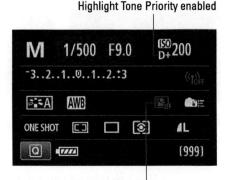

Auto Lighting Optimizer disabled

Figure 7-27: These symbols indicate that Highlight Tone Priority is enabled and Auto Lighting Optimizer is disabled.

matically records three images at different exposures and then blends the three to create a photograph that contains a broader range of shadows and highlights than could be captured with a single exposure.

Figure 7-28 offers an example of the difference the feature can make. In the left shot, I exposed the scene for the exterior, which left the interior too dark. For the middle image, I exposed for the interior, but now the view out the doors becomes way too bright — notice that the pool water is no longer visible. To produce the final image, I enabled HDR mode. Is it perfect? Not in my eyes: I'd like that interior to be slightly brighter and the exterior to be a tad darker. But because the HDR mode limits the shift between frames to a maximum of 3 stops, this is the best that it could do. Even so, it's a definite improvement over the other two exposures.

Another option for an interior/exterior view like this is to use flash to light the interior. Assuming that the exterior is beyond the reach of the flash, it will be exposed by the ambient light. The problem, as in this case, is that the flash light can be reflected in windows, doors, and in other reflective subjects.

Exposed for highlights

Exposed for shadows

HDR Mode, 3-stop setting

Figure 7-28: HDR mode blends darker and lighter exposures to create a single image that contains more detail in both shadows and highlights.

You can take advantage of HDR mode in P, Tv, Av, M, or C exposure mode. (B mode won't work.) Take these steps:

1. Select JPEG as the file format (Image Quality).

HDR mode is off limits when Raw shooting is enabled. (You can change the Image Quality setting via Shooting Menu 1 or the Quick Control screen; see Chapter 2 for details.)

- 2. Make sure the following features are turned off:
 - AEB (automatic exposure bracketing, Shooting Menu 3)
 - White Balance bracketing (Shooting Menu 3)
 - Multi Shot Noise Reduction (High ISO Speed NR option, Shooting Menu 4)
 - Multiple Exposure (Shooting Menu 4)
- 3. Choose HDR Mode from Shooting Menu 4 to display the HDR Mode menu, as illustrated in Figure 7-29.

Figure 7-29: Set up your HDR shooting session via Shooting Menu 4.

4. Specify the way you want the HDR frames to be recorded via the options shown on the right in Figure 7-29.

The options work as follows:

• Adjust Dyn Range: Select this option to display the menu shown in Figure 7-30. Here, you specify how you want the camera to adjust exposure between frames. At the Auto setting, the camera analyzes the scene and makes the call for you. Or you can specify that you'd like a 1-, 2-, or 3-stop exposure between frames. (I used the 3-stop setting for my example image.)

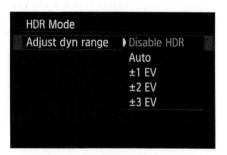

Figure 7-30: You can specify an exposure shift between frames of up to 3 stops.

• *Continuous HDR:* By default, the camera captures just one HDR image and then returns to normal shooting. If you want to record a series of HDR images, set the option to Every Shot instead of 1 Shot Only. The camera remains in HDR mode until you disable the feature.

Auto Image Align: This feature, when enabled, analyzes your three
captures and then fiddles with them to ensure that the images are
aligned as closely as possible. Turn this option on when you're
handholding the camera; when you use a tripod, disable it.

When this feature is enabled, the resulting image area may be slightly less than what you saw through the viewfinder because the camera may need to crop the image slightly in order to align the images. The cropped image is then stretched to fill the frame.

5. Exit the menu, frame, focus, and shoot.

After you release the shutter button, the camera records and blends the three images. The three separate images aren't preserved; you get only the single HDR version.

While HDR is enabled, the letters *HDR* appear on the Shootings Settings screen, as shown in Figure 7-31, as well as next to the exposure meter in the LCD panel.

Note a few more caveats related to this feature:

Enabling HDR mode disables certain other functions.

Specifically, Auto Lighting
Optimizer, Highlight Tone
Priority, and Live View exposure
simulation are unavailable, and
the available ISO range tops out at

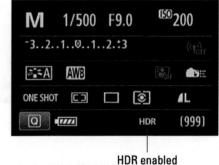

Figure 7-31: This symbol tells you that HDR Mode is enabled.

the available ISO range tops out at ISO 12800 even if you have selected a higher maximum for the ISO range.

- ✓ Flash is unavailable. Even if the built-in flash is raised, it won't fire in HDR mode.
- Moving subjects may appear blurry. The problem occurs if the subject moves within the frame as the three images are being captured. So this feature, as with the HDR Backlight Control mode, is best reserved for stationary subjects.

Experimenting with Auto Lighting Optimizer

When you select one of the JPEG Image Quality settings, the camera tries to enhance your photo while it's processing the picture. By default, the camera applies a feature called Auto Lighting Optimizer, which, in essence, is a contrast enhancement.

In the fully automatic exposure modes as well as in Creative Auto, you have no control over how much adjustment is made. But in the advanced exposure modes, you can decide whether to enable Auto Lighting Optimizer. You also can request a stronger or lighter application of the effect than the default setting. Figure 7-32 offers an example of the impact of each setting.

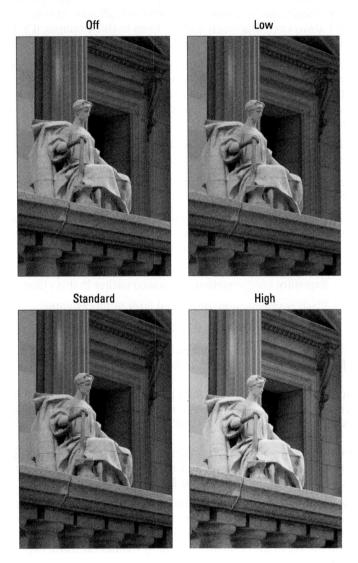

Figure 7-32: For this image, Auto Lighting Optimizer brought more life to the shot by increasing contrast.

Given the level of improvement that the Auto Lighting Optimizer correction made to this photo, you may be thinking that you'd be crazy to ever disable the feature, but note a few points:

- ✓ The level of shift that occurs between each Auto Lighting Optimization setting varies depending on the subject. This particular example shows a fairly noticeable difference between the High and Off settings, but you don't always see this much impact. Even in this example, it's difficult to detect much difference between Off and Low.
- Although the filter improved this scene, you may not find it beneficial. For example, maybe you're purposely trying to shoot a backlit subject in silhouette or produce a low-contrast image. Either way, you don't want the camera to insert its opinions on the exposure or contrast you're trying to achieve.
- Because the filter is applied after the shot, it takes longer for the camera to write the data to the memory card.
- In some lighting conditions, Auto Lighting Optimizer can produce an increase in image noise.
- The corrective action taken by Auto Lighting Optimizer can make some other exposure-adjustment features less effective. So turn it off if you don't see the results you expect when you're using the following features:
 - Exposure compensation, discussed earlier in this chapter
 - · Flash compensation, discussed later in this chapter
 - Automatic exposure bracketing, also discussed later in this chapter
- Auto Lighting Optimizer is unavailable if you enable Highlight Tone Priority, HDR Mode, or Multiple Exposure mode.

By default, the camera applies the Auto Lighting Optimizer feature at the Standard level *except* in M (Manual exposure) and B (Bulb) modes, in which case the feature is turned *off* by default. Here's how to choose a different setting:

✓ Shooting Menu 3: Select the option, as shown on the left in Figure 7-33, to display the screen shown on the right in the figure. Select your choice and then tap Set or press the Set button.

If you *don't* want the feature to be disabled in the M and B exposure modes, tap the Info icon or press the Info button. Doing so removes the check mark from the Disabled in M or B Modes option, and the feature is set to the Standard setting by default for those exposure modes.

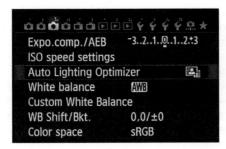

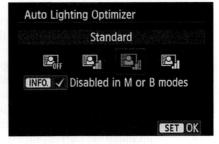

Figure 7-33: You can select the Auto Lighting Optimizer level via Shooting Menu 3.

✓ **Quick Control screen:** After highlighting the option, labeled in Figure 7-34, rotate the Main dial or Quick Control dial to set the level of adjustment. Or tap the option's symbol to access the same setup screen shown on the right in Figure 7-33.

Notice the little vertical bars that appear as part of the setting icon — the number of bars tells you how much adjustment is being applied. Two bars, as in Figure 7-34, represent the Standard setting; three bars,

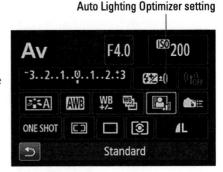

Figure 7-34: You also can adjust the setting via the Quick Control screen.

High, and one bar, Low. The bars are replaced by the word *Off* when the feature is disabled.

If you're not sure what level of Auto Lighting Optimization might work best or you're concerned about the other drawbacks of enabling the filter, consider shooting the picture in the Raw file format. For Raw pictures, the camera applies no post-capture tweaking, regardless of whether this filter or any other one is enabled. Then, by using Canon Digital Photo Professional, the software provided free with the camera, you can apply the Auto Lighting Optimizer effect when you convert your Raw images to a standard file format. (See Chapter 6 for details.)

Correcting vignetting with Peripheral Illumination Correction

Because of some optical science principles that are too boring to explore, some lenses produce pictures that appear darker around the edges of the frame than in the center, even when the lighting is consistent throughout.

This phenomenon goes by several names, but the two heard most often are *vignetting* and *light fall-off*. How much vignetting occurs depends on the lens, your aperture setting, and the lens focal length.

To help compensate for vignetting, your camera offers Peripheral Illumination Correction, which adjusts image brightness around the edges of the frame. Figure 7-35 shows an example. In the left image, just a slight amount of light fall-off occurs at the corners, most noticeably at the top of the image. The right image shows the same scene with Peripheral Illumination Correction enabled.

Peripheral Illumination Correction off

Figure 7-35: Peripheral Illumination Correction tries to correct the corner darkening that can occur with some lenses.

Now, this "before" example hardly exhibits serious vignetting — it's likely that most people wouldn't even notice if it weren't shown next to the "after" example. But if you're a stickler for this sort of thing or your lens suffers from stronger vignetting, it's worth trying Peripheral Illumination Correction.

The adjustment is available in all your camera's exposure modes, but a few factoids need spelling out:

- ✓ The correction is applied only to photos captured in the JPEG file format. For Raw photos, you can apply the correction during the Raw conversion process if you use Canon Digital Photo Professional or the incamera Raw conversion tool, as detailed in Chapter 6.
- For the camera to apply the proper correction, data about the lens must be included in the camera's *firmware* (internal software). You can determine whether your lens is supported by opening Shooting Menu 2 and selecting Lens Aberration Correction, as shown on the left in Figure 7-36. You then see the right screen in the figure. If the screen reports that correction data is available, as in the figure, the Peripheral Illumination Correction feature is enabled by default. (See Chapter 8 for information about the Chromatic Aberration feature, which deals with a lens-related color defect.)

Figure 7-36: If the camera has information about your lens, you can enable the feature.

If your lens isn't supported, you may be able to add its information to the camera; Canon calls this step "registering your lens." You do this by cabling the camera to your computer and then using some tools included with the free EOS Utility software, also provided with your camera. I must refer you to the software manual for help on this bit of business because of the limited number of words that can fit in these pages. (The manuals for all the software are located on one of the CDs that ship in the camera box.)

✓ For non-Canon lenses, Canon recommends disabling Peripheral Illumination Correction even if correction data is available. Just set the menu option to Disable.

✓ In some circumstances, the correction may produce increased noise at the corners of the photo. This problem occurs because exposure adjustment can make noise more apparent. At high ISO settings, which also cause noise, the camera applies the filter at a lesser strength to avoid adding even more noise.

Dampening noise

Noise, the defect that gives your pictures a speckled look (refer to Figure 7-6), can occur for two reasons: a long exposure time and a high ISO setting. Your camera offers two noise-removal filters, one to address each cause of noise; the next two sections provide details. However, you can control whether and how they're applied only in the advanced exposure modes; in other modes, the camera makes the call for you.

Long Exposure Noise Reduction

This filter, found on Shooting Menu 4 and featured in Figure 7-37, goes after the type of noise that's caused by a slow shutter speed. The settings work as follows:

- Off: No noise reduction is applied. This setting is the default.
- Auto: Noise reduction is applied when you use a shutter speed of 1 second or longer, but only if the camera detects the type of noise that's caused by long exposures.

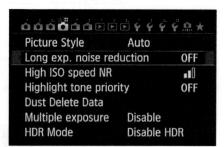

Figure 7-37: This filter attacks noise that can occur when you use a very slow shutter speed.

✓ **On:** Noise reduction is always applied at exposures of 1 second or longer. (*Note:* Canon suggests that this setting may result in more noise than either Off or Auto when the ISO setting is 1600 or higher.)

Long Exposure Noise Reduction can be fairly effective, but it has a significant downside because of the way it works. Say that you make a 30-second exposure. After the shutter closes at the end of the exposure, the camera takes a second 30-second exposure to measure the noise by itself, and then subtracts that noise from your real exposure. So your shot-to-shot wait time is twice what it would normally be. For some scenes, that may not be a problem, but for shots that feature action, such as fireworks, you definitely don't want that long wait time between shutter clicks.

High 150 Speed Noise Removal

This filter, also found on Shooting Menu 4 and spotlighted in Figure 7-38, attempts to do just what its name implies: eradicate the kind of noise that's caused by using a very high ISO setting. You can select from these settings:

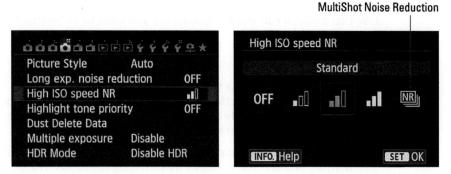

Figure 7-38: The MultiShot setting captures four images and merges them into a single JPEG file.

- Low: Applies a little noise removal.
- Standard: Applies a more pronounced amount of noise removal; this setting is the default.
- ✓ High: Goes after noise in a more dramatic way.
- MultiShot: Tries to achieve a better result than High by capturing four frames in a quick burst and then merging them together into a single JPEG shot. (More about this option momentarily.)
- Off: Turns off the filter.

As with the Long Exposure Noise Reduction filter, this one is applied after you take the shot, slowing your capture rate. In fact, using the High or MultiShot setting reduces the maximum frame rate (shots per second).

It's also important to know that High ISO noise-reduction filters work primarily by applying a slight blur to the image. Don't expect this process to eliminate noise entirely, and expect some resulting image softness. You may be able to get better results by using the blur tools or noise-removal filters found in many photo editors because then you can blur just the parts of the image where noise is most noticeable — usually in areas of flat color or little detail, such as skies.

So what about this mysteriously named MultiShot setting? Canon promises that this setting delivers a better result than the High setting by capturing a burst of four images and merging them into a single JPEG frame, similar to

the result of using the Handheld Night Scene mode detailed in Chapter 3. Like that mode, it can work very well, but you need to understand these caveats:

- Flash is not possible.
- ✓ The feature is off-limits when any of the following are enabled: Long Exposure Noise Reduction, Auto Exposure Bracketing, White Balance Bracketing, Dust Delete Data, Multiple Exposure, or HDR Mode. You also can't use the feature in B (Bulb) mode.
- The merged images may not align properly, resulting in ghosting or blurring, if there's any camera shake during the exposures. So for best results, use a tripod. In addition, any moving objects may also appear blurry, so this feature works best with still life and landscape shots.
- The setting automatically reverts to Standard if you turn off the camera, switch to a fully automatic exposure mode or Movie mode, or set the exposure mode to Bulb.
- ✓ Direct printing of shots taken with this setting isn't possible. Okay, so that's not a biggie for most folks; see Chapter 10 for more information

about direct printing (available via the Print Order option on Playback Menu 1).

Your end result is a JPEG photo, even if the Image Quality setting is set to Raw or Raw+JPEG. So if you're a Raw fan, don't use this setting.

If you opt for the MultiShot setting, you see a little multi-box symbol in the Shooting Settings screen, as shown in Figure 7-39. The same symbol appears in the LCD panel.

MultiShot Noise Reduction enabled

Figure 7-39: This symbol represents MultiShot Noise Reduction.

Locking Autoexposure Settings

When you combine Spot, Partial, or Center-weighted metering with the P, Tv, or Av exposure modes, your camera continually meters the light until the moment you press the shutter button fully to shoot the picture. The same thing happens with Evaluative metering if you use Live View.

For most situations, this approach works great, resulting in the right settings for the light that's striking your subject when you capture the image. But on occasion, you may want to lock in a certain combination of exposure settings. For example, perhaps you want your subject to appear at the far edge of the frame. If you were to use the normal shooting technique, you would place the subject under a focus point, press the shutter button halfway to lock focus and set the initial exposure, and then reframe to your desired composition to take the shot. The problem is that exposure is then recalculated based on the new framing, which can leave your subject under- or overexposed.

The easiest way to lock in exposure settings is to switch to M (manual exposure) mode and use the same f-stop, shutter speed, and ISO settings for each shot. In manual exposure mode, the camera never overrides your exposure decisions; they're locked until you change them.

But if you prefer to use autoexposure, you can lock the current exposure settings by pressing the AE (autoexposure) Lock button while holding the shutter button halfway down. Exposure is locked and remains locked for four seconds, even if you release the AE Lock button and the shutter button. To remind you that AE Lock is in force, the camera displays an asterisk in the viewfinder and Shooting Settings display. If you need to relock exposure, just press the AE Lock button again.

Note: If your goal is to use the same exposure settings for multiple shots, you must keep the AE Lock button pressed during the entire series of pictures. Every time you let up on the button and press it again, you lock exposure anew based on the light that's in the frame.

One other critical point to remember about using AE Lock: The camera establishes and locks exposure differently depending on the metering mode, the focusing mode (automatic or manual), and on an autofocusing setting called AF Point Selection mode. (Chapter 8 explains this option thoroughly.) Here's the scoop:

- Evaluative metering and automatic AF Point Selection: Exposure is locked on the focusing point that achieved focus.
- ✓ Evaluative metering and manual AF Point Selection: Exposure is locked on the selected autofocus point.
- All other metering modes: Exposure is based on the center autofocus point, regardless of the AF Point Selection mode.
- Manual focusing: Exposure is based on the center autofocus point.

By combining autoexposure lock with Spot metering, you can ensure a good exposure for photographs in which you want your subject to be off-center, and that subject is significantly darker or lighter than the background. Imagine, for example, a dark statue set against a light blue sky. First, select Spot metering so that the camera considers only the object located in the center of the frame. Frame the scene initially so that your statue is located in the center of the viewfinder. Press and hold the shutter button halfway to establish focus and then lock exposure by pressing the AE Lock button. Now reframe the shot to your desired composition and take the picture.

Bracketing Exposures Automatically

Many photographers use a strategy called *bracketing* to ensure that at least one shot of a subject is properly exposed. They shoot the same subject multiple times, slightly varying the exposure settings for each image.

To make bracketing easy, your camera offers *Automatic Exposure Bracketing* (AEB). When you enable this feature, your only job is to press the shutter button to record the shots; the camera automatically adjusts the exposure settings between each image. You can record from two to seven shots in your bracketed series (three shots is the default).

Aside from cover-your, uh, "bases" shooting, bracketing is useful for doit-yourself HDR imaging — by which I mean HDR photos that you capture without the help of the HDR Mode or HDR Backlight Control Mode features discussed earlier in this chapter. Of course, you then have to merge the images using HDR software. The payoff is that HDR programs give you control over how the lightest and darkest areas of the image are blended. A popular program in this arena is Photomatix Pro (www.hdrsoft.com).

Whether you're interested in automatic exposure bracketing for HDR or just to give yourself an exposure safety net, keep these points in mind:

Exposure mode: AEB is available only in the P, Tv, Av, M, and C exposure modes.

How the camera arrives at the different exposures depends on your exposure mode. In Av mode, the shutter speed is adjusted and your selected f-stop is maintained, which ensures that depth of field doesn't change between shots. In Tv mode, the f-stop is adjusted; in P mode, the camera may adjust either shutter speed or aperture; in M mode, the camera maintains the selected f-stop if possible and instead varies shutter speed. However, in all cases, if Auto ISO is enabled, the camera may instead choose to vary ISO to achieve the exposure shift.

- ✓ Flash, MultiShot Noise Reduction, and Creative Filters: AEB isn't available when you use these features.
- ✓ Bracketing amount: You can request an exposure change of up to three stops, in 1/3-stop increments.
- Exposure Compensation: You can combine AEB with Exposure Compensation. The camera simply applies the compensation amount when it calculates the exposure for the three bracketed images.
- ✓ **Auto Lighting Optimizer:** Because that feature is designed to automatically adjust images that are underexposed or lacking in contrast, it can render AEB ineffective, so disable the feature when bracketing.

The next two sections explain how to set up the camera for automatic bracketing and how to record your bracketed shots.

Setting up for automatic bracketing

The following steps show you how to turn on automatic exposure bracketing via Shooting Menu 3. (More about another option for enabling the feature momentarily.)

1. Display Shooting Menu 3 and choose Expo. Comp./AEB, as shown on the left in Figure 7-40.

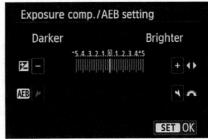

Figure 7-40: Automatic exposure bracketing records your image at three exposure settings.

After you select the option, you see the screen shown on the right in the figure. This is the same dual-natured screen that appears when you apply exposure compensation, as explained earlier in this chapter. The figure shows the screen as it appears in the P, Tv, or Av modes.

In M mode, exposure compensation isn't relevant. If you want a darker or brighter image, you just adjust the f-stop, shutter speed, or ISO. So the Exposure Compensation controls are dimmed on the Exp. Comp/AEB screen if the Mode dial is set to M. (What you see in C mode depends on the exposure mode on which you based that custom mode.)

2. Rotate the Main dial to establish the amount of exposure change you want between images.

What you see onscreen after you rotate the dial depends on your exposure mode.

• P. Tv. or Av modes: You see the scale for both the **Exposure Compensation** value and the AEB amount. The top meter expands. as shown in Figure 7-41, to show a range of \pm 8 stops. Where does the 8-stop thing come from? Well, if you turn on Exposure Compensation and set that value to +5.0 and then set the bracketed amount to +3.0, your brightest shot in the bracketed series is captured at +8.0. Your darkest

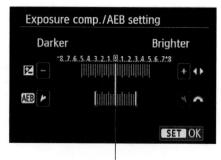

Autoexposure bracketing amount

Figure 7-41: To set the bracketing amount, rotate the Main dial.

shot is captured at +2.0, and the "neutral" shot is captured at +5.0.

• *M mode*: In this exposure mode, only the AEB setting is active.

Either way, each whole number on the meter represents one stop. The red lines under the meter show the amount of shift that will occur in your bracketed series. For example, the settings in Figure 7-41 represent three stops of adjustment.

3. Tap Set or press the Set button.

AEB is now enabled. To remind you of that fact, the exposure meter for the menu item shows the three exposure indicators to represent the exposure shift you established in Step 2, as shown in Figure 7-42. You see the same markers with the meter in the viewfinder, LCD panel, and Shooting Settings display. In addition, you see three little boxes in the LCD panel, just to the right of the exposure meter.

Figure 7-42: The three bars under the meter remind you that automatic exposure bracketing is enabled.

If you prefer, you can also enable AEB through the Quick Control screen. Just tap the exposure meter (or highlight it and press Set) to access the screen you see in Figure 7-41, where you can set the amount of bracketing.

To turn off auto exposure bracketing, change the AEB setting to 0.

In addition to specifying the amount of exposure adjustment between frames, you can customize certain aspects of the bracketing feature through the following options, all residing in the Exposure section of the Custom Functions menu:

- ✓ C. Fn I-3: Bracketing Auto Cancel: By default, AEB is automatically turned off when you shut off the camera, engage the flash, or switch to Movie mode. But if you select Off for this option, the AEB function remains enabled even if you turn the camera off. If you use flash or set the camera to Movie mode, the AEB function is cancelled only while you're using those features.
- ✓ C. Fn I-4: Bracketing Sequence: By default, the camera records your first exposure at the neutral exposure, the second at the darker exposure, and the third at the brightest exposure. By selecting option 1 for this menu setting, you get the darkest exposure first, the neutral exposure second, and the brightest exposure last. Option 2 takes things in the other direction.
- C. Fn I-5: Number of Brackets Shots: Shown in Figure 7-43, this Custom Function enables you to set the number of pictures captured in each bracketed series. Here's what you get at each setting:
 - 3 shots: This is the default; you get one shot at neutral, one darker shot, and one brighter shot.
 - 2 shots: One neutral exposure and one brighter or darker, depending on the bracketing amount you set in Step 2.
- C.Fn I :Exposure
 Number of bracketed shots

 0:3 shots
 1:2 shots
 2:5 shots
 3:7 shots

Figure 7-43: You can vary the number of bracketed shots through this Custom Function.

- 5 shots: One neutral exposure, two incrementally darker shots, and two incrementally brighter shots.
- 7 shots: One neutral exposure, and three incrementally brighter and three incrementally darker exposures.

Shooting a bracketed series

After you enable auto bracketing, the way you record your bracketed exposures depends on whether you set the Drive mode to Single or one of the Continuous modes. (Press the Drive button on top of the camera to adjust the Drive mode setting.)

- ✓ AEB in Single mode: You take each exposure separately, pressing the shutter button fully each time to record your series of images.
- ✓ AEB in Continuous modes: The camera records all exposures with one press of the shutter button. To record another series, release and then press the shutter button again.
- ✓ **Self-Timer/Remote modes:** All exposures are recorded with a single press of the shutter button, as with Continuous mode.

Using Flash in Advanced Exposure Modes

Sometimes, no amount of fiddling with aperture, shutter speed, and ISO produces a bright enough exposure — in which case you simply have to add more light. The built-in flash on your camera offers the most convenient solution.

Chapter 2 offers a primer in flash basics, but here's a quick recap:

✓ In Scene Intelligent Auto and Creative Auto modes, you can set the flash to on, off, or auto (the camera decides whether flash is needed). Some Scene (SCN) modes also give you this choice. Set the flash mode via the Ouick Control screen.

The advanced exposure modes leave flash decisions up to you. If you want to use the built-in flash, press the Flash button on the left side of the camera. The flash pops up and fires on your next shot. To turn off the flash, just press down on the flash assembly to close it.

In order for the flash to fire, though, it must be enabled via the Flash Control option on Shooting Menu 2. After selecting that option, as shown on the left in Figure 7-44, set Flash Firing to Enable (the default setting), as shown on the right. For details about the other options on the menu, see the upcoming section, "Exploring more flash options." To restore all the flash options to their defaults, use the Clear Settings option on the menu.

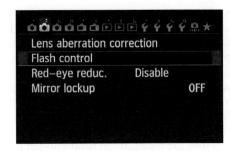

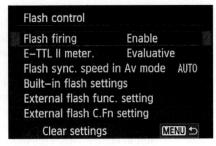

Figure 7-44: Make sure that flash is enabled via this menu option.

You can set the flash to Red-Eye Reduction mode via Shooting Menu 2. When you take a picture with the feature enabled, the camera lights the Red-Eye Reduction lamp on the front of the camera for a brief time before the flash goes off in an effort to constrict the subject's pupils and thereby lessen the chances of red-eye. See Chapter 2 for a few more pointers about using this feature.

- When you use the built-in flash, the fastest shutter speed possible is 1/250 second. The limitation is needed for the camera to synchronize the timing of the flash with the opening and closing of the shutter. So, fast-action photography and the built-in flash really aren't compatible. (If you use some compatible external flash units, you can access the entire range of shutter speeds.) This flash feature is known as high-speed sync.
- Pay careful attention to your results when you use the built-in flash with a long telephoto lens. You may find that the flash casts an unwanted shadow when it strikes the lens. For best results, try switching to an external flash head.

The next section goes into a little background about how the camera calculates flash power. This stuff is a little technical, but it will help you to understand how to get the results you want. Following that discussion, the rest of the chapter covers advanced flash features.

Understanding your camera's approach to flash

When you use flash, your camera automatically calculates the flash power needed to illuminate the subject. This process is sometimes referred to as *flash metering*. Your camera uses a flash-metering system that Canon calls E-TTL II. The *E* stands for *evaluative*, *TTL* stands for *through the lens*, and

II refers to the fact that this system is an update to the first version of the system. It isn't important that you remember what the initials stand for or even the flash system's official name. What is helpful to keep in mind is how the system is designed to work.

First, you need to know that a flash can be used either as the primary light source or as a fill flash. When flash is the primary light source, both the subject and background are lit by the flash. In dim lighting, this typically results in a brightly lit subject and a dark background, as shown on the left in Figure 7-45. This assumes that the background is far enough from the subject that it's beyond the reach of the flash, of course.

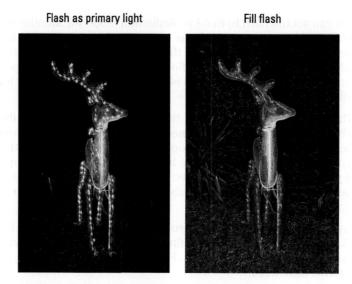

Figure 7-45: Fill flash produces brighter backgrounds.

With fill flash, the background is exposed primarily by ambient light, and the flash adds a little extra illumination to the subject. Fill flash typically produces brighter backgrounds and, often, softer lighting of the subject because not as much flash power is needed. The downside is that if the ambient light is dim, as in this nighttime example, you need a slow shutter speed to properly expose the image, and both the camera and the subject must remain still to avoid blurring. The shutter speed for the fill-flash image, shown on the right in Figure 7-45, was 1/30 second. Fortunately, I had a tripod, and the

deer was happy to stay perfectly still as long as I needed. Well, at least until the wind whipped up later that night and, sadly, blew him a few feet down the driveway.

Neither flash approach is right or wrong: Whether you want a dark background depends on the scene. If you want to diminish the background, you may prefer the darker background you get when you use flash as your primary light source. But if the background is important to the context of the shot, allowing the camera to absorb more ambient light and adding just a bit of fill flash may be more to your liking.

So how does this little flash lesson relate to your camera? Well, the exposure mode you use (P, Tv, Av, or M) determines whether the flash operates as a fill flash or as the primary light source. The exposure mode also controls the extent to which the camera adjusts the aperture and shutter speed in response to the ambient light in the scene.

In all modes, the camera analyzes the light both in the background and on the subject. Then it calculates the exposure and flash output as follows:

- P: In this mode, the shutter speed is automatically set between 1/60 and 1/250 second. If the ambient light is sufficient, the flash output is geared to providing fill-flash lighting. Otherwise, the flash is determined to be the primary light source, and the output is adjusted accordingly. In the latter event, the image background may be dark, as in the left example in Figure 7-45, depending on its distance from the flash.
- ✓ **Tv:** After you select a shutter speed, the camera determines the proper aperture to expose the background with ambient light. Then it sets the flash power to provide fill-flash lighting to the subject.
 - You can select a shutter speed between 30 seconds and 1/250 second. If the aperture (f-stop) setting blinks, the camera can't expose the background properly at the shutter speed you selected. You can adjust either the shutter speed or ISO to correct the problem.
- ✓ **Av:** After you set the f-stop, the camera selects the shutter speed needed to expose the background using ambient light. The flash power is geared to fill in shadows on the subject.

Depending on the ambient light and your selected f-stop, the camera sets the shutter speed at anywhere from 30 seconds to 1/250 second. So be sure to note the shutter speed before you shoot — at slow shutter speeds, you may need a tripod to avoid camera shake. Your subject also must remain still to avoid blurring.

If you want to avoid the possibility of a slow shutter speed, visit Shooting Menu 2, choose Flash Control, and then choose the Flash Sync. Speed in AV Mode option, as shown in Figure 7-46. At the default setting, Auto, the camera operates as just described. You also have two other choices: 1/250-1/60 Sec. Auto (tells the camera to choose any shutter speed between 1/60 and 1/250 second) and 1/250 Sec. (fixed) (restricts the camera to *always* setting the shutter speed to 1/250 second when you use flash in Av mode).

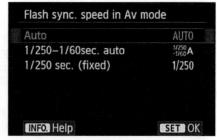

Figure 7-46: You can limit the camera to a fast shutter speed when using Av mode with flash.

The latter two options both ensure that you can handhold the camera without blur, but obviously, in dim lighting, it can result in a dark background because the camera doesn't have time to soak up much ambient light.

- ✓ M: In this mode, the shutter speed, aperture, and ISO setting you select determine how brightly the background will be exposed. The camera takes care of illuminating the subject with fill flash. The maximum shutter speed you can select is 1/250 second; the slowest is 30 seconds.
- ✓ B (Bulb): In Bulb mode, which keeps the shutter open as long as you keep the shutter button pressed, the flash fires at the beginning of the exposure if the Shutter Sync setting is set to the 1st Curtain setting; with the 2nd Curtain setting, the flash fires at the beginning of the exposure and again at the end. You access this control by choosing Built-in Flash Settings from the screen shown on the left in Figure 7-46; see the last section of the chapter for more details.

If the flash output in any mode isn't to your liking, you can adjust it by using flash exposure compensation, explained a little later in this chapter. Also check out the upcoming section "Locking the flash exposure" for another trick to manipulate flash results. In any autoexposure mode, you can also use

exposure compensation, discussed earlier, to tweak the ambient exposure — that is, the brightness of your background. The big takeaway is that you have multiple points of control: exposure compensation to manipulate the background brightness, and flash compensation and flash exposure lock to adjust the flash output.

Again, these guidelines apply to the camera's built-in-flash. If you use certain Canon external flash units, you not only have more flash control but can also select a faster shutter speed than the built-in flash permits.

Using flash outdoors

Although most people think of flash as a tool for nighttime and low-light photography, adding a bit of light from the built-in flash can improve close-ups and portraits that you shoot outdoors during the day. After all, your main light source — the sun — is overhead, so although the top of the subject may be adequately lit, the front typically needs some additional illumination. And if your subject is in the shade, getting no direct light, using flash is even more critical. For example, the two photos in Figure 7-47 show you the same scene, captured with and without flash. The fruit stand was shaded by an awning, so even though it was a bright, cloudless day, I popped up the built-in flash to bring just a smidge more light to the scene and produce a better result.

Without flash

With flash

Figure 7-47: Flash often improves daytime pictures outdoors.

You do need to be aware of a couple issues that can arise when you supplement the sun with the built-in flash:

- You may need to make a White Balance adjustment. Adding flash may result in colors that are slightly warmer (more yellow/red), as in the flash example here, or cooler (bluish) because the camera's white balancing system can get tripped up by mixed light sources. If you don't appreciate the shift in colors, see Chapter 8 to find out how to make a white balance adjustment to solve the problem.
- You may need to stop down the aperture or lower ISO to avoid over-exposing the photo. The top shutter speed for the built-in flash, 1/250 second, may not be fast enough to produce a good exposure in very bright light when you use a wide-open aperture, even if you use the lowest possible ISO setting. If you want both flash *and* the short depth of field that comes with an open aperture, you can place a neutral density filter over your lens. This accessory reduces the light that comes through the lens without affecting colors. In addition, some Canon external flash units enable you to access the entire range of shutter speeds on the camera.

Adjusting flash power with Flash Exposure Compensation

When you shoot with flash, the camera attempts to adjust the flash output to produce a good exposure in the current lighting conditions. On some occasions, you may find that you want a little more or less light than the camera thinks is appropriate.

You can adjust the flash output by using the Flash Exposure Compensation feature. Similar to exposure compensation, discussed earlier in this chapter, flash exposure compensation affects the output level of the flash unit, whereas exposure compensation affects the brightness of the background in your flash photos. As with exposure compensation, flash exposure compensation is stated in terms of EV (exposure value) numbers. A setting of 0.0 indicates no flash adjustment; you can increase the flash power to +3.0 or decrease it to -3.0.

Figure 7-48 shows an example of the benefit of this feature — again, available only when you shoot in the advanced exposure modes. The first image shows a flash-free shot. Clearly, a little more light was needed, but at normal flash power, the flash was too strong, blowing out the highlights in some areas, as

shown in the middle image. Reducing the flash power to EV -1.3, resulted in a softer flash that straddled the line perfectly between no flash and too much flash.

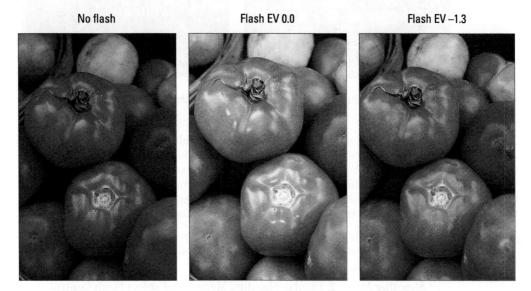

Figure 7-48: When normal flash output is too strong, lower the Flash Exposure Compensation value.

As for boosting the flash output, well, you may find it necessary on some occasions, but don't expect the built-in flash to work miracles even at a Flash Exposure Compensation of +3.0. Any built-in flash has a limited range, so the light simply can't reach faraway objects.

Whichever direction you want to go with flash power, you have two ways to do so:

✓ Quick Control screen: This path is by far the easiest. Highlight the Flash Exposure Compensation value, as shown on the left in Figure 7-49, and then rotate the Main dial or Quick Control dial to set the amount of flash adjustment. Or if you prefer to do things the hard way, tap the icon or press Set to display the second screen in the figure, where you can adjust the setting by using the Main dial, Quick Control dial, or Multicontroller; dragging your finger along the scale; or tapping the Brighter and Darker arrows. Tap the return arrow or press Set when you finish.

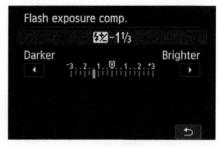

Figure 7-49: The quickest way to adjust flash power is via the Quick Control screen.

When flash compensation is in effect, the value appears in the Shooting Settings screen, in the area occupied by the icon in the left screen in Figure 7-49. You see the same plus/minus flash symbol in the view-finder but without the actual value. If you change the Flash Exposure Compensation value to zero, the flash-power icon disappears from all the displays until you enter Quick Control mode again.

Unfortunately, this method of setting flash power isn't available in Live View mode; for Live View shooting, trudge through the steps outlined next.

✓ **Shooting Menu 2:** Display Shooting Menu 2 and select Flash Control to display the left screen shown in Figure 7-50. Choose Built-in Flash Settings to display the right screen. Now choose Flash Exp. Comp., as shown on the right in the figure, to display the same adjustment screen shown on the right in Figure 7-49.

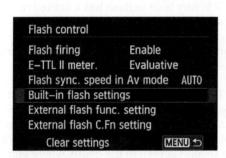

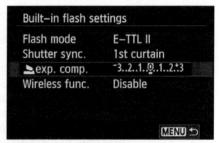

Figure 7-50: You can also change flash power by using the menus, but it's a tedious task.

As with exposure compensation, any flash-power adjustment you make remains in force until you reset the control, even if you turn off the camera. So be sure to check the setting before using your flash. Additionally, the Auto Lighting Optimizer feature, covered earlier in this chapter, can interfere with the effect produced by flash exposure compensation, so you might want to disable it.

Locking the flash exposure

You might never notice it, but when you press the shutter button to take a picture with flash enabled, the camera emits a brief "preflash" before the actual flash. This preflash is used to determine the proper flash power needed to expose the image.

Occasionally, the information that the camera collects from the preflash can be off-target because of the assumptions the system makes about what area of the frame is likely to contain your subject. To address this problem, your camera has a feature called *Flash Exposure Lock*, or FE Lock. This tool enables you to set the flash power based on only the center of the frame.

Unfortunately, FE Lock isn't available in Live View mode. If you want to use this feature, you must abandon Live View and use the viewfinder to frame your images.

After raising the flash, follow these steps to use FE Lock:

1. Frame your photo so that your subject is in the center of the frame.

You can reframe the shot after locking the flash exposure, if you want.

2. Press the shutter button halfway.

The camera meters the light in the scene. If you're using autofocusing, focus is set on your subject. (If focus is set on another spot in the frame, see Chapter 8 to find out how to select the center autofocus point.) You can now lift your finger off the shutter button, if you want.

3. Press and release the AE Lock button.

The camera emits the preflash, and the letters FEL display for a second in the viewfinder. (FEL stands for *Flash Exposure Lock*.) You also see the asterisk symbol — the one that appears above the AE Lock button on the camera body — next to the flash icon in the viewfinder.

4. If needed, reestablish focus on your subject.

In autofocus mode, press and hold the shutter button halfway. (Take this step only if you released the shutter button after Step 2.) In manual focus mode, twist the focusing ring on the lens to establish focus.

5. Reframe the image to the composition you want.

While you do, keep the shutter button pressed halfway to maintain focus if you're using autofocusing.

6. Press the shutter button the rest of the way.

The image is captured using the flash output setting you established in Step 3.

Flash Exposure Lock is also helpful when you're shooting portraits. The preflash sometimes causes people to blink, which means that with normal flash shooting, in which the actual flash and exposure occur immediately after the preflash, their eyes are closed at the exact moment of the exposure. With FE Lock, you can fire the preflash and then wait a second or two for the subject's eyes to recover before you take the actual picture.

Better yet, the flash exposure setting remains in force for about 16 seconds, meaning that you can shoot a series of images using the same flash setting without firing another preflash at all.

Exploring more flash options

When you set the Mode dial to the advanced exposure modes, Shooting Menu 2 offers a Flash Control option. Using this menu item, you can adjust flash power, as I explain a couple of sections earlier (although using the Quick Control screen is easier). The Flash Control option also enables you to customize a few other aspects of the built-in flash as well as control an external flash.

To explore your options, choose Flash Control, as shown on the left in Figure 7-51, to access the screen shown on the right in the figure. Here's the rundown of the available options:

✓ Flash Firing: Normally, this option is set to Enable. If you want to disable the flash, choose Disable. However, you don't have to take this step in most cases — just close the flash if you don't want to use flash.

What's the point of this option, then? Well, if you use autofocusing in dim lighting, the camera may need some help finding its target. To that end, it sometimes emits an AF-assist beam from the flash head. The beam is a series of rapid pulses of light. If you want the benefit of the AF-assist beam but you don't want the flash to fire, disable flash firing. Remember that you have to pop up the flash unit to expose the lamp that emits the beam. You also can take advantage of this option when you attach an external flash head.

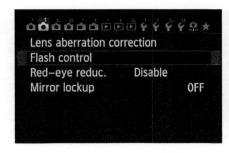

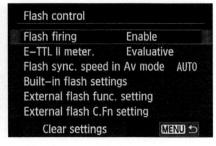

Figure 7-51: You can customize additional flash options via Shooting Menu 2.

- ✓ E-TTL II Meter: This option enables you to switch from the default flash metering approach, called Evaluative. In this mode, the camera operates as described in the earlier section, "Understanding your camera's approach to flash." If you instead select the Average option, the flash is always used as the primary light source. Typically, this results in more powerful (and possibly harsh) flash lighting and dark backgrounds.
- ✓ Flash Sync. Speed in Av Mode: This is the option that prevents the shutter speed from dropping beyond a certain level when you shoot in the Av exposure mode. See "Understanding your camera's approach to flash," earlier in this chapter, for details.
- ✓ Built-in Flash Settings: Select this option, as shown on the left in Figure 7-52, to display the screen shown on the right. The options work like so:
 - Flash mode: This option enables you to set the flash power manually instead of having the camera set it automatically. If you select the option, the Flash Exposure Compensation control on the menu (see the right screen in Figure 7-52) is replaced by a Flash Output option. Set the flash power through that option.
 - *Shutter Sync:* By default, the flash fires at the beginning of the exposure. This flash timing, known as *1st Curtain sync*, is the best choice for most subjects. However, if you use a very slow shutter speed and you're photographing a moving object, 1st Curtain sync causes the blur that results from the motion to appear in front of the object, which doesn't make much visual sense.

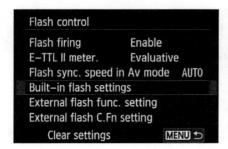

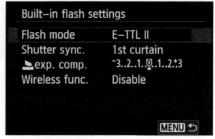

Figure 7-52: These advanced flash options affect only the built-in flash.

To solve this problem, you can change the Shutter Sync option to *2nd Curtain sync*, also known as *rear-curtain sync*. In this flash mode, the motion trails appear behind the moving object. The flash fires twice in this mode: once when you press the shutter button and again at the end of the exposure.

- Flash Exposure Compensation: This setting adjusts the power of the built-in flash; again, see the earlier section "Adjusting flash power with Flash Exposure Compensation" for details.
- Wireless Func.: When you enable this option, you can use the builtin flash to trigger remote flash units. See the sidebar, "Using one flash to control others" for more on this possibility.
- External Flash controls: The last two options on the Flash Control list relate to external flash heads; they don't affect the built-in flash. They apply only to Canon EX-series Speedlites that enable you to control the flash through the camera. Refer to the flash manual for details.
- ✓ Clear Settings: Choose this option to access three settings that restore flash defaults. The first one, Clear Built-in Flash Set, restores the settings for the built-in flash. Sorry, you probably could have figured that out for yourself. The second option restores defaults for external flash settings, and the third restores the external flash head's Custom Function menu settings.

You can probably discern from these descriptions that most of these features are designed for photographers schooled in flash photography who want to mess around with advanced flash options. If that doesn't describe you, don't worry about it. The default settings selected by Canon will serve you well in most every situation — the exception is flash exposure compensation, which you can just as easily adjust via the Quick Control screen instead of digging through the menus.

Using one flash to control others

If you're ready to try some multiple-light shooting, you can use your built-in flash to wirelessly trigger off-camera (remote) flash units. You can even set the power of the remote units through the camera's flash options and specify whether you want the built-in flash to simply trigger the other flash heads or add its own flash power to the scene. This option provides great added lighting flexibility without requiring you to spend lots of money (although you certainly can) or carrying around lots of bulky, traditional lighting equipment.

To use this camera function, your external flash units must support wireless control, of course. You can find a list of compatible Canon flash products in the camera manual. You also have to change the Built-in Flash Settings option to one of the available modes under the Wireless Function setting. You get to this option via the Flash Control option on Shooting Menu 2.

Your camera manual offers complete details on setting up the camera and your flash for wireless operation.

Manipulating Focus and Color

In This Chapter

- ▶ Controlling the camera's focusing performance
- Sorting through autofocusing options
- Understanding focal length and depth of field
- Exploring white balance and Picture Styles

o many people, the word *focus* has just one interpretation when applied to a photograph: Either the subject is in focus or it's blurry. But an artful photographer knows that there's more to focus than simply getting a sharp image of a subject. You also need to consider *depth of field*, which is the distance over which focus appears acceptably sharp. This chapter explains all the ways to control depth of field and also discusses how to use your camera's advanced autofocus options.

.

In addition, this chapter dives into the topic of color, explaining *White Balance*, a feature that compensates for the varying color casts created by different light sources, and *Picture Styles*, which affect image sharpness and contrast as well as color.

Note: Focusing information in this chapter relates to viewfinder photography only. Both automatic and manual focusing work differently in Live View and Movie modes, so see Chapter 4 for focusing help when using those features.

Reviewing Focus Basics

Earlier chapters touch on various focus issues. In case you're not reading this book from front to back, the following steps provide a recap of the basic process of focusing using the default options. (The next section explains how to stray from the defaults.)

If the camera is currently in Live View or Movie mode, exit to viewfinder mode before taking Step 1. If you move the focus switch on the lens while the Live View/Movie mode continuous autofocusing system is engaged, you can damage your equipment.

1. Set the focusing switch on the lens to manual or automatic focusing.

For autofocusing with the 18–55mm or 18–135mm kit lens, set the switch to the AF position. For manual focusing, move the focusing switch to the MF position.

2. Set focus:

• To autofocus: In any exposure mode except the Sports Scene mode, frame your subject within the autofocus area brackets, labeled in Figure 8-1. Then press and hold the shutter button halfway. The focus lamp in the viewfinder lights, one or more of focus points flashes red and then turns black, as shown in the figure. to show you which focus points were used. You also hear a beep when focus is achieved.

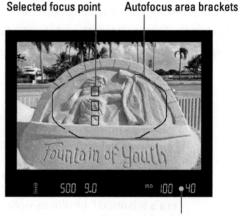

Focus-achieved light

Figure 8-1: The viewfinder offers these focusing aids.

Focus is locked as long as you hold down the shutter button halfway.

The exception to this result happens when you shoot a moving subject in Scene Intelligent Auto, Creative Auto, or Flash Off modes. In this case, the camera adjusts focus as needed up to the time you take the shot. The focus symbol doesn't light but the camera beeps softly to let you know it's still focusing.

Sports mode always uses continuous autofocusing. Frame your subject initially so that it's under the black rectangle that appears at the center of the frame (which represents the active autofocus point) and press and hold the shutter button halfway. You can then reframe as needed as long as you keep the subject within the autofocusing brackets.

Shutter speed and blurry photos

A poorly focused photo isn't always related to the issues discussed in this chapter. Any movement of the camera or subject can also cause blur. Both problems are related to shutter speed, which is an exposure control that I cover in Chapter 7. Also visit Chapter 9, which provides additional tips for capturing moving objects without blur.

In both cases, if the focus light blinks rapidly, the camera can't find a focusing target. Try focusing manually instead.

• For manual focus: Turn the focusing ring on the lens.

Even in the manual-focus mode, you can confirm focus by pressing the shutter button halfway. The autofocus point or points that achieved focus flash for a second, the viewfinder focus lamp lights, and you hear the focus-achieved beep.

Introducing the AF-ON button

If you're nervous about pressing the shutter halfway for fear that you'll accidentally take a photo, allow me to introduce you to the AF-ON button, labeled in Figure 8-2. In the advanced exposure modes (P, Tv, Av, M, B, and C), you can hold down this button to accomplish the same goal as pressing the shutter button halfway. If you're using Evaluative exposure metering, exposure is also locked with your press of the AF-ON button; in other metering modes, exposure is set at the time you fully depress the shutter button, just as when you use the shutter button to set focus. You'll notice that when you do go to take the shot, the shutter button has already lowered its head halfway as if by magic.

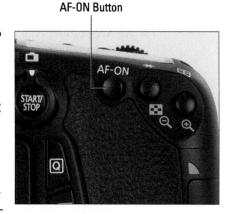

Figure 8-2: You can press the AF-ON button to autofocus instead of pressing the shutter button halfway.

Using the AF-ON button can also save time when you're shooting a series of images of the same subject. If you use the shutter button to set focus, you have to press halfway to set focus for each shot. But if you keep pressing the AF-ON button, you can take as many shots as you want, and the camera will use the same focusing distance.

You also have the option of using the AF-ON button to set focus only and the shutter button to set exposure only, or vice versa. Some photographers like to use this setup so that exposure isn't locked along with focus in the Evaluative metering mode. Chapter 11 tells you more about customizing the performance of the shutter button and AF-ON button; for now, though, (please) don't take this step, or things aren't going to work the way they're described throughout this book.

Adjusting Autofocus Performance

In the point-and-shoot photography modes that I cover in Chapter 3, you're stuck with the choices the camera makes for each exposure mode. But in the advanced exposure modes, you can tweak autofocusing behavior through two controls:

- ✓ **AF (autofocus) mode:** This option determines whether the camera locks focus when you press the shutter button halfway or continues to adjust focus from the time you press the shutter button halfway until you press it the rest of the way to take the shot.
- ✓ **AF Area mode:** This setting determines which of the 19 autofocus points the camera uses to establish focusing distance. At the default setting, all points are in play, and the camera typically focuses on the closest object, but you can choose to base focus on one of five focusing zones or on a single point that you select.

The next few sections detail both options. But two reminders before you dig in:

Information in this chapter assumes that you haven't changed the default functions of camera buttons (such as the AF-ON button and the shutter button). I detail those customization options in Chapter 11. If you need to reset the camera to its defaults, choose the Clear All Camera Settings from Setup Menu 4. Next, visit the Custom Functions menu and choose Clear All Custom Func. (C.Fn). The Custom Functions menu, in particular, contains a bevy of autofocusing tweaks, and straying from the defaults will definitely confuse your journey as your familiarize yourself with the autofocusing system.

Again, the settings and techniques described here relate to viewfinder photography. Autofocusing works differently in Live View and Movie modes; Chapter 4 covers those topics.

AF Area mode: One focus point or many?

In the advanced exposure modes, you can specify how you want the camera to select that autofocus point that's used to set the focusing distance. The option that controls this autofocusing behavior is the AF Area mode, and gives you three choices:

- ✓ 19-point automatic selection: This is the default mode; the camera selects the autofocusing point for you.
- Zone AF: The 19 points are divided into five zones, and you select which zone you want to use. The camera typically focuses on the closest object that falls within the selected zone. The center zone contains the most points (nine); the surrounding zones contain just four points each.
- Single-point AF: You select 1 of the 19 points to set the focusing distance. You must then frame your subject so that it falls under that focusing point.

The fastest route to the option you want to use is the AF Area mode button, found on the top of the camera, just in front of the Main dial. (Look for the symbol shown in the margin here.) If the Shooting Settings display is active, the screen shown in Figure 8-3 appears. The icons at the top represent the three AF Area modes; to cycle through them, press the AF Area mode button.

(The symbol to the right of the three mode icons reminds you that you must use the button for this job.) You see a similar display in the viewfinder, minus the AF Area button symbol and the touchscreen return symbol.

In Figure 8-3, the 19-point Automatic Selection setting is selected, and the focusing brackets in the middle of the screen represent the area that contains the 19 points. If you set the AF mode (explained in the next section) to AI Servo, which is the continuous autofocusing mode, however, you see 19 rectangles within the brackets, with a single point

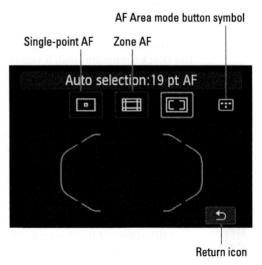

Figure 8-3: Press the AF Area mode button to switch from 19-point automatic focus point selection to Zone AF or Single-point AF.

selected. The camera will use that selected point as the starting focusing distance, but will look to the other 18 points for focusing information if your subject moves from that initial point.

In Zone AF, the displays look like the one you see on the left in Figure 8-4. The brackets indicate which zone is selected; the focus points within the brackets are active. On the left screen in Figure 8-4, for example, the center zone is selected. For Single-point AF, you see just one large rectangle; that's the selected focus point. Again, in Figure 8-4, I chose the center focus point.

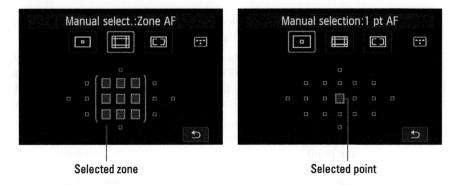

Figure 8-4: Use the Multi-controller, Quick Control dial, or Main dial to select a focus zone (left) or point (right).

To select a different zone or point, press the Multi-controller up, down, left, or right. In Zone AF mode, you also can use the Main dial or Quick Control dial to cycle through the available zones; in Single-point mode, you can select a horizontal point by rotating the Main dial and a vertical point by rotating the Quick Command dial. If you're working with the Shooting Settings display instead of monitoring things through the viewfinder, you can also simply tap the point or zone you want to use (although tapping a single point can be tricky because they're so small).

In addition to using the AF Area mode button to change the setting, you can use the Quick Control screen to get the job done, as shown in Figure 8-5.

Here are a few additional related bits of info:

✓ If all three AF Area modes don't appear as available, visit the Custom Functions menu, select the Autofocus category of options, and check the status of the item named Select AF Area Selec. Mode. On this screen, you can enable and disable the individual AF Area modes. By default, all three AF Area modes are enabled, and you see a check mark above each mode icon. If the check mark is gone, the mode is disabled. Bring it back into the game by pressing the Set button and then tapping the mode

- icon or highlighting it and pressing the Set button again. Tap OK or highlight it and press the Set button to finalize your choice.
- In Zone or Single-Point mode, you can quickly select the center focus point or zone by pressing the Set button.
- ✓ While the AF Area mode button is pressed and the 19-point auto or Zone mode is in force, the bottom of the viewfinder display shows the letters AF next to a dashed rectangle to remind you that the camera will automati-

Current AF Area mode setting

Figure 8-5: You also can access the AF Area mode setting via the Quick Control screen.

- cally choose the focus point for you. This same readout appears in the LCD panel while the AF Area mode button is pressed.
- For Single-Point mode, the displays show the letters *SEL* plus a bracket symbol when the center point is selected. If you select a different point, you see the letters *SEL* and *AF*. Again, these indicators appear only in the viewfinder and LCD panel while the AF Area mode button is pressed.

✓ You also can display the initial AF Area mode selection screen (refer to Figure 8-3) by pressing the AF Point Selection button on the back of the camera. However, you still have to use the AF Area Mode button to cycle through the available settings. It's easy to mix up the purpose of the two buttons, so I simply use the AF Area Mode button for both tasks and leave the AF Point Selection button out of the mix.

Changing the AF (autofocus) mode

In addition to telling the camera where you want it to set focus, you can control how and when focus is set by selecting one of the following AF modes:

One Shot: This mode, geared to shooting stationary subjects, locks focus when you press and hold the shutter button halfway down. This setting is used for all scene modes except Sports. It's also the default mode for the advanced exposure modes.

One important point to remember about One Shot mode is that if the camera can't achieve focus, it won't let you take the picture, no matter how hard you press the shutter button. Also be aware that if you pair One Shot autofocusing with one of the Continuous Drive modes, detailed in Chapter 2, focus for all frames in a burst is based on the focus point used for the first shot.

AI Servo: In this mode (the AI stands for artificial intelligence, if you care), the camera adjusts focus continually as needed from when you press the shutter button halfway to the time you take the picture. This mode is designed to make focusing on moving subjects easier, and it's the one the camera uses when you shoot in the Sports scene mode.

For Al Servo to work properly, you must reframe as needed to keep your subject under the active autofocus point or zone if you're using the Single-point or Zone AF Area modes. If the camera is set to 19-Point Automatic Selection, the camera bases focus initially on the center focus point, but you can select a different point if you like. (See the preceding section for how tos.) If the subject moves away from the point, focus should still be okay as long as you keep the subject within the area covered by one of the other autofocus points.

In either case, the green focus dot in the viewfinder blinks rapidly if the camera isn't tracking focus successfully. If all is going well, the focus dot doesn't light, nor do you hear the beep that normally sounds when focus is achieved. (You can hear the autofocus motor whirring a little when the camera adjusts focus.)

If you use this AF mode with the Continuous Drive mode, focus is adjusted as needed between frames, which may slow the maximum shots-per-second rate. However, it's still the best option for shooting a moving subject.

AI Focus: This mode automatically switches the camera from One Shot to AI Servo as needed. When you first press the shutter button halfway, focus is locked on the active autofocus point (or points), as in One Shot mode. But if the subject moves, the camera shifts into AI Servo mode and adjusts focus as it thinks is warranted. AI Focus is the setting used when you shoot in the Scene Intelligent Auto, Flash Off, and Creative Auto modes.

I prefer not to use AI Focus because I don't want to rely on the camera to figure out whether I'm interested in a moving or stationary subject. So I stick with One Shot for stationary subjects and AI Servo for focusing on moving subjects.

One way to remember which mode is which: For still subjects, you need only *one shot* at setting focus. For moving subjects, think of a tennis or volleyball player *serving* the ball — so AI *Servo* for action shots.

You can the view current AF mode in the Shooting Settings screen, as shown on the left in Figure 8-6. To change the mode, you have two options:

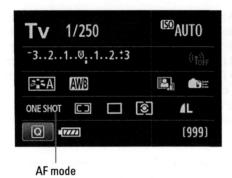

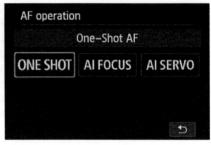

Figure 8-6: The current AF mode appears here.

✓ **AF button:** Your fastest move is to press this button (on top of the camera, just above the LCD panel). All data but the current setting disappears from the LCD panel; rotate the Main dial to change the setting. If the Shooting Settings screen is active, you see the screen shown on the right in Figure 8-6. Again, either rotate the Main dial to choose a setting or just tap its icon and tap the return icon.

✓ Quick Control screen: Select the AF mode icon, as shown in Figure 8-7. The selected AF mode setting appears at the bottom of the screen. Rotate the Main dial to cycle through the three mode options.

If you prefer, you can tap the icon or press Set to display the screen shown in Figure 8-6, where all the mode choices appear.

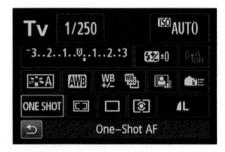

Figure 8-7: You also can adjust the setting via the Quick Control screen.

Choosing the right autofocus combo

You'll get the best autofocus results if you pair your chosen AF mode with the most appropriate AF Point Selection mode because the two settings work in tandem. Here are the combinations that I suggest:

For still subjects: One Shot and Single-Point AF Area Mode. You select a specific focus point, and the camera locks focus on that point at the time you press the shutter button halfway or press the AF-ON button. Focus remains locked on your subject even if you reframe the shot after you press the button halfway.

For moving subjects: AI Servo and 19-point Automatic AF Area Mode. Begin by selecting an initial focusing point; by default, the center point is selected, but you can select a different point if you prefer. Frame your subject initially so that it's under the selected point and then press the shutter button halfway (or press the AF-ON button) to set the initial focusing distance. The camera adjusts focus as needed if your subject moves within the frame before you take the shot. All you need to do is reframe to keep your subject within the boundaries of the autofocus brackets.

Keeping these two combos in mind should greatly improve your autofocusing accuracy. But in some situations, no combination will enable speedy or correct autofocusing. For example, if you try to focus on a very reflective subject, the camera may hunt for an autofocus point forever. And if you try to focus on a subject behind a fence, the autofocus system may continually insist on focusing on the fence instead of your subject. In such scenarios, don't waste time monkeying with the autofocus settings — just switch to manual focusing.

Finally, remember that to have this level of control over autofocusing, you must use one of the advanced exposure modes.

Manipulating Depth of Field

Getting familiar with the concept of depth of field is one of the biggest steps you can take to becoming a more artful photographer. *Depth of field* refers to the distance over which objects appear acceptably sharp:

- Shallow (small) depth of field: Only your subject and objects at the same (or nearly the same) distance from the lens appear sharp. Objects at a distance appear blurry.
- Deep (large) depth of field: The zone of apparent focus extends to include distant objects.

Shallow depth of field

Figure 8-8: A shallow depth of field blurs the background and draws added attention to the subject.

Which arrangement works best depends on your creative vision. In portraits, for example, a classic technique is to use a shallow depth of field, as in Figure 8-8. This approach increases emphasis on the subject while diminishing the impact of the background. Comparatively, for the photo shown in Figure 8-9, the goal was to give the historical marker, the lighthouse, and the cottage equal weight in the scene, so I used settings that produced a large depth of field to keep them all in focus.

Note, though, that with a shallow depth of field, which part of the scene appears blurry depends on the spot at which you establish focus. In the lighthouse scene, for example, had I used settings that produce a short depth of field and set focus on the lighthouse, both the historical marker in the foreground and the cottage in the background might be blurry.

So how do you adjust depth of field? You have three points of control:

Figure 8-9: A large depth of field keeps both near and far subjects in sharp focus.

Aperture setting (f-stop): The aperture is one of three main exposure settings, all explained fully in Chapter 7. Depth of field increases as you stop down the aperture (by choosing a higher f-stop number). For shallow depth of field, open the aperture (by choosing a lower f-stop number).

Figure 8-10 offers an example. Notice that the trees in the background are more softly focused in the f/5.6 example than in the f/11 version. Of course, changing the aperture requires adjusting the shutter speed or ISO to maintain the equivalent exposure; for these images, I adjusted shutter speed.

Lens focal length: In lay terms, focal length, which is measured in millimeters, determines what the lens "sees." As you increase focal length (use a "longer" lens), the angle of view narrows, objects appear larger in the frame, and — the important point in this discussion — depth of field decreases. Additionally, the spatial relationship of objects changes as you adjust focal length.

For example, Figure 8-11 compares the same scene shot at focal lengths of 138mm and 255mm. The aperture was set to f/22 for both examples.

f/5.6, 1/1000 second f/11, 1/200 second

Figure 8-10: Raising the f-stop value increases depth of field.

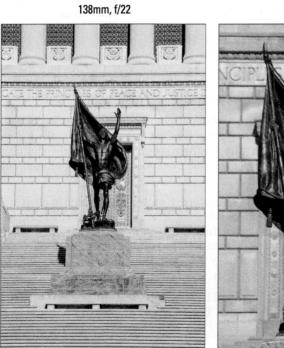

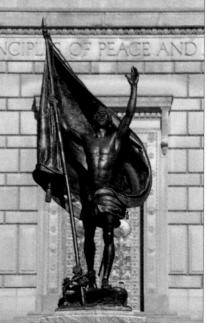

255mm, f/22

Figure 8-11: Using a longer focal length also reduces depth of field.

Whether you have any focal-length flexibility depends on your lens: If you have a zoom lens, you can adjust the focal length by zooming in or out. If your lens offers only a single focal length — a *prime* lens, in other words — scratch this means of manipulating depth of field (unless you change to a different prime lens, of course).

Camera-to-subject distance: When you move the lens closer to your subject, depth of field decreases.

Together, these three factors determine the maximum and minimum depth of field you can achieve, as illustrated by Figure 8-12 and summed up in the following list:

Greater depth of field:

Select higher f-stop
Decrease focal length (zoom out)
Move farther from subject

Shorter depth of field:

Select lower f-stop Increase focal length (zoom in) Move closer to subject

Figure 8-12: Aperture, focal length, and your shooting distance determine depth of field.

- ✓ To produce the shallowest depth of field: Open the aperture as wide as possible (select the lowest f-stop number), zoom in to the maximum focal length of your lens, and move as close as possible to your subject.
- ✓ **To produce maximum depth of field:** Stop down the aperture to the highest possible f-stop setting, zoom out to the shortest focal length your lens offers, and move farther from your subject.

Here are a few additional tips and tricks related to depth of field:

- Subject to camera distance: The extent to which background focus shifts as you adjust depth of field also is affected by the distance between the subject and the background. For increased background blurring, move the subject farther away from the background.
- Aperture-priority autoexposure (Av) mode: When depth of field is a primary concern, try using aperture-priority autoexposure (Av). In this mode, you set the f-stop, and then the camera selects the appropriate shutter speed to produce a good exposure.

In dim lighting, you may encounter a situation where the shutter speed is too slow to permit handholding the camera. Lenses that offer optical image stabilization enable most people to handhold the camera at slower shutter speeds than nonstabilized lenses, but double-check your results. You can also raise the ISO setting to make the image sensor more reactive to light, but remember that high ISO can equal image noise. See Chapter 7 for help understanding all these issues.

- ✓ Creative Auto mode: Creative Auto mode also gives you some control over depth of field via the Background Blur slider. Chapter 3 has details.
- ✓ Scene modes: Some of the scene modes are designed with depth of field in mind. Portrait and Close-up modes produce shortened depth of field; Landscape mode produces a greater depth of field. You can't adjust aperture in these modes, however, so you're limited to the setting the camera chooses. And in certain lighting conditions, the camera may not be able to choose an aperture that produces the depth of field you expect from the selected mode.
- Depth of field preview: When you look through your viewfinder and press the shutter button halfway to initiate autofocusing and exposure metering, you can see only a partial indication of the depth of field that your current camera settings will produce. You can see the effect of focal length and the camera-to-subject distance, but because the aperture doesn't actually stop-down to your selected f-stop until you take the picture, the viewfinder doesn't show you how that setting will affect depth of field.

By using the Depth-of-field Preview button, however, you can do just that in the advanced exposure modes. Found on the front of your camera, the button is labeled in Figure 8-13.

Press and hold the shutter button halfway and then press and hold the Depth-of-field Preview button with a finger on the other hand. Depending on the selected f-stop, the scene in the viewfinder may get darker. This effect doesn't mean that your picture will be darker; it's just how the preview works.

Note that the preview doesn't engage if the aperture and shutter speed aren't adequate to expose the image properly. You have to solve the exposure issue before you can use the preview.

Controlling Color

Compared with understanding some aspects of digital photography, making sense of your camera's color options is easy-breezy. First, color problems aren't all that common, and when they are, they're usually simple to fix with a quick shift of your camera's White Balance control. Second, getting a grip on color requires learning only a couple of new terms, an unusual state of affairs for an endeavor that often seems more like high-tech science than art.

The rest of this chapter explains your camera's major color options. Also check out Chapter 11, which explains an option that affects the color space of your photos (sRGB or Adobe RGB), available on Shooting Menu 3 when you use the advanced exposure modes. Stick with the default, sRGB, for now.

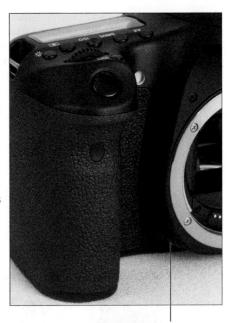

Depth-of-field Preview button

Figure 8-13: Press this button to see how the aperture setting will affect depth of field.

Correcting colors with white balance

Every light source emits a particular color cast. The old-fashioned fluorescent lights found in most public restrooms, for example, put out a bluish-green light, which is why our reflections in the mirrors in those restrooms always look so sickly. And if you think that your beloved looks especially attractive by candlelight, you aren't imagining things: Candlelight casts a warm, yellow-red glow that's flattering to the skin.

Science-y types measure the color of light, officially known as *color temperature*, on the Kelvin scale, which is named after its creator. You can see an illustration of the scale in Figure 8-14.

When photographers talk about "warm light" and "cool light," though, they aren't referring to the position on the Kelvin scale — or at least

Figure 8-14: Each light source emits a specific color.

not in the way people usually think of temperatures, with a higher number meaning hotter. Instead, the terms describe the visual appearance of the light. Warm light, produced by candles and incandescent lights, falls in the red-yellow spectrum at the bottom of the Kelvin scale; cool light, in the bluegreen spectrum, appears at the top of the scale.

At any rate, most folks don't notice these fluctuating colors of light because our eyes automatically compensate for them. Similarly, a digital camera compensates for different colors of light through a feature known as *white balancing*. Simply put, white balancing neutralizes light so that colors are rendered accurately.

Your camera's Automatic White Balance setting, which carries the label AWB, tackles this process remarkably well in most situations. In some lighting conditions, though, the AWB adjustment doesn't quite do the trick, resulting in an unwanted color cast like the one you see in the left image in Figure 8-15.

Figure 8-15: Multiple light sources resulted in a color cast in Auto White Balance mode (left); switching to manual White Balance control solved the problem (right).

Problems most often occur when your subject is lit by a variety of light sources. For example, I shot the figurine in Figure 8-15 under a mix of tungsten photo lights and strong window light. In Automatic White Balance mode.

the camera didn't properly account for the mixed light, giving the original image a yellow tint. Switching to the Tungsten Light White Balance setting did the trick. The right image in Figure 8-15 shows the corrected colors.

Unfortunately, you can't access the White Balance setting in any of the pointand-shoot exposure modes, although you can sometimes address color issues via the Shoot by Lighting or Scene Type setting when you shoot in a couple of the scene modes. (Chapter 3 has details on that setting and its relative, Shoot by Ambience.) So if color problems arise, shift to an advanced exposure mode and take advantage of the White Balance solutions outlined in the next few sections.

Changing the White Balance setting

The available White Balance settings are represented by the symbols shown in Table 8-1. You can view the current setting in the Shooting Settings screen, as shown in Figure 8-16. To adjust the setting, you have two options:

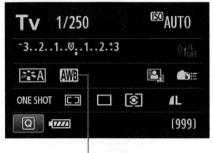

White Balance setting

✓ **Quick Control screen:** After you highlight the White Balance icon, the selected setting appears at the bottom of the screen, as shown in Figure 8-17, and you

Figure 8-16: This symbol represents the Automatic White Balance setting.

can then rotate the Main dial to cycle through the various options. If you want to see all settings at one time, tap the icon or press Set to display the selection screen you see on the right in the figure.

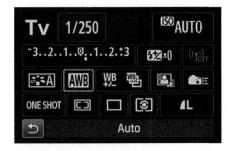

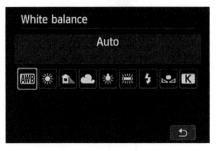

Figure 8-17: The Quick Control screen offers the fastest way to adjust the setting.

✓ **Shooting Menu 3:** Select White Balance, as shown in Figure 8-18, to display the same selection screen you see on the right in Figure 8-17.

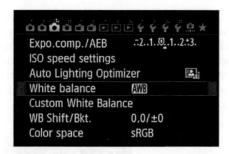

Figure 8-18: You also can set White Balance via Shooting Menu 3.

Table 8-1	White Balance Settings	
symbol	Setting	
AWB	Auto	
*	Daylight	
a	Shade	
2	Cloudy	
*	Tungsten	
	White Fluorescent	
4	Flash	
7 №	Custom	
K	Color Temp (in degrees Kelvin)	

A couple of quick tips related to white balance:

- ✓ The K (Kelvin) setting enables you to specify a color temperature. After selecting the option, rotate the Main dial to select a value between 2500 and 10000.
- ✓ If the scene is lit by several sources, choose the setting that corresponds to the strongest one. The Tungsten Light setting is usually best for regular incandescent household bulbs, by the way. Selecting the right setting for the new energy-saving CFL (compact fluorescent) bulbs can be a little tricky because the color temperature varies depending on the bulb you buy.

- Your White Balance setting remains in force until you change it. To avoid accidentally using an incorrect setting later, get in the habit of resetting the option to Auto (AWB) after you finish shooting whatever subject it was that caused you to switch from automatic to manual white balancing.
- ✓ Not sure which setting to choose? Try switching to Live View temporarily. As you adjust the White Balance setting, the live preview shows you the impact on your scene. See Chapter 4 for details on using Live View.
- If none of the settings produce neutral colors, you can tweak the selected setting or even create a custom setting, as outlined in the next sections.

Creating a custom White Balance setting

If none of the preset white balance options produces the right amount of color correction, you can create your own, custom setting. To use this technique, you need a piece of card stock that's either neutral gray or absolute white — not eggshell white, sand white, or any other close-but-not-perfect white. (You can buy reference cards made just for this purpose in many camera stores for less than \$20.)

Position the reference card so that it receives the same lighting you'll use for your photo. Then follow these steps:

1. Set the camera to the P, Tv, Av, M, or C exposure mode.

You can't create a custom setting in any of the fully automatic modes or in B (Bulb) mode.

2. Set the White Balance setting to Auto (AWB).

The preceding section shows you how.

3. Set the lens to manual focusing.

This step helps because the camera may have a hard time autofocusing on the card stock.

4. Frame the shot so that your reference card fills the center area of the viewfinder.

Make sure that at least the center autofocus point and the six surrounding points fall over the reference card.

5. Set focus and make sure that the exposure settings are correct.

Just press the shutter button halfway to check exposure. If necessary, adjust ISO, aperture, or shutter speed to get a proper exposure; Chapter 7 explains how.

6. Take the picture of your reference card.

The camera will use this picture to establish your custom White Balance setting.

7. Display Shooting Menu 3 and choose Custom White Balance, as shown in Figure 8-19.

After you select the option, you see the screen shown on the left in Figure 8-20. The image you just captured should appear. If it doesn't, use the normal playback controls to scroll to it. (Note that you may see additional data on the screen depending on the current playback display mode; press the Info button to cycle through the various displays.)

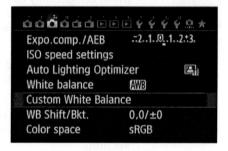

Figure 8-19: You can create a custom White Balance setting from Shooting Menu 3.

8. Tap the Set icon (or press the Set button).

You see the message shown on the right in Figure 8-20, asking you to confirm that you want the camera to use the image to create the custom White Balance setting.

Figure 8-20: Your white image appears on the screen (left); press or tap Set and then confirm that you want to store that image as your White Balance preset (right).

9. Tap OK or highlight it and press the Set button.

Now you see the screen shown on the right in Figure 8-21. This message tells you that the White Balance setting is now stored. The little icon in the message area represents the custom setting.

10. Tap OK (or highlight it and press Set).

Your custom White Balance setting remains stored until the next time you work your way through these

Figure 8-21: This screen reminds you to select the Custom Setting icon when you want to use your stored White Balance option.

steps. Any time you're shooting in the same lighting conditions and want to apply the same white balance correction, just select the Custom option as your White Balance setting. Remember, the icon for that setting looks like the one on the screen in Figure 8-21.

Fine-tuning White Balance settings

In addition to creating a custom White Balance setting based on a gray card, you can tell the camera to shift all colors to make them a little more blue, amber, magenta, or green no matter what White Balance setting you use. To access this option, White Balance Correction, follow these steps:

1. Set the Mode dial to an advanced exposure mode.

You can take advantage of White Balance Correction only in these modes.

2. Select WB Shift/Bkt. from Shooting Menu 3 or from the Quick Control screen, as shown on in Figure 8-22.

The first two numbers next to the option name in the menu indicate the current amount of fine-tuning, or *shift*, and the second value represents the amount of white balance bracketing enabled. (See the next section for details on that topic.) In the figure, all values are 0, indicating that no fine-tuning or bracketing is enabled.

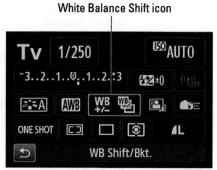

Figure 8-22: White Balance Correction offers one more way to control colors.

After you select the option, you see the screen shown in Figure 8-23. The screen contains a grid oriented around two color pairs: green and magenta (represented by the G and M labels) and blue and amber (represented by B and A). The little white square indicates the amount of white balance shift.

3. Use the Multi-controller to move the shift indicator marker in the direction of the shift you want to achieve.

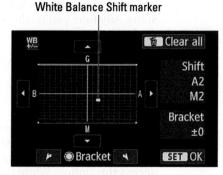

Figure 8-23: Move the marker around the grid to affect colors.

You also can tap the scroll arrows located on each side of the grid. Either way, the Shift area of the display tells the amount of color bias you've selected. For example, in Figure 8-23, the shift is two levels toward amber and two toward magenta.

If you're familiar with traditional lens filters, you may know that the density of a filter, which determines the degree of color correction it provides, is measured in *mireds* (pronounced "my-reds"). The white balance grid is designed around this system: Moving the marker one level is the equivalent of adding a filter with a density of 5 mireds.

4. Tap Set or press the Set button to apply the change and return to the menu.

After you apply White Balance Correction, an alert symbol appears next to the White Balance symbol in the Shooting Settings display, as shown on the left in Figure 8-24. It's your reminder that White Balance Shift is being applied.

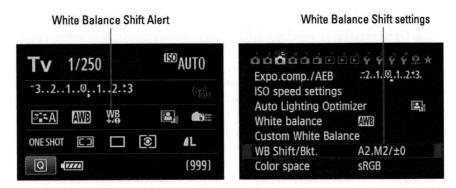

Figure 8-24: These indicators tell you that White Balance Shift is applied.

An alert symbol also appears in the viewfinder by default. (You can disable the alert via Custom Function 3 in the Operation/Others group of Custom Functions.)

You can see the exact shift values in Shooting Menu 3, as shown on the right in Figure 8-23, and also in the Camera Settings display. (To go from the Shooting Settings display to the Camera Settings display, press the Info button twice.) For example, in Figure 8-24, the values indicate a shift two steps toward amber (A) and two toward magenta (M).

Your adjustment remains in force for all advanced exposure modes until you change it. And the correction is applied no matter which White Balance setting you choose. Check the monitor or viewfinder before your next shoot; otherwise you may forget to adjust the white balance for the current light.

5. To cancel White Balance Correction, repeat the steps but move the marker back to the center of the grid in Step 3.

Be sure that both values in the Shift area of the display are set to 0.

As an alternative, press the Erase button or tap its onscreen icon, found in the upper-right corner of the screen shown on the right in Figure 8-23. However, doing so also cancels White Balance Bracketing, which I explain in the next section.

Many film photography enthusiasts place colored filters on their lenses to either warm or cool their images. Portrait photographers, for example, often add a warming filter to give skin tones a healthy, golden glow. You can mimic the effects of these filters by simply fine-tuning your camera's White Balance settings as just described. Experiment with shifting the white balance a tad toward amber and magenta for a warming effect or toward blue and green for a cooling effect.

Eliminating color fringing (chromatic aberration)

Pictures taken with some lenses may reveal chromatic aberration, a defect that creates weird color halos along the edges of objects. This phenomenon is also known as color fringing.

Your camera offers a Chromatic Aberration filter designed to address this problem. By default, the filter is turned on; you disable it via the Lens Aberration Correction option on Shooting Menu 2, as shown here.

As is the case with the companion filter, the Peripheral Illumination filter (covered in Chapter 7), turn this option on only if the second screen in the figure indicates that correction data is available for your lens. Otherwise, leave the option disabled. In fact, Canon recommends that you keep the option off when you use a non-Canon lens even if the screen indicates that correction data is available.

Note these other important aspects of the Chromatic Aberration filter:

- The correction is applied only to JPEG images. You can manually apply the correction to Raw images if you process them using the built-in Raw converter or Digital Photo Professional, a program provided with your camera. See Chapter 6 for help.
- You can register additional lenses with the camera by using another free program, Canon EOS Utility. See that program's user manual, found on one of the CDs that ships with the camera, for instructions.
- Because the filter is applied after you take the shot, enabling it slows down the number of frames you can record per second when you use one of the Continuous Drive modes, covered in Chapter 2.

Bracketing shots with white balance

Chapter 7 introduces you to automatic exposure bracketing, which enables you to easily record the same image at three different exposure settings.

Similarly, your camera offers automatic White Balance Bracketing. With this feature, the camera records the same image multiple times, using a slightly different white balance adjustment for each one. You might try this feature to experiment with different color takes on a scene, for example.

Note a couple of things about this feature:

- Because the camera records multiple images each time you press the shutter button, White Balance Bracketing reduces the maximum capture speed when you use the Continuous Drive modes. Of course, recording three images instead of one also eats up more space on your memory card.
- ✓ The White Balance Bracketing feature is designed around the same grid used for White Balance Correction, explained in the preceding section. As a reminder, the grid is based on two color pairs: green/magenta and blue/amber.
- ▶ By default, the camera records three images with each press of the shutter button. (I get into the topic of recording more than three shots after I show you the steps for using the default settings.) The camera always records the first of the three bracketed shots using a neutral white balance setting or, at least, what it considers to be neutral, given its own measurement of the light. The second and third shots are then recorded using the specified shift along either the green/magenta or blue/amber axis of the color grid.

If you're picky about stuff like this, you can modify the order in which the shots are recorded via the Bracketing Sequence Custom Function, found in the Exposure grouping of Custom Functions. Select setting 1 to get the blue/magenta image first, then the neutral shot, and then the amber/green image. Select setting 2 to go the opposite direction. The 0 setting gives you the default setup.

If all that is as clear as mud, just take a look at Figure 8-25 for an example. These images were shot using a single tungsten studio light and the candle-light. White Balance Bracketing was set to work along the blue/amber color axis. The camera recorded the first image at neutral, the second with a slightly blue color bias, and the third with an amber bias.

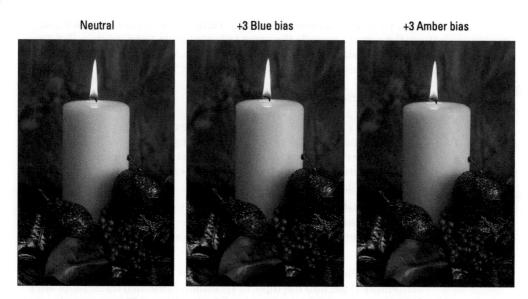

Figure 8-25: I captured one neutral image, one with a blue bias, and one with an amber bias.

To enable White Balance Bracketing, follow these steps:

- 1. Set the Mode dial to an advanced exposure mode.
- 2. Display Shooting Menu 3 and choose WB/Shift Bkt., as shown on the left in Figure 8-26. Or select the option from the Quick Control screen, as shown on the right.

Either way, you see the screen shown in Figure 8-27.

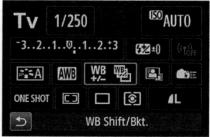

Figure 8-26: Access White Balance bracketing through Shooting Menu 3 or the Quick Control screen.

3. Rotate the Quick Control dial to set the amount and direction of the bracketing shift.

Rotate the dial as follows to specify whether you want the bracketing to be applied across the horizontal axis (blue to amber) or the vertical axis (green to magenta).

- Blue to amber bracketing: Rotate the dial right.
- Green to magenta bracketing: Rotate the dial left.

As you rotate the dial, three markers appear on the grid, indicating the amount of shift that will be applied to your trio of bracketed images. You can apply a maximum shift of plus or minus three levels of adjustment.

You also can tap the markers on either side of the word Bracket, at the bottom of the screen. Tap the right arrow to move markers along the blue to amber axis; tap the left one to move the markers along the green/blue axis. After you reach the maximum marker positions (+/–3), the arrow dims, and then you can tap the opposite arrow to lower the bracketing amount until the marker returns to 0 (zero).

The BKT area of the screen indicates the shift; for example, in Figure 8-27, the display shows a bracketing amount of plus and minus three levels on the blue/amber axis.

If you want to get truly fancy, you can combine White Balance Bracketing with White Balance Shift. See the preceding section to learn about White Balance Shift.

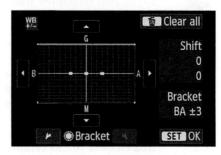

Figure 8-27: Rotate the Quick Control dial to set the amount and direction of the bracketing shift.

When White Balance bracketing is in effect, you see selected bracketing values on Shooting Menu 3, as shown on the left in Figure 8-28. In the Shooting Settings display, you see the symbol shown on the right in the figure. The Camera Settings display, which you bring up by pressing Info twice when the Shooting Settings screen is displayed, also reports the bracketing setting.

White Balance Bracketing setting

Expo.comp./AEB ..2..1..0..1...2.*3.

ISO speed settings
Auto Lighting Optimizer
White balance
Custom White Balance
WB Shift/Bkt. 0.0/BA±3
Color space sRGB

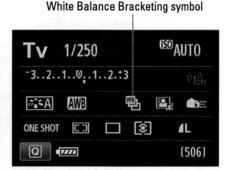

Figure 8-28: These symbols indicate that White Balance Bracketing is turned on.

By default, the bracketing setting remains in effect until you turn off the camera. If you *don't* want that to happen, travel to the Exposure group of the Custom Functions menu and set Custom Function 3, Bracketing Auto Cancel, to Off. Just remember that this setting also affects exposure bracketing, which I cover in Chapter 7.

You can also cancel bracketing by revisiting the grid screen shown earlier, in Figure 8-27, and rotating the Quick Control dial until you see only a single grid marker. You also can wipe out both your bracketing setting and any White Balance Shift amount by pressing the Erase button or tapping its icon. Either way, tap Set or press the Set button to officially turn off bracketing.

Now for the aforementioned option that enables you to capture more than three frames when you use White Balance Bracketing. You get to this option via the Number of Bracketed Shots option, found in the Exposure Section of the Custom Functions menu and shown in Figure 8-29. Here's what you get at each setting:

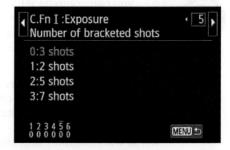

Figure 8-29: You can instead capture a series of 2, 5, or 7 bracketed frames.

- 2 shots: One neutral shot and one that's either warmer or cooler, depending on where you put the shift marker in the setup screen.
- ✓ **5 shots:** One neutral shot, two that are progressively warmer, and two that are progressively cooler.
- ✓ 7 shots: One neutral shot, three that are progressively warmer, and three that are progressively cooler.

Although White Balance Bracketing is a fun feature, if you want to ensure color accuracy, creating a custom White Balance setting is a more reliable idea than bracketing white balance; after all, you can't be certain that shifting the white balance a couple of steps is going to produce accurate colors. Shooting in the Raw format offers the best color safety net, however: You can assign a White Balance setting when you process the Raw images, whether you're after a neutral color platform or want to lend a slight color tint to the scene.

Taking a Quick Look at Picture Styles

In addition to all the aforementioned focus and color features, your camera offers *Picture Styles*. Using Picture Styles, you can further tweak color as well as saturation, contrast, and image sharpening.

Sharpening is a software process that adjusts contrast in a way that creates the illusion of slightly sharper focus. The key word here is *slightly*: Sharpening cannot remedy poor focus but instead produces a subtle tweak to this aspect of your pictures.

The camera offers the following Picture Styles:

- ✓ **Auto:** This is the default setting; the camera analyzes the scene and determines which Picture Style is the most appropriate.
- Standard: This option captures the image by using the characteristics that Canon offers as suitable for the majority of subjects.
- ✓ Portrait: This mode reduces sharpening slightly from the amount that's applied in Standard mode, with the goal of keeping skin texture soft. Color saturation, on the other hand, is slightly increased.
- Landscape: In a nod to traditions of landscape photography, this Picture Style emphasizes greens and blues and amps up color saturation and sharpness, resulting in bolder images.
- ✓ Neutral: This setting reduces saturation and contrast slightly compared to how the camera renders images when the Standard option is selected.
- ✓ Faithful: The Faithful style is designed to render colors as closely as possible to how your eye perceives them.
- ✓ Monochrome: This setting produces black-and-white photos or, to be more precise, grayscale images. Technically speaking, a true black-and-white image contains only black and white, with no shades of gray.

If you set the Quality option to Raw (or Raw + Large/Fine), the camera displays your image on the monitor in black and white during playback. But during the Raw converter process, you can either choose to go with your grayscale version or view and save a full-color version. Or even better, you can process and save the image once as a grayscale photo and again as a color image.

If you *don't* capture the image in the Raw format, you can't access the original image colors later. In other words, you're stuck with *only* a black-and-white image.

The extent to which Picture Styles affect your image depends on the subject as well as on exposure settings and lighting conditions. Figure 8-30 shows you a test shot at each setting (except Auto) to give you a general idea of what to expect. As you can see, the differences are subtle, with the exception of the Monochrome option, of course.

The level of control you have over Picture Styles, like most other settings in this chapter, depends on your camera's exposure mode:

- ✓ In Scene Intelligent Auto, Creative Auto, Flash Off, and the SCN modes: The camera sets the Picture Style for you.
- ✓ In the advanced exposure modes: You can not only select any Picture Style but also tweak each style to your liking and create up to three custom styles, which are listed as User Def. 1, 2, and 3.
- Movie mode: If you set the Mode dial to P, Tv, Av, M, or C, you can select any Picture Style, including any custom styles you create. (Want to shoot a black-and-white movie? Set the Picture Style to Monochrome before you start recording.)

Chapter 4 explains how to select movie-recording options. For still photography, you can select a Picture Style in three ways:

✓ Quick Control screen: Highlight the Picture Style icon, as shown on the left in Figure 8-31, and then rotate the Main dial to cycle through the available styles. Again, the User Def. 1, 2, and 3 settings relate to custom Picture Styles that you can create; more on that topic momentarily. If you haven't created a custom style, the Auto style is used if you select one of those three settings.

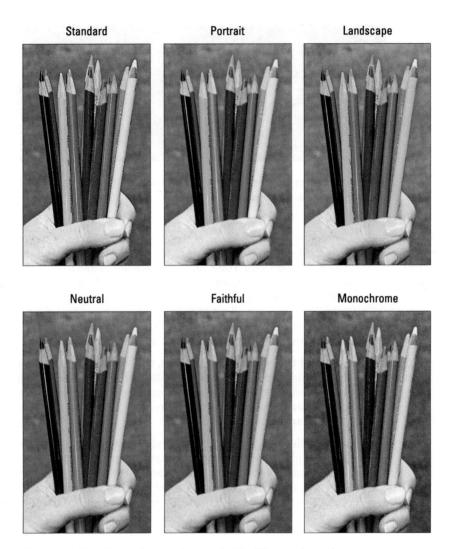

Figure 8-30: Each Picture Style produces a slightly different take on the scene.

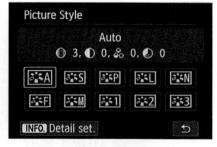

Figure 8-31: You can quickly select a Picture Style by using the Quick Control screen or pressing the bottom cross key.

The numbers you see in the bottom-right corner of the screen represent the four characteristics applied by the style: Sharpness, Contrast, Saturation, and Color Tone. Sharpness values range from 0 to 7; the higher the value, the more sharpening is applied. At 0, no sharpening is applied (3 is the initial setting for the Auto Picture Style). The other values, however, are all set to 0, which represents the default setting for the selected Picture Style. (Using certain advanced options, you can adjust all four settings; more on that momentarily.)

If you want to see all available styles, tap the Picture Style icon or press Set to display the screen you see on the right in Figure 8-31. Highlight the style you want to use, and the four style values appear along with the style name, as shown in the figure. Tap the return arrow or press Set to exit the screen.

Shooting Menu 4: Choose Picture Style, as shown on the left in Figure 8-32, to display a list of all the styles, as shown on the right. You again can see the values for the four style characteristics on the screen shown on the right in the figure. To scroll the list of options, press Multi-controller up/down or tap the scroll arrows along the right side of the screen. Choose an option and tap Set or press the Set button to exit the screen.

Picture Style	Auto	
Long exp. noise red	luction	OFF
High ISO speed NR		0
Highlight tone prior	ity	OFF
Dust Delete Data		
Multiple exposure	Disable	
HDR Mode	Disable I	HDR

Picture Style	0.0.8.0		
Auto	3,0,0,0		
Standard Standard	3,0,0,0		
Portrait	2,0,0,0		
Landscape Landscape	4,0,0,0		
Neutral Neutral	0,0,0,0		
Faithful	0.0.0.0		
INFO. Detail set.	SET OK		

Figure 8-32: You also can access Picture Style options via Shooting Menu 2.

This discussion touches on just the basics of using Picture Styles. The camera also offers some advanced Picture Style features, including the following:

Modifying a Picture Style: You can tweak each style, varying the amount of sharpness, contrast, saturation, and color tone adjustment that the style produces. After selecting a Picture Style — whether you're doing so from the Quick Setting screen shown on the right in Figure 8-31 or the menu screen shown on the right in Figure 8-32 — tap the Info icon or press the Info button to access a screen similar to the one you see in Figure 8-33. Here,

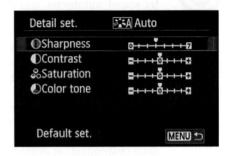

Figure 8-33: You can adjust the characteristics of one of the preset styles.

tap one of the adjustment options to display a screen where you can change the setting.

- ✓ Storing a custom style: The process is the same as for modifying a style, except that instead of starting with an existing style, you choose one of the three User Defined options, as shown in Figure 8-34.
- Using your computer to create and download styles: For übergeeks (you know who you are), the CD accompanying your camera includes a software package named are you ready? Picture Style Editor, where you can create and save Picture Style files to your heart's content. You

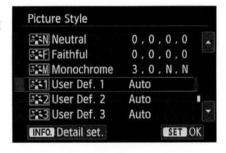

Figure 8-34: Scroll down the list of Picture Styles to access the three User Defined options, which enable you to store your own Picture Styles.

then download the styles to your camera via the memory card.

And I would be remiss if I didn't also mention that some Canon user groups swap Picture Styles with each other online. (I'd be equally remiss if I didn't warn you that you play at your own risk any time you download files from persons unknown to you.)

Unless you're just tickled pink by the prospect of experimenting with Picture Styles, I recommend that you just stick with the default settings. First, you have way more important camera settings to worry about — aperture, shutter speed, autofocus, and all the rest. Why add one more setting to your list, especially when the impact of changing it is minimal? Second, if you want to mess with the characteristics that the Picture Style options affect, you're much better off shooting in the Raw (CR2) format and then making those adjustments on a picture-by-picture basis when you convert your Raw image. Chapter 6 shows you how to work with Raw files.

For these reasons, I opt in this book to present you with just this brief introduction to Picture Styles to make room for more details about functions that do make a big difference in your daily photography life, such as the white balance customization options presented earlier. But again, if you're really into Picture Styles and you can't figure out one of the advanced options from the descriptions here, the camera manual walks you step by step through all the various Picture Style features.

Putting It All Together

In This Chapter

- Reviewing the best all-around picture-taking settings
- Adjusting the camera for portrait photography
- Discovering the keys to super action shots
- Dialing in the right settings to capture landscapes and other scenic vistas
- Capturing close-up views of your subject

arlier chapters break down critical picture-taking features on your camera, detailing how the various controls affect exposure, picture quality, focus, color, and the like. This chapter pulls all that information together to help you set up your camera for specific types of photography.

Keep in mind, though, that there's no one "right way" to shoot a portrait, a landscape, or whatever. So feel free to wander off on your own, tweaking this exposure setting or adjusting that focus control, to discover your own creative vision. Experimentation is part of the fun of photography, after all, and thanks to your camera monitor and the Erase button, it's an easy, completely free proposition.

Recapping Basic Picture Settings

For some camera options — such as exposure mode, aperture, and shutter speed — the best settings depend on your subject, lighting conditions, and creative goals. For certain basic options, though, you can rely on the same settings for almost every shooting scenario.

Table 9-1 offers recommendations for these basic settings and lists the chapter where you can find more information about each option. Figure 9-1 shows you where on the Shooting Settings screen you can find the symbols representing some settings along with a few not included in the table; don't forget that you can adjust these options via the Quick Control screen. Of course, you can see some of the same settings in the viewfinder and LCD panel.

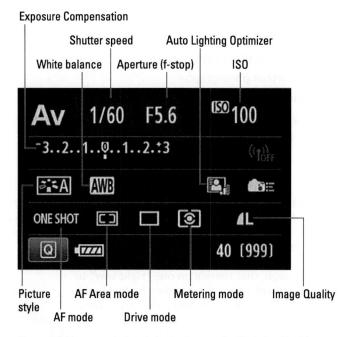

Figure 9-1: You can monitor these options on the Shooting Settings display.

One key point: Instructions in this chapter assume that you use one of the advanced exposure modes and bypass the fully auto modes (Scene Intelligent Auto, Flash Off, Creative Auto, and the SCN modes). The problem with these point-and-shoot modes is that they prevent you from accessing certain settings that can be critical to capturing great shots of certain subjects, especially in difficult lighting. Chapter 7 introduces you to the advanced exposure modes, but if you're just getting the hang of the camera, you can simplify things a little by sticking with one of these two options:

Use Av (aperture-priority autoexposure) for stationary subjects. For these shots, depth of field is the primary concern, and one way to affect depth of field is to vary the aperture setting (f-stop). In Av mode, you can set the f-stop and then let the camera take care of choosing the right shutter speed, doing half of the heavy lifting for you.

- ✓ Use Tv (shutter-priority autoexposure) for moving subjects. In this case, you want to control shutter speed because that setting determines whether the subject appears blurry or sharp. The camera then selects the appropriate f-stop to expose the picture.
- ✓ Use P mode for point-and-shoot operation with access to all camera controls. In this mode, the camera sets the f-stop and shutter speed for you, but you can rotate the Main dial to select different combinations of the two. The advantage of this mode over the fully automatic modes is that you can adjust color, autofocus, and other settings that are off-limits in the fully auto modes.

After you're comfortable with those modes, you may want to take total control by shifting to M (manual exposure) mode, where you set both aperture and shutter speed. You can also investigate B (Bulb) mode, in which the shutter remains open for as long as you hold down the shutter button. (You can control f-stop in this mode.) And when you're really feeling savvy, check out Chapter 11, which tells you how to create your own, custom exposure mode (C, on the Mode dial).

As you read the rest of this chapter, remember that it discusses viewfinder photography; Chapter 4 guides you through Live View photography and movie recording. (For Live View photography, however, most settings work the same as discussed here, with the exception of the autofocus options.)

Table 9-1	All-Purpose Picture-Taking Settings		
Option	Recommended Setting	See This Chapter	
mage Quality	Large/Fine (JPEG), Medium/Fine (JPEG), or Raw (CR2)	2	
Drive mode	Action photos, Continuous Hi or Low; all others, Single	2	
ISO	100 or 200 (available light permitting)	7	
Metering mode	Evaluative	7	
AF mode	Moving subjects, AI Servo; stationary subjects, One-Shot	8	
AF Area Mode	Moving subjects, 19-point Automatic; stationary subjects, Single-point	8	
White Balance	Auto (AWB)	8	
Auto Lighting Optimizer	Standard for P, Tv, and Av modes; Disable for M and B modes	7	
Picture Style	Auto	8	

Setting Up for Specific Scenes

For the most part, the settings detailed in the preceding section fall into the "set 'em and forget 'em" category. That leaves you free to concentrate on a handful of other settings that you can manipulate to achieve a specific photographic goal, such as adjusting aperture to affect depth of field. The next four sections explain which of these additional options typically produce the best results when you're shooting portraits, action shots, landscapes, and close-ups.

Shooting still portraits

By *still portrait*, I mean that your subject isn't moving. For subjects who aren't keen on sitting still long enough to have their picture taken, skip to the next section and use the techniques given for action photography instead.

Assuming that you do have a subject willing to pose, the classic portraiture approach is to keep the subject sharply focused while throwing the background into soft focus, as shown in Figure 9-2. This artistic choice emphasizes the subject and helps diminish the impact of any distracting background objects in cases where you can't control the setting. The following steps show you how to achieve this look:

1. Set the Mode dial to Av and rotate the Main dial to select the lowest f-stop value possible.

As Chapter 7 explains, a low f-stop setting opens the aperture, which not only allows more light to enter the camera but also shortens depth of field, or the range of sharp focus. So dialing in a low f-stop value is the first step in softening your portrait background.

I recommend using aperture-priority mode when depth of field is a primary concern because you can control the

Figure 9-2: To diminish a distracting background and draw more attention on your subject, use camera settings that produce a short depth of field.

f-stop while relying on the camera to select the shutter speed that will properly expose the image. But you do need to pay attention to shutter speed also to make sure that it's not so slow that any movement of the subject or camera will blur the image.

You can monitor the current f-stop and shutter speed in the Shooting Settings display, as shown in Figure 9-1. The settings also appear in the viewfinder and LCD panel. (If you don't see the settings, give the shutter button a quick half-press and release to wake up the exposure meter.)

2. To further soften the background, zoom in, get closer, and put more distance between subject and background.

As covered in Chapter 8, zooming in to a longer focal length also reduces depth of field, as does moving closer to your subject. And the greater the distance between the subject and background, the more the background blurs.

A lens with a focal length of 85–120mm is ideal for a classic head-and-shoulders portrait. But don't fret if you have only the 18–55mm kit lens; just zoom all the way to the 55mm setting. You should avoid using lenses with a much shorter focal length; they can cause features to appear distorted — sort of like how people look when you view them through a security peephole in a door.

3. For indoor portraits, shoot flash-free if possible.

Shooting by available light rather than flash produces softer illumination and avoids the problem of red-eye. To get enough light to go flashfree, turn on room lights or, during daylight, pose your subject next to a sunny window. If flash is unavoidable, see the flash tips at the end of the steps to get best results.

4. For outdoor portraits in daylight, use a flash if possible.

Even in daylight, a flash adds a beneficial pop of light to subjects' faces, as illustrated in Figure 9-3. A flash is especially important when the background is brighter than the subjects, as in this example; when the subject is wearing a hat; or when the sun is directly overhead, creating harsh shadows under the eyes, nose, and chin.

No flash

With flash

Figure 9-3: To better illuminate the face in outdoor portraits, use flash.

In the Av exposure mode, press the Flash button on the side of the camera to enable the built-in flash. For outdoor daytime portraits, disable the Red-Eye Reduction feature (Shooting Menu 2); you don't need it because the pupils are already constricted because of the bright ambient light.

One warning about using flash outdoors: The fastest shutter speed you can use with the built-in flash is 1/250 second, and in extremely bright conditions, that speed may be too slow to avoid overexposing the image even if you use the lowest ISO (light sensitivity) setting. If necessary, move your subject into the shade. (On some external Canon flashes, you can select a faster shutter speed than 1/250 second; see your flash manual for details.)

5. Press and hold the shutter button halfway to engage exposure metering and, if using autofocusing, to establish focus.

As spelled out in Table 9-1, the One-Shot AF mode and Single-point AF Area mode options work best for portrait autofocusing. After selecting a focus point, position that point over one of your subject's eyes and then press and hold the shutter button halfway to lock focus. Chapter 8 explains more about using autofocus, but if you have trouble, simply set your lens to manual focus mode and then turn the focusing ring to set focus.

6. Press the shutter button the rest of the way to capture the image.

A few other tips can also improve your people pics:

- Do a background check. Scan the frame for intrusive objects that may distract the eye from the subject. If necessary (and possible), reposition the subject against a more flattering backdrop. Inside, a softly textured wall works well; outdoors, trees and shrubs can provide attractive backdrops as long as they aren't so ornate or colorful that they diminish the subject (for example, a magnolia tree laden with blooms).
- Frame loosely to allow for later cropping to a variety of frame sizes. Because your camera produces images that have an aspect ratio of 3:2, your portrait perfectly fits a 4 x 6 print size, but requires cropping to print at any other proportions, such as 5 x 7 or 8 x 10. The printing section of Chapter 6 talks more about this issue.
- Pay attention to white balance if your subject is lit by both flash and ambient light. If you use the automatic White Balance setting (AWB), as recommended in Table 9-1, photo colors may be slightly warmer or cooler than neutral because the camera can become confused by mixed light sources. A warming effect typically looks nice in portraits, giving the skin a subtle glow. Cooler tones, though, usually aren't as flattering. Either way, see Chapter 8 to find out how to fine-tune white balance.
- For group portraits, be careful that depth of field doesn't get too shallow. Otherwise, people in the front or back of the group may be beyond

the zone of sharp focus. Depth of field may extend only a few inches from your focusing point, in fact, if you're using a long focal length (telephoto lens), select a very low f-stop value and position yourself very close to your subjects. So it's easy to wind up with a wedding photo in which the bride's face is in sharp focus, for example, while that of her loving groom, standing just behind, is blurry. (Try explaining *that* to the mother of the groom. . . .)

- When flash is unavoidable for indoor and nighttime portraits, try these tricks to produce better results:
 - Indoors, turn on as many room lights as possible. By using more ambient light, you reduce the flash power that's needed to expose the picture. This step also causes the pupils to constrict, further reducing the possibility of red-eye. (Pay heed to the preceding white-balance warning, however.) As an added benefit, the smaller pupil allows more of the subject's iris to be visible in the portrait, so you see more eye color.
 - Try setting the flash to Red-Eye Reduction mode. Warn your subject to expect both a light coming from the Red-Eye Reduction lamp, which constricts pupils, and the actual flash. See Chapter 2 for details about using this flash mode, which you enable on Shooting Menu 2.
 - Pay extra attention to shutter speed. In dim lighting, the camera may select a shutter speed as slow as 30 seconds when you enable the built-in flash in Av mode, so keep an eye on that value and use a tripod if necessary to avoid blurring from camera shake. Also warn your subject to remain as still as possible.
 - For nighttime pictures, try switching to Tv exposure mode and purposely selecting a slow shutter speed. The longer exposure time enables the camera to soak up more ambient light, producing a brighter background and reducing the flash power needed to light the subject. Again, though, a slow shutter means that you need to take extra precautions to ensure that neither camera nor subject moves during the exposure.
 - For professional results, use an external flash with a rotating flash head. Then aim the flash head upward so that the flash light bounces off the ceiling and falls softly down on the subject (bounce lighting) An external flash isn't inexpensive, but the results make the purchase worthwhile if you shoot lots of portraits. Compare the portraits in Figure 9-4 for an illustration. In the first example, the built-in flash resulted in strong shadowing behind the subject and harsh, concentrated light. Bounced lighting produced the better result on the right.

Direct flash

Bounce flash

Figure 9-4: To eliminate harsh lighting and strong shadows (left), use bounce flash and move the subject farther from the background (right).

- Invest in a flash diffuser to further soften the light. Whether you use the built-in flash or an external flash, attaching a diffuser is also a good idea. A diffuser is simply a piece of translucent plastic or fabric that you place over the flash to soften and spread the light much like sheer curtains diffuse window light. Diffusers come in lots of different designs, including small, fold-flat models that fit over the built-in flash.
- To reduce shadowing from the flash, move your subject farther from the background. Moving the subject away from the wall helped eliminate the background shadow in the second example in Figure 9-4.

The increased distance also softened the focus of the wall a bit (because of the short depth of field resulting from the f-stop and focal length).

Capturing action

A fast shutter speed is the key to capturing a blur-free shot of a moving subject, whether it's a spinning Ferris wheel, a butterfly flitting from flower to flower, or, in the case of Figures 9-5 and 9-6, a hockey-playing teen. In the first image, a shutter speed of 1/125 second was too slow to catch the subject without blur. For this subject, who was moving at a fairly rapid speed, I needed a shutter speed of 1/1000 second to freeze the action, as shown in Figure 9-5. (The backgrounds are blurry in both shots because the camera settings I used produced a shallow depth of field; in the first image, the skater is a little farther from the background, blurring the background more than in the second image.)

Figure 9-5: A too-slow shutter speed (1/125 second) causes the skater to appear blurry.

Figure 9-6: Raising the shutter speed to 1/1000 second froze the action.

Along with the basic capture settings outlined earlier (refer to Table 9-1), try the techniques in the following steps to photograph a subject in motion:

1. Set the Mode dial to Tv (shutter-priority autoexposure).

In this mode, you control shutter speed, and the camera chooses the f-stop that will produce a good exposure.

2. Rotate the Main dial to select the shutter speed.

You can monitor the shutter speed in the Shooting Settings display (refer to Figure 9-1), the viewfinder, and LCD panel.

The shutter speed you need depends on how fast your subject is moving, so you have to experiment. Another factor that affects your ability to stop action is the *direction* of subject motion. A car moving toward you can be stopped with a lower shutter speed than one moving across your field of view, for example. Generally speaking, 1/500 second should be plenty for all but the fastest subjects — speeding hockey players, race cars, or boats, for example. For slower subjects, you can even go as low as 1/250 or 1/125 second.

Remember, though, that when you increase shutter speed in Tv exposure mode, the camera opens the aperture to maintain the same exposure. At low f-stop numbers, depth of field becomes shorter, so you have to be more careful to keep your subject within the sharp-focus zone as you compose and focus the shot.

You also can take an entirely different approach to capturing action: Instead of choosing a fast shutter speed, select a speed slow enough to blur the moving objects, which can create a heightened sense of motion and, in scenes that feature very colorful subjects, cool abstract images. I took this approach when shooting the carnival ride featured in Figure 9-7, for example. For the left image, I set the shutter speed to 1/30 second; for the right version, I slowed things down to 1/5 second. In both cases, I used a tripod, but because nearly everything in the frame was moving, the entirety of both photos is blurry — the 1/5 second version is simply more blurry because of the slower shutter.

Figure 9-7: Using a shutter speed slow enough to blur moving objects can be a fun creative choice, too.

If the aperture value blinks after you set the shutter speed, the camera can't select an f-stop that will properly expose the photo at that shutter speed and the current ISO setting.

3. Raise the ISO setting to produce a brighter exposure, if needed.

In dim lighting, you may not be able to create a good exposure at your chosen shutter speed without taking this step. Raising the ISO increases the possibility of noise, but a noisy shot is better than a blurry shot. (The current ISO setting appears in the upper-right corner of the Shooting Settings display, as shown in Figure 9-1; press the ISO button or use the Quick Control screen to adjust the setting.)

If Auto ISO is in force, ISO may go up automatically when you increase the shutter speed. Auto ISO can be a big help when you're shooting fast-paced action; just be sure to limit the camera to choosing an ISO setting that doesn't produce an objectionable level of noise. Chapter 7 provides details on Auto ISO.

Why not just add flash to throw some extra light on the scene? That solution has a number of drawbacks. First, the flash needs time to recycle between shots, which slows down your shooting pace. Second, the fastest possible shutter speed when you enable the built-in flash is 1/250 second, which may not be fast enough to capture a quickly moving subject without blur. (You can use a faster shutter speed with certain Canon external flash units, however.) And finally, the built-in flash has a limited range, so unless your subject is pretty close to the camera, you're just wasting battery power with flash, anyway.

4. For rapid-fire shooting, set the Drive mode to one of the Continuous settings.

In High-speed Continuous mode, you can take approximately seven frames per second; Low-speed Continuous gives you about three frames per second. The camera continues to record images as long as the shutter button is pressed. You can access the Drive mode setting by pressing the Drive button or by using the Quick Control screen. (Refer to the labeling in Figure 9-1.)

If possible, use manual focusing; otherwise select AI Servo AF (autofocus) mode and 19-Point Automatic AF Area Mode.

With manual focusing, you eliminate the time the camera needs to lock focus during autofocusing. Chapter 1 shows you how to focus manually, if you need help. Of course, focusing manually gets a little tricky if your subject is moving in a way that requires you to change the focusing distance quickly from shot to shot. In that case, try these two autofocus settings for best performance:

- Set the AF (autofocus) mode to AI Servo (continuous-servo autofocus). Press the AF button or use the Quick Control screen to access this setting.
- Set the AF Area Mode setting to 19-Point Automatic. Press the button shown in the margin to access the setting; keep pressing the button to cycle through the available settings. You also can adjust the option via the Quick Control screen.

By default, the center focus point is used as the starting focusing target when AI Servo mode is in force. If you want to choose a different point, use the Multi-selector, Quick Control dial, or Main dial to do so. (Or just tap the point you want to use.)

Frame your subject under the selected focus point, press the shutter button halfway to set the initial focusing distance, and then reframe as necessary to keep the subject within the 19-point autofocusing area, indicated by the brackets in the center portion of the viewfinder. As long as you keep the shutter button pressed halfway, the camera continues to adjust focus up to the time you actually take the shot. Chapter 8 details these autofocus options; also see Chapter 11 for some ways to further fine-tune the autofocusing system.

6. Compose the subject to allow for movement across the frame.

Don't zoom in so far that your subject might zip out of the frame before you take the shot — frame a little wider than usual. You can always crop the photo later to a tighter composition. (Many examples in this book were cropped to eliminate distracting elements.) For an alternate effect, try panning with the movement. The central subject will remain relatively sharp but the background will be blurred.

These action-shooting strategies also are helpful for shooting candid portraits of kids and pets. Even if they aren't running, leaping, or otherwise cavorting when you pick up your camera, snapping a shot before they move or change positions is often tough. So, if an interaction or scene catches your eye, set your camera into action mode and then just fire off a series of shots as fast as you can.

One other key to shooting sports, wildlife, or any moving subject: Before you even put your eye to the viewfinder, spend time studying your subject so that you get an idea of when it will move, where it will move, and how it will move. The more you can anticipate the action, the better your chances of capturing it.

Capturing scenic vistas

Providing specific camera settings for landscape photography is tricky because there's no single best approach to capturing a beautiful stretch of countryside, a city skyline, or another vast subject. Depth of field is an example: One person's idea of a super cityscape might be to keep all buildings in the scene sharply focused. Another photographer might prefer to shoot the same scene so that a foreground building is sharply focused while the others are less so, thus drawing the eye to that first building.

That said, here are a few tips to help you photograph a landscape the way *you* see it:

✓ Shoot in aperture-priority autoexposure mode (Av) so that you can control depth of field. If you want extreme depth of field so that both near and distant objects are sharply focused, as shown in Figure 9-8, select a high f-stop value. An aperture of f/22 worked for this shot.

Figure 9-8: Use a high f-stop value to keep foreground and background sharply focused.

If the exposure requires a slow shutter, use a tripod to avoid blurring. The downside to a high f-stop is that you need a slower shutter speed to produce a good exposure. If the shutter speed is slower than you can comfortably handhold, use a tripod to avoid picture-blurring camera shake.

You can always increase the ISO setting to increase light sensitivity, which in turn allows a faster shutter speed, too, but that option brings with it the chance of increased image noise. See Chapter 7 for details. Also see Chapter 1 for details about image stabilization, which can help you take sharper handheld shots at slow shutter speeds.

For dramatic waterfall and fountain shots, consider using a slow shutter to create that "misty" look. The slow shutter blurs the water, giving it a soft, romantic appearance, as shown in Figure 9-9. Shutter speed for this shot was 1/15 second. Again, use a tripod to ensure that camera shake doesn't blur the rest of the scene.

In bright light, a slow shutter speed may overexpose the image even if you stop the aperture all the way down and select the camera's lowest ISO setting. As a solution, invest in a neutral-density filter for your lens. This filter works something like sunglasses for your camera: It reduces the amount of light that passes through the lens so that you can use a slower shutter than would otherwise be possible.

Figure 9-9: For misty water movement, use a slow shutter speed (and tripod)

✓ At sunrise or sunset, base exposure

on the sky. The foreground will be dark, but you can usually brighten it in a photo editor, if needed. If you base exposure on the foreground, on the other hand, the sky will become so bright that all the color will be washed out — a problem you usually can't easily fix after the fact.

You can also invest in a graduated neutral-density filter, which is a filter that's clear on one side and dark on the other. You orient the filter so that the dark half falls over the sky and the clear side over the dimly lit portion of the scene. This setup enables you to better expose the foreground without blowing out the sky colors.

Enabling Highlight Tone Priority or the HDR Mode feature can also improve your results, so take some test shots using those options, too. Chapter 7 offers more information.

For cool nighttime city pics, experiment with a slow shutter. Assuming that cars or other vehicles are moving through the scene, the result is neon trails of light, like those you see in Figure 9-10. Shutter speed for this image was 10 seconds. The longer your shutter speed, the blurrier the motion trails.

Because long exposures can produce image noise, you also may want to enable the Long Exposure Noise Reduction feature. Chapter 7 discusses this option.

For the best lighting, shoot during the "magic hours." That's the term photographers use for early morning and late afternoon, when the light cast by the sun is soft and warm, giving everything that beautiful, gently warmed look.

Can't wait for the perfect light? Tweak your camera's White Balance setting, using the instructions laid out in Chapter 8, to simulate magic-hour light.

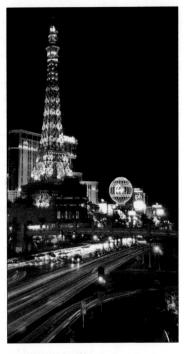

Figure 9-10: A slow shutter also creates neon light trails in street scenes

Your camera offers automatic exposure bracketing (AEB) when you shoot in the advanced exposure modes. See Chapter 7 to find out how to take advantage of this feature.

Also experiment with the Auto Lighting Optimizer and Highlight Tone Priority options; capture some images with the features enabled and then take the same shots with the features turned off. Remember, though, that you can't use both features concurrently; turning on Highlight Tone Priority disables Auto Lighting Optimizer. For high-contrast scenes, also try the HDR Mode feature, which records three images at different exposures and then blends them into a single shot that contains a higher range of darks to lights than can be recorded in a single exposure. Again, Chapter 7 explores all these features.

Capturing dynamic close-ups

For great close-ups, start with the basic capture settings outlined earlier, in Table 9-1. Then try the following additional settings and techniques:

- Check your owner's manual to find out the minimum close-focusing distance of your lens. How "up close and personal" you can be to your subject depends on your lens, not on the camera body.
- ✓ Take control over depth of field by setting the camera mode to Av (aperturepriority autoexposure) mode. Whether you want a shallow, medium, or extreme depth of field depends on the point of your photo. For the romantic scene shown in Figure 9-11, for example, setting the aperture to f/5.6 blurred the background, helping the subjects stand out more from the similarly colored background. But if you want the viewer to clearly see all details throughout the frame - for example, if you're shooting a product shot for your company's sales catalog go in the other direction. stopping down the aperture as far as possible.

Figure 9-11: Shallow depth of field helps set the subject apart from the background.

field. Back to that product shot: If you need depth of field beyond what you can achieve with the aperture setting, you may need to back away

- or zoom out (or switch to a shorter focal length lens if you use a prime lens), or both. You can always crop your image to show just the parts of the subject that you want to feature.
- When shooting flowers and other nature scenes outdoors, pay attention to shutter speed, too. Even a slight breeze may cause your subject to move, causing blurring at slow shutter speeds.
- ✓ Use fill flash for better outdoor lighting. Just as with portraits, a tiny bit of flash typically improves close-ups when the sun is your primary light source. You may need to reduce the flash output slightly, via the camera's Flash Exposure Compensation control. Chapter 7 offers details.
 - Keep in mind that the maximum shutter speed when you use the built-in flash is 1/250 second. (Some Canon Speedlites enable you to use a faster shutter speed.) So in extremely bright light, you may need to use a high f-stop setting to avoid overexposing the picture. You also can lower the ISO speed setting.
- When shooting indoors, try not to use flash as your primary light source. Because you're shooting at close range, the light from your flash may be too harsh even at a low Flash Exposure Compensation setting. If flash is inevitable, turn on as many room lights as possible to reduce the flash power that's needed even a hardware store shop light can work in a pinch as a lighting source. Remember that if you have multiple light sources, though, you may need to tweak the White Balance setting.
- ✓ To get very close to your subject, invest in a macro lens or a set of diopters. A true macro lens is an expensive proposition; expect to pay \$300 or more. If you enjoy capturing the tiny details in life, it's worth the investment.

For a less expensive way to go, you can spend about \$40 for a set of *diopters*, which are sort of like reading glasses you screw onto your existing lens. Diopters come in several strengths: +1, +2, +4, and so on, with a higher number indicating a greater magnifying power. In fact, a diopter was used to capture the rose in Figure 9-12. The left image shows the closest shot possible with the regular lens; to produce the right image, a +6 diopter was attached. The downfall of diopters, sadly, is that they typically produce images that are very soft around the edges, as in Figure 9-12, and that problem doesn't occur with a good macro lens.

No diopter +6 diopter

Figure 9-12: To extend the close-focus ability of a lens, add magnifying diopters.

Part IV The Part of Tens

Check out ten cool digital photography websites at www.dummies.com/extras/canon.

- Use Creative Filters for fun special effects.
- Tag your files with copyright information.
- Explore Wi-Fi functions.
- Create slide shows and video snapshots.
- Customize your camera ten ways to Sunday.

IL CANDY LAND

*CAMPAPPLES GOTTON CANDY ! PORCORN

Ten Features to Explore on a Rainy Day

In This Chapter

- Taking advantage of mirror lockup shooting
- Tagging files with cleaning instructions and copyright data
- Exploring more wireless features
- ▶ Playing around with special effects
- Creating slide shows and video snapshots
- Trimming frames from the beginning and end of a movie

onsider this chapter the literary equivalent of the end of one of those late-night infomercial offers — the part where the host exclaims, "But wait! There's more!" Options covered here aren't the sort of features that drive people to choose one camera over another, and they may come in handy only for certain users on certain occasions. Still, they're included at no extra charge with your camera, so check 'em out when you have a spare moment. Who knows? You may discover just the solution you need for one of your photography problems.

Because my publishers nixed the idea of making this book as long as *War and Peace*, I offer just brief introductions to features in this chapter. For more details, root around in your 70D camera box and look for a CD containing the camera manual in electronic (PDF) format. You also can download a copy from the Canon website if you lost the CD. For the United States version, go to www.usa.canon.com.

Enabling Mirror Lockup Shooting

One component in the optical system of a dSLR camera is a mirror that moves when you press the shutter button. The vibration caused by the mirror movement can result in image blur when you use a very slow shutter speed, shoot with a long telephoto lens, or take extreme close-ups, even if the camera is mounted on a tripod. To eliminate this possibility, your camera offers *mirror lockup*, which tells the camera to wait until the mirror movement is complete to record the shot. You can enable the Mirror Lockup feature only in the advanced exposure modes (P, Tv, Av, M, B, and C); look for it on Shooting Menu 2.

Mirror lockup shooting requires two full presses of the shutter button. Press once to lock up the mirror, release the button, and press again to take the picture. (If you don't press any buttons for 30 seconds after you lock up the mirror, it automatically flips back down.) Remember that while the mirror is up, you can't see anything through the viewfinder; the mirror's function is to display in the viewfinder the scene that the lens will capture, and mirror lockup prevents it from serving that purpose.

Adding Cleaning Instructions to Images

If spots appear in the same location in every shot and cleaning your lens doesn't resolve the problem, you may have a dirty image sensor. Try running the camera's automated cleaning routine, accessible through Setup Menu 4. Still seeing spots? The best solution is to take your camera to a repair shop for professional cleaning. (I don't recommend that you clean the sensor yourself because you can easily ruin your camera if you don't know what you're doing.) Until you can have the camera cleaned, however, you can run your photos through a dust-removal filter found in Digital Photo Professional, a program that ships with your camera.

The first step is to help the camera locate the dust on the sensor. Set the Mode dial to one of the advanced exposure settings, select Dust Delete Data from Shooting Menu 4, and then take a picture of a white piece of paper, making sure that the paper fills the frame. The camera records a map of the dust spots to its internal memory and then attaches the data to every subsequent image, regardless of your exposure mode.

To clean a photo, open it in Digital Photo Professional and choose Tools Start Stamp Tool. Your photo appears in an editing window; click the Apply Dust Delete Data button to start the dust-busting feature, which reads the attached dust data and tries to zap those spots into oblivion. The program's Help system (choose Help Digital Photo Professional Help) offers details.

Tagging Files with Your Copyright Claim

By using the Copyright Information feature on Setup Menu 4, you can add copyright information to the image *metadata* (extra data) recorded with the image file. You can view metadata in the Canon software; Chapter 6 shows you how.

This feature isn't available in the fully automatic shooting modes. So set the Mode dial to P, Tv, Av, M, B, or C and then select Copyright Information from Setup Menu 4 to display the screen shown on the left in Figure 10-1. Select Enter Author's Name to display the keyboard screen shown on the right in the figure.

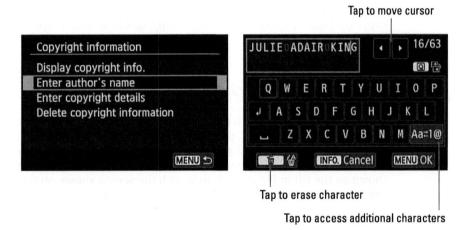

Figure 10-1: Look for the copyright function on Setup Menu 4.

Any time you see a keyboard screen, enter data by using these techniques:

- ✓ **Touchscreen entry:** Just tap the letters you want to enter. Tap the symbol labeled Tap to Access Additional Characters in the figure to switch the keyboard from displaying all uppercase letters, all lowercase letters, or numbers and symbols. To move the cursor, tap inside the text or tap the arrows at the end of the text entry box; to erase the character to the left of the cursor, tap the Erase icon.
- Button-based typing: Enter text as follows:
 - Press the Q button to alternate between the text box and the keyboard.

- In the keyboard, use the Multi-controller, Quick Control dial, or Main dial to highlight the character you want to enter. Press Set to enter the character.
- In the text box, use the Multi-controller to move the cursor.

 To delete a character, move the cursor just past the letter and press the Erase button.

Either way, after you enter your name, press the Menu button or tap the Menu icon. Then select Enter Copyright Details from the screen shown on the left in Figure 10-1 and enter your copyright data. You might want to add the word *Copyright* and the year, for example, or your company name.

To check the accuracy of your data, select Display Copyright Information from the screen shown on the left in Figure 10-1. You can later disable the copyright tagging by using the Delete Copyright Information option on the same screen.

Exploring Wi-Fi Functions

Your camera enables you to connect via a wireless network to various devices for picture sharing, printing, and downloading. To try out these features, visit Setup Menu 3 and set the Wi-Fi option to Enable, which then makes the Wi-Fi Function menu option available. Choose that option, as shown on the left in Figure 10-2, to launch the screen shown on the right, which is the starting point for all the Wi-Fi functions.

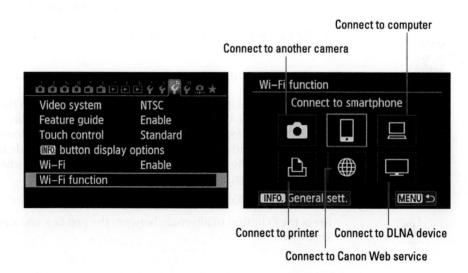

Figure 10-2: Launch Wi-Fi connections from this main control screen.

Chapter 6 explains how to connect your camera via Wi-Fi to your computer for picture downloading. That chapter includes initial setup steps you need to take for using all the Wi-Fi functions, so I don't repeat them here. (Basically, you have to give your camera a nickname by entering data through the same type of keyboard described in the preceding section.)

After you get through the initial setup, you can take advantage of the following wireless features by selecting the icons indicated in the figure:

- ✓ Transfer images between cameras: You can connect to another camera that has compatible Wi-Fi features and then copy pictures from your memory card to the card on the other camera. The connection must be made through your wireless network; the cameras can't talk directly to each other.
- ✓ **Connect to smartphone:** Through this feature, shown selected on the right in Figure 10-2, you can view pictures on a compatible smartphone or tablet. Even better, you can transfer pictures so that you can display them on that device instead of having to drag your camera along every time you want to show off your work.

A couple of important points:

- You first need to download and install the Canon EOS Utility app on your phone or tablet. For Android-based devices, it's available through Google Play; for Apple devices, search the App Store.
- You can transfer only low-resolution copies of your images to your phone or tablet. Don't worry; they'll be plenty large for viewing on your device and for uploading to Facebook or whatever social media site you use.

The app also makes it possible to use your smart device to trigger the camera's shutter. The hitch is that there's a noticeable delay between the time you tap the Take Picture control on the device and the time the picture is recorded, and you can't really adjust any camera settings through the app.

Remote control (EOS Utility): Select the icon labeled Connect to Computer in the figure to download your original files to your computer using the EOS Utility software, as I outline in Chapter 6.

You also can use the EOS Utility software to control the camera from your computer both wirelessly and via the USB cable that shipped with your camera. This feature is better than using the phone/tablet app because the computer-based software enables you to establish settings such as f-stop, shutter speed, white balance, and so on. If you shoot in Live View mode, you also can see the live preview on your computer monitor. You can even view pictures on the computer monitor in playback mode.

- Print from Wi-Fi printer: You can enjoy wireless printing if you have a printer hooked up to your Wi-Fi network and if that printer supports a technology known as PictBridge.
- ✓ **Upload to the Canon web service:** This option connects the camera to Canon Image Gateway, the Canon online picture-storage and sharing site. You can upload photos to the site and also configure your gallery to share pictures via Facebook and other third-party sites. To use this function, you must set up an account (it's free) and register your camera at the Canon Image Gateway web page.
- View images on DLNA devices: If you have a television or media player that's connected to your wireless network and carries the DLNA (Digital Living Network Alliance) specification, you can connect to the device for wireless playback.

Of all these features, I think the one people will appreciate most is being able to upload low-res pictures for playback on a smartphone or tablet. Fortunately, after you install the app, getting the two devices to connect is pretty easy, and using the app is fairly intuitive — which cannot be said about the other wireless functions. There's a brief paper guide to Wi-Fi hookups in the camera box, but unless you're a networking guru, you're going to need to dig out the instructional manual on CD to find step-by-step instructions for using all the features with various types of wireless networks. Because the steps vary depending on your computer's operating system and your wireless-network setup, I can't be of much help with that part of the process.

Be sure, too, to check the Canon website to make sure you have the latest copy of the Canon EOS Utility software. It was updated shortly after the camera was released, and at least in this office, things didn't work correctly until I installed that update. (Go to the 70D product support page and look for the software link.)

Finally, remember that you can't record movies while the Wi-Fi option on Setup Menu 3 is set to enable. The camera displays a warning screen when you turn on the Wi-Fi system, but it's easy to forget that you enabled Wi-Fi and then find yourself locked out of movie shooting just as the perfect cinematic moment presents itself. So always turn off the Wi-Fi feature when you're done using it. (You'll also save battery power.)

Experimenting with Creative Filters

Enough of the dry technical stuff — time for something a bit more entertaining. With the Creative Filters, you can add special effects to your pictures. For example, I used this feature to create the three versions of the city scene shown in Figure 10-3.

Miniature Effect

Figure 10-3: I used the Creative Filters feature to create these variations on a city scene.

You can apply Creative Filters to copies of photos already on your memory card. This approach lets you experiment with different effects while keeping the original photo unaltered. Alternatively, you can add Creative Filters as you shoot in Live View, in which case you get only photos with the effect applied.

You can choose from the following filters:

- ✓ **Grainy B/W:** This filter turns your photos into old-fashioned, grainy, black-and-white photos.
- ✓ **Soft Focus:** This filter blurs the photo so details look soft and fuzzy, as if you had rubbed petroleum jelly on the lens.
- Fish-eye: This option distorts your photo so that it appears to have been shot using a fish-eye lens, as shown in the top-right example in Figure 10-3.
- Art Bold: Do you like your colors bold? Is over-the-top vivid your thing? Give this filter a try.
- Water Painting: Sort of the opposite of Art Bold, this filter sucks some color out of your image. The resulting image looks similar to a painting done in pastel colors.
- ✓ Toy Camera: This filter creates an image with dark corners called a vignette effect. Vignetting is caused by poor-quality lenses not letting enough light in to expose the entire frame of film (like in toy cameras). When you choose this effect, you can also add a warm (yellowish) or cool (blue) tint. For example, I applied the effect with a warm tint to create the lower-left variation in Figure 10-3.
- Miniature: This filter creates a trick of the eye by playing with depth of field. It blurs all but a very small area of the photo to create a result that looks something like one of those miniature dioramas you see in museums. I applied the filter to the city scene to produce the lower-right variation in Figure 10-3. This effect works best on pictures taken from a high angle.

Creative Filters icon

Here's how to try out the filters:

button to enter Quick Control mode and then select the Creative Filters icon, labeled in Figure 10-4. Or choose Creative Filters from Playback Menu 1 and then press Set. You then see the current photo along with six icons representing the filters and one representing the setting that disables the effects, as shown in the figure. Use the Multicontroller or Quick Control dial to scroll through the icons. The name of the selected filter

Filter options

Figure 10-4: You can apply creative filters to existing photos.

appears on the screen, but the image doesn't change to reflect the filter's effects.

After choosing a filter, press or tap Set to display a screen where you can play with various settings to affect the result of the filter. In some cases, you do see the result of your selection on this screen. Which controls appear depend on the effect; the only one that might stump you is the screen for the Miniature Effect. When you choose this filter, a box appears to indicate the area that will remain in sharp focus when the rest of the image is blurred. Use the Multi-controller to move the box up or down or just tap the spot on the screen where you want to position the box. To change the box orientation from horizontal to vertical, press the Info button or tap the Info icon.

To finish applying the effect, press Set or tap the Set icon. You see a confirmation screen; after you give the camera the go-ahead, it creates a copy of your image, applies the effect, and then displays a message telling you the folder number and last four digits of the file number of the altered photo. If you captured the original by using the Raw Quality setting, the altered image is stored in the JPEG format.

Mapplying filters during shooting: First, set the camera to Live View mode and then set the camera to any exposure mode except the Handheld Night Scene or HDR Backlight Control scene (SCN) modes. Select one of the JPEG settings as the Image Quality option; the filters don't work when Raw is the selected format. Also make sure that Auto Exposure Bracketing (AEB), White Balance Bracketing, and MultiShot Noise Reduction are turned off.

After the live preview appears, enter Quick Control mode and select the Creative Filters icon. It's the same one found on the Quick Control screen during playback (see Figure 10-4), except that it appears on the lower-right side of the screen in Live View. When you select it, the individual filter icons appear along the bottom of the screen. This time, as you scroll through the options, the preview updates to show you the result of the filter.

If you see an Info icon after selecting a filter, tap that icon or press the Info button to access the filter settings. Tap the return arrow or press Info again to return to the Quick Control screen; press the Q button to exit the Quick Control screen and return to shooting mode.

For the Miniature effect, you see the focus-zone box after exiting Quick Control mode. Use the Multi-controller to position it. To change the orientation of the box, press the AF Point Selection button. After adjusting an effect, take the picture. The image is stored in the JPEG format.

Shooting in Multiple Exposure Mode

Through the Multiple Exposure option on Shooting Menu 4 (available only in the advanced exposure modes), you can capture two to nine images and then let the camera blend them into a single photo. I used this feature to create both images shown in Figure 10-5. For the first example, I blended a picture of some sheet music with a photo of piano keys. This example shows you the normal blending of the photos, which results in both images being partially transparent. For the second example, I shot both views of the watch against a solid black background and positioned the watch in each frame so the two views wouldn't overlap in the blended image. Using this technique, you can make the subject appear as a solid object.

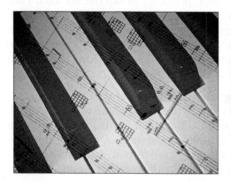

Figure 10-5: Here are two images I created using the Multiple Exposure feature on Shooting Menu 4.

When you choose the Multiple Exposure setting from the menu, you find the following options:

- Multiple Exposure: Enables or disables the feature.
- Multi-expos Ctrl: Varies the way photos are blended (experiment to see which one works best for your subject).
- ✓ No. of Exposures: Sets the number of shots to be recorded.
- Continue Mult-exp: Tells the camera to use the feature for just one round of shooting or continue creating multiple exposures until you disable the feature.
- Select Image for Multi. Expo.: Allows you to use an existing photo as the first image in your multiple exposure.

Shooting in Live View mode makes shooting your exposures easier. After you take the first picture, it appears superimposed over the live view, which helps you know how to frame your next shot. See Chapter 4 for details of Live View shooting.

Although using the Multiple Exposure feature is a fun parlor trick, if you're really into compositing (blending) photos, I suggest you shoot your images normally and then join them in your photo-editing program. You'll have more control over how the images are blended, both in terms of where the subjects appear in the final image and at what opacity each subject appears.

Investigating Two More Printing Options

In addition to the wireless printing option discussed earlier in this chapter, you can access the following printing options through Playback Menu 1:

- ✓ Print Order: You select pictures from your memory card and then specify how many prints you want of each image. Then, if your photo printer has a card reader compatible with your memory card and supports DPOF (Digital Print Order Format), you just pop the card into the reader. The printer checks your "print order" and outputs just the requested prints. You also can print by connecting the camera to the printer using the USB cable supplied in the camera box.
- Photobook Set-up: Many photo-printing sites make it easy to print books featuring your favorite images; this feature is a nod to this trend. You can use it to tag photos that you want to include in a photobook. Then, if you use the Canon EOS Utility software to transfer pictures to your computer, tagged photos are dumped into a separate folder so that they're easy to find. This feature works only when you download pictures by connecting the camera to the computer. In addition, it doesn't work with Raw files.

Presenting a Slide Show

The Slide Show function on Playback Menu 2 creates a slide show featuring the best images and movies on your memory card. You can play the show on the camera monitor or connect your camera to a TV and present the show to a roomful of people.

After you select the menu option, you see a screen where you can set up your show. First, specify which images or movies you want to include in the show. You can include just stills, just movies, files stored in a particular folder, files created on a specific date, or photos assigned a certain picture rating. (Chapter 5 explains how to rate photos.)

You also can adjust the display time for each photo (movies are always played in their entirety); set the show to play repeatedly until people beg you to stop; choose a slide transition effect; and even enable some background music. For this last option, you must first use the EOS Utility software that ships with your camera to transfer music files to the camera memory card.

During the show, control the display as follows:

- Pause playback: Press the Set button. While the show is paused, you can rotate the Quick Control dial or press the Multi-controller right/left to view the next or previous photo. Press Set again or tap the onscreen Set icon to restart playback.
- Change the information display: Press the Info button.
- ✓ **Adjust sound volume:** Rotate the Main dial.
- **Exit the show:** Press the Menu button.

Editing Movies

Although not a substitute for computer-based video-editing software, the 70D movie-edit feature makes it easy to remove unwanted frames from the beginning or end of a movie.

To access the editing tools, set the camera to playback mode and begin playing the movie. Then press the Set button or tap the Set icon to display the controls shown on the left in Figure 10-6. Tap the Edit icon (or highlight it and press Set) to enter the editing screen, shown on the right in the figure.

To trim frames from the start of a movie, select the Cut Beginning icon, labeled in Figure 10-6. The bar at the top of the screen becomes active, and little arrows appear under the bar. (Not shown in the figure.) You can tap those arrows to advance or rewind the movie clip frame by frame. Or, if it's easier, press the Multi-controller left and right to do the job. When you reach the first frame you want to keep, tap or press Set. Then select the Save Edited Movie icon (labeled in Figure 10-6) and choose New File to save your trimmed movie as a new file instead of overwriting your original.

To trim the end of a movie, follow the same process but choose the Cut Ending icon (labeled in Figure 10-6) instead of the Cut Beginning icon. You can preview your edited clip by selecting the Play Edited Movie icon, also labeled in the figure.

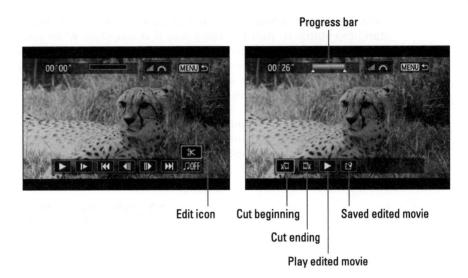

Figure 10-6: From the playback screen, tap the scissors icon to get to the editing functions.

Creating Video Snapshots

The Video Snapshot feature on Movie Menu 2 captures short video clips that are stitched into a single recording, called a *video album*. A few pertinent facts before I go any farther:

- Each clip can be no more than 8 seconds long. You also can record 2and 4-second clips.
- All clips in an album must be the same length.

To create your first album, set the camera to Movie mode, pull up Movie Menu 2, and select Video Snapshot. You then see the screen shown in Figure 10-7. After setting Video Snapshot to Enable, select Album Settings and then select Create a New Album. You're then presented with an option that enables you to set the length of the snapshot. After setting that option, highlight OK and press Set (or just tap the OK icon).

Figure 10-7: Video Snapshots are short movie clips combined into a single recording.

Press the shutter button halfway to exit the menu screens and then press the Start/Stop button to start recording your first snapshot. When you reach the maximum clip length, recording stops automatically. The monitor temporarily shuts off, and then you see the last frame of the clip along with a screen offering three options: Save as Album, Play Clip, or Delete Clip. Select the Save as Album option to store the clip in your first album.

When you record your second clip, you can choose to start a second, new album or add the clip to your existing album. Again, the option appears after the clip is recorded. To stop capturing snapshots, return to Movie Menu 2 and set the Video Snapshot option to Disable. You can then shoot regular movies again.

You also can use the Quick Control screen to enable and disable Video Snapshot recording. Just select the icon labeled in Figure 10-8. To disable snapshot shooting, tap the Off icon at the bottom of the screen. Tap the neighboring icon to enable the feature using the snapshot length that's currently selected via Movie Menu 2. (You can't adjust the length using the Quick Control options.)

A few final notes about recording video snapshots:

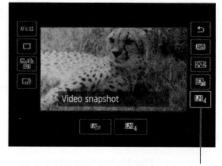

Video snapshot icon

Figure 10-8: You also can enable and disable the Video Snapshot feature via the Quick Settings screen.

- Sound recording: By default, audio is recorded; you can control audio recording through the Sound Recording option on Movie Menu 2, just as for regular movies. However, if you change the setting between recording snapshots, the camera creates a new album for the next snapshot.
- Movie Recording Size: All clips in an album must use the same Movie Recording Size option (Movie Menu 2). If you change the setting, the camera automatically creates a new album for your next snapshot.
- Autofocusing: Your options are the same as for normal movie recording; Chapter 4 has details.
- Normal playback: To play a video snapshot after you exit the creation process, use the normal movie-playback steps, detailed at the end of Chapter 4.

Ten More Ways to Customize Your Camera

In This Chapter

- ▶ Storing your favorite settings as a custom exposure mode (C mode)
- Creating your own menu and custom folders
- Changing the color space (sRGB versus Adobe RGB)
- Assigning new functions to camera buttons
- Exploring a host of autofocus tweaks

ave you ever tried to cook dinner in someone else's house or work from another colleague's desk? Why is *nothing* stored in the right place? The coffee cups, for example, should be stowed in the cabinet above the coffee maker, and yet there they are, way across the kitchen, in the cupboard near the fridge. And everyone knows that the highlighter pens belong in the middle top drawer, not the second one on the left. Yeesh.

In the same way, you may find a particular aspect of your camera's design illogical or maybe a tad inconvenient. If so, check out this chapter, which introduces you to a slew of customization options not considered in earlier chapters.

Creating Your Own Exposure Mode

One of the most useful features for the experienced photographer is the C setting on the Mode dial. This option, which stands for Camera User Settings, enables you to set up your own exposure mode. You start by selecting and saving all the camera settings you want to use when you switch to C mode. Then when you're out shooting, you can invoke all those settings simply by setting the Mode dial to C, as shown in Figure 11-1.

To take advantage of C mode, follow these steps:

1. Set up your camera.

Start by selecting the exposure mode on which you want to base the custom mode (Tv, Av, M, and so on). Then set the initial exposure, flash, autofocusing, Drive mode, and color options you want to use when you switch to C mode. Next, take a trip through the menus and select your preferred settings. You can store all menu settings except the following:

> • Shooting Menu 4: Dust Delete Data, HDR Mode on/off, and Multiple Exposure on/off. The options that you can select when using HDR Mode and

- Live View Menu 1: Touch Shutter.
- Movie Menu 2: Time Code (although the Movie recording count and Movie play count settings available for this menu option are stored).
- Playback Menu 1: No options on this menu can be stored.
- Playback Menu 2: Resize and Rating; for Slide Show, show settings are stored.
- Playback Menu 3: Ctrl over HDMI.
- Setup Menu 1: Select Folder and Format Card.
- Setup Menu 2: Date/Time, Language, and GPS Device Settings.
- Setup Menu 3: Video System, Feature Guide, Wi-Fi, and Wi-Fi Function.
- Setup Menu 4: None can be stored except the Auto Cleaning setting available for the Sensor Cleaning option.
- Custom Functions Menu, Operation/Others category: Warnings in viewfinder.
- My Menu: Your custom menu options aren't stored, either.

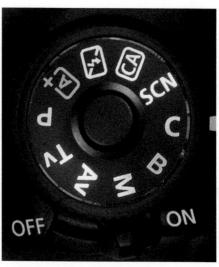

2. Open Setup Menu 4 and choose Custom Shooting Mode (C Mode), as shown on the left in Figure 11-2.

The screen shown on the right in Figure 11-2 appears.

3. Choose Register Settings.

You see a confirmation screen; choose OK. The camera stores your settings and returns you to the screen shown on the right in Figure 11-2.

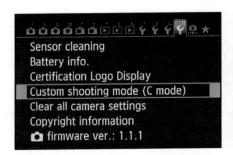

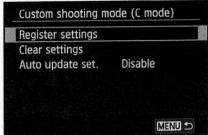

Figure 11-2: Register your settings through this menu option.

As for the other two options on that menu, they work like so:

- ✓ Clear Settings: Select this option to return C to its default state, which is modeled after the P (programmed autoexposure) mode.
- Auto Update Set(tings): When you're working in C mode, you can still change any camera setting you're not locked into the registered settings. If you enable this menu option and then vary a registered setting, the camera automatically registers that *new* setting as part of your C mode. Needless to say, you can get off track quickly if you enable this function, which is why it's turned off by default.

One quirk to note about C mode: When the Mode dial is set to C, you can't restore the camera defaults by choosing Clear All Camera Settings from Setup Menu 4 or Clear All Custom Functions from the Custom Functions menu.

Creating Your Very Own Camera Menu

You can create a custom menu containing up to six items from the camera's other menus. Logically enough, the custom menu goes by the name My Menu and is represented by the green star icon. To create your menu, take these steps:

1. Set the camera Mode dial to P, Tv, Av, M, B, or C.

You can create and order from the custom menu only in these exposure modes.

 $2. \ \,$ Press the Menu button to display the menus and then select the My Menu menu.

You see the screen shown on the left in Figure 11-3.

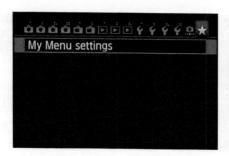

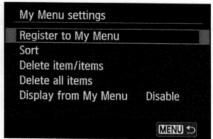

Figure 11-3: Choose Register to My Menu to add an item to your custom menu.

- 3. Choose My Menu Settings to display the screen shown on the right in Figure 11-3.
- 4. Choose Register to My Menu.

You see a scrolling list that contains every item found on the camera's other menus, as shown in Figure 11-4.

Select an item to include on your custom menu and then tap Set or press the Set button.

To add a specific Custom Function to your menu, scroll past the Custom Function category items to find the individual function. (The category items just

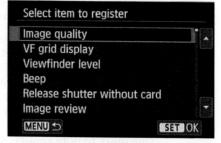

Figure 11-4: Highlight an item to put on your menu and press or tap Set.

take you to the initial menu screen for that category, and you still have to wade through multiple levels of steps to reach your function.)

After you choose the item, you see a confirmation screen.

6. Tap OK (or highlight it and press the Set button).

You return to the list of menu options. The option you just added to your menu is dimmed in the list.

- 7. Repeat Steps 5 and 6 to add up to five additional items to your menu.
- 8. Tap the Menu icon or press the Menu button.

You then see the My Menu settings screen (right screen in Figure 11-3).

9. Tap the Menu icon or press the Menu button again.

The My Menu screen appears, and the items you added are listed on the menu.

After creating your menu, you can manage it as follows:

- Give your menu priority. You can tell the camera to display your menu anytime you press the Menu button. To do so, choose My Menu Settings on the main My Menu screen to display the screen shown on the right side of Figure 11-3. Then set the Display from My Menu option to Enable.
- Change the order of menu items. Once again, navigate to the right screen in Figure 11-3. This time, choose Sort. Tap an item (or highlight it and press Set) and then tap the up/down arrows at the bottom of the screen or press the Multi-controller up/down to move the menu item up or down in the list. Tap the Set icon or press the Set button to glue the menu item in its new position. Tap the Menu icon or press the menu button to return to the My Menu Settings screen; press or tap Menu again to return to your custom menu.
- ✓ Delete menu items. Display your menu, choose My Menu Settings, and then choose Delete Item/Items. (Refer to the right screen in Figure 11-3.) Choose the menu item that you want to delete; on the resulting confirmation screen, tap OK or highlight it and press the Set button.

To remove all items from your custom menu, choose Delete All Items. (Again, see the right side of Figure 11-3.)

Creating Custom Folders

Normally, your camera automatically creates folders to store your images. The first folder has the name 100Canon; the second, 101Canon; the third, 102Canon; and so on. Each folder can hold 9,999 photos. If you want to create a new folder before the existing one is full, choose Select Folder from Setup Menu 1 and then choose Create Folder, as illustrated in Figure 11-5. You might take this organizational step so that you can segregate work photos from personal photos, for example.

The folder is automatically assigned the next available folder number and is selected as the active folder — the one that will hold any new photos you shoot. To make a different folder the active folder, just choose it from the list. The number next to a folder name indicates how many photos are in the folder.

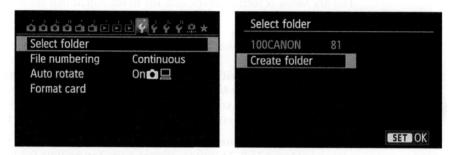

Figure 11-5: You can create a new image-storage folder at any time.

Changing the Color Space from sRGB to Adobe RGB

By default, your camera captures images using the *sRGB color space*, which refers to an industry-standard spectrum of colors. (The *s* is for *standard*, and the *RGB* is for *red*, *green*, *blue*, which are the primary colors in the digital color world.) The sRGB color space was created to help ensure color consistency as an image moves from camera or scanner to monitor and printer; the idea was to create a spectrum of colors that all devices can reproduce.

However, the sRGB color spectrum leaves out some colors that *can* be reproduced in print and onscreen, at least by some devices. So, as an alternative, your camera also enables you to shoot in the Adobe RGB color space, which includes a larger spectrum (or *gamut*) of colors. Some colors in the Adobe RGB spectrum can't be reproduced in print. (The printer just substitutes the closest printable color.) Still, I usually shoot in Adobe RGB to avoid limiting myself to a smaller spectrum from the get-go.

However, that doesn't mean that it's right for you. First, if you print and share your photos without making any adjustments in your photo editor, you're better off sticking with sRGB because most printers and web browsers are designed around that color space. Second, to retain all original Adobe RGB colors when you work with your photos, your editing software must support that color space — not all programs do. You also must be willing to study the whole topic of digital color a little bit because you need to use some specific settings in your photo and printer software to avoid mucking up the color works.

If you do want to switch to Adobe RGB, make the adjustment via the Color Space option on Shooting Menu 3. However, you can access this option only in the advanced exposure modes. In all other modes, you're locked into sRGB. Additionally, your color space selection is applied to only your JPEG images; with Raw captures, you select the color space as you process the Raw image and convert it to a JPEG or TIFF, not when you capture it. (See Chapter 6 for details about Raw-image processing.)

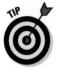

After you transfer pictures to your computer, you can tell whether you captured an image in the Adobe RGB color space by looking at its filename: Adobe RGB images start with an underscore, as in _MG_0627.jpg. Pictures captured in the sRGB color space start with the letter *I*, as in IMG_0627.jpg.

Changing the Direction of the Dials

When you shoot in the Tv and Av exposure modes, you adjust shutter speed or f-stop, respectively, by rotating the Main dial. In M mode, you rotate the Main dial to change the shutter speed and rotate the Quick Control dial to adjust the f-stop.

Normally, turning the dials clockwise or to the right increases the value being adjusted. If this seems backwards to you, head for the Custom Functions menu, choose the Operation/Others category, and then select the first Custom Function in the group, as shown in Figure 11-6. Then select the Reverse Direction option.

Figure 11-6: This option determines which direction you rotate the Main dial and Quick Control dial to raise or lower the f-stop and shutter speed.

Changing All the Furniture Around

In addition to modifying the direction of the Main dial and Quick Control dial, you can change the function of the Set button, shutter button, AE Lock button, and a host of other controls. Please *don't* take advantage of any of these options, though, until you're thoroughly familiar with how the camera works using the original function settings. If you modify a control, it's not going to behave the way my instructions in the book indicate that it should.

Q

When you're ready to explore your options, take either of these routes:

Quick Settings screen: Select the Custom Controls icon, as shown on the left in Figure 11-7, to display the mind-numbing screen shown on the right in the figure. This screen serves as Grand Central Station for customizing nine camera controls.

Figure 11-7: You can modify the functions of nine camera controls through this Quick Control setting.

Custom Functions Menu: Open the Operation/Others section of the menu and then navigate to the Custom Controls screen, shown in Figure 11-8. Select one of the nine controls to display the same screen you see on the right in Figure 11-7.

Here's how to make adjustments after you land on the screen shown on the right in Figure 11-7:

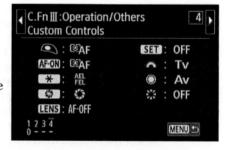

Figure 11-8: You can access the same options via the Custom Controls menu item.

Selecting a control to customize:

The controls are presented as two rows of icons running down the right side of the screen. The icons are, as you can see, somewhat cryptic, so it's nice that as you highlight each one, the name of the button appears, along with its default function. For example, on the right screen in Figure 11-7, the shutter button icon is selected, and the label at the top of the screen indicates that the button is set to initiate exposure metering and autofocusing with a half-press of the button.

As you select the different controls, the camera graphic on the left side of the screen highlights the button you're adjusting. In the figure, for example, the shutter button is lit.

One option, Lens control (last setting in left column of icons), is related only to certain super-telephoto lenses that have an AF Stop button. If your lens doesn't have this button (the two kit lenses don't), don't worry about this setting. You also can't assign the AF Stop function to any other button.

Setting the button function: After highlighting a control, tap Set or press the Set button to display the options available for that button. For example, Figure 11-9 shows the options available for the shutter button. As you scroll through the choices, the label above the icons shows you what the button will accomplish at that setting. Make your choice and tap Set or press the Set button to return to the initial

setup screen.

Figure 11-9: After you select a button icon, the functions available for that button appear; here you see the functions for the shutter button.

If you need help understanding the individual functions that are available, dig out the electronic manual found on the CD that came with your camera. The section in the manual titled "Custom Controls" explains what happens when you select the various button settings.

✓ Resetting the default functions: To restore a button to its original function, choose the first option available for that button. To reset all the buttons to their defaults, tap the Default Set icon you see on the screen shown on the right in Figure 11-7 or press the Erase button.

You can't simply choose the Clear All Custom Functions option on the Custom Functions menu to restore the defaults; neither does choosing the Clear All Camera Settings option on Setup Menu 4 do the trick. You must visit the Custom Controls screen to get back to square one.

Exit the configuration screen: Press the Menu button or tap the Menu icon.

Disabling the AF-Assist Beam

In dim lighting, your camera emits an AF-assist (autofocus) beam from the built-in flash when you press the shutter button halfway — assuming that the flash unit is open, of course. This pulse of light helps the camera find its focusing target. In situations where the AF-assist beam might be distracting to your subject or to others in the room, you can disable it when you shoot

in the advanced exposure modes. Open the Custom Functions menu, choose the Autofocus category, and then track down Function 5, AF-Assist Beam Firing.

You can choose from these settings:

- ✓ 0: The default; lets the AF-assist beam fire when needed
- ✓ 1: Disables the AF-assist beam of both the built-in flash and compatible Canon EX-series Speedlite external flash units
- ✓ 2: Disables the beam of the built-in flash while allowing the beam of a compatible EX-series Speedlite to function normally
- 3: Allows the external Canon EOS-dedicated Speedlite with infrared (IR) AF-assist to use only the IR beam, which prevents the external flash from pulsing a series of small flashes (such as the built-in flash) from firing

An external Canon Speedlite has its own provision to disable the AF-assist beam: If you disable the AF-assist on the external flash, it doesn't emit the AF-assist beam even if you select Option 3. In other words, the external flash's own setting overrides the camera's Custom Function setting.

Regardless of the menu setting, the AF-assist beam continues to light from the built-in flash when the camera deems it necessary in the automatic exposure modes.

Controlling the Lens Focus Drive

It's pretty annoying when you try to autofocus and the camera doesn't get a good lock, but the lens motor keeps churning away like it's trying to swim the English Channel. This problem occurs most often when you're shooting low-contrast subjects in low light. If that keeps happening, consider changing the lens focus drive behavior.

You can make this adjustment only in the advanced exposure modes. So set the Mode dial to P, Tv, Av, M, B, or C and then pull up the Custom Functions menu and select the Autofocus category. Navigate to Function 6, Lens Drive When AF Impossible. If you change the setting to Stop Focus Search, the camera won't keep trying to focus when autofocusing fails.

Of course, you have another option when the autofocus motor can't hone in on its target: Just set the lens to manual focusing and do the job yourself. Often, that's the easiest solution to a focus problem.

Making the Flashing Red AF Points Go Away

In dim lighting, the autofocus points that are used to establish focus flash red in the viewfinder when you initiate autofocusing. If you find them distracting, you can turn them off; if you instead want them to appear even in bright light, you can make it so. The control that adjusts this behavior is VF Display Illumination, which is Custom Function 12 in the Autofocus section. Figure 11-10 offers a look. You get three choices:

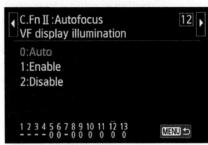

Figure 11-10: This option determines whether the focus points flash red in the viewfinder when you autofocus.

- 0: Auto: This is the default; the focus points flash red only in dim lighting.
- ✓ 1: Enable: Here's the option to select if you always want to see the focus points flash red.
- ✓ 2: Disable: I know you figured out this one already. But do note that even if you choose Off, you still see the red AF points light up when you're using an AF Area mode that enables you to select a specific point or zone. Otherwise you wouldn't know what AF point you were selecting. See Chapter 8 for more about the AF Area mode.

Considering a Few Other Autofocusing Tweaks

Believe it or not, the preceding few sections only scratch the surface of the Autofocus section of the Custom Functions menu. Because my goal in this book is to tell you about every possible setting on your camera, the following list provides an introduction to the remaining menu options. They will no doubt delight the autofocusing wonks in the crowd, but for me, and for most others, I think, they just make me wonder "Does it *really* need to be this complicated?" (Wait, I write books explaining how things work; I should probably be celebrating complicated things.)

Anyhoo . . . here are the autofocus functions you can modify that I haven't already covered. For more details, open the electronic version of the camera manual (it's on the CD that shipped with the camera) and review the section on Autofocus Custom Functions. Also see Chapter 8 for information about

one final menu option, Select AF Area Selection Mode, which determines which AF Area modes are available to you. This particular Custom Function option is critical to everyday shooting; leave all three options enabled, as they are by default, for now.

- Tracking Sensitivity: Related to the AI Servo AF mode; this setting controls how much the autofocus system reacts when an object other than your subject enters the focusing area or when your subject strays from the focusing points.
- ✓ Accel./Decel. Tracking: This one is also related to AI Servo AF mode; the default setting is designed for subjects moving at a fixed speed. The other settings are geared to subjects that are moving erratically.
- AI Servo 1st Image Priority: When you use one of the Continuous Drive modes and AI Servo AF mode, this setting determines whether the camera takes the first shot as soon as the shutter button is pressed, even if focus is not yet achieved. You can tell the camera to wait for focusing to occur (choose the Focus Priority setting) or to go ahead and take the shot (choose Release Priority). The default, Equal Priority, tries to achieve a balance between the two.
- ✓ AI Servo 2nd Image Priority: This function controls what happens for shots taken *after* the first shot when you're using Continuous shooting and AI Servo AF mode. Choose Shooting Speed Priority to make achieving the maximum frames per second rate the priority; choose Focus Priority to restrict the camera to taking the shot until after focus is achieved. The default setting gives equal priority to both concerns.

- ✓ AF Area Selection Method: By default, you change the AF Area Selection mode by pressing the AF Area Selection button once to activate the setting and then pressing again to cycle through the three focusing options. If you change the setting of this Custom Function option to Main Dial, you instead rotate the Main dial to cycle through the settings. You also can then use the Multi-controller to move the AF point horizontally.
- orientation Linked AF Point: Normally, the AF Area mode you select, as well as the AF point or zone you choose, remain in effect whether you orient the camera horizontally or vertically. If you change this setting to Select Separate AF Points, the camera remembers the settings you choose while holding the camera horizontally, vertically with the grip on top, and vertically with the grip on the bottom. Then when you rotate the camera, it automatically shifts to those settings.
- Manual AF Point Selection Pattern: By default, when you're selecting an autofocus point, you hit a wall when you reach the edge of the grid of autofocus points. For example, if you select the far-right point, pressing the Multi-controller right accomplishes nothing. If you change this menu option to Continuous, the selection instead jumps to the point on the opposite edge of the grid.

- ✓ AF Point Display During Focus: By default, the selected AF point(s) are always displayed when you're choosing an AF point, when the camera is ready to shoot but you haven't yet pressed the shutter button halfway, during autofocusing, and when focus is achieved. Through this menu option, you can specify when you want the focus points to appear or specify that you always want to see all 19 points. (You probably are going to get tired of that last option quickly.)
- AF Microadjustment: Do not, I repeat, do *not* fool with this option unless you really understand autofocusing and you determine that the camera is consistently focusing in front of or behind the selected focus point. Even then, know that this feature, which enables you to fine-tune the autofocusing system, may just make things worse. In fact, I recommend that if you're having this problem, you take your camera to a good camera shop and ask an expert for help. Not only are you likely to get better results, but you'll get to enjoy looking at all the shiny new camera gadgets, one of which is sure to make the perfect addition to your camera bag.

Appendix

Glossary of Digital Photography Terms

an't remember the difference between a pixel and a bit? Resolution and resampling? Turn here for a quick refresher on that digital photography term that's stuck somewhere in the dark recesses of your brain and refuses to come out and play.

For more information about a topic, check the book's index.

24-bit image: An image containing approximately 16.7 million colors.

Adobe RGB: One of two color space options available on your camera; determines the spectrum of colors that can be contained in the image. Adobe RGB includes more colors than the default option, sRGB, but also involves some complications that make it a better choice for advanced photographers than beginners.

AEB: Auto Exposure Bracketing, a feature that automatically records three exposures: one at the selected exposure settings, one using settings that produce a darker image, and one using settings that produce a brighter image. It's a useful tool for ensuring that at least one exposure is good when you shoot in tricky lighting.

AE lock: A way to prevent the camera's autoexposure (AE) system from changing the current exposure settings if you reframe the picture or the lighting changes before the image is recorded.

AF mode: Short for *autofocus mode*. A setting that determines whether the camera locks focus when you press the shutter button halfway, continuously adjusts focusing up to the time you take the shot, or chooses which of the two strategies to employ. *See also* AI Servo, AI Focus, and One Shot AF mode.

AF Point Selection mode: The setting that tells the camera whether to base focus on any of its autofocus points (automatic point selection) or on a single point that you select (manual point selection). It's available for viewfinder photography in the P, Tv, Av, and M exposure modes.

AI Focus: One of three AF mode settings available for viewfinder photography; the camera locks focus when you press the shutter button halfway unless it senses motion, in which case it adjusts focus to track the subject continuously, up to the time you press the shutter button all the way to take the shot.

Al Servo: A viewfinder-photography autofocus mode in which the camera continually adjusts focus up to the moment you take the picture; useful for focusing on moving subjects.

aperture: One of three critical exposure controls; an opening in an adjustable diaphragm in the camera lens. The size of the opening is measured in f-stops (f/2.8, f/8, and so on), with a smaller number resulting in a larger aperture opening. Aperture also affects depth of field (the distance over which focus remains acceptably sharp).

aspect ratio: The proportions of an image. Pictures from your camera have an aspect ratio of 3:2, the same as a 35mm-film photo. But in Live View mode, you can select from a few other aspect ratios. Movies have an aspect ratio of 16:9 or 4:3, depending on the Movie Recording Size setting (Movie Menu 2).

autoexposure: A feature that puts the camera in control of choosing the proper exposure settings.

Auto Lighting Optimizer: A feature designed to improve underexposed or low-contrast shots automatically.

Av mode (aperture-priority autoexposure): A semiautomatic exposure mode: The photographer sets the aperture and the camera selects the appropriate shutter speed to produce a good exposure at the current ISO (light-sensitivity) setting. *Av* stands for *aperture value*.

backlight: Bright light coming from behind your subject, which can cause your subject to be underexposed in autoexposure shooting modes.

Basic Zone modes: Canon's way of referring to all exposure modes except the advanced modes (P, Tv, Av, and M). Exposure modes in this category provide automated exposure control and limit access to advanced camera features.

bit: Stands for *binary digit*; the basic unit of digital information. Eight bits equals one *byte*.

bit depth: Refers to the number of bits available to store color information. More bits means more data.

bulb mode: A shutter speed setting that keeps the shutter open as long as you hold down the shutter button. Available only in the M (manual) exposure mode.

burst mode: Another name for the Continuous Drive mode setting, which records several images in rapid succession with one press of the shutter button.

byte: Eight bits. See also bit.

Camera Raw: A file format that records the photo without applying any of the in-camera processing or file compression that is usually done automatically when saving photos in the other standard format, JPEG. Also known as *Raw.* Indicated by the file extension .CR2 on the T4i/650D.

camera shake: Any movement of the camera during the image exposure. Can lead to allover blurring of the photo and is common when photographers handhold their cameras and use a long exposure time. (Use a tripod to prevent it.)

card reader: A device used to transfer images from your camera memory card to your computer.

chromatic aberration: A defect produced by some lenses; looks like small halos of color along object edges. May be lessened by enabling the Chromatic Aberration feature (available through the Lens Aberration Correction function on Shooting Menu 1).

Close-up mode: An automated exposure mode designed for shooting subjects at close range; chooses settings designed to produce a blurry background, thereby emphasizing your subject.

color model: A way of defining colors. In the RGB color model, for example, all colors are created by blending red, green, and blue light.

color space: A specific spectrum of colors that can be rendered by a camera or other digital device. *See also* sRGB and Adobe RGB.

color temperature: Refers to the color cast emitted by a light source; measured on the Kelvin scale.

compression: A process that reduces the size of the image file by eliminating some image data.

continuous autofocus: An autofocus feature that continuously adjusts focus as needed to keep a moving subject in focus. Enabled by selecting the AI Servo AF mode; also occurs in AI Focus mode if the camera detects subject motion.

contrast: The amount of difference between the brightest and darkest values in an image. High-contrast images contain both very dark and very bright areas.

CR2: The Canon Camera Raw format.

Creative Auto exposure mode: An automatic-exposure mode that gives you a little more flexibility than the other fully automatic modes; for example, this mode offers an option that enables you to specify whether you prefer the background to be blurry or sharp.

Creative Zone mode: Canon's term for the advanced exposure modes: P (programmed autoexposure), Tv (shutter-priority autoexposure), Av (aperture-priority autoexposure), and M (manual exposure).

crop: To trim away unwanted areas around the perimeter of a photo, typically done in a photo-editing program.

Custom Functions: A group of eight advanced camera options accessed via Shooting Menu 4 and available only in the P, Tv, Av, and M exposure modes.

depth of field: The distance from the subject over which focus appears acceptably sharp. With shallow depth of field, the subject is sharp but distant objects are not; with large depth of field, both the subject and distant objects are in focus. Manipulated by adjusting the aperture, lens focal length, or camera-to-subject distance.

diopter adjustment control: The wheel next to the viewfinder that enables you to adjust the viewfinder to your eyesight.

downloading: Transferring data from your camera to a computer.

dpi: Short for *dots per inch.* A measurement of how many dots of color a printer can create per linear inch. Higher dpi means better print quality on some types of printers; on other printers, dpi is not as crucial.

DPOF: Stands for *digital print order format*. A feature that enables you to add print instructions to the image file and then print directly from the memory card. Requires a DPOF-capable printer.

Drive mode: The camera setting that determines when and how the shutter is released when you press the shutter button. Options include Single, which produces one picture for each button press; Continuous, which records a continuous burst of images as long as you hold down the button; and three self-timer modes (one of which also works for remote-control operation).

dSLR: Stands for *digital single-lens reflex*. One type of digital camera that accepts interchangeable lenses.

dynamic range: The overall range of brightness values in a photo, from black to white. Also refers to the range of brightness values that a camera, scanner, or other digital device can record or reproduce.

edges: Areas where neighboring image pixels are significantly different in color; in other words, areas of high contrast.

EV compensation: A control that slightly increases or decreases the exposure chosen by the camera's autoexposure mechanism. EV stands for *exposure value*; EV settings appear as EV 1.0, EV 0.0, EV –1.0, and so on.

EXIF metadata: See metadata.

exposure: The overall brightness and contrast of a photograph, determined mainly by three settings: aperture, shutter speed, and ISO.

exposure compensation: Another name for EV compensation.

Face+Tracking AF: A Live View and movie-only autofocus method that searches for faces in the scene and, if it finds them, automatically focuses on them and tracks them through the frame if they move.

FE Lock: Stands for *flash exposure lock*. A feature that forces the camera to base flash exposure only on the subject at the center of the frame.

file format: A way of storing image data in a digital file; your camera offers two formats, JPEG and Camera Raw (CR2).

fill flash: Using a flash to fill in darker areas of an image, such as shadows cast on subjects' faces by bright overhead sunlight or backlighting.

firmware: The internal software that runs the camera's "brain." Canon occasionally releases firmware updates that you should download and install in your camera (follow the instructions at the download site).

flash exposure (EV) compensation: A feature that enables the photographer to adjust the strength of the camera flash.

Flash Off mode: The same as Scene Intelligent Auto exposure mode (fully automated shooting), but with flash disabled.

FlexiZone-Multi AF: A Live View and movie-only autofocus option; the camera automatically selects the focus point from all available points or from a specific zone of points that you select.

FlexiZone-Single AF: A Live View and movie-only autofocus option; you specify a single focus point for the camera to use when setting focus.

f-number, f-stop: Refers to the size of the camera aperture opening. A higher number indicates a smaller aperture opening. Written as f/2, f/8, and so on. Affects both exposure and depth of field.

formatting: An in-camera process that wipes all data off the memory card and prepares the card for storing pictures.

frame rate: In a movie, the number of frames recorded per second (fps). A higher frame rate translates to crisper video quality.

gamut: Say it *gamm-ut*. The range of colors that a monitor, printer, or other device can produce. Colors that a device can't create are said to be *out of gamut*.

gigabyte: Approximately 1,000 megabytes, or 1 billion bytes. In other words, a really big collection of bytes. Abbreviated as GB.

grayscale: An image consisting solely of shades of gray, from white to black. Often referred to generically as a *black-and-white image* (although, in the truest sense, an actual black-and-white image contains only black and white with no grays).

Handheld Night Scene mode: An automatic exposure mode designed to produce sharper images when you shoot in dim lighting and handhold the camera. Records a burst of four shots and then merges those shots for the final result.

HDR: Stands for *high dynamic range* and refers to a picture that's created by merging multiple exposures of the subject into one image using special computer software. The resulting picture contains a greater range of brightness values — a greater dynamic range — than can be captured in a single shot.

HDR Backlight Control mode: An automated exposure mode designed to produce a better exposure when you shoot high-contrast scenes. Records a burst of three shots at three different exposures and then merges them for the final image.

Highlight Tone Priority: A feature designed to produce better results when you shoot high-contrast scenes; brightens shadows without making highlights too bright. Available only in the P, Tv, Av, and M exposure modes.

histogram: A graph that maps out shadow, midtone, and highlight brightness values in a digital image; an exposure-monitoring tool that can be displayed during image playback. During Live View shooting, can also be displayed over the live image.

hot shoe: The connection on top of the camera where you attach an auxiliary flash

image sensor: The array of light-sensitive computer chips in your camera that senses light and converts it into digital information.

Image Stabilization: A feature designed to compensate for small amounts of camera shake, which can blur a photo. Indicated on Canon lenses by the initials IS; enabled via the Stabilizer switch on the lens.

Image Zone modes: Canon nomenclature for the automated, scene-specific exposure modes that are part of the Basic Zone modes. Includes Portrait, Landscape, Close-up, Sports, Night Portrait, Handheld Night Scene, and HDR Backlight Control modes.

Index mode: A playback feature that displays four or nine image thumbnails at a time.

ISO: Traditionally, a measure of film speed; the higher the number, the faster the film. On a digital camera, it means how sensitive the image sensor is to light. Raising the ISO allows faster shutter speed, smaller aperture, or both, but also can result in a noisy (grainy) image. Stands for *International Organization for Standardization*, the group that devised the ISO standards.

jaggies: Refers to the jagged, stairstepped appearance of curved and diagonal lines in low-resolution photos that are printed at large sizes.

JPEG: Pronounced *jay-peg.* The primary file format used by digital cameras; also the leading format for online and web pictures. Uses *lossy compression*, which eliminates some data in order to reduce file size. A small amount of compression does little discernible damage, but a high amount destroys picture quality. Stands for *Joint Photographic Experts Group*, the group that developed the format.

JPEG artifact: A defect created by too much JPEG compression.

Jump mode: A playback feature that enables you to jump through images 10 at a time, 100 at a time, or by date, by type of file (photo or movie), by folder, or by rating.

Kelvin: A scale for measuring the color temperature of light. Sometimes abbreviated as K, as in 5000K. (Note that in computer-speak, the initial K more often refers to kilobytes, as described next.)

kilobyte: One thousand bytes. Abbreviated as *K*, as in 64K.

Landscape mode: An automated exposure mode designed to render landscapes in the traditional fashion, with high contrast and bold, crisp colors, especially in the blue and green spectrums.

LCD: Stands for *liquid crystal display*. Often used to refer to the display screen included on digital cameras.

Live View: The feature that enables you to use the camera monitor instead of the viewfinder to compose your shots.

lossless compression: A file-compression scheme that doesn't sacrifice any vital image data in the compression process, used by file formats such as TIFF. Lossless compression tosses only redundant data, so image quality is unaffected.

lossy compression: A compression scheme that eliminates important image data in the name of achieving smaller file sizes, used by file formats such as JPEG. High amounts of lossy compression reduce image quality.

M (manual) exposure mode: An exposure mode that enables you to control both aperture and shutter speed.

manual focus: A setting that turns off autofocus and instead enables you to set focus by twisting the focusing ring on the lens.

megabyte: One million bytes. Abbreviated as MB. See also bit.

megapixel: One million pixels; used to describe the resolution offered by a digital camera.

metadata: Extra data that gets stored along with the primary image data in an image file. Metadata often includes information such as aperture, shutter speed, and EV compensation setting used to capture the picture, and can be viewed using special software. Often referred to as *EXIF metadata*; EXIF stands for *Exchangeable Image File Format*.

metering mode: Refers to the way a camera's autoexposure mechanism reads the light in a scene. Modes available on your camera include *spot*, which bases exposure on a small area at the center of the frame; *partial*, which uses a little larger metering area than spot; *center-weighted average*, which reads the entire scene but gives more emphasis to the subject in the center of the frame; and *evaluative*, which calculates exposure based on the entire frame.

mirror lockup: A feature that ensures that the movement of the camera's internal mirror is completed long before the shutter is released; used for long-exposure shots to ensure that the mirror movement doesn't blur the image.

monopod: A telescoping, single-legged pole on which you can mount a camera and lens in order to hold it more stably while shooting. It will not stand on its own, unlike a tripod.

Movie Servo AF: The continuous autofocusing option available during movie recording.

Night Portrait mode: Designed for photographing people at night or in dim lighting; combines a slow shutter speed with flash for brighter backgrounds and softer flash lighting. For good results, use a tripod and ask your subject to remain very still.

noise: Graininess in an image, caused by a very long exposure, a too-high ISO setting, or both.

NTSC: A video format used by televisions, DVD players, and VCRs in North America, Mexico, and some parts of Asia (such as Japan, Taiwan, South Korea, and the Philippines). Many digital cameras can send picture signals to a TV, DVD player, or VCR in this format.

One Shot AF: An autofocus mode for viewfinder photography (that is, not Live View or Movie mode) that locks focus when you press the shutter button halfway. Focus remains locked as long as you hold the button down halfway. Useful for photographing portraits and other non-moving subjects.

P mode: *Programmed autoexposure* shooting mode. The camera selects both f-stop and shutter speed, but you can select from different combinations of the two and access all other camera features.

PAL: The video format common in Europe, China, Australia, Brazil, and several other countries in Asia, South America, and Africa. *See also* NTSC.

Peripheral Illumination: A feature designed to correct *vignetting*, a lens defect that causes the corners of the image to appear darker than the rest of the scene. (Accessed via the Lens Aberration Correction option on Shooting Menu 1.)

PictBridge: A feature that enables you to connect your camera to a PictBridge-enabled printer for direct printing.

Picture Styles: Settings designed to render images using different color, sharpness, and contrast characteristics; options include Auto, Standard, Portrait, Landscape, Neutral, Faithful, and Monochrome. You can also create three custom styles.

pixel: Short for *picture element*. The basic building block of every image.

pixelation: A defect that occurs when an image has too few pixels for the size at which it is printed; pixels become so large that the image takes on a mosaic-like or stairstepped appearance.

platform: A fancy way of saying "type of computer operating system." Most folks work either on the Windows platform or the Macintosh platform.

Portrait mode: An automated mode designed to render portraits in the traditional style, with softer skin texture, warmer skin tones, and a blurry background.

ppi: Stands for *pixels per inch*. Used to state image output (print) resolution. Measured in terms of the number of pixels per linear inch. A higher ppi usually translates to better-looking printed images.

Quick Control screen: The monitor display that enables you to adjust critical camera settings quickly by using the touchscreen or the camera buttons rather than menus.

Quick Mode AF: A Live View–only autofocusing option; you tell the camera to automatically select from one of the same nine autofocus points used for viewfinder photography or to base focus on a specific point that you select.

Raw: See Camera Raw.

Raw converter: A software utility that translates Camera Raw files into a standard image format such as JPEG or TIFF. Canon Digital Photo Professional, provided free with your camera, offers this tool.

red-eye: Light from a flash being reflected from a subject's retina, causing the pupil to appear red in photographs. It can sometimes be prevented by using the Red-Eye Reduction flash setting; can also be removed later in most image-editing programs.

resampling: Adding or deleting image pixels. Adding a large amount of pixels degrades images.

resolution: A term used to describe the number of pixels in a digital image. Also a specification describing the rendering capabilities of scanners, printers, and monitors; means different things depending on the device.

RGB: The standard color model for digital images; all colors are created by mixing red, green, and blue light.

Scene Intelligent Auto: The most automatic of automatic exposure modes on your camera, represented by the A+ symbol on the Mode dial. The camera analyzes the subject and selects the settings it deems appropriate for capturing the photo.

SD card: The type of memory card used by your camera; stands for *Secure Digital*.

SDHC card: A high-capacity form of the SD card; stands for *Secure Digital High Capacity* and refers to cards with capacities ranging from 4MB to 32MB.

SDXC card: Secure Digital Extended Capacity; used to indicate an SD memory card with a capacity greater than 32MB.

sharpening: Applying an image-correction filter to create the appearance of sharper focus.

shutter: A light-barrier inside the camera that opens when you press the shutter button, allowing light to strike the image sensor and expose the image.

shutter-priority autoexposure: A semiautomatic exposure mode in which the photographer sets the shutter speed and the camera selects the appropriate aperture. It's selected via the Tv option on the Mode dial.

shutter speed: The length of time the shutter remains open; or, to put it another way, the duration of the image exposure. It's measured in fractions of a second, as in 1/60 or 1/250 second.

slow-sync flash: A special flash setting that allows (or forces) a slower shutter speed than is typical for the normal flash setting. It results in a brighter background than normal flash.

Sports mode: An automated exposure mode designed for capturing action; selects a fast shutter speed to "freeze" the subject in mid-motion.

sRGB: Stands for *standard RGB*, the default color space setting on your camera (and the one recommended for most users). It was developed to create a standard color spectrum that (theoretically) all devices could capture or reproduce.

Stop: An increment of exposure adjustment. Increasing the exposure by one stop means to select exposure settings that double the light; decreasing by one stop means to cut the light in half.

TIFF: Pronounced *tiff*, as in a little quarrel. Stands for *tagged image file format*. A popular image format supported by most Macintosh and Windows programs. It is *lossless*, meaning that it retains image data in a way that maintains maximum image quality. It's often used to save Raw files after processing.

tripod: Used to mount and stabilize a camera, preventing camera shake that can blur an image; characterized by three telescoping legs.

Tv mode: Shutter-priority autoexposure; you set the shutter speed and the camera selects the f-stop to properly expose the image. Tv stands for *time value* (length of exposure).

UHS: A classification assigned to some SD memory cards; stands for *Ultra High Speed*.

UHS-1: At present, the fastest rated UHS type card.

USB: Stands for *Universal Serial Bus*. A type of port for connecting your camera to your computer. Your camera ships with the USB cable necessary for the connection.

Video Snapshot: A special movie mode that records a 2-, 4-, or 8-second movie clip. Multiple clips can be combined into a snapshot *album*.

white balance: Adjusting the camera to compensate for the color temperature of the lighting. It ensures accurate rendition of colors in digital photographs.

Index

• A • AC power adapter kit ACK-E6 connection, 30 action photography anticipating action, 311 AF Area mode flash considerations, 310 ISO setting, 309 manual focusing, 310 motion direction, 308 panning, 311 shooting steps, 308-311 shutter speed, 307-309 subject, composing, 311 subject, framing, 310 zooming, 311 Adobe RGB color space, 193, 338–339 advanced exposure modes. See also specific exposure modes by name AF icon, 109 AF Area mode autofocusing, 269–274 aperture control, 225–226 flash, enabling, 59–60 Flash Exposure Compensation, 256–259 flash photography, 250–255 ISO control, 222-224 metering modes, 219-221 Picture Styles, 294 AF Points, 343–345 Safety Shift feature, 227 shutter speed control, 225-226 AE Lock button, 26, 132, 150, 157, 245–246 AEB. See Automatic Exposure Bracketing AF (autofocus) modes AF Point Selection mode, pairing, 273–274 Al Focus, 272 Al Servo, 272, 274, 301, 310, 344 changing, 272–273 Face+Tracking, 101, 104, 109, 111–112, 125 FlexiZone-Multi, 109, 112-114 286, 291 FlexiZone-Single, 109, 114-115 focus, setting in, 14 One Shot, 81, 86, 88, 271, 304

overview, 109 Quick mode, 109, 115-117 recommended setting, 301 setting, changing, 110-111 viewing current, 272 zone, selecting, 114-115 modes, disabling, 270-271 modes, enabling, 270–271 19-point automatic selection, 116, 269–270 recommended setting, 301 Single-point AF, 269, 271, 304 Zone AF, 269, 270, 271 AF Area mode button, 269, 271 AF Area mode selection screen, 271 AF Area Selection button, 23, 116 AF Area Selection mode, 115-116, 344 AF Area Selection screen, 117 AF button, 24, 110, 273 AF Method option, 110-111, 133 AF Microadjustment option, 161, 345 AF mode setting, Quick Control screen, 125 AF Point Display option, 158, 166 AF Point Selection modes, 273-274, 344 AF Point Selection/Magnify button, 26, 118–119, 132, 150, 157 AF-Assist Beam, 60, 76, 261, 341–342 AF/MF (autofocus/manual focus) switch, 14 AF-ON button, 26, 108, 112, 132, 267–268 AI Focus AF mode, 272 AI Servo 1st Image Priority, 344 Al Servo 2nd Image Priority, 344 Al Servo AF mode, 272, 274, 301, 310, 344 alignment grid, Live View mode, 104 ALL-l compression, 136 amber (A) label, White Balance Correction, anti-shake, vibration compensation. See image stabilization

aperture current settings, viewing, 225 defined, 209 depth of field, affecting, 212, 275 f-stops, 10-11, 209-210 image-exposure formula, 211 range, 10-11 recommendations, 215-216 Aperture-priority autoexposure (Av) mode AEB, 246, 248 close-up photography, 314 depth of field, 278, 300 exposure compensation, 231 exposure meter, 218 flash calculation, 253-254 overview, 208 shutter speed and aperture, changing, 225 still subjects, 300, 302-304 Art Bold filters, 326 artifacting, 69 aspect ratio, 113, 120, 141, 198, 304 attaching lenses, 11-12 Attenuator feature, Movie Menu 2, 138 audio, movie, 134, 137-138, 332 Auto cleaning option, Sensor cleaning, 47 - 48auto flash option, 57 Auto Image Align option, HDR mode, 236 **Auto Lighting Optimizer** experimenting with, 236-239 overview, 126, 191, 233 when bracketing, 247, 313 Auto Power Off, 36, 45 Auto White Balance. See Automatic White Balance autofocus (AF) modes AF Point Selection mode, pairing, 273–274 Al Focus, 272 Al Servo, 272, 274, 301, 310, 344 changing, 272-273 Face+Tracking, 101, 104, 109, 111-112, 125 FlexiZone-Multi, 109, 112-114 FlexiZone-Single, 109, 114-115 focus, setting in, 14 One Shot, 81, 86, 88, 271, 304 overview, 109 Quick mode, 109, 115-117

recommended setting, 301 setting, changing, 110-111 viewing current, 272 zone, selecting, 114-115 autofocus brackets, 76 autofocusing Close-up mode, 83 customizing AF Points display, 343 Dual Pixel CMOS, 8 Face+Tracking, 101 Handheld Night Scene mode, 86 Landscape mode, 81 lens focus drive, controlling, 342 Live mode considerations, 106–107 Movie mode considerations, 106–107 Night Portrait mode, 84 Portrait mode, 80-81 Sports mode, 83 STM lenses, 8, 106 video snapshots, 332 Automatic AF Point Selection mode, 245 Automatic Exposure Bracketing (AEB) Continuous drive modes, 250 customizing, 249 enabling, 230, 246 Exposure Compensation, 247 exposure modes, 246 landscape photography, 313 Live View display, 123 overview, 246 Self-Timer/Remote modes, 250 setup, 247-249 Single drive mode, 250 turning off, 249 unavailable filters, 247 Automatic White Balance (AWB), 126, 280-283, 301, 304 A/V cables, 106 Av mode. See Aperture-priority autoexposure mode A/V Out/Digital port, 30, 180–181

B exposure mode. See Bulb exposure mode back of camera controls, 24–27 Background Blur setting, Creative Auto mode, 96–97 backgrounds, 304, 306 banding, 71 Basic Information display mode, 158, 159-160 Basic Zone exposure modes. See also Creative Auto mode; Scene Intelligent Auto mode Flash Off mode, 52, 57, 74-77, 294 limitations, 300 overview, 52 Scene modes, 52-53, 77-78, 294 types of, 52-53 batteries Battery info option, Setup Menu 4, 48 chamber, 30 conserving, 14, 45, 75, 107 during file transfer, 180 Live View mode, 103 Movie mode, 103 status, 36-37, 38, 40, 122 beep, disabling, 50, 54, 112 bit depth, 70-71, 195 black-and-white images, 293-294 blown highlights, 163 blue (B) label, White Balance Correction, 286, 291 blue/amber color axis, 288, 291 blur creative, 309, 311-314 depth of field, 267, 305, 307 mirror movement, 320 shutter speed, 212-213, 267, 307-308, 314 bounce lighting, 305-306 bracketing. See also Automatic Exposure Bracketing defined, 246, 313 landscape photography, 313 White Balance, 35, 235, 288–293 Brighter option, Shoot by Ambience setting, 89 brightness, monitor calibration, 200-201 brightness histograms, 103–104, 160, 163-164 Bulb (B) exposure mode aperture, changing, 226 control, 301

flash settings, 254 overview, 53, 208–209 shutter speed, 218, 226 burst mode. *See* Continuous drive mode Busy alert, 57 Button Display Options, Setup Menu 3, 34 button zooming, 157 button-based typing, 321–322

C mode. See Camera User Settings mode CA mode. See Creative Auto mode cables, 106, 174, 180-181 calibration utility, 201 camera back, 24–27 connection ports, 28-30, 174 front, 27–28 recommended settings, 301 sides, 27-30 top. 22–24 waking up, 15, 22, 34, 40, 100 Camera Raw. See Raw file format Camera Settings display, 35–36 camera shake, 55, 103, 213, 226, 312 Camera User Settings (C) mode AEB, 246 custom mode, creating, 333-335 custom settings, 334-335 overview, 35, 208-209, 333 shutter speed and aperture, changing, Canon AVC-DC400ST cable, 174 Canon Digital Photo Professional, 179, 192-196, 202, 239, 320 Canon EOS Utility software camera, operating remotely, 106 closing, 187 downloading images from camera, 185–187, 323 music files, copying, 143 overview, 179 photobooks, 329 updating, 324

Canon EOS-dedicated Speedlite with IR AF-assist, 342 Canon EX-series Speedlites, 262, 342 Canon Image Gateway, 324 Canon ImageBrowser EX, 178-179 Canon Remote Switch RS-60E3 wired controller, 29 Canon website, 8, 49, 178, 319 card readers, 187-189, 329 center-weighted average metering mode, 220 CFL (compact fluorescent) bulbs, 283 chromatic aberration, 191, 288 cleaning images, 320 lenses, 62 overview, 52 sensors, 47-48, 62, 320 touchscreen, 17 using, 95 clipped highlights, 163 Close-up mode autofocusing, 83 depth of field, 278 Drive mode setting, 83 flash setting options, 57–58 overview, 53, 82-83 close-up photography Av mode, 314 adjusting, 33 depth of field, 314 diopters, 15-16, 315-316 fill flash, 315 dimmed, 121 flowers, 314 exiting, 33 focal length, 314 indoors, 315 lens factor, 314 macro lenses, 315 scrolling, 33 White Balance, 315 Cloudy setting, White Balance, 282 color channels, 70, 164-165 Menu 4, 48 fringing, 288 customizing monitor calibration, 200-201 AEB, 249 saturation, 165 temperature, Kelvin scale, 279-280 color cast defect, 61, 92-93 color space, 35, 191, 338-339 Color Temp setting, White Balance, 35, 282 colorimeter, 201

compact fluorescent (CFL) bulbs, 283 compression, file, 130, 136 connecting camera to computer, 180-184 connection ports, 28-30, 174 continuous autofocusing, 107-108 Continuous drive mode, 56, 121, 250 controls, customizing, 340-341 Cool option, Shoot by Ambience setting, 89 copyright, image, 48, 321-322 CR2 file format. See Raw file format Creative Auto (CA) mode adjustment options, 94 default Drive mode, 97 depth of field, 278 flash setting options, 57-58, 250 Picture Styles, 294 Creative Filters, 126, 324-327 Creative Zone modes, 53, 250. See also specific exposure modes by name crop factor, lenses, 9 cropping images, 304 CRW file format. See Raw file format custom exposure mode, 301 Custom Functions menu AF Points, customizing display, 343 AF-Assist Beam, customizing, 341–342 lens focus drive, controlling, 342 Multi Function Lock option, 49 overview, 32-33 settings, restoring, 48 Custom setting, White Balance, 282 Custom Shooting mode (C), Setup AF Area Selection, 344 AF Microadjustment, 345 AF Points display, 343 AF Points orientation, 344 AF-Assist Beam, 341–342 Al Servo AF mode, 344

built-in flash, 260–262 camera settings in C mode, 334–335 controls, 339–341 dial direction, 339 folders, 337–338 Image Review option, 147–148 lens focus drive, 342 menu to My Menu, 335–337 tracking, 344 viewfinder display, 38–39 White Balance, 283–285 White Balance Correction, 285–287

· D ·

d (dynamic range), 233 Darker option, Shoot by Ambience setting, 89 Datacolor Spyder4Express, 201 Date/Time/Zone option Camera Settings screen, 36 Setup Menu 2, 46 Daylight setting, White Balance, 282 decibels (dBs), 138 deep depth of field, 274-275, 277 depth of field adjusting, 275–278 aperture affecting, 207–208, 212 close-up photography, 314 deep, 274-275, 277 defined, 8, 265, 274 distance to subject, 277 focal length, lenses, 8-9, 275-277 group photography, 304-305 Portrait mode, 80 preview, 278 shallow, 274-275, 277 Depth-of-field Preview button, 28, 39, 123, 278 dials, changing direction, 339 diffuser, flash, 306 Digital Living Network Alliance (DLNA), 324 digital noise. See noise, digital Digital Photo Professional, 179, 192-196, 202, 239, 320

photobooks, 329 digital single lens reflex (dSLR) camera, 7 digital zoom, 134, 139-140 diopters, 15-16, 315-316 Disable option Live View Menu 1, 105 Silent LV Shooting, 121 disabling AF-Assist beam, 341–342 beep, 50, 54, 112 IS using tripod, 14 red-eye reduction flash, 60 Safety Shift feature, 226 shutter button release, 50 touchscreen function, 19 touchscreen response, 19 touchscreen sounds, 19-20, 50 displays AF Point Display, 166 Basic Information mode, 158, 159-160 Highlight Alert, 165 Histogram display mode, 158, 163–165 Index, 149-150 No Information mode, 158 Playback Grid, 158, 166 Shooting Information mode, 158, 160–162 DLNA (Digital Living Network Alliance), 324 dots per inch (dpi), 197 downloading images, 177, 185–189 DPOF (Digital Print Order Format), photobooks, 329 drag gesture, 18 Drive button, 23, 56, 75 Drive mode setting, Quick Control screen, 79, 125–126, 131, 310 Drive modes changing, 56 Close-up, 83 Creative Auto mode default, 97 Handheld Night Scene, 85 HDR Backlight Control, 88 Landscape, 81 Night Portrait, 84 options, 54-55 overview, 54

Digital Print Order Format (DPOF),

Drive modes (continued)
Portrait, 80
recommended setting, 301
Sports, 83
dSLR (digital single lens reflex) camera, 7
Dual Pixel CMOS autofocusing, 8
dust-removal filters, 320
dynamic range (d), 233

· E ·

EF (electro focus) lenses, 8, 12 EF-S (electro focus, short back focus) lenses, 8, 12 electronic level indicator, 35, 104 EOS Utility. See Canon EOS Utility software Erase button, 27, 114, 119 E-series diopter adjustment lens adapter, 16 E-TTL ll (Evaluative through the lens) flash metering, 251-252, 261 EV (exposure value) compensation, 256. See also Exposure Compensation Evaluative (whole frame) exposure metering, 130, 221 evaluative metering mode, 126, 219, 245 Exit Zone mode icon, 114 exposure aperture control, 225–226 Auto Lighting Optimizer, 236–239 autoexposure settings, locking, 244-246 balancing, 215-216 basic elements, 209-211 bracketing, 246–250 Exposure Compensation, 227–231 high-contrast shots, improving, 231–236 ISO control, 222–224 metering modes, 219-221 noise reduction, 242-244 Safety Shift, 226 setting side effects, 211-215 settings, locking in, 245 settings, monitoring, 216-219 shutter speed control, 225-226 vignetting, correcting, 239-241 Exposure Compensation, 218, 227–231, 247

exposure indicator, 217
exposure metering mode, 217–221, 225
exposure modes. See also specific exposure
modes by name
Movie modes, 101
overview, 52–53
exposure stops, 218
exposure value (EV) compensation, 256.
See also Exposure Compensation
external flash. See flash, external
Eye-Fi memory cards, 21, 45

Face+Tracking autofocusing, 101, 104, 109,

· F ·

111-112, 125 FE Lock button, 26 file formats. See JPEG file format; Raw file format files compression, 130, 136 copyright, adding, 48, 321-322 identifying, 339 naming, 43-44 numbering, 43-44 fill flash, 58, 252-253, 315 filters altered images, storing, 327 Chromatic Aberration, 288 creative, 126, 324-327 dust-removal, 320 graduated neutral-density, 312 lens, 286 neutral-density, 256, 312 Peripheral Illumination Correction, 191, 239-241, 288 firmware, 49, 241 1st Curtain sync, 262 Fish-eye filters, 326 flash, built-in action photography, 310 advanced exposure modes, 59-60 diffusers, 306 E-TTL ll metering, 251-252, 261 exposure mode settings, 253-254 fill flash, 252-253, 315

Flash Control options, 59–60, 250, 260–262 Flash Exposure Lock, 259–260 Handheld Night Scene mode, 85 limitations, 251 Live View mode considerations, 121 modes where disabled, 57 outdoors in daylight, 255-256, 304 overview, 56-57 portraits, 304-305 preflash, 259-260 primary light source, 252–253 red-eye reduction feature, 36, 60, 251, 304-305 remote units, triggering, 263 setting, changing, 58–59 tips for using, 57, 305–306 flash, external action photography, 310 Canon Speedlites, 262, 342 controls, 262 diffusers, 306 portraits, 305-306 wireless trigger, 263 Flash button, 27, 59, 108 Flash Control option, Shooting Menu 2, 59-60, 250, 260-262 flash diffuser, 306 Flash Exposure Compensation, 256–259 Flash Exposure Lock (FEL), 121, 259–260 Flash firing option, Shooting Menu 2, 59-60, 250-251, 261 flash metering, 251 Flash Off mode, 52, 57, 74-77, 294 Flash ready symbol, Live View display, 123 Flash setting Quick Control screen, 79 White Balance, 282 FlexiZone-Multi autofocusing, 109, 112–114 FlexiZone-Single autofocusing, 109, 114-115 flick gesture, 19 focal length, 8-9, 275-277, 314 focal plane indicator, 24 focus, viewfinder adjusting, 15–16 AF-On button, 267–268 autofocus, 266

considerations, 267-268 depth of field, 274-278 manual, 245, 267 method, choosing, 14 setting, 14 switch, setting, 266 Focus Priority setting, Al Servo 2nd Image Priority, 344 folders capacity, 337 custom, creating, 337–338 images, erasing, 167 initial, 43, 337 force flash option, 58 Format card option, Setup Menu 1, 21, formatting memory cards, 21, 44–45 fountains, shooting, 312 frames per second (fps) rate, 80, 135-136, 137 front of camera controls, 27–28 f-stops, 10–11, 209–210. See also aperture Full HD video, 136 full-frame display, 156 fully automatic exposure modes. See Basic Zone exposure modes

gamut, color, 338 gigabytes (GB), 20 graduated neutral-density filters, 312 Grainy B/W filters, 326 grayscale images, 293–294 green (G) label, White Balance Correction, 286, 291 green/magenta color axis, 291 grid display, 134, 166, 286, 288, 291

Handheld Night Scene mode, 53, 58, 84–86 HDMI cables, 106, 174 HDMI CEC TV playback, 174 HDMI terminal, 30

HDR Backlight Control mode, 53, 57, 86-88, 231 HDR mode, 231, 233-236, 246, 312 HDTV playback, 174 headroom, 138, 199 heat, camera, 102 High ISO Speed NR option, Camera Settings screen, 36 high-definition (HD) video, 136 highlight alert, 158, 164, 165, 166 Highlight Tone Priority, 123, 231–233, 313 highlights, 163 High-speed continuous drive mode, 54. 83, 310 high-speed sync, 251 histograms, 103-104, 158, 163-165 horizontal axis, White Balance grid, 286, 291 horizontal orientation, 154 horizontal tilt, 39 Hot shoe, 23

• 1 •

ICC (International Color Consortium), 195 Image Download button, 188 image quality control options, 63-65 defects, diagnosing, 61-63 file types, 68-72 overview, 60-61 resolution, 65-68, 196-198 settings, recommended, 301 Image Quality setting Ouick Control screen, 126 Shooting Menu 1, 75, 79 Image Review setting, Shooting Menu 1, 147-148 image sensors, 209 image stabilization (IS), 13-14, 103, 213, 312 image stabilization (IS) lenses, 8, 13-14 Image Stabilizer switch, 13–14, 75, 103 image-exposure formula, 211 images cleaning, 320 copyright, 48, 321-322

downloading, 177, 185-189, 323 erasing, 166-169 playing on TV, 174-175 printing, 324 protecting, 169-172 rating, 172-174 removing protection, 172 resizing, 202-203 rotating, 154-156 saving, 70 shooting while recording, 140-141 uploading to Canon Image Gateway, 324 viewing, 102 Index button, 26 Index display mode, 149-150, 156 index view, 149-150 indoor portraits, 303, 305-306, 315 Info button, 25-26, 34, 192 Info/Help icon, 42 infrared (IR) AF-assist Speedlite, 342 International Color Consortium (ICC), 195 IPB compression, 130, 136 IS (image stabilization), 13-14, 103, 213, 312 IS (image stabilization) lenses, 8, 13–14 IS (image stabilization) switch, 13–14 ISO adjusting, 222–223 Highlight Tone Priority effects, 232 image-exposure formula, 211 noise, 213-215 options, 224 overview, 210, 222 Safety Shift feature, 226 setting, recommendations, 215, 301 ISO button, 23, 125, 222 ISO feature, Live View display, 125

• 7 •

JPEG artifacts, 61, 69
JPEG file format
advantages, 68–69
aspect ratio, 120
bit depth, 70–71
Chromatic Aberration filter, 288
default setting, 68

disadvantages, 69
Handheld Night Scene mode, 86
HDR Backlight Control mode, 88
HDR mode, 234–235
options, 64
Peripheral Illumination Correction, 241
versus Raw, 72
resizing, 202–203
Jump feature, 151–154

• K •

Kelvin (K) setting, White Balance, 283 Kelvin scale, 279–280

. [.

Landscape mode, 52, 57, 81, 278 landscape orientation, 155 landscape photography, 8–9, 311–313 Language option, Setup Menu 2, 46 large depth of field, 274-275 LCD Off/On button, Setup Menu 2, 46 LCD panel illuminating, 24, 45 reading, 40 shutter speed presentation, 216-217 viewing Drive mode, 55 left side controls, camera, 27-30 Lens Aberration Correction feature, Shooting Menu 2, 241, 288 lens creep, 12-13 lens filters, 286 Lens lock switch, 12-13 Lens release button, 27 lenses attaching, 11–12 choosing, 8–11 cleaning, 62 compatibility, 8 crop factor, 9 dSLR, 7 EF. 8 EF-S. 8 filters, 286

focal length, 8-9 focus drive, controlling, 342 IS, 8 macro, 315 normal, 9 Peripheral Illumination Correction, 241 prime, 10, 277 removing, 12 sleeping, 15 STM, 8, 106 telephoto, 9, 251 TS-E, 121 waking up, 15 wide-angle, 8-9 zoom, 10, 11, 277 light fall-off, 240 Live View mode alignment grid, 104 autofocusing, 106-107 creative filters, applying, 327 display options, 122–126 electronic level display, 104 exiting, 102 exposure, 221 exposure-information display shutdown, 105 focusing points, 113 histogram, 103-104 limitations, 120–121 multiple exposures, 329 noise, 102 photo aspect ratio, 120 playback, 102, 141–143 Quick mode autofocusing, 107 safety rules, 102–103 settings, adjusting, 101 shooting, 101 shutter speed, monitor, 216–217 Silent LV Shooting, 121 simulating exposure, 105 touch shutter, 127-128 turning on, 100–101 viewfinder, switching from, 100–101, 128-130 White Balance preview, 283 zooming, 118-119

Live View Shoot option, Live View Menu 1,

100-101 Live View/Movie mode button, 26 Lock switch camera, 27, 49-50, 229 memory cards, 22 Long Exposure Noise Reduction, 36, 242, 313 lossy compression. See JPEG file format Low Effect option, Shoot by Ambience setting, 89-90 low-level formatting, 45 Low-speed continuous drive mode, 54, 80 M exposure mode. See Manual exposure mode macro lens, 315 magenta (M) label, White Balance Correction, 286, 291 magic hours, landscape photography, 313 Magnify button, 26, 118–119, 132, 150, 157 Main dial direction, changing, 339 file format settings, changing, 65 flash setting, changing, 58-59 images, adjusting, 191 menu, selecting, 31 overview, 24 Manual (M) exposure mode AEB, 246, 247-248 control, 301 exposure meter, 217, 225 flash settings, 254 overview, 208 shutter speed and aperture,

changing, 226

manual focus (MF) mode, 14

maximum burst frames, 37

megapixels (MP), 64, 66 memory buffer, 37

manual Automatic AF Point Selection, 245

Manual Reset option, File numbering, 44

Maximum burst, Live View display, 122

file numbering options, 43-44 formatting, 21, 44-45 images, erasing, 167-169 inserting, 21 locking, 22 protection, 22, 169-172 removing, 21 types of, 20-21, 128 Menu button, 25 menus, 30-32. See also individual menus by name metadata, 48, 178-179, 321 Metering mode button, 23, 221 Metering mode setting, 126, 301 Metering timer, 105, 133 MF (manual focus) mode, 14 microphone jack, 29 microphones, 23, 128-129, 138 midtones, 87, 163-164 Miniature filter, 326 mireds, lens filters, 286 mirror lockup, 320 Mode dial, 22-23 monitor adjusting, 16-17 brightness, 45 calibrating, 200-201 movie playback, 102, 141-143 positions, 16 shutter speed in Live View mode, 216-217 monitor profile, 201 monochrome, 89, 293-294 monopods, 14 motion blur. See blur mounting indexes, 11-12 MOV format, 128 Movie mode alignment grid, 104 autofocusing, 106-108 customizing display, 103-106 electronic level, 104 exposure modes, 101 exposure-information display shutdown, 105

memory cards

focusing points, 113 noise, 102 Picture Styles, 294 safety rules, 102-103 Silent LV Shooting, 121 Movie Servo AF option, 106-108, 132, 133 Movie Uploader, 180 movies audio options, 134, 137-138, 332 customizing, 132, 133, 134-135 default settings, 130 digital zoom, 139-140 editing, 330-331 focusing, 130 frames, trimming, 330-331 length, 130 playback, 102, 141–143 recording options, adjusting, 132–137 recording process, 101, 128-130 still-image shooting while recording, 140-141 viewing, 102, 106 Wi-Fi lockout, 324 MP (megapixels), 64, 66 Multi Function Lock switch, 27, 49–50, 229 Multi-controller, 26-27, 31, 33, 157 Multiple Exposure mode, Shooting Menu 4, 235, 328-329 multiple-light shooting, 263 MVI_files, 128 My Menu, 335-337

· N ·

neutral-density filters, 256, 312
nickname, entering, 182
Night Portrait mode, 53, 58, 84
noise, digital
causes, 242
defined, 61, 77, 83, 102
Highlight Tone Priority, 233
ISO, 213–215
Live View mode, 102
Movie mode, 102
Peripheral Illumination Correction, 241
reduction, 242–244

Non-Drop Frame (NDF), 135 normal lens, 9 NTSC video standard, 46, 135, 136, 174

Off switch, 22
On switch, 22
One-Shot autofocus (AF) mode, 81, 86, 88, 271, 304
operating system (OS), 201
orientation
AF Points, linking, 344
horizontal, 154, 159
landscape, 155
portrait, 155
rotation options, 44
vertical, 154
outdoor portraits, 255–256, 303–305

P mode. See Programmed Autoexposure mode pairing software, 179, 183–184 PAL video standard, 46, 136, 174 panning, 107, 311 Pantone huey PRO, 201 partial metering mode, 219 Peripheral Illumination Correction, 191, 239 - 241photobooks, 329 Photomatix Pro HDR program, 246 photos. See images PhotoStitch, 180 PictBridge technology, 324 picture data display options, 158–160 Picture Style Editor, 180, 297 Picture Style setting, Quick Control screen, 126 Picture Styles control factors, 294 custom, storing, 297 downloading, 297

Picture Styles (continued) effect, 265, 293 modifying, 297 options, 293 Picture Style Editor, 180, 297 Raw format, 294 recommendations for, 298, 301 selecting, 294-296 User Defined options, 297 pinch in/out gesture, 19, 149-150, 157 pixelation, 61, 197 pixels (px), 61, 65-68, 120, 196-197 pixels per linear inch (ppi), 66, 196-197 playback arrow, 141-142, 148 movies, 102, 141-143 pause, 142 start, 142 on TV, 174-175 video snapshots, 332 Playback button, 26, 102, 148, 153, 157 playback displays AF Point Display, 166 Basic Information mode, 158, 159-160 full-frame view, 149 Highlight Alert, 165 histograms, 158, 163-165 Index, 149-150 No Information mode, 158 picture data display options, 157–159 Playback Grid, 158, 166 Shooting Information mode, 158, 160-162 thumbnails, 149-150 Playback mode. See also playback displays erasing images, 166-169 image protection, removing, 172 Jump feature, 151-154 overview, 148-149 picture data display options, 157–159 protecting images, 169-172 rating images, 172-174 returning to shooting, 148 rotating images, 154-156 viewing options, 149-150 zooming, 156-157

Portrait mode default drive mode setting, 54 depth of field, 80, 278 Drive mode, 80 flash setting options, 57–58 Low-speed continuous drive mode, 80 versus Night Portrait mode, 84 overview, 52 portrait orientation, 155 portrait photography. See still portrait photography ports, connection, 28-30, 174 posterization, 71 ppi (pixels per linear inch), 66, 196-197 preflash, 259-260 prime lens, 10, 277 Print Order option, Playback Menu 1, 329 printing Adobe RGB color space, 338 image size, 198-200 monitor calibration, 200-201 photobooks, 329 resolution for, 196-198 wireless, 324 Programmed Autoexposure (P) mode AEB, 246, 248 benefits of, 301 exposure compensation, 231 exposure meter, 218 flash calculation, 253 overview, 208 shutter speed and aperture, changing, 225 protection image, 169-172 memory card, 22, 169-172 touchscreen, 17 px. See pixels (px)

Quick Control dial direction, changing, 339 Exposure Compensation, 229 file format settings, changing, 65 flash setting, changing, 58–59 images, adjusting, 191
menus, adjusting, 31–32, 33
overview, 27
scrolling, 41
settings, displaying all, 41
Quick Control icon location, 101
Quick Control (Q) button, 26
Quick Control screen, 40–42, 196
Quick mode autofocusing, 109, 115–117
Quick Settings screen, 64–65, 91–92

. R .

rating images, 172–174 Raw file format advantages, 70-71 aspect ratio, 120, 194 bit depth, 70-71 Chromatic Aberration filter, 288 conversion software, 70 Digital Photo Professional conversion, 192-196, 202 disadvantages, 71 in-camera conversion, 189-192, 202 versus JPEG, 72 overview, 64 Picture Styles, 294 Raw setting, RAW file format, 64, 71 RBG images, 164 rear-curtain sync, 262 red-eye reduction, 36, 60, 251, 304-305 Red-Eye Reduction/self-timer lamp, 28 Reduce button, 26 reference cards, 283-285 remote control, 28, 55, 174, 323 remote-control terminal, 29 resampling, 197 resolution choosing settings for, 65–68 compression settings, 136 defined, 60-61 for prints, 196-198 restoring original settings, 48 review period, Image Review, 148 RGB histograms, 164-165

right side controls, camera, 28 rotation options, picture orientation, 44

safety rules, 102-103 Safety Shift feature, 226 saving images, 70 Scene (SCN) modes, 52-53, 77-78, 294 Scene Intelligent Auto mode flash setting options, 57-58, 250 overview, 52, 74 Picture Styles, 294 shooting, 74-77 scrolling, 148, 150, 157 SD (secure digital) cards. See memory SD (standard definition) video, 136, 137 2nd Curtain sync, 262 self-timer function, 55 Self-Timer/Remote modes, 250 sensitive touchscreen response setting, 19 sensors, 28, 47-48, 62, 209, 320 Set button Custom Functions menu, adjusting, 33 focus zone, displaying, 114 images, adjusting, 192 magnification frame, shifting, 119 menus, adjusting, 31-32 overview, 26-27 playback, starting, 142 Setup menus, 43-49 Shade option, Shoot by Light or Scene type setting, 93 Shade setting, White Balance, 282 shallow depth of field, 274-275, 277 sharpening, Picture Styles, 293 shift, White Balance, 285-286 Shoot by Ambience setting, 78, 88–92, 95 Shoot by Light or Scene type setting, 79, 92 - 94Shooting Information display mode, 158,

160-162

Shooting Settings display adjusting, 37 basic settings displayed, 36-37, 300 battery status, 37 Creative Auto mode, adjusting in, 95 Drive mode, viewing in, 55 overview, 36-37 shots remaining, 36-37, 40, 122 viewing settings, 37 Shooting Speed Priority, AI Servo 2nd Image Priority, 344 shots remaining status, 36–37, 40, 122 shutdown, setting delay, 45 shutter lag, 54 Shutter release button, 24 shutter release sound, 121 shutter speed blur, 212-213, 267, 307-308, 314 current settings, viewing, 225 in dim lighting, 278 image-exposure formula, 211 moving vehicles, 313 Night Portrait mode, 84, 305 overview, 210 range, 210 recommendations, 215 Safety Shift feature, 226 as whole numbers, 216 Shutter-priority Autoexposure (Tv) mode action photography, 308-311 AEB, 246, 248 exposure compensation, 231 exposure meter, 218 flash calculation, 253 moving subjects, 301 nighttime portraits, 305 overview, 208 shutter speed, 225, 301 sides of camera, 27–30 Silent continuous shooting mode, 54 Silent LV Shooting feature, 121, 133 Silent single shooting mode, 54 Single drive mode, 56, 75, 250 Single-point AF mode, 116, 269, 271, 304 slide shows, 329-330 small depth of field, 274-275

smartphone, connecting, 323 Soft Focus filters, 326 Soft option, Shoot by Ambience setting, 89 software installation warning, 178 software manual, 241 sound movies, 134, 137-138, 332 slide shows, 330 touchscreen, 19-20, 50 video snapshots, 332 Sound Recording option, Movie Menu 2, 137, 332 speakers, 28 Speedlites, Canon, 262, 342 Sports mode A1 Servo mode, 83 anticipating action, 311 autofocusing, 83 default drive mode setting, 54 Drive mode setting, 83 flash disabled, 57, 83 overview, 53, 83 spot metering mode, 220, 246 sRGB (standard red, green, blue) color space, 193, 338-339 standard definition (SD) video, 136, 137 Standard Effect option, Shoot by Ambience setting, 89-90 standard high-definition (Standard HD) video, 136 Standard option Picture Styles, 293 Shoot by Ambience setting, 89 standard touchscreen response setting, 19 still portrait photography aperture, 215-216 Av mode, 300 background, 304, 306 depth of field, 275, 304-305 filters, 287 Flash Exposure Lock, 260 frame size, 304 groups, 304-305 indoors, 303, 305-306 lens recommendation, 303 nighttime with flash, 305-306

One Shot AF mode, 273, 301, 304 outdoors in daylight, 303 playback, 143 shooting, 302-304 Single-point AF Area mode, 273, 301, 304 tips, 304-306 White Balance, 304 STM (stepping motor technology) lens, 8, 106 Strong Effect option, Shoot by Ambience setting, 89-90 sun exposure, 102 sunrise/sunset images, 312 Sunset option, Shoot by Light or Scene type setting, 94 swipe gesture, 19

· 7 ·

tap gesture, 17–18, 124 telephoto lens, 9, 251 television playback, 174-175 10-Second self-timer/remote control mode, 55 text, entering, 321–322 35mm equivalent focal lengths, 9 thumbnails, 149-150 TIFF file format, 70 Tilt-Shift for EOS (TS-E) lens, 121 Time code option, Movie Menu 2, 134-135 Tool Palette, Digital Photo Professional, 193-194 top of camera controls, 22–24 **Touch Control option** Live View display, 124–125 Setup Menu 3, 35, 47 Touch Shutter feature, Live View display, 124, 127–128 Touch to Silence option, 20 touchscreen cleaning, 17 continuous autofocusing, disabling via, 108 disabling, 19 entering data, 321 file format settings, changing, 65

gestures, 17–18 menu selection, 31 menus, adjusting, 31-32, 33 Quick Control icon location, 101 response settings, 19 sensitivity control, 19, 35 Shoot by Ambience setting, adjusting, 92 sound effects, 19-20, 50 thumbnails, viewing, 149-150 touch control, 19, 35, 47 touch shutter, 127-128 zooming, 157 Toy Camera filters, 326 tripods disabling image stabilization when using, with HDR Backlight Control mode, 87 slow shutter speed, 213, 312 socket for, 30 TS-E (Tilt-Shift for EOS) lens, 121 Tungsten setting, White Balance, 282, 283 Tv mode. See Shutter-priority Autoexposure mode 2-Second self-timer/remote control mode, 55

· 4 ·

UHS (Ultra High Speed) memory cards, 20 upsampling, pixels, 66 USB cables, 106, 180–181 USB connection terminal, 30

. U .

vertical axis, White Balance grid, 286, 291
vertical orientation, 154
VF Display Illumination control, Custom
Function 12, 343
VF Grid Display option, Shooting Menu 1,
38–39
vibration compensation. See image
stabilization
video albums, 331
video playback, 174

video snapshots, 135, 331-332 Video System option, Setup Menu 3, 46, 135, 174 videos. See movies viewfinder adjusting, 15-16 battery status, 38 camera information, viewing, 38 covering, 102 customizing display, 38-39 Live View mode, switching to, 100–101 shutter speed presentation, 216-217 Viewfinder Level option, Shooting Menu 1, 39 vignetting, 240, 326 Vivid option, Shoot by Ambience setting, 89

• W •

waking up camera, 15, 22, 34, 40, 100 lenses, 15 Warm option, Shoot by Ambience setting, 89 Warnings in Viewfinder option, Custom Functions menu, 39 waterfall shots, 312 WFT Pairing software, 179, 183-184 White Balance close-up photography, 315 color temperature, 279-280 correcting colors with, 279-281 custom, 283-285 defined, 265 magic-hour light, 313 outdoors with flash, 256 Quick Control screen setting, 126 RAW Image Processing option, 190 settings, adjusting, 281-283 settings, fine-tuning, 285-287 settings, recommended, 301 White Balance Bracketing, 35, 235, 288–293 White Balance Correction, 285–287 White Balance Shift, 35, 286 whole frame (Evaluative) exposure metering, 130, 221 wide-angle lens, 8-9 Wi-Fi connecting to computer via, 181–184 disabling, 101 enabling, 47 functions, 322-324 shooting remotely, 106 status, 37, 123 wildlife photography, 9, 311 Wind Filter/Attenuator option, Movie Menu 2, 138 wireless control, Canon EOS Utility software, 323 wireless downloading, 186 wireless printing, 324 wireless remote control, 55, 323 WTF pairing software, 179, 183-184

· X ·

X-Rite ColorMunki Display, 201

• Z •

Zone AF mode, 116, 269, 270, 271
Zoom icon, 118–119
zoom lens, 10, 11, 277
zoom ring, 12–13
zooming
button, 157
Face+Tracking autofocusing, 125
lenses, 10, 11, 277
Live View mode, 118–119
movement, allowing, 311
overview, 11–13
playback, 156–157
touchscreen, 157

About the Author

Julie Adair King is the author of many books about digital photography and imaging, including the best-selling Digital Photography For Dummies. Her most recent titles include a series of For Dummies guides to Canon dSLR cameras, including the Canon EOS Rebel T5i/700D and Canon EOS 60D. Other works include Digital Photography Before & After Makeovers, Digital Photo Projects For Dummies, Julie King's Everyday Photoshop For Photographers, Julie King's Everyday Photoshop Elements, and Shoot Like a Pro!: Digital Photography Techniques. When not writing, King teaches digital photography at such locations as the Palm Beach Photographic Centre. A native of Ohio and graduate of Purdue University, she resides in West Palm Beach, Florida.

Author's Acknowledgments

I am deeply grateful for the chance to work once again with the wonderful publishing team at John Wiley and Sons. Kim Darosett, Jennifer Webb, Steve Hayes, Teresa Artman, and Patrick Redmond are just some of the talented editors and designers who helped make this book possible. And finally, I am also indebted to technical editor Dave Hall, without whose insights and expertise this book would not have been the same.

Publisher's Acknowledgments

Executive Editor: Steven Hayes

Senior Project Editor: Kim Darosett

Senior Copy Editor: Teresa Artman

Technical Editor: David Hall

Editorial Assistant: Anne Sullivan

Sr. Editorial Assistant: Cherie Case

Project Coordinator: Patrick Redmond

Cover Image: Front Cover Image: ©iStockphoto.

com / Spotmatik; Camera courtesy of Julie Adair King. Back Cover Images:

Julie Adair King

Printed and bound by CPI Group (UK) Ltd, Croydon, CR0 4YY 09/06/2025

14685922-0002